Surrealists in New York

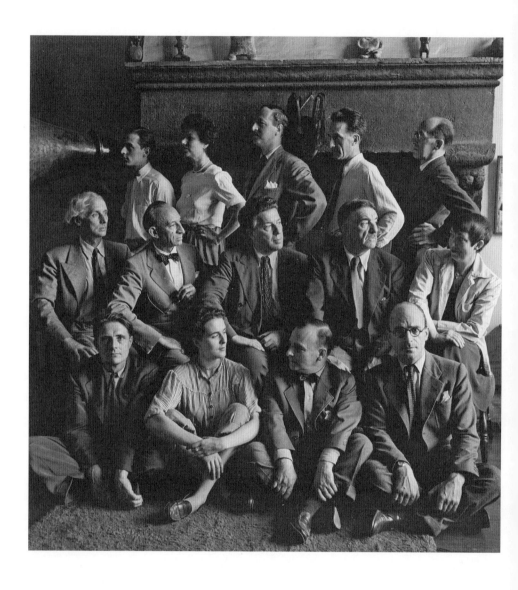

CHARLES DARWENT

Surrealists in New York
Atelier 17 and the Birth of Abstract Expressionism

*To Adrian Lynch (1950–2021)
and Benedict Cruft (1949–2022).*

Frontispiece: The European art world in exile, New York. Photographed by Hermann Landshoff, 1942. Back row: Jimmy Ernst, Peggy Guggenheim, John Ferren, Marcel Duchamp, Piet Mondrian; middle row: Max Ernst, Amédée Ozenfant, André Breton, Fernand Léger, Berenice Abbott; front row: Stanley William Hayter, Leonora Carrington, Frederick Kiesler, Kurt Seligmann.

First published in the United Kingdom in 2023 by
Thames & Hudson Ltd, 181A High Holborn, London WC1V 7QX

First published in the United States of America in 2023 by
Thames & Hudson Inc., 500 Fifth Avenue, New York, New York 10110

Surrealists in New York: Atelier 17 and the Birth of Abstract Expressionism
© 2023 Thames & Hudson Ltd, London

Text © 2023 Charles Darwent
Page 37 extract from Christophe Boltanski,
La cache © Éditions Stock, 2015

It has not been possible to make contact with the rights owners of all the quotations that require clearance that appear in this book. Thames & Hudson will be happy to amend copyright credits in future printings of this book.

All Rights Reserved. No part of this publication may be reproduced or transmitted in any form or by any means, electronic or mechanical, including photocopy, recording or any other information storage and retrieval system, without prior permission in writing from the publisher.

British Library Cataloguing-in-Publication Data
A catalogue record for this book is available from the British Library

Library of Congress Control Number 2022945745

ISBN 978-0-500-09426-6

Printed and bound in China by Shenzhen Reliance Printing Co. Ltd

Be the first to know about our new releases, exclusive content and author events by visiting
thamesandhudson.com
thamesandhudsonusa.com
thamesandhudson.com.au

Contents

Introduction . 6

CHAPTER 1 **Before** . 14

CHAPTER 2 **The New School** 36

CHAPTER 3 **The French Arrive** 58

CHAPTER 4 **Towards A New Painting** 80

CHAPTER 5 **Pollock Makes A Print** 102

CHAPTER 6 **To Eighth Street** 124

CHAPTER 7 **Blake, Bourgeois, Miró** 146

CHAPTER 8 **After** . 168

Acknowledgments . 188
Notes . 189
Further Reading . 214
Picture Credits . 215
Index . 218

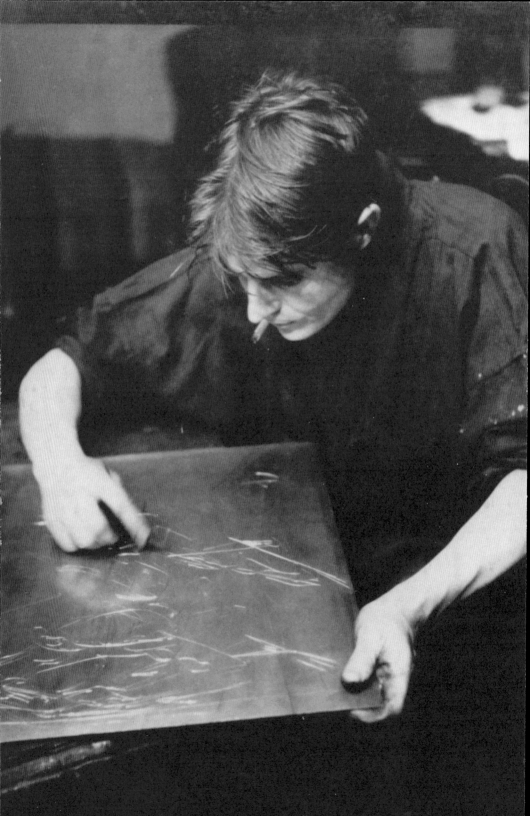

Introduction

In 1957, in the catalogue essay to a show at the Whitney Museum, the American artist Robert Motherwell made an unexpected claim. 'I have only known two painting milieus well personally,' Motherwell wrote. 'The Parisian Surrealists, with whom I began painting seriously in New York in 1940, and the native movement that developed in New York that has come to be known as "abstract expressionism", but which genetically would have been more properly called "abstract surrealism".'[1]

Two things were surprising about his remarks. The first was that Motherwell was himself counted among the founders of abstract expressionism, along with Jackson Pollock, Mark Rothko and Willem de Kooning. All four were American (in De Kooning's case, by adoption) – the movement they had founded ergo likewise. The second surprise was the place Motherwell had chosen to stake his claim: in a catalogue for the Whitney Museum of American Art.

In 1957, with Khrushchev threatening the US with thermonuclear annihilation, Motherwell's musings seemed to verge on the treasonous. What he appeared to be saying – what he *was* saying – was that AbEx (as it was by then known to the cognoscenti) was neither new nor native. It had been born of a brief liaison between America and France, and its paternity was French. And he was saying all this at the Whitney, the lion's den of American art.

–––––

That Motherwell's remark should, in 1957, have seemed mildly shocking is, at least peripherally, the story of this book.[2] The factual basis of his claim was beyond question. Sensing the Nazi disaster that was about to break over Europe, Parisian artists had begun to arrive in New York even before the outbreak of the Second World War. As in Paris itself, the majority of these were surrealists. By 1941, the heavy hitters of surrealism – André Masson, Salvador Dalí, Max Ernst – had made their way to Manhattan by various and often perilous routes. So, too, the so-called Pope of Surrealism, André Breton. Along with these came boatloads of lesser-known names: the Swiss painter Kurt Seligmann; an Englishman

Stanley William Hayter, date unknown.

8INTRODUCTION

called Stanley William Hayter; and the French artist Louise Bourgeois, who, though not a surrealist, was deeply influenced by surrealist ideas.

This migration had come about at a crucial moment for surrealism. In Paris, Breton, author of the two surrealist manifestos, ruled as an absolute monarch. By 1940, though, his autocratism – courtiers might be dismissed for liking people Breton did not, or for backing non-Bretonian political horses – had made him an unpopular ruler. So many people had been exiled from his court, or simply left it, that Breton's rule was in danger. It rested on adherence to a belief that automatism – the making of artworks direct from the unconscious, via trances or games or engineered accidents – was key to what surrealism was. Now, in New York, this assumption could (and would) be questioned.

This freedom was not the only novelty for the arriving Parisians. If the view of America from across the Atlantic had been broadly antagonistic – a place of slavers and capitalists – what exiles such as André Masson found there was something rather different. Long before the skyscrapers of Manhattan, there had been another America, and it still lay deep beneath the concrete streets; a place of Navajo sand painters and Apache shamans. The French could spot this country in the most unexpected locations: at the Central Park Zoo, or in the decorous exurbs of Connecticut. But the excitement they felt at it was real. At the heart of surrealist belief lay the worship of the Freudian unconscious, a wellspring of creativity that could only be tapped by circumventing the finger-wagging superego of civilization. Now, in this many-layered place, the world became the unconscious, and vice versa.

Key to this understanding was another Parisian émigré who had left France on the same boat as Breton and now painted his Greenwich Village flat with his own surrealist murals: the anthropologist Claude Lévi-Strauss. For the rest of his long life, Lévi-Strauss would acknowledge the debt his anthropological method owed to surrealism – its fascination with the 'primitive', its juxtaposing of unalike things. But the young scholar also acted as a guide to Masson and the rest in their exploring of pre-Columbian and Mesoamerican cultures, helping them amass the collections of artefacts they would ship back to France at the end of the war. These would appear, again and again, in the art they made in America.

INTRODUCTION

It was, for the French, a variously New World. Old hierarchies, old iconographies were supplanted by new ones. The excitement of this is palpable above all in the outpouring of work made in America by André Masson, evident both in its quantity and in its novelty. But it also meant that the surrealists, those giants of the European avant-garde, were once again made students. Where in Paris they had taught, now in New York they learned. This was to be of huge importance to the young Americans who had watched their arrival – Lipchitz! Max Ernst! – with a mixture of excitement and trepidation.

Unlike in Europe, there had never been an American equivalent of the artist-aristocrat. If Wilde quipped that good Americans went to Paris when they died, good American artists had long done so in life. The proletarianizing of those who had stayed behind had taken on a more literal meaning when, with the collapse of the art market during the Depression, they had become employees of the state under Roosevelt's New Deal. Of the four abstract expressionists mentioned above, all but Motherwell had made their work in the pay of the Federal Art Project.

What this meant was that domestic American avant-garde art was something of a contradiction in terms. Throughout the 1930s, this fact had been brought brutally home by the kind of work sold in New York galleries. Where Masson et al. were in hot demand from US collectors and museums, American artists had found it difficult to get exhibitions in Manhattan, let alone to sell there. When they did, it was at a fraction of the prices fetched by European art. The arrival of the surrealists only seemed set to make this situation worse.

And yet it didn't. The clearest evidence of what happened next is provided by the change that took place in the work of Rothko, Motherwell, De Kooning and Pollock in the years between 1940 and 1946. Before that time, all four were broadly representational artists and, by European standards, old-fashioned. It is clear from works such as Pollock's famous drip paintings of 1947, or Rothko's miasmic planes, that one of the greatest cultural exchanges in modern history had taken place. The form this took has been the subject of much discussion during the past thirty years, most notably in Martica Sawin's magisterial study *Surrealism in Exile*

10 INTRODUCTION

and the Beginning of the New York School.[3] Even this, though, shies away from the thorny questions of where and how the exchange had happened.

————

At its most basic, the problem was one of language. Robert Motherwell, always the odd one out, was alone among the four artists in speaking passable French. The other three spoke little or none. From the other side, Breton set out from his arrival in America not to learn a word of English, and, in his five years there, didn't. My reading of the Masson literature finds him using a solitary English word between 1941 and 1946, and that word is 'chocolates'. Even had Pollock managed to spend time with him socially – and, other than perhaps at a couple of private views, there is no suggestion that he did – the two could have said nothing to each other.

And yet, clearly, there was an exchange, and that exchange was direct. Masson's work was already well known in New York before the war, having been shown there by Pierre Matisse and Curt Valentin and bought and exhibited by the Museum of Modern Art. It was his physical presence in the city that changed Pollock's work. And since that presence could not have involved speech, the exchange must have taken some other form. This book looks at the place where Pollock and the rest saw surrealism in action, the Parisians at work. That place was a small print workshop called Atelier 17.

————

While Stanley William Hayter (1901–1988) and the studio he created are very well known indeed to printmakers and their followers, they are much less so elsewhere. The etchers and engravers who trained at Atelier 17 between 1926 and 1988 went on to influence printmaking all over the world, through both their teaching and their work. The studio's name and that of its founder have a quasi-mythic status in the world of print that is entirely unmatched outside it.

History erases itself. For the last forty years of its life, Atelier 17 was indeed a print workshop, in the sense that its main business was the making of prints. This is not to suggest that it was commercial; indeed, possibly not enough so. Hayter had trained first as a scientist

INTRODUCTION

and artists came to his studio as to a laboratory, to experiment, to push boundaries. It was a place of trial proofs, of one-offs and small print runs. As a result, evidence of what went on there is surprisingly sparse. Yet the experiments that were made at Atelier 17 in its first two decades, the boundaries that were pushed there, were to be among the most influential in 20th-century art.

There are many people now alive who remember the atelier in its several, peripatetic iterations in Paris after Hayter returned there from America in 1950. The number who knew it before 1949 is tiny and dwindling. It is thus the more recent, print-focused Atelier 17 that has lodged in the historical imagination: Hayter has become a master printer, a magician of intaglio, and that is all. He was both of those things, but also very much more.

The previous Ateliers 17, first in Paris and then, from 1940 to 1950, in New York, had been rather different. Yes, prints were made in them and experiments in printing undertaken, not least in an attempt to recreate the lost relief method of William Blake. But for all that, the emphasis was on the experiment, not the prints that came from it.

Hayter had gone into printmaking with the quixotic idea of rescuing the burin – an engraving tool with a mushroom-like handle at one end and a sword-sharp edge at the other – from the desuetude into which it had fallen. His reasoning for this was that the burin, being pushed rather than pulled, was an active rather than a passive instrument. Its motion preempted the hand, and the control of the hand. This, in his thinking, made it the perfect tool for modernism, constantly outwitting conscious intent. For all that it had been the instrument of choice of Dürer and Doré, the burin was by nature anti-classical.

Rather than the print, then, the locus of art-making at the early Ateliers 17 had been the plate. Prints, before 1949, had been mere records of an action that had taken place on a plane of copper or zinc, of gouging and twisting. Hayter encouraged his studio's followers to work directly on metal, *alla prima*, without premeditation or underdrawing. The mark of the burin was thus a trace not merely of the hand but of the unmediated mind: what Freud would have called the pre-conscious.

Strategies of this kind – methods that might lead to a mode of working that could loosely be called 'automatic' – were common

12 INTRODUCTION

enough in a prewar Paris in thrall to surrealism. Even so, Atelier 17 in
rue Campagne-Première attracted a stellar cast of fans, from Picasso
to Ernst and just about everyone in between. When Hayter moved the
studio to New York in 1940, however, it found itself quite unique.

—

It was not just a unique place, but a unique time. Everybody at Atelier 17
was learning, and their interests and excitement were unexpectedly alike.
If, thanks to Lévi-Strauss, Masson and Ernst were now spellbound by
Native American art, Pollock had come to it, separately and at the same
time, via a show of Navajo sand painting at the Museum of Modern Art.
And where Americans such as him, horny-handed from the Federal Art
Project, might sneer at the apparent frivolity of a Dalí or a Duchamp,
what they found at Hayter's workshop was a surrealism that was arti-
sanal and muscular; of the hand. There was no need for language when
you could watch Masson or Miró at work on a plate.

One of the many extraordinary things about Atelier 17 in New York
was the role played there by women. This was particularly true of the
later workshops, from 1945 to 1955. Some of the greatest names in
American printing would emerge from their dingy rooms, many of them
female. (And not just American: the studio was also to be enormously
influential in Chile, Japan and elsewhere).

An excellent scholarly study of these has recently shown that more
than half of the printmakers at the atelier during its last decade in New
York were women, at a time when American women in general were
being driven back into prewar 'feminine' roles. I strongly recommend
that Christina Weyl's book *The Women of Atelier 17* be read in conjunc-
tion with mine.[4]

Relatively few of the artists who emerged from Atelier 17 would
become famous, regardless of gender. That would have been (and still
is) true of art schools and workshops in general. This book covers a spe-
cific period, from the arrival of the first Parisians in New York during
1940–41 to the departure of the last – Joan Miró – in 1947. It is the story
of an overlap of cultures: when the Europeans returned home, Atelier 17
became a different place. Given the liberal nature of Hayter's attitude
to opening hours – the studios were available twenty-four hours a day

INTRODUCTION 13

to those with keys – it is impossible to say how many young Americans passed through them while Yves Tanguy, Masson et al. were working there: a very rough guess would be between one and two thousand. If few of those went on to become what what would now be called 'canonical', the ones that did would be very canonical indeed. That Louise Bourgeois, Jackson Pollock, Mark Rothko, Willem de Kooning, William Baziotes and Robert Motherwell all made art in Hayter's two grubby rooms is remarkable.

———

Writers on art are, I think, justly wary of the phrase 'forgotten masterpiece'. It is in the nature of masterpieces that they are not forgotten: the term is an oxymoron. Similarly with 'inexplicably overlooked', when applied to events in art history. There is almost always an explanation.

If the broad forgetting of Atelier 17 in New York is easily explicable, it is an omission that seems historically unfair. The other aim of this book is to right a wrong. None of the key American figures in the story worked primarily as printmakers, and some of them hardly did so at all. Their sole experience of the medium was at Hayter's American atelier. But collectively, the cast that assembled in the studio's two New York spaces – the first in West 12th Street, the second in East Eighth Street – helped effect perhaps the greatest shift to take place in mid-century culture. In 1939, Paris had been the unchallenged world capital of modern art. By 1949 its place had been taken by New York. Much of this exchange occurred at the two Ateliers 17, both sooty-windowed places that smelled of hot wax and oil and were not much more than eight metres (twenty-six feet) square. They were unlikely *Wunderkammern*; little rooms of infinite riches.

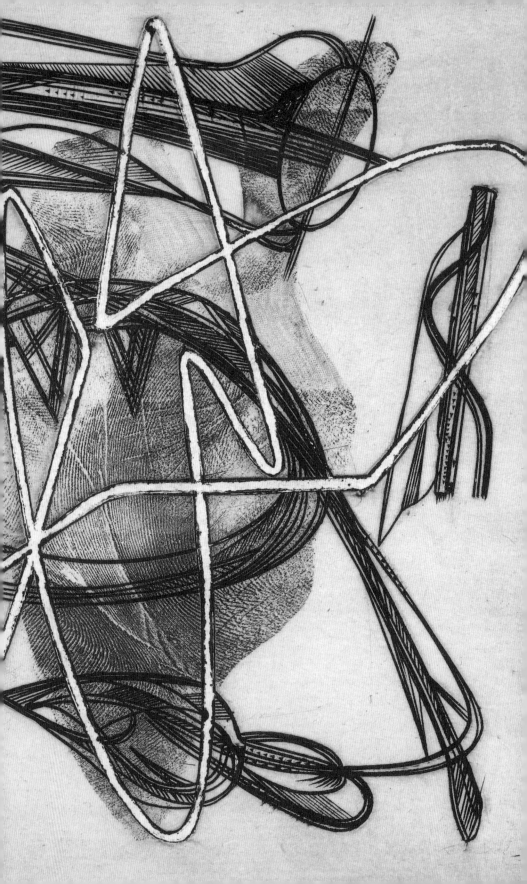

Before

CHAPTER 1

Probably, no modern British artist has been so influential internationally.
'Hayter, Stanley William', *Oxford Dictionary of Art*[1]

In the early autumn of 1926, Edith Fletcher saw an unexpected figure lumbering between the tram tracks of the boulevard du Montparnasse. Fletcher, an American painter, was sitting on the terrace of the Le Select café with the man she was to marry that December, a twenty-five-year-old Englishman called Stanley William Hayter.[2] Half a century later, Hayter would recall his first sight of his wife-to-be's late fellow pupil at the Art Students League in New York, newly arrived in Paris: 'like a stoutish baby staggering with no seeming trust in the security of biped progress...a bearlike figure [in] a bright mustard suit lively enough to scare the horses...and a walrus moustache'.[3] Fletcher called out to the bear, who came over. His name was Alexander Calder.

It was a propitious meeting. Both Calder and Hayter had come to the city earlier that year, with the same motive and similar histories. Although both now meant to be artists, each had trained and worked in other fields: Calder who had studied engineering before working as a newspaper illustrator, and Hayter as a chemist and geologist with the Anglo-Persian Oil Company in what was soon to be called Iran. For both men, the jettisoning of science for art was a reversion to familial type. Calder's parents were artists, as was his paternal grandfather; Hayter, for his part, had four successive generations of artists behind him.

The pull of Paris as the home of modern art had been strong on both of them, too. Calder had worked his way across the Atlantic from New York on a freighter to get there while Hayter, having thrown in his job in Abadan, arrived from London on a second-hand motorcycle. Bar a decade in New York in the 1940s, he would stay in Paris for the rest of his life. Calder would be there for the most part of seven years, returning to America in 1933. His friendship with Hayter would last until his death in 1976. For much of that time, the two men worked, and made work, together, in the print studio that Hayter had founded in Paris in 1927 and then, in 1940, moved to New York.

Twenty years after that meeting in the boulevard du Montparnasse and by now rather famous, Alexander Calder was one of fourteen American sculptors asked to write about his work in the avant-garde magazine *The Tiger's Eye*. Surprisingly, he wrote not about his mobiles or stabiles, but about his printmaking.

'[F]or the past several weeks, I've been making etchings,' Calder said, 'and what with the acid spots, which itch, and the black of the "ground" all over my hands, the stickiness of everything, and the mass of dirty rags and newspapers, to say nothing of the fire hazard, I feel rather as though I were once again in the "black gang" of a ship.' His favoured technique, he went on, was 'to spit on the plate, and then dump a little acid on it, and then watch the solvent and the dissolvent fume and bubble, all the while tickling the plate, and brushing away the bubbles, with a partridge feather'.[4]

The interesting thing about Calder's piece is the insistently unaesthetic – even anti-aesthetic – nature of both its style and the thing it describes. This is printing (and writing) not as effete but as manly, part of a masculinizing of the arts after the Second World War. The rough-handed incidents Calder recalls may well have taken place in Hayter's transplanted New York studio, where he made work throughout the 1940s. Earlier prints, though, had been pulled in the studio's first, Paris iteration. None of these survives, although Hayter recalled one that had been made 'by hammering a wire sculpture into a log of wood so that the indentation could be printed as a white line on a black wood-grained background'.[5]

Calder's lost work and the place it was made were inextricably linked. After studying with the master printmaker Józef Hecht, Hayter had set up a teaching workshop of his own, first in a rented space in the rue Moulin Vert and then, when this became too small – his fame as a teacher quickly spread – in his new wife's studio in the Villa Chauvelot, near the Paris abattoir. This last began to attract the attention of neighbours such as Fernand Léger and Ossip Zadkine.[6]

It was with its move to a bigger space in the rue Campagne-Première in 1933, though, that the workshop was to acquire both its name and

BEFORE 17

a central place in the Parisian avant-garde.[7] By then, the studio had become a necessary stopping-off point for the young British and American artists who had flocked to Paris in the 1920s in search of the modern. One, the painter Julian Trevelyan, suggested Hayter name his new studio after its street number. It became, accordingly, Atelier Dix-Sept, or, more commonly, Atelier 17.[8]

———

For some idea of what Calder's lost print may have looked like, we need to turn to a work not on paper but on raw canvas, and made not by Calder but by Hayter. This, a painting called *Composition with String* (1934), is an intriguing object (FIG.1). Although what would later come to be known as 'combine painting' was no longer a novelty by the 1930s – Picasso and Braque had collaged found objects onto their canvases two decades before – Hayter's twine is doing something new.

Marooned on their islands of zinc white, the two shapes of *Composition with String* are intently equivocal. They beg to be read, *à la* Wittgenstein's rabbit-duck, equally as biomorphic – representing something that might exist – and as wholly abstract. They raise parallel and overlapping questions. Were the string shapes premeditated or, in their throwaway medium, simply flung at the canvas? Are they drawing (or painting) or are they sculpture, to be seen as two-dimensional or three?

These ambiguities were at the heart of both Calder and Hayter's early Paris work. By the summer after their meeting, Calder had begun to ask the questions that would preoccupy him for the next fifty years. Hayter recalled his new friend making a portrait of the tennis player Helen Wills, a piece dated 1927 and now in the collection of the Calder Foundation.[9] Seen in a photograph, this appears as a line drawing, done in black. And so it is, although its line is drawn not in ink or graphite but in wire. In the summer of that same year, Calder would join the Hayters at St Tropez, where he would continue to work on the circus figures – the *Cirque Calder* – that would finally bring him to the attention of the Parisian avant-garde.[10] Where *Helen Wills* had evoked motion through form, these new works would now actually move. They would also invert the idea of sculpture-as-drawing by taking the two-dimensional wire line back into three dimensions: drawing as

André Kertész, *Portrait of Alexander Calder with* Cirque Calder, 1929.

sculpture and performance. That Calder might one day flatten one of these works by hammering it into a piece of wood seems just another step along the road – a two-dimensional material made three-dimensional and then flattened again into two dimensions, to produce a work that evoked the very volume its making had destroyed.

Hayter, for his part, approached the same problem from the opposite direction: while Calder was hammering metal filaments into a surface, he was busily gouging them out. Under Hecht, he had learned the principal techniques of intaglio printmaking, although lessons were restricted to the various methods of etching.[11] These did not include engraving, the incising of forms into a metal plate using a burin. It was this that would become the object of Hayter's particular fascination.

Engraving had, by the 20th century, lost its relevance as an art form, being by now used mainly for the illustrative reproduction of paintings. The method's appeal to Hayter lay in its directness, its lack of the intervening grounds and acids called for in etching. From the start, he steered his students away from making preparatory drawings on the

BEFORE

19

plate, encouraging them to work *alla prima*, so that drawing and sculpting became the same thing.[12]

In time, the plate at Atelier 17 would come to be at least as important as the print that was pulled from it; if, indeed, a print *was* pulled from it. 'I have engraved three hundred plates and helped to make five thousand more,' Hayter would recall in middle age, boasting not of the prints he had worked on but of the things that had led to them.[13] It is typical that what he recalled of Calder's lost print was not the print itself but the plate that prefigured it.

How many of the five thousand plates Hayter had helped make ended in editions of prints is impossible to say. Plates are singular and unglamorous things, often, at Atelier 17, given to the people who had made them to take home for safekeeping. They were not always safely kept. Much later, in 1966, a stack of old copper-faced zinc plates would be found among the effects of an American artist by his widow. These had been made at Hayter's studio in New York in 1944. They were the only engravings the artist had made; the only prints known to have come from them were pulled in 1967, the year after their rediscovery. By that time, the man who had engraved the plates – Jackson Pollock – had been dead for a decade.

This ambiguity in its founder's own mind about precisely what his creation was may, together with a certain diffidence in his nature, help explain why Atelier 17 is very much less well known outside the world of printmaking than in it. Hayter's studio is certainly famed as a print workshop, but printing itself tends to rank lower in the public mind than painting or sculpture. Yet printing is by no means the only thing that went on at Atelier 17. It is arguable that it was not even the most important one.

It would be easier to list the avant-garde sculptors and painters who did not pass through the atelier's doors between 1927 and 1947 than those, from Picasso to Pollock, who did. What they took away from the experience would be far from limited to printmaking. Hayter's glee in seeing boundaries pushed made the workshop a creatively febrile place, where destruction and failure and occasional disaster were a cause for celebration. The enlivening effect this might have had is suggested by the experience of the young Oregon-born artist John Ferren.

20 CHAPTER 1

It was inevitable that the twenty-five-year-old Ferren, arriving in Paris from San Francisco in 1931, should be drawn to Hayter's workshop. Trained as a stonecutter but by now working as a painter, he was set on reviving the forgotten 19th-century French craft of plaster printing: pressing an engraved and inked plate into a framed dam of wet plaster of Paris, which would be lifted away when dry. The resulting works would remain among the most beautiful Ferren was to make, and the most innovative – paintings that were low-relief sculptures that were prints; prints that dispensed with paper. As was typical, these fomented decades of experiments at Atelier 17, including ones where the plaster relief itself became a vestigial printing plate.

The works Ferren made at the studio also drew him to the attention of Pierre Matisse, who, in 1936 and 1937, gave him a series of one-man shows at his gallery in New York. Some of the plaster works from these – *Untitled (No. 34)* is one – would be among the first purchases made by Solomon R. Guggenheim for the founding collection of the museum that would bear his name. Thus, from the mid-1930s, Atelier 17 was already the nexus of a transatlantic cultural trade, in which a French gallerist in New York might show work made by an American artist in Paris.[14]

––––––

If Ferren's plaster reliefs were revolutionary in terms of technique and material, they were also progressive formally. The Guggenheim's *Untitled (No. 34)* is up-to-the-minute in its fascination with line; more specifically, in its use of line – a flat, static thing – to imply volume and motion (**FIG.2**). This, too, showed the influence of Atelier 17 and of its founder's fascination with what he called 'the nature of space in a linear world'. The helical figure to the right of *Untitled (No. 34)* seems to corkscrew upwards, held together and moored in place by the guy-rope lines between its curved forms. It calls to mind Naum Gabo's *Torsion* studies of the same date, or the lines sketched invisibly in space by the filaments of Alexander Calder's new hanging mobiles, the first of which were made in 1932. Ferren's lines also echo a contemporaneous change in Hayter's own work.

In 1930, he had engraved a print now in the collection of the Museum of Modern Art in New York. This, *Rue de la Villette,* is a strange, unresolved

work in which the steepness of the titular road is suggested by a trapezoid grid laid over a conventionally soft-cubist street scene (FIG.3). Uncomfortable though it is, Hayter's composite print reads like a manifesto: goodbye cubism, hello geometric abstraction. Central to this was a new focus on line not as a means of reproduction, but as a thing in its own right.

The Renaissance had pitched Venetian *colore*, or colour, against Florentine *disegno* – roughly translatable as 'drawing', although perhaps more usefully so as 'line'. If colour was emotional, line was a thing of invention, of intellect; of the mind. The two jockeyed for position for centuries, one or the other prevailing in different places and at different times. Paris, in the 1930s, was to come down heavily on the side of *disegno*. For this it had in great measure to thank an artist working not in Paris but in Dessau, Paul Klee.

In 1918, the English critic Roger Fry had preempted Klee on line. 'It... seemed to me likely that the revolution in art which our century had witnessed would...enable [the artist] to find fuller expression in line drawing than has been the case since the 14th century,' Fry wrote. 'The complexity and fullness of matter, on the one hand, and the bare geometric abstraction of mind, is brought, not, indeed, to a point, but literally to a line.'[15] As Cézanne had freed the plane from the need to represent, so now the line was made autonomous. Squaring Fry's circle – evoking nature through unnatural curves and lines – would be left to Klee.

He had arrived in Paris the year before Hayter and Calder, and taken the city by storm. In 1925, teaching at Walter Gropius' Bauhaus, Klee had published what would be his most widely influential theoretical work, the *Pedagogical Sketchbook*.[16] From its opening words, this nailed its linearity to the mast: 'An active line on a walk, moving freely, without goal. A walk for a walk's sake. The mobility agent is a point, shifting its position forward.'[17] For thirty aphoristic pages, Klee sketched out a new topography of art, with the line – horizontal, recessional, parallel, passive, active, dynamic and static – the means by which it would be charted. *Nulla dies sine linea* – 'Never a day without a line' – he would later write in his sketchbook, echoing Pliny's *Natural History*.[18] In Klee's hands, the line took on a life of its own, the artist merely the agent of its walking.

CHAPTER 1

In that same year, 1925, Klee had his first exhibition in Paris, at the Galerie Vavin-Raspail.[19] At midnight on the night before it closed, another show opened, also with his work in it: 'La Peinture surréaliste' at the Galerie Pierre in rue Bonaparte.[20] Coming just a year after the publication of André Breton's *Manifeste du surréalisme*, this was the first ever exhibition of surrealist painting. It featured, along with Klee's, the work of Max Ernst, Joan Miró, Man Ray, Giorgio de Chirico and Picasso. Klee was represented by a work of 1921 which he had called *Zimmerperspektive mit Einwohnern (Room-Perspective with Inhabitants)* – illustrated in the small catalogue to the show (FIG. 4). Its title in French, however, was given not as *Vue d'une chambre avec les résidents* but *Chambre spirite (Spirit Room)*. The translation was Breton's.

This change of emphasis was intentional. Ernst, Miró and Masson had returned from the opening of Klee's Vavin-Raspail show agog at what they had seen. Typical of the work the newcomer was making at the time was the mixed oil and watercolour painting *Komödie (Comedy, 1925)*, shown in Paris and now in the Tate collection. To the newly formed surrealists, the appeal of such a work lay in its menagerie of cartoonish figures standing in front of an implied recessional space: creatures from an imaginary world or, perhaps, a dream. But the figures also suggested a quite separate quality in Klee, which was his grasp of line.

This interplay of uncanniness and graphic certainty was even more pronounced in the *Zimmerperspektive* – what Roger Fry would have called a 'purely ideal, logical and intelligible drawing', and yet one that evoked a world as wholly imagined and irrational as that of *Komödie*. Klee's title had played on the work's logical/illogical dichotomy; Breton's dispensed with the logic. In his determination to co-opt Klee as a surrealist, he positioned him purely as a purveyor of dreams. It worked. The critic and surrealist apologist René Crevel was soon describing Klee as a 'dreamer...who frees a swarm of small lyrical lice from mysterious abysses'.[21]

German critics, for their part, were delighted to discover that one of their own was now among the leaders of an avant-garde movement rapidly taking over Paris. Soon they were not only claiming Klee as a surrealist, but Germany as the natural home of surrealism. Predictably,

BEFORE 23

this enraged the autocratic Breton. When Klee's friend, the Berlin critic Will Grohmann, dared to suggest in the pages of *Cahiers d'art* that the creator of *Zimmerperspektive mit Einwohnern* 'was...by no means a dreamer [but] a modern man who is a professor at the Bauhaus', things came to a head.[22] As was to happen to many another artist in the future, Klee was consigned to the Bretonian outer darkness. 'Masson and I discovered Paul Klee together,' Miró wrote soon afterwards. 'Éluard and Crevel are also interested in [him], and have even visited him. But Breton despises him.'[23] By then, though, the damage was done. An artist for whom line was as important as imagination – indeed, for whom the one allowed access to the other – had been introduced into the surrealist fold.

———

These things were still in the air when Stanley William Hayter, known always as Bill, alighted from his motorcycle in Paris the following year. The decision to turn his own studio into a place for teaching seems initially to have been wished on him by a group of his new wife's friends.[24] Friends of his own warned him against it: 'We all criticised him, saying that it was difficult enough to *arrive* in painting or printmaking by oneself without a roomful of students tacked on behind,' recalled the English artist Anthony Gross, who had met Hayter during a mutually brief stay at the Académie Julian in 1926.[25]

When the heavily pregnant Mrs Hayter left her husband and returned to America in 1929, her family allowance went with her. As Gross had predicted, the first years of what would become Atelier 17 were a struggle for survival. There was little money for experimentation and little space in which to experiment. The tensions of the years from 1927 to 1932 – an impulse to move forward without the luxury of being able to do so coherently – are clear in Hayter's *Rue de la Villette*. What happened next is equally clear from another of his works, *Oedipus* (1934), also in the collection of the Museum of Modern Art (FIG.5).

Where Hayter's earlier print had included passages of both abstraction and what might be called representation, *Oedipus* is straightforwardly abstract. If the uppermost form seems phallic and the fanged ovoid below it a possible *vagina dentata*, the work's power

24 CHAPTER 1

rests in its form rather than allusion. The swirling lines of *Oedipus* evoke both the web of unconscious desire and the remorselessness with which it is woven. There is a correlation between the thing suggested and the means of suggesting. The blurred areas in the middle of the print have been made with a *roulette*, a small, stippled wheel that leaves a pattern of fine dots when pressed into the metal surface of a plate. It is the double knot of deeply incised lines that tells the story of *Oedipus*, though, and these have been made with a burin.

The burin, archaically a graver, is a chisel, typically about 20 centimetres (8 inches) long and made of steel, with a wooden handle at one end and a razor-like cutting edge at the other. Where etching tools tend to be fine, the burin – in essence a gouger – looks, and is, more crude. Driving its point through a plate of copper or zinc to lift off a curl of metal requires a combination of skill and strength. Part of the tool's appeal for Hayter lay precisely in its connotations of workmanliness, not to say of manliness. Possibly because of this last, women working at Atelier 17 tended to be less enthusiastic about the burin; notably so, in New York in the late 1940s, a young Frenchwoman called Louise Bourgeois.

The burin's other appeal for Hayter lay in its mode of use. Etching needles, like pens or pencils, are drawn across the plate by the hand. The burin, by contrast, is pushed, preceding the hand rather than following it. This, for Hayter, made it an active rather than a passive thing, forward-looking where the etching needle looked backwards. It also made the burin more prone to accident, less open to conscious control. The story of *Oedipus*, the title of Hayter's new print, is of a battle between the conscious and unconscious minds. The burin and its trace became metaphors for this Freudian struggle.

———

Hayter was by no means the only person in Paris to be thinking in this way. Two years before he had arrived in the city, a year before Breton's *Manifesto of Surrealism*, André Masson had made his first automatic drawings.[26] The virtues of automatism – the accessing of the unconscious mind by means of bypassing the conscious one – had already been tried out by proto-surrealist poets, most famously in the book *Les Champs magnétiques* (1919) by André Breton and his friend Philippe

BEFORE 25

Soupault.[27] Breton, in the first manifesto, had gone so far as to prescribe 'pure psychic automatism...the dictation of thought in the absence of all control exercised by reason and outside all moral or aesthetic concerns' as the unique wellspring of surrealist verse. The condition that allowed this dictation to take place he saw as '[un état] psychique qui correspond assez bien à l'état de rêve' (a psychic state much like a dream).[28] This led, inevitably, to that strand of oneiric image-making most famously represented by Salvador Dalí: a topography of dreams. It was Masson, though, who, before meeting Breton, had brought the principles of *écriture automatique* to the visual arts, and his view of automatism was quite different.

One of his earliest such drawings, almost certainly dating from the spring of 1924, is in the collection of the Museum of Modern Art (FIG.6). A quick look at this suggests that automatism was not quite the cut and dried thing Breton would shortly make it out to be.[29] While most of the drawing looks to have been done randomly – Masson claimed to be able to put himself into a near-trance by singing or chanting – some areas have clearly been worked over: the three hands, for example, that cup curved forms suggestive of breasts or buttocks. Although he stressed the need for what he called 'speed of writing' in the initial drawings, Masson was quite open about his later overworking of these. In the 1960s, he would describe the process of working automatically: 'Physically, you must find a void in yourself: the automatic drawing taking its source in the unconscious, must appear as an unforeseen birth. The first graphic apparitions on the paper are pure gesture, rhythm, incantation, and as a result pure scrawl.' Tellingly, though, he went on: 'That is the first phase. In the second phase, the image (which was latent) reclaims its rights.'[30]

As with Klee's *Zimmerperspektive*, in other words, the automatic accessing of the unconscious was not an end in itself but the means to an end. Taking a line for a walk might call up a pattern that suggested an image; but image-making itself remained a conscious event, as, implicitly, did the making of art. Automatic drawing might even be done with a conscious end in sight: perhaps the most beautiful of Masson's early such drawings were the series of portraits he made of literary friends such as the poet Benjamin Péret. In Masson's mind, automatism could even be pressed into the service of something rather like representation.

On this, he found Breton ambiguous. 'In the end [Breton's] definition of automatism was confused,' Masson later wrote. 'No distinction between image in the Freudian sense, metaphor and analogy.'[31] The question of what, precisely, constituted automatism would come to a head in the 1940s, in New York rather than Paris, and be played out in a later Atelier 17. By then, paintings such as Masson's *Battle of Fishes* (1926), made by spreading sand on a glued canvas by hand and spontaneously adding arabesques of paint squeezed from the tube, had gained an American following (FIG.7). While the work had been ignored in Paris, *Battle of Fishes* created a stir among artists in New York when it was bought by MoMA in 1937. It was to be Masson's rather than Breton's automatism that would prevail.

Masson was the only original member of the surrealist group who had been working as a printmaker at the time of its emergence. His lithographs appeared in *Simulacre* (1925), a book of verse by his friend Michel Leiris, to be followed by prints in such sallies into surrealist erotica as Louis Aragon's *Le Con d'Irène* (*Irene's Cunt*, 1928) and Georges Bataille's *L'Histoire de l'oeil* (*The Story of the Eye*, 1928). In 1929, though, Breton's *Second Manifesto of Surrealism* commanded members to commit to collective action – to place the movement, as Breton put it, at the service of the revolution. Masson and others refused, breaking with the surrealists.

The *Second Manifesto* had also contained a vituperative attack on Masson's friend Bataille, whom Breton saw as a threat to his position. Breton turned the Sadean novelist-philosopher's own words against him: *souillé, sénile, rance, sordide, grillard, gâteux* – filthy, senile, sordid, lewd, doddering.[32] Bataille fought back in kind, gathering the newly purged surrealists about him and publishing a collective counterblast against Breton called *Le lion châtré (The Castrated Lion)*.[33] The feud simmered on. In 1936, Bataille founded a review-cum-secret-society called *Acéphale (Headless)*, the cover of its first issue bearing the design of a decapitated man by Masson.[34] *Acéphale* set out to be an all-new myth, the first of surrealism. It also suggested that artistic movements did not necessarily need to have heads.

Hayter thus joined the surrealists just as Masson decisively broke with them. Although the two men had by then become friends – Masson and his wife, Rose, lived around the corner from Hayter at 45 rue Blomet –

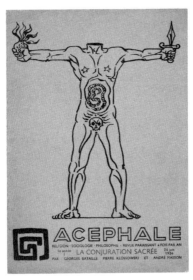

André Masson, cover of *Acéphale*, no. 1, 1936.

Masson would only make a single work in Hayter's Paris atelier: a print for *Solidarité* (1937/8), a portfolio of etchings and engravings by Picasso, Miró, Masson, Hayter and three others, accompanying a poem by Paul Éluard of the same name and sold in aid of children orphaned in the Spanish Civil War (FIG. 8). By far Masson's greatest body of work as a printmaker would be made in the later Atelier 17, in New York. It was to be Yves Tanguy who would sign Hayter up to surrealism and collaborate with him in the Paris workshop – although he too would work extensively in the American atelier after 1940.

Hayter explained his belated conversion to surrealism. 'I was acquainted with members of the group quite early, but did not actually exhibit with them until the second Surrealist Manifesto for the simple reason that the first one, which had to do with oneiric, or dream material, did not appeal to me,' he said. 'Making literal projection[s] of matters of dream did not impress me as valid. My first view of any work of art is: is it a thing? Is it real? Because unless you are convinced of that, you have got nothing.'[35]

Breton's thinking in the years between the first and second manifestos had turned to correlating art with Marxism. Creative chains, like socioeconomic ones, must now be broken. As of 1929, the duty of surrealist art was to be 'as far removed as possible from the desire to make sense, as free as possible of any ideas of responsibility which are always prone to act as brakes, as independent as possible of everything which is not "the passive life of the mind".'[36] Whether he meant it to or not, Breton's new dictum sounded like a rallying call to abstraction.

Hayter was not alone in hearing that call. In the year of the second manifesto, he had met Yves Tanguy. The son of a Breton naval officer, Tanguy had been introduced to surrealism early on by the poet Jacques Prévert. The same age as Hayter, Tanguy, like him, lacked formal artistic training; where Hayter had worked as a geologist, Tanguy, like Calder, had been in the merchant navy. He had also had a recent coup. In 1929, Tanguy's new painting, *Titre inconnu (Noyer indifférent)*, had been bought from a show at the Zurich Kunsthaus by the psychiatrist and analyst Carl Gustav Jung. Jung had hung it in his study, where he

Yves Tanguy, *Self-Portrait*, c. 1929.

BEFORE 29

canvassed his patients' responses to it (FIG.9). He was to praise the work for combining a 'minimum of intelligibility with a maximum of abstraction', its ability to trigger the collective unconscious through involuntary association.[37] It was the beginning of a mutual interest between Jung and the younger surrealists that would shape the thought of both.

Untypically of the surrealists, Tanguy was also an Americanophile. It may have been this that led Breton, in 1927, to show his work alongside ethnographic pieces from the Americas in an exhibition called 'Tanguy et objets d'Amérique' at the short-lived Galerie Surréaliste.[38] These objects, ranging from pre-Columbian Mexican pieces to contemporary artefacts from British Columbia, had been borrowed from Paul Éluard, Louis Aragon and Nancy Cunard, among others. Breton, in his catalogue to the show, saw America as a place of Tanguy's imagining, one that 'he had truly discovered'. The appeal to the young artist of Hayter and his American wife was obvious.

In 1932, Tanguy would make his first print with Hayter – an untitled etching, done as a frontispiece to a new volume of Éluard's poetry called *La Vie immédiate* (FIG.10).[39] Although this was a small-scale undertaking – only twenty-two luxe copies of the book contained Tanguy's print – the experience was enlivening. With one minor exception, all of Tanguy's remaining printmaking until his death in 1955 would be done at Hayter's workshops in Paris or New York.[40] The year after this first print, 1933, Hayter would finally move into the new studio at 17 rue Campagne-Première. The *Vie immédiate* frontispiece, made in the old studio, had been an etching. Now, at Atelier 17, Tanguy would sign up for a course in engraving with Hayter as his teacher. With him would come a trio of friends, Max Ernst, Joan Miró and Alberto Giacometti.[41] The following year, all five men would take part in the first group show of work made at the workshop.[42] Similar exhibitions would follow in Paris in 1936, 1937 and 1939, and in London, at Peggy Guggenheim's Guggenheim Jeune gallery, two months before the outbreak of the Second World War.[43]

———

It may be as well at this point to consider the word 'teacher'. Not all the artists who were drawn to Hayter's new studio were as well known as the four above. Among others was a Hungarian-born prodigy called Gabor

Peterdi, who, at sixteen, had come to Paris having graduated from the fine arts academy in Budapest and won a Prix de Rome. He arrived at Hayter's door in rue Campagne-Première shortly before his eighteenth birthday. Forty years later, he would recall what he found.

'I went to work in the Hayter studio doing engraving,' Peterdi said. 'But of course that was not art instruction. As a matter of fact, that wasn't a school at all.' If he had expected classical instruction in print-making at Atelier 17, what he found was something quite different. 'Hayter had his own press and so on in his own studio,' the Hungarian recalled. 'He saw some of my drawings; he liked them, he said, "Come over, you're going to engrave." So I went there. He stuck a burin in my hand and showed me how to hold it. He gave me a plate.' The excitement stayed with Peterdi four decades on: 'You talk about education! There was Ernst and Tanguy and Miró and Chagall and Dalí; and Picasso came, and so on. So suddenly I was seventeen years old and I was in Hayter's workshop with these people.'[44]

Peterdi recalled other things about the newly opened Atelier 17, among them Hayter's obsession with the revival of engraving, 'which had become like a lost art' to him. So, too, his unworldliness. 'It wasn't like a school where you paid tuition,' Peterdi said in 1971. 'If you had the money, you paid; if you didn't have the money, you worked and that was the way it went....As far as I can remember and until the present day... Hayter was always broke. That's true. Even with all his reputation and success.' The most striking impression, though, was of the atelier's lack of hierarchy. 'Once Hayter had shown [you] how to engrave – and this is something you can do in half an hour – from then on you are on your own; you are in business. And then of course the osmosis, the fact that you are working next to somebody that you see – Hayter is working and So-and-So is working so that it becomes a kind of process of stimulation and just doing it.'[45]

Another unknown to turn up at Hayter's door was the English artist Julian Trevelyan. Arriving in the new studio's first weeks, he stayed at Atelier 17 for a year, lodging next to Calder in the *impasse*-turned-artists' colony, Villa Brune; Hayter, he said, was 'living in a shack of a studio near the abattoirs...[looking]...lean, wiry and hungry, which he probably was'. Like Peterdi, Trevelyan was awestruck at the presence in the studio of

BEFORE 31

the likes of Miró and Ernst. 'The major preoccupation of most of these artists', he recalled, 'was the aesthetic treatment of the line.' As to the atelier's founder, Hayter's work was 'still partly figurative', but with 'lines that were taut and *voulu* [decided]'.[46]

The year after Trevelyan left, in 1935, the French printmaker-to-be Roger Vieillard gave up a career in banking to join Atelier 17. 'When I saw the kind of line [Hayter] was making, I said, "But that's amazing! That's just what I need!",' Vieillard remembered. 'I saw that here was a way to draw in space – not the usual drawing in two dimensions, but one that moves spatially, in three dimensions....This is perhaps the uniqueness of the burin: it introduces a third dimension into the work of art.'[47]

These three – Peterdi, Trevelyan and Vieillard – give us a composite picture of life at rue Campagne-Première in the new studio's first years. Perhaps its most compelling feature was that it was run cooperatively. Hayter's role there was less that of master than of organizer. Where Hecht had perfected a personal style which he taught to students, Hayter's style was itself in a state of flux: the change in his work between 1930 and 1934, from *Rue de la Villette* to *Oedipus*, suggests that he was as much a student at the early Atelier 17 as he was a teacher. He was as enmeshed as everyone else in the preoccupation with line.

In this sense, the atelier was profoundly anti-classical. For every member who had been to art school, there was another – Vieillard, Tanguy, Hayter himself – who had not. That the burin, as Peterdi pointed out, was easy to learn was part of its point: the aim was not mastery of technique but its ease. That the burin knew where it was going before its user did made it the perfect tool for automatic working. Very much later, Michel Leiris would write of André Masson's having made 'lines which discover, which...learn but do not teach', whose point was to be in motion rather than 'to outline structure'.[48] These were also the lines of Atelier 17.

And they were lines that, as Vieillard pointed out, operated in three dimensions rather than two, whose making – the gouging of curls of metal from a copper plate – was essentially sculptural. Although Atelier 17 was to be remembered as a print workshop, it is arguable that its real experimentation lay in low-relief sculpture. Many of its alumni, most famously Alexander Calder and Louise Bourgeois, were to find fame not as printmakers but as sculptors.

The other thing our trio suggests – an Englishman, a Hungarian and a Frenchman – is the international nature of the early atelier. It was certainly not the only cosmopolitan meeting place of artists in 1930s Paris – the city's variously modern academies were packed with foreigners – but it was a particular mecca for English speakers. As well as the artists who signed on at Atelier 17 there were fellow travellers, such as the surrealist poet David Gascoyne, who used the studio as a talking shop.

After an initial visit to rue Campagne-Première in the summer of 1933, Gascoyne had returned in the spring of 1935 to interview André Breton for his forthcoming book *A Short Survey of Surrealism*.[49] The first comprehensive study of its subject in English, this would introduce the movement to an anglophone audience. Hayter had arranged the meeting with Breton, at the master's flat in rue Fontaine. The relationship between the two men, Gascoyne recalled, 'was manifestly one of mutual esteem, but the warmth characteristic of Hayter's friendship with Paul Éluard...was not in evidence where Breton was concerned'.[50]

What the young Englishman did not realize was that this coolness on Breton's part sprang from Hayter's friendship with André Masson. 'I had not failed to observe that probably the closest affinity between Hayter's work and that of the original surrealists was that to be discerned between [himself] and André Masson,' Gascoyne said. 'Like Hayter, Masson's outstanding trait was the formidable dynamic vitality of his calligraphic line, evident in the automatic drawings reproduced in early numbers of *La Révolution Surréaliste*.'[51] This likeness did Hayter no favours at rue Fontaine.

Still, Breton was compelled to be civil to him. German surrealizing of Klee notwithstanding, surrealism remained a French phenomenon. By now, Breton viewed the movement as necessarily international, like communism. By far its keenest non-Parisian adherents were British, with Hayter as their resident ambassador. As Gascoyne recalled: 'At the time when Roland Penrose, Herbert Read, E.L.T. Mesens and myself were working with a committee to organize what became the First International Exhibition of Surrealism at the New Burlington Galleries in London during the summer of 1936, Bill Hayter became a most precious liaison officer between London and Paris in assisting the preparations.

Two paintings and a dozen etchings by Hayter were among the many hundreds of works to be seen at the time of this sensational (for the British capital) and lastingly influential event.'[52]

The French art historian Michel Rémy went further. 'The part [Hayter] played in the transmission of surrealism into England is enormous,' he wrote. 'His Atelier 17 in Paris was the rallying point...for all artists arriving from England as well as for most French surrealists. He is undeniably the painter of automatism, developed through the techniques of engraving. For him the line is a pure creation of the hand dictated by thought, the engraving plate the stage where physical, chemical and psychological phenomena *dramatically* happen.'[53]

All this suggests another reason for Breton's coolness towards Hayter. Devoutly as he wished for an international surrealism, there was no question in his mind that he would be its leader. The 1936 London exhibition shook that assumption. Although Breton wrote the introduction to the show's catalogue, he is listed on the title page merely as a French committee member, alongside the hated Éluard and below the nine British members. His essay had been translated by David Gascoyne: in his five years in America, the intractably monoglot Breton would learn not a word of English for fear, he said, of 'polluting' his French.[54] These years would also coincide with a shift in surrealism's centre of gravity from the literary to the visual, with Breton being at heart a writer rather than an artist.

The London exhibition would remain the movement's defining moment until 1938, when Breton organized a Parisian counterblast – a surrealist *tour de force* in which the gallery where the show was held itself became an artefact.[55] With the ceiling of the main room hung by Marcel Duchamp with 1,200 coal sacks and the entrance dominated by a Salvador Dalí taxi in which rain ceaselessly fell, this was the first surrealist *Gesamtkunstwerk*.

That French critics were almost uniformly scathing about Breton's exhibition came as no surprise; that was rather its point. There was in their antagonism, though, a sense that now was not the time for what they saw as frivolity. In the month after the show, Germany would annex Austria. By the end of the year, Kristallnacht and the Nazi invasion of Czechoslovakia made it clear that war was on its way. As with geopolitics,

34 CHAPTER 1

so with surrealism. When, in the summer of 1938, Éluard declared himself a Stalinist, Breton made it impossible for him to stay in the group. In solidarity with the poet, Max Ernst, Man Ray and Hayter all quit it as well.

At Atelier 17, art had already been pressed into the anti-fascist cause. In 1936 Hayter had begun his engraving *Combat*, its tortured line redolent of the violence that had made it.[56] Echoing Masson's dictums on automatism, Hayter wrote: 'The first drawing was made in late May. It was completely automatic – that is, there was no preconceived subject, nor were there any particular images sought for. The recumbent horse, skull, figures fighting, shield motif, etc., appeared as the drawing developed.'[57] Seen as a reaction to the Spanish Civil War, the print had actually begun life a month before it. The work developed as history did.

This tolerance – or embracing – of accident ran against the grain of traditional printmaking studios. The most vivid demonstration of this came a few months after Hayter's *Combat*, when Max Ernst was working on an *édition de luxe* of his artist's-book-cum-graphic-novel, *Une Semaine de Bonté*.[58] In an absent-minded moment, Ernst plunged the zinc plate on which he was working into a bath of concentrated nitric acid meant for copper plates. The violence of the ensuing reaction produced clouds of livid orange smoke. When the two men rushed to rescue the plate, though, they found that, far from destroying it, the mishap had caused an umbra to appear around the shapes with which Ernst had been working. It would become a stock process of Atelier 17.[59]

Shortly afterwards, in the autumn of 1937, Hayter would leave for Spain, invited by the Ministry of Arts to advise on printing for the republican cause. By now, Francoist forces were closing in. Back in France, Atelier 17 was put to more urgent use. As the Franco-Cuban novelist Anaïs Nin would record, 'Refugees from Spain began to slip into Paris. The laws were rigid: if one sheltered or fed them, there would be a punishment of jail and a fine. These were the fighters, the wounded, the sick. Everybody was afraid to help them. William Hayter hid them in his studio….We [Nin and her lover, Gonzalo More] had to keep on finding places. I was busy cooking gallons of soup, which had to be brought in small containers to Hayter's studio.'[60]

The next year, 1938, *Solidarité* would be published at Atelier 17, with prints by Picasso, Hayter, Tanguy, Masson and Miró. This was followed in

BEFORE 35

1939 by *Fraternity*, with text by the English poet Stephen Spender, cover by Hayter and prints by, among others, Miró and Wassily Kandinsky. Like *Solidarité*, profits from the sale of *Fraternity* would go to help the Spanish Republic.

————

Around this time, Hayter met an Englishman rather like himself. In 1937, Gordon Onslow Ford had come to Paris to paint.[61] A decade younger than Hayter, he too was from a family of artists while having no formal training of his own: Onslow Ford had lately resigned a commission in the Royal Navy to follow his new path. In Paris, he would study briefly with Fernand Léger before throwing his lot in with the surrealists. By 1938, he was moving in the circles of Hayter and Masson, the former soon to join those ex-surrealists cast out by Breton as rebels in 1929. By 1939, Onslow Ford was experimenting with a technique he called *coulage*, in which enamel paint was poured or dripped onto a canvas or, occasionally, thrown at it. All this was done in the name of what he would call 'painting in the instant' – 'painting just faster than rational thought, just faster than the painter's speed of consciousness, while giving full attention to what is appearing in the painting as it appears'.[62]

The closeness of this to Masson's 'speed of writing' is obvious, as to Hayter's understanding of automatism as a means rather than an end – that image-making would still require the artist's full (and implicitly conscious) attention. If Hayter and Masson were present in Onslow Ford's thinking, though, he was careful not to admit it. As often with the surrealists, this had to do with Breton. In 1942, in Mexico, Onslow Ford would be invited by the Austrian polymath Wolfgang Paalen to contribute to his new avant-garde magazine, *Dyn*. He refused. In the first issue of *Dyn*, Paalen had announced his abandonment of surrealism, or at least of Bretonian surrealism. 'I couldn't participate without [also] giving notice to Breton, and I was so fond of [him],' Onslow Ford explained. 'I think Breton was very, very hurt [by Paalen's renunciation]. In fact, I know he was.'[63] Siding against the master was not in Onslow Ford's nature. In this, among the Parisian exiles in New York, he would be almost alone.

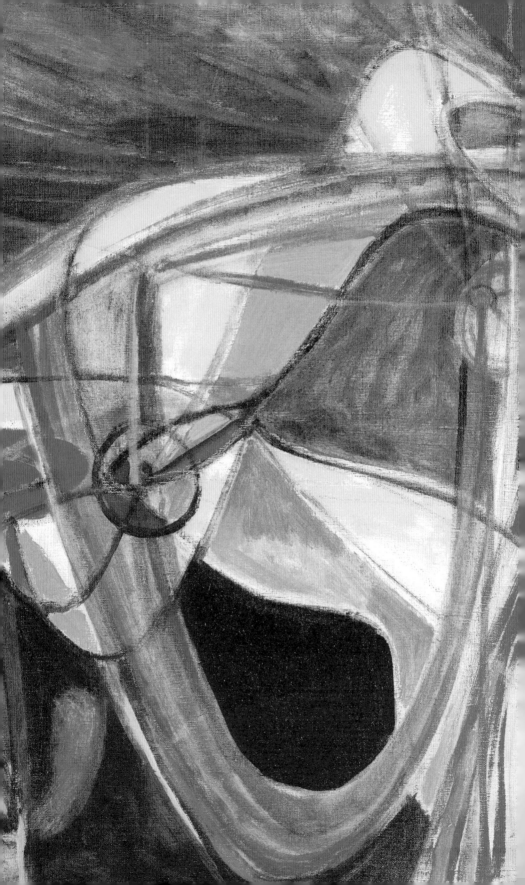

The New School

CHAPTER 2

'With his other hand, he made ever faster circular movements....His repetitive, feverish gestures, like those of a dervish in a trance...entirely focused on his activity, as if he had gone back to the beginnings of the world. He seemed to be...fulfilling the immemorial rituals of a lost tribe.'
Christophe Boltanski[1]

On 21 September 1940, the *New York Post* ran a short piece under the leaden headline 'New School Adds 17 To Faculty'. Among those listed was 'Stanley William Hayter, French artist, founder Atelier 17 school of modern technique of engraving and etching'. A week later, the *New York Times* expanded: 'Stanley William Hayter, who established his "Atelier 17" in Paris in 1927 and who fled from that city shortly after the outbreak of the present war, will open a studio at the New School for Social Research, 66 West 12th Street. He arrived in this country last June having done camouflage work for the British Government. During the last summer he taught in the California School of Fine Arts in San Francisco.'[2]

On 30 September, as announced, the American Atelier 17 opened its doors on the top floor of the New School building in Manhattan's Greenwich Village.[3] Teaching at the studio would be conducted on Monday and Thursday afternoons and evenings, cost $5 a week, $15 for four weeks or $40 for three months.

It had been an eventful year. When Britain declared war on Nazi Germany in September 1939, Hayter, a reservist in the British army, had left at once for London. To his annoyance, he was declared medically unfit.[4] 'The doctors wouldn't pass me or I should never have come to America,' he later grumbled to a friend.[5] Barred from active service, he volunteered his skills instead as a camoufleur. As the Phoney War dragged on through 1940, this came to seem growingly pointless. Frustrated, he took up the offer of a summer teaching job in San Francisco, where his Californian fiancée, Helen Phillips, was making sculptures for the Golden Gate International Exposition.[6] On the way, passing through New York, he had called in at the New School.

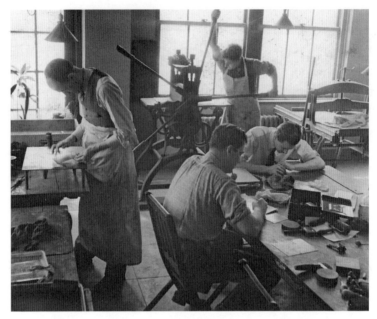

Interior of Atelier 17 at the New School, *c.* 1940–5.

'I must have met somebody that knew about [the school] because I knew nothing of New York at all,' Hayter hazarded, thirty years later. 'I hadn't the faintest idea where to go and what to do....I did meet some of the trustees of the place, who seemed very sympathetic....A number of people there thought it would be possible to set up a workshop again.... So I came back in October of that year, and made a proposition to set up this thing in the New School.'[7] He and Phillips moved into a fourth-floor, cold-water walk-up flat in a crumbling brownstone on Green Street, south of Washington Square. It cost $20 a month. For heating, the couple burned fruit crates and old furniture found on the street outside.[8]

The introduction was to prove fortuitous. If Atelier 17 had been unique in Paris in its anti-classical teaching, the New School for Social Research played something of the same role in New York. Key to its philosophy were social relevance and what was to become known as interdisciplinarity – an

THE NEW SCHOOL 39

anthropologist might teach modern history at the New School, or a perceptual psychologist art. Drawing on the experience of German *Volkshochschulen*, there was a strong emphasis on learning by doing: teaching-with rather than teaching-to. Courses were, at least theoretically, open to anyone. Above all, and unusually in isolationist America, the New School was internationalist.

It had been set up in 1919 by a group of professors who had quit their jobs at Columbia University rather than take a newly enforced oath of national loyalty. One of this group, the school's first director, Alvin Johnson, was quick to spot the threat of totalitarianism in Europe: 'For the next generation, the natural home of scholarship and science must be the United States,' Johnson said.[9] On Hitler's taking over the German chancellorship in 1933, the New School had named its graduate department the University in Exile.

This would provide a safe haven for hundreds of European intellectuals in the decade that followed. In 1936, the school had hosted the First American Artists' Congress against War and Fascism; among the attendees was Alexander Calder. It may have been he who introduced the New School and the provenly anti-fascist Hayter to each other. Also at the Congress was art historian Meyer Schapiro, whose 1937 essay 'The Nature of Abstract Art' would find an equivalence between political freedom and freedom from subject matter in the art of Kandinsky.[10] If Breton's *Second Manifesto* had been a debatable call to abstraction, Schapiro's essay was overtly so.

By September 1940, the New School had become a fixture on New York's growing exilic art circuit. In February, W.H. Auden lectured on 'half truths' there; a few months later, Otto Klemperer began a series of chamber concerts. It was, though, predominantly exiled Parisians who would gravitate to the New School, not least for the preponderance of French speakers on its staff. Among the first arrivals was Le Corbusier's partner in purism, Amédée Ozenfant, who had come to New York in 1938 and started teaching art with Schapiro soon after. In January 1942, the Ecole Libre des Hautes Etudes – a specifically French university in exile – would open next to the New School and under its aegis. The area around West 12th Street was quickly, and not entirely ironically, dubbed *le Quartier Latin*. If Atelier 17 in Paris had been a meeting place

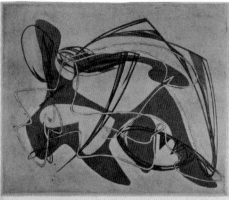

TOP Cover from *New School for Social Research - Art Classes* bulletin, 1942–3.

ABOVE Interior spread from *New School for Social Research - Art Classes* bulletin, 1942–3.

THE NEW SCHOOL

for English speakers, its new American iteration would provide a clubhouse for the French.

For Hayter, the small, shared studio he was allocated up on the top floor held promise of another kind. While providing him with a workshop, it also lent his atelier a new gloss of academic respectability. Surrealism in France had been seen as at best frivolous, at worst immoral. Now, thanks to Schapiro, an early American fan of the movement, adherents past and present had intellectual cachet.[11] This did not mean compromising Hayter's pedagogic views; rather the opposite. The atelier's history of taking in anyone – geologists, sailors, mechanics, bankers – fitted nicely with the New School's. It also sat well with hybrid tendencies in Hayter's recent painting, seen, for example, in the nude-cum-landscape *Paysage anthropophage* (FIG.11). Later, Hayter would recollect his first American workshop as unique in being at the same time a working studio and an educational establishment.[12]

If the New School's egalitarian temper meant that Atelier 17 was required to take in anyone who applied for entry, attendees had at the least to think of themselves as professionals. 'Introduction to Composition by Amédée Ozenfant is for artists and laymen alike, while Atelier 17 is designed for artists exclusively,' notes the *New School for Social Research Curriculum* for 1940–1.[13] 'It is a new workshop in technique in the graphic arts given by Stanley William Hayter, who is transplanting his Atelier 17 from Paris where his group included Picasso, Tanguy, Miró, Kandinsky and other moderns.' Initially, afternoon courses were for beginners and evening ones for advanced students, although the two were merged after the first year.

As important as the courses themselves was that Hayter allowed sufficiently experienced printmakers to use the studio, unsupervised, on evenings when there was no teaching in it. Thanks to the school's amiable Maltese security staff, these *soirées* could stretch into the early hours of the morning, with people dropping by to talk or experiment.[14]

This informality would prove particularly attractive to the group of largely young Americans who would come to Atelier 17 from 1940 on. If working in proximity to some of the great names in contemporary European art would be stimulating, it was also intimidating. As one

42 CHAPTER 2

French critic was to note, 'The philosophical, intellectual and social dialogue between Europe and the New World, a dialogue of equals, which is a central theme of the American novel from Henry James to Hemingway, had no equivalent in the visual arts.'[15] The sense of awe American artists felt towards the Europeans was old and deep.

For Americans to succeed on an international stage, they had had until now to leave for Europe, preferably Paris. Whistler and Sargent were cases in point, as, more recently, had been Calder. Quite apart from their reputation as makers, artists in Europe had been held in a social esteem that artists in the United States simply had not. The well-known anecdote about Ingres – he had walked into a Parisian theatre, crooked a forefinger at a figure in the front row and said, 'Stand up, young man, and give me your seat: *I* am Monsieur Ingres' – could never have translated culturally in New York.

This sense of an artistic aristocracy had come to sit particularly ill with young Americans. In 1935, President Roosevelt had launched the Federal Arts Project, part of his Depression-busting Works Progress Administration. By the outbreak of war in Europe, some five thousand American artists were effectively employed by the state, more than half of them in and around New York City: among these last were Mark Rothko, Jackson Pollock, William Baziotes, Arshile Gorky and Willem de Kooning. If the Project's New York director was to recall, in the 1970s, that 'almost all of the painters, sculptors, graphic artists, and muralists [of] those days remember little or no artistic stricture', there had nonetheless been an expectation that work produced by the FAP would be aesthetically accessible to the man in the street.[16] That this notional figure might prove difficult to please was suggested by the reaction of New York's mayor, Fiorello La Guardia, at the unveiling of a suite of murals by Gorky at Newark Airport in 1937. 'If this is art,' La Guardia had growled, 'then I'm a horse's ass.'[17]

The result of this state intervention was, in critical terms, viewed at the time as disastrous, not least by leftists such as Meyer Schapiro, who attacked the regionalist and social realist styles that predominated in Project art as regressive in 'detach[ing] art from fantasy'.[18] The once-surrealist Hayter might have been expected to side with Schapiro on this; but in fact he was, and remained, an avid supporter of the WPA.

THE NEW SCHOOL

This was variously surprising. Fantasy apart, the thrust of Project art-making was that work should be recognizably American, which tended in practice to translate as anti-European. To be avant-garde was to be un-American: artists such as Marsden Hartley and Stuart Davis – the latter on the staff of the New School – were dismissed by WPA artists as would-be Frenchmen. What won the Project favour in Hayter's eyes even so was its egalitarianism. 'The WPA was the most wonderful experiment of national aid to the arts the world has ever seen,' he maintained, 'because it was indiscriminate.'[19] 'Reggy Marsh, Isabel Bishop...Fred Becker. Most...had been on the Project,' he would recall much later. 'A wonderful scheme...completely indiscriminate, no matter how bad a person was. I think it is the only way to do it.'[20]

From the American point of view, this made Atelier 17 a unique hybrid. If the studio's fame in New York grew from its roots in Paris – and if, by the end of its first year, it was to be the haunt of some of the most famous names in the French avant-garde – its philosophy had little to do with a European aristocracy of the arts. WPA artists had prided themselves on being manual labourers who merely happened to paint or sculpt: they might equally have been farmers or construction workers. Hayter's habit of referring to his own pictures as 'jobs of work' sat well with them, as did the workmanlike way he ran his studio.[21] 'He made something of a mystique of the common touch,' said the photographer Milton Gendel, recalling that Hayter had loved to tell how his carpenter had responded at once to his abstract prints at a time when Picasso was still widely viewed in America as incomprehensible.[22]

This critical acumen was, unfortunately, not shared by Manhattan gallery-goers. A fortnight after Atelier 17 opened at the New School, Hayter exhibited sixty of his engravings in the NSSR's small sixth-floor gallery, in a show briefly noted in the *New York Times*.[23] 'I made a little exhibition there – the only one in my life where not only was nothing sold, but nothing was even asked for,' he recalled, ruefully, four decades later. 'A couple of the copper plates I put up were defaced – rude words scratched on them. The only reaction I got. That's why when people talk to me about the Modern movement in America – in 1940, you could not give away a print. So I got together what people I could there.'[24]

44 CHAPTER 2

In November 1988, friends and colleagues gathered again at the New School to celebrate the life of Stanley William Hayter, who had died six months before.[25] Among them was the painter and printmaker Jacob Kainen, who delivered the address. 'My first glimpse of Bill Hayter was in this very building, in 1941,' Kainen said. 'I was then a member of the WPA Graphic Art Project and knew that the famous surrealists from Paris could be seen making prints here in Atelier 17. I just peered in the door once, but still recall the image of Hayter, taut as a boxer, lank chestnut hair fallen over his eyes, his hands black with printer's ink.'[26]

Kainen's recollection tallied with that of another of Hayter's friends, Anaïs Nin, who had fled Paris for New York in 1939. 'When I saw him at parties, at cafés, or exhibitions, it was his intensity which was overwhelming,' Nin recalled in her diaries. 'He was like a stretched bow or a coiled spring...his face...engraved rather than sculptured in flesh.... If ever an artist seemed made of the elements he liked to use, Hayter was one. Steel, sharp edges, sharpened instruments, acids, presses.'[27]

Nin had hardly known Hayter in Paris. Now, in America, she came to know both him and his studio well. 'The place was enticing to me, with piles of paper, inks, the presses, the vats of acid, the copper being worked upon,' she wrote. 'The miraculous lines appearing from the presses, the coloured inks, the sharpened burins....His lines were like projectiles thrown in space, sometimes tangled like antennae caught in a wind storm.'[28]

So, too, with Fred Becker. In 1936, Becker, a Californian, had been the only WPA/FAP printmaker included by Alfred Barr in his groundbreaking show 'Fantastic Art, Dada, Surrealism' at the Museum of Modern Art.[29] He was also one of only three American artists included in the show's catalogue as a surrealist: apart from Man Ray, who had spent pretty well his entire career in Paris, the other exception was Joseph Cornell. Calder was listed among 'Artists Independent of the Dada-Surrealist Movement', along with Georgia O'Keeffe and Walt Disney: in Barr's mind, apparently, being a surrealist and being an American were mutually exclusive. Hayter, still counted as a surrealist, had shown a single work, an engraving called *Chiromancy* (1935). On the strength of his MoMA debut Becker was offered his first Manhattan show, at the Marion Willard Gallery, in 1938. Willard had then offered to put him on a stipend of $35 a week, with the

THE NEW SCHOOL

45

recommendation that he spend it on signing up at Atelier 17. Becker was thus part of the first intake at the New School studio, in September 1940. As he recalled, 'I went down to the New School and up to the seventh floor....The room was very small so you were all elbow to elbow....It was a very friendly place. You walked in and you had the feeling that you could do as you pleased and you would be accepted, no matter who you were.' As to the man who ran the room, Becker was quickly won over. '[Willard had] said [Hayter] was the most dynamic artist in New York,' he said. 'I could see he was a wonderful artist.'[30]

What really struck the art-school-trained Becker was the informality of the atelier's teaching, if teaching it was.[31] '[Hayter] did very little in the way of criticism,' he marvelled, half a century later. 'We never had a formal critique, never. It wasn't run like a school. There were old masters, famous artists, and students just out of school and everyone was treated the same....[Hayter] was doing his own work there, and that was an inspiration. Among the things he did there was engraving on plaster. I was living on Seventh Avenue and 27th Street and in the kitchen I took Hayter's biggest print, *Combat*, and I cast it in plaster and I added to the plaster and cast a kind of mount around it.'[32]

Finally, there is the recollection of Leo Katz, an Austrian émigré who had come to America in 1920 and would later manage Atelier 17's New York studio after Hayter himself had returned to Paris. 'What is the secret of this place?' Katz asked rhetorically. 'It starts with "Bill" Hayter's personality. A wiry shortish figure, a physiognomy that looks somewhat like Field Marshal Montgomery or at others like a suggestion of Napoleon (without the pompousness), a magnetic presence, charm, humour, irrepressible energy, sparkling intellect, a brilliant teacher, all this adds up to a human dynamo that attracts people from all over the world.'[33]

An impression common to all four of these witnesses of the early New York atelier was of its founder in motion, or about to be: cyclonic, taut, coiled. For Nin, this quality was also to be found in Hayter's work. If he was perpetually moving, then his art was a by-product of movement. Above all, his energy, his kinetic restlessness, showed itself in the line – thrown out, scrambled, projected into space. This connection of motion and line-making, movement and trace, was to become a hallmark of a certain kind of work produced at Atelier 17 in New York, made most

46 CHAPTER 2

famous not by Hayter himself or even by his fellow kineticist-in-exile, André Masson, but by Jackson Pollock.

———

Jacob Kainen again, on Atelier 17 at the New School: '[Students] had no proofs. Everyone was on his own. Hayter would tell them to ruin the plate. Start without sketches, take proofs, re-etch, dry point, do everything. The idea was to make the artist lose his fear of the plate and also to make it an intuitive process. So that, I think, had a lot to do with the development of the automatic point of view. [Robert] Motherwell was there too, you know. Of course he was. He can't deny it.'[34]

It is unlikely that Motherwell would have done. He, more than any other American painter, was to acknowledge his debt, and that of his countrymen, to France, and more specifically to the French at Atelier 17. As he wrote in the 1957 Whitney catalogue previously discussed: 'I have only known two painting milieus well personally, the Parisian Surrealists, with whom I began painting seriously in New York in 1940, and the native movement that developed in New York that has come to be known as "abstract expressionism", but which genetically would have been more properly called "abstract surrealism".'[35] He said this in 1957, when the New York School – a name Motherwell had himself coined – had triumphed as the dominant force of its day.[36]

The shoe, now, was on the other foot: where, twenty years earlier, American painters had had to go to Paris to find an avant-garde, the direction of travel had turned about face. Motherwell was also clear about where this *volte-face* had begun. 'Hayter's workshop was a beehive of professional activity, of optimism, of accomplishment, of sheer human decency, of the will to continue,' he said. 'We had been surrounded, we Americans, by the dominance of "American" art of the '30s, of "social realism", "social protest", "regionalism", and so on, and Hayter's collaborative optimism felt – for those of us who were "modernists" – much more sympathetic.'[37]

For all that, as we shall see, Motherwell did not enjoy what he saw as the performative element of printmaking at Atelier 17, watched over by the likes of André Masson and Max Ernst. Nor was his classical meticulousness suited to the studio's destroy-to-create temper. After producing

THE NEW SCHOOL

a handful of prints there in 1942/3, he gave up on printmaking for twenty years. He would never return to the burin. Perhaps the most faithful of Hayter's apostles was to be Anaïs Nin's American husband, Hugh Parker Guiler, better known by his *nom d'artiste* of Ian Hugo.

Hugo, a member of the original Atelier 17, had fled Paris with Nin in 1939. The following year, he became the first of what Hayter called his *anciens* to sign up at the New School studio.[38] Five years later, Hugo gave a talk on engraving at a college symposium. 'My purpose [is] to show that the well-engraved copper plate is itself an original work of art,' he said, echoing the man he described as having 'fathered my own birth as an engraver, and whom I consider the greatest technician of all times in the graphic arts'. Hugo went on: 'In fact it is the only thing in the graphic arts that can properly be called original. A so-called "original print" is not original in the sense that a painting or a piece of sculpture is an original work of art. It is rather a reproduction on paper of the original, which is the engraved plate.'[39] This, to an audience of would-be printmakers, was fighting talk.

Hugo warmed to his theme. 'Engraving, before paper came to the west in quantity about the year 1400, [was] an intensely alive metal craft which, with a few exceptions, started to die when the interest shifted from the metal plate, and therefore from the craft as such, to the reproduction on to paper.' Reproduce an artist, he said, 'and you kill the very thing in him that makes him an artist'. This was particularly true of etching. 'Anyone who can draw lines with a pen or a pencil can take up a needle and make lines,' Hugo sniffed. 'In true engraving as I understand it, a fundamental change is necessary....That is exactly where I think the great difference lies between engraving on the one hand and drawing and etching on the other. Engraving is sculpting metal.'[40]

It is difficult, now, to imagine just how seditious the things Hugo and Kainen described must have seemed to the young Americans who flocked to the New School in 1940. Atelier 17's artistic rule-breaking went beyond the way prints were pulled. If being attached to an academic institution had brought the workshop intellectual kudos, it also provided Hayter with a stream of ideas from his new colleagues.

Central to the New School's ethos was that its tutors should lecture in each other's subjects. Among those whose courses Hayter would teach – and who, in turn, taught his – were the Gestalt psychologists Max Wertheimer and Rudolf Arnheim, refugees from Nazism and researchers into visual perception. The Parisian practice of bypassing the conscious to access the unconscious – of which Hayter was, in 1940–1, the New School's sole seasoned practitioner – was a source of fascination to them. 'I was an ex-member of the Surrealist group,' Hayter was blithely to recall. Wertheimer and Arnheim 'were enormously interested in the graphic implications of this game'.[41]

What this interaction between disciplines brought to Atelier 17 in return was not just a new way of seeing art, but of seeing altogether. Rather than being a mere neutral neurological function, perception now became charged with value. From 1940 until Wertheimer's sudden death in 1943, he and Hayter would conduct a series of collaborative experiments in mirroring – a thing of particular interest in printmaking, where the print is a reverse image of the plate. In the seventh-floor studio, students were encouraged to make automatic drawings in burin on zinc plates prepared with a soft ground and then to examine the results in a mirror at each state of the plate's production, first right way up and then rotated through 360°. In particular, Hayter encouraged the examination of lines in his students' work and their position in space. This, in turn, opened up a world in which actions immemorially taken for granted were revealed as having unremarked significance.[42]

Among other things, the Hayter-Wertheimer experiments demonstrated that the normal eye moves invariably from left to right, even among left-handed subjects and people such as the Chinese who read from right to left; that the eye tracks diagonally upwards from right to left but downwards in the other direction; and that its natural resting point in any empty rectangle is just below the geometric centre.[43] To these dry discoveries, Arnheim added others that explored the process by which all marks, no matter how abstract, become imbued with potential meaning.

His particular focus, prompted by Hayter, was on the line. 'A single line drawn on a piece of paper cannot be seen simply as itself,' Arnheim was to write in his magnum opus, *Art and Visual Perception* (1954). 'It is

Max Wertheimer with his family, arriving on the SS *Majestic* in New York, 1933.

always related to the two-dimensional extent around it....There seems to be no way of seeing the line strictly as a flat plane. Instead, it is seen as lying in front of (or within) an uninterrupted ground....Our first, surprising discovery, then, is that there is no such thing as a strictly flat, two-dimensional image....[Lines] are perceived as one-dimensional objects, as though they were wrought in iron or made of some other solid material.'[44]

Much later, he would recall his own lessons with Hayter at the New School in 1940–1. 'Some thirty years ago at the American college where I was teaching psychology, I took part in a short course in drawing offered that summer by S.W. Hayter,' Arnheim wrote. 'I recall

50 CHAPTER 2

particularly a method of drawing the human figure that Hayter suggested to us although it was really beyond our powers. For each horizontal level of the human body, from head to toe, he made us draw a contour as though we were slicing the body like a sausage...making the opaque body penetrable by turning it into a kind of transparent cocoon, a wraith of pure shape. This belief in the revelatory powers of transparency is also characteristic of Hayter's own work.'[45] It would also be typical of the work of his best-known American alumnus, Jackson Pollock.

Hayter drilled these discoveries into his students, and with apparently contradictory aims. First, he intended his findings to be used formally, to generate lines and shapes that would induce in the viewer imagined sensations such as those of flying and falling (FIG.12). At the same time, he hoped to provoke unease in his students – to unmask perception as something uncanny, governed by forces that could be channelled but never wholly controlled.

In this, he was formulating an aesthetics based on Wertheimer's associationist gestalt. Wertheimer held that the imagination was not a wellspring of preformed Platonic ideas, but a back-and-forth exchange of stimulus and response. Seen like this, making and thinking became as one. Work made with a burin was neither solely shaped by the conscious mind nor solely a shaper of it, but both at once: it was, as it were, its own state of being. In this sense, the burin was the perfect automatist's tool, liable to the experience of the hand and yet, crucially, preempting control by it. Here, potentially, was a means of making art that was universal and comprehensible while still being entirely abstract. 'Instinctive thought may provide a higher order of reality than sensory observation of the phenomenal world,' Hayter said, with the air of a rational mystic.[46]

A third influence on his own thinking in those first months at the New School was that of Ernst Kris. Kris, another refugee from the Nazis, was a Viennese psychoanalyst and friend and apostle of the great Freud himself, although his doctorate had been in art history. In 1936 he had published a paper in Freud's journal, *Imago*, arguing that the difference between artists and psychotics was that the former could return from the world of imagination at will while the latter could not. The surrealists'

THE NEW SCHOOL

fascination with the irrational mind might have been made for him. From Hayter's point of view, Kris' appeal lay primarily in his belief that entry to the unconscious might be effected not simply by such rapid means as game-playing and the juxtaposing of discordant things, but by the slow examination of the surface of an image; that the kind of mirror-experiments he encouraged in his own students might themselves constitute a kind of automatism.[47]

As we have seen, the question of precisely what constituted automatism was very much up for grabs in 1940. Breton's original definition, in the first surrealist manifesto, had been of a bypassing of the conscious mind by any means necessary, the accessing the unconscious being an end in itself. While this lent itself easily to the writing of verse, it fitted less well with the making of paintings. Aware of this, Breton revisited the subject in his 1928 essay *Le surréalisme et la peinture (Surrealism and Painting)*, although his sole reference to automatism in this is in his appreciation of Miró and it offers little in the way of concrete guidance to painters in general.[48] In any case, by the mid-1930s, the purged André Masson had evolved a practice of his own. Work produced automatically was, as it were, mere psychic underdrawing, with further and more conscious overworking required to qualify it as artwork. (This classic/romantic strain is also seen in paintings of Hayter's such as the faintly anthropomorphic *Untitled* [1946, FIG.13].) For this belief, he had the imprimatur of Carl Gustav Jung, who, in 1922, had written of 'the creative process [as] consist[ing] in the unconscious activation of an archetypal image and elaborating and shaping the image into the finished work'.[49]

Hayter, for his part, had reached the same conclusion by the late 1930s: accessing the unconscious was a means rather than an end. It was a thinking that would dominate in his New York atelier, and shape the work made there by both its French and American habitués. Apart from being the first of the Parisian émigrés to achieve public prominence in New York, Hayter was also both a native English speaker and – at a time when American public opinion recoiled at the collaborationist mood of the Vichy regime – British rather than French.[50] Now, at the New School, he grafted the discoveries he had made with Wertheimer, Arnheim and Kris onto this earlier model.

Key to Hayter's automatism was the existence of what he called an 'image-making imagination'. This was not a subconscious wellspring of Freudian forms waiting eagerly to be called up by word games, but a Wertheimerian psyche shaped by, and shaping, experience and habit. Avoiding the word 'automatism', Hayter now spoke of *imagination*, using the French to differentiate the word from its habitual English meaning.

Accident was still key to the process, but it was an accident that would shape, and be shaped by, experience. 'An idea is nothing until it is up where it can be seen,' Hayter was later to say. Drawings '[take] form, and that form...affect[s] the thought of the artist'.[51] The initial image would not be a final one, but the first in a chain of images leading to a conclusion and which had to be examined each step of the way.[52] Later, he would refine this idea into a two-way traffic, psyche and image enriching each other by turns, the 'reciprocal effect of that image which is growing almost organically, in the medium...acting upon the imagination of the artist'.[53]

———

In 1940, Hayter had the field to himself as an English-speaking surrealist in New York, but it would not be long before reinforcements arrived. In the summer of 1939, just before the declaration of war, Gordon Onslow Ford had rented a chateau in the Rhone valley with his sister, Elizabeth. To this came *tout le monde surréaliste* – Breton, his wife Jacqueline Lamba and their daughter, Aube; Yves Tanguy and his soon-to-be wife, the American painter Kay Sage; and Robert Motherwell, spending a year in France.[54] There, too, was the Chilean surrealist Roberto Matta, although he left for America soon after. In March 1940 he wrote to Onslow Ford saying that he was trying to arrange a show of his work at the New School that May. This never took place, although Onslow Ford himself would arrive at the school in January 1941.

He came not to show his own work (**FIG.14**), however, but as a fully fledged emissary of surrealism. Early in January, advertisements appeared in the New York press: 'Surrealist Painting: an adventure into Human Consciousness; 4 sessions, alternate Wednesdays, 8:20 to 10 p.m. $4.' Each session would be accompanied by an exhibition, held in

THE NEW SCHOOL 53

EXHIBITION
ARRANGED BY HOWARD PUTZEL JANUARY 22 TO MARCH 19
 Current with the lectures by GORDON M. ONSLOW-FORD
CHIRICO
ERNST
MIRÓ DELVAUX BRAUNER PAALEN HAYTER
MAGRITTE SELIGMANN MATTA ONSLOW-FORD FRANCÉS
TANGUY
 TO BE REARRANGED EVERY TWO WEEKS
NEW SCHOOL FOR SOCIAL RESEARCH • 66 WEST 12TH STREET

Flyer for an exhibition in conjunction with Gordon Onslow
Ford's lecture series 'Surrealist Painting: An Adventure into
Human Consciousness', 1941.

the New School's small gallery. The first, featuring the work of Giorgio de Chirico, would be on 22 January.

Quite who had arranged for Onslow Ford to lecture is not known, although Hayter, being on the New School faculty, is the obvious choice. The exhibitions were hung by Howard Putzel, a young Californian who in 1938 had opened a gallery in Hollywood showing the likes of Miró and Ernst. By the end of that year Putzel was in Paris, working as Peggy Guggenheim's assistant. Trusting her taste to her new adviser's eye, Guggenheim undertook to buy a work a week – 125 in all, the core of her future collection. In July 1940, Putzel fled the Nazis for New York.[55]

After the De Chirico show, on 5 February, came another of ten paintings by Miró and Max Ernst; then one of Tanguy and Magritte.[56] The fourth exhibition, hung for the 5 March lecture, was a group show of fifteen recent surrealist works: it was called 'Adventures in Surrealist Painting during the Last Four Years'. Among other artists this included the work of Wolfgang Paalen, of Kurt Seligmann, Roberto Matta, Onslow Ford himself and Stanley William Hayter. Visitors were given pads of paper – pink for women, blue for men – on which to play Exquisite Corpses. A rubbish bin with the word 'Dalí' painted on it stood by the lecture room door.

CHAPTER 2

Of the studio's early days at the New School, Jacob Kainen recalled that he had 'never wanted to go into Atelier 17, because no matter how Hayter talked about giving everyone carte blanche to do everything, all the students looked like Hayter in the end'. 'He had so strong a personality,' Kainen said, 'no matter how he trie[d] they c[ouldn]'t get away from him.'[57] This would not have pleased his subject to hear. Like his fellow exile in America, Josef Albers, Hayter was firmly of the belief that art could not – should not – be taught. All that could be imparted was experience, which opened the door to the imagination. 'I've got to get [students] to see something they've never seen before,' Hayter said. 'But [something] that's theirs, not mine.'[58]

Kainen's recollection was that of a young American, impressed – intimidated – by Hayter's Parisian fame. Onslow Ford's memory, by contrast, was of Hayter in Paris, moving among such giants as Miró and Masson. It is a more dispassionate view, of Hayter's role as a thinker and maker rather than a figure of myth. How Hayter was viewed by his *anciens* was a matter of interest, since those same ancients were soon to join him in America.

In his concluding remarks to the 5 March lecture, Onslow Ford heralded their arrival: 'Tonight I have given you a brief glimpse of the works of the young painters who were members of the Surrealist group in Paris at the outbreak of the war. Perhaps it is not by chance that all of us...have managed to find our way to these shores.' He paused for dramatic effect, then went on: 'I am overjoyed to tell you that I hope soon André Breton will be with us....I think I can speak for all my friends when I say that we are completely confident in our work and slowly but surely with the collaboration of the young Americans we hope to make a vital contribution to the transformation of the world.'[59]

Two things were notable in this. First, Onslow Ford now took it as read that surrealism was not inherently French – indeed, that its future lay in the hands of young Americans, whom he addressed, companionably, as 'we'. Second, the new world to which surrealism was a portal was no longer that of Breton's Marxian paradise but rather a quasi-mystical realm of Jungian cosmic consciousness. One of the clearest changes in surrealism's move across the Atlantic was a commensurate shift from Freud to Jung. If both men had put myth at the centre

THE NEW SCHOOL 55

of their psychoanalytic method, Freud's approach to it had been historical and empirical, Jung's altogether more mystical. Masson and Bataille's *Acéphale*, part review, part secret society, had been at heart a Jungian project. Jung's assertion that dreams did not need analysing – that they were, as he put it, 'pure nature...the unvarnished, natural truth' – had already found favour among artists such as Jackson Pollock, who increasingly equated spontaneity with revelation.[60] So, too, Jung's refusal, in his essay 'The Real and the Surreal', to distinguish between the two, citing Aquinas's Peripatetic axiom as authority: *Nihil est in intellectu quod non sit prius in sensu* (nothing in the intellect that was not first in the senses).[61] Émigrés such as Onslow Ford and Masson would suggest how this changed truth might be integrated into the making of art.

Onslow Ford also saw Hayter through Jungian eyes. To appreciate Hayter's *Three Dancing Women*, he said, viewers must engage the 'cycloptic eye' in the middle of their foreheads, to 'switch to a speed that is different from the normal, where the present moment can be expanded at will to embrace an action...tear[ing] down, one by one, the veils that hide the reality of our own incomprehensible universe'.[62] This equation of speed with transcendence was quickly taken up by American critics. A month later, one praised Hayter's 'singular illusion of interchanging shapes and alternately receding and advancing planes', his 'fourth-dimensional speed element'.[63]

———

If Hayter's appraisal of his own work took a more rationalist tone than Onslow Ford's, 'Adventures in Surrealist Painting during the Last Four Years' nonetheless placed him centre stage in surrealism's new double migration: from France to America, from Freud to Jung. Of the artists in the final New School show, only four were as yet in New York.[64] A few weeks later, Onslow Ford would leave the city, first for Mexico and then California; Seligmann and Matta were busy with their own careers. Only Hayter had a public platform from which to preach the new gospel, whatever it might turn out to be.

Later, Onslow Ford would claim to have been the only bilingual surrealist in New York at the time of his visit: 'When I came to NY, it so

happened that I was the only Surrealist who spoke English well enough to lecture in public....No one thought about giving lectures much in Europe, but in NY people liked to know, they liked to know the answer to questions. So I introduced Surrealist painting to the young painters in NY.'[65] This, of course, was not true: Hayter's arrival had predated his by six months. Nonetheless, Atelier 17's audience did now include those artists who had attended the New School lectures, among them Robert Motherwell and his Stanford classmate Jacqueline Johnson, who was to marry Onslow Ford later that year.[66]

'As I remember,' Motherwell said, 'the lecture was a very good one, intelligent, clear, and filled with an enthusiasm that bordered on Onslow Ford's sense of an ultimate revelation.' This the young Englishman had accompanied with a party trick. 'Onslow Ford began with lines seemingly at random and very rapidly drawn,' an awestruck Motherwell recalled. 'At a certain critical moment, with the addition of several more lines, to my stupefaction, there appeared a typical classical de Chirico before one's eyes.'[67]

Motherwell misconstrued what he had seen: Onslow Ford's visual parlour trick proved automatism to be the very opposite of autonomous. What is more, this new quasi-automatism had been pioneered by Masson and Tanguy. Both artists were firmly of the belief that working automatically merely opened a door: it was up to the artist's conscious mind to explore what lay beyond it. Later, Motherwell would criticize Masson and Miró (and Picasso) for not being automatist *enough*, there being 'actually very little a question of the unconscious' in their work.[68] Then again, he would hold that 'To give oneself over completely to the unconscious is to become a slave.'[69] These readings and misreadings mattered, because the question of what automatism was would be central to a new, and specifically American, idea of surrealism, and to what would follow on from it.

———

Motherwell would not have been the only member of the New School audience to ponder such things. Also at the lectures were Jackson Pollock, William Baziotes, Arshile Gorky and, possibly, Mark Rothko.[70] With the exception of Gorky, all these would make work at Atelier 17

between 1941 and 1945. If Onslow Ford's lectures had proved the lure to get them to the studio in the first place, what they found there would bring them back. For the moment, however, Hayter had other things on his mind.

In May, not long before Onslow Ford left for Mexico, an exhibition called 'Britain at War' opened at MoMA.[71] Although he did not show his own work in it, Hayter advised on the section to do with camouflage. As one critic marvelled, this included the building of 'an apparatus which can duplicate the angle of the sun and consequent length of cast shadows at any time of day or latitude...[a] complex of turntables, discs inscribed with a scale of weeks, allowances for seasonal declination, and so on'. It was, she went on, 'just the kind of working mathematics [Hayter] really delights in'.[72] By the time the exhibition closed, he would finally have been joined in New York by several more of his *anciens*, notably André Breton and André Masson. As important as these, though, would be another Frenchman, invited by the Rockefeller Foundation to teach at the New School. He was not an artist but an anthropologist, and his name was Claude Lévi-Strauss.

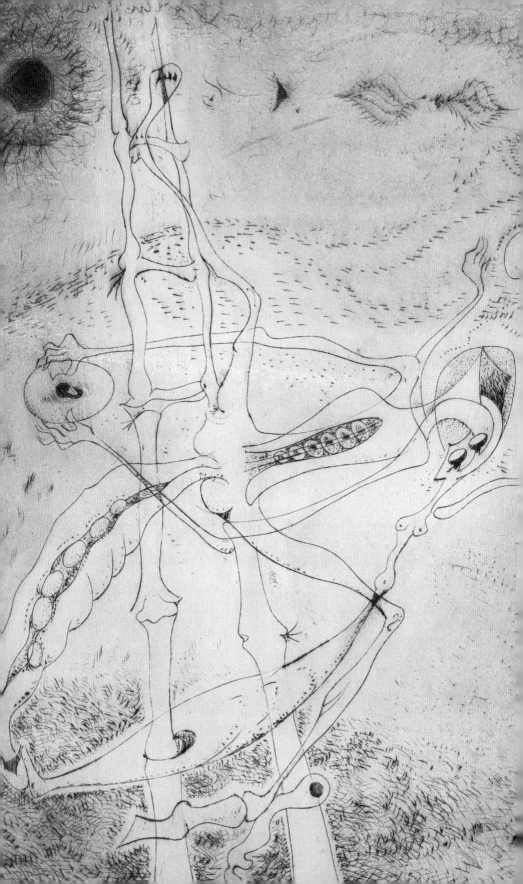

The French Arrive

CHAPTER 3

This is where words betray us completely. Words are one medium.
Communication by graphic means is completely different.
 S.W. Hayter[1]

At the tail end of May 1941, the Dominican cargo ship SS *Presidente Trujillo* arrived in New York harbour from Fort-de-France, Martinique. On board were André Breton, Jacqueline Lamba and their daughter, Aube. They were met at the dockside by Stanley William Hayter.[2]

The preceding six months had been strange ones for Breton. Like other members of the Parisian avant-garde – Max Ernst and André Masson among them – he had fled the Nazi-occupied capital for Marseilles and the Villa Air-Bel: a safe house run by the Harvard classicist Varian Fry, an American Scarlet Pimpernel to Europe's cultural elite. Fry's recollections of the man he referred to as 'the dean of surrealism' paint Breton as a king, in exile perhaps but holding court all the same. 'He talked magnificently...about everything and everybody, and held Surrealist reunions on Sunday afternoons, attended by the entire Deux Magots crowd,' Fry wrote. After dinner, 'Breton would get out his collection of old magazines, coloured paper, pastel chalks, scissors and paste pots' and direct the assembled company in games of Exquisite Corpses. 'At the end of the evening,' ended Fry, 'André would decide who had done the best work, crying *"Formidable!" "Sensationel!"* or *"Invraisemblable!"* at each.'[3]

This convivial state of affairs came to an end on 24 March 1941 when Fry found the Bretons passage on the SS *Capitaine-Paul-Lemerle*, bound for Martinique.[4] Onto a ship with two cabins and seven couchettes were crammed 222 passengers, among them the art historian John Rewald and a thirty-two-year-old anthropologist who, hearing Breton announce his name to the purser, introduced himself as Claude Lévi-Strauss. By the time the *Paul-Lemerle* docked in Martinique on 20 April, the two men were fast friends.

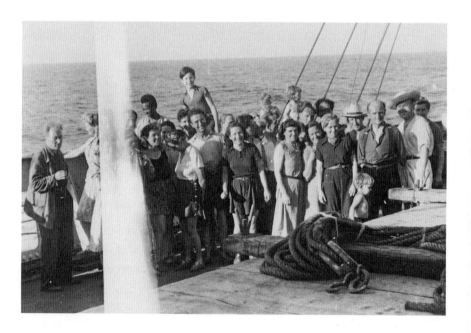

TOP Max Ernst, Jacqueline Lamba, André Masson, André Breton and Varian Fry photographed by Ylla (Camilla Koffler) in Marseilles, 1941.

ABOVE European refugees, including Jacqueline Lamba and Wifredo Lam, on board the converted cargo ship SS *Capitaine-Paul-Lemerle* sailing from Marseilles to Martinique, 1941.

THE FRENCH ARRIVE 61

After dropping the Bretons at their new flat at 60 West Ninth Street, Hayter's first act was to take André Breton for a *pastis* at the Brevoort Hotel.[5] That great chronicler of midcentury Village life, Joseph Mitchell, described the pavement café in front of the Brevoort as 'one of the novelties of the Village'. 'It was just a couple of rows of tables set back behind a hedge growing in a row of wooden boxes painted white,' he mused, 'but people thought it was very European and very elegant.'[6]

Hayter's choice of venue acknowledged what he had correctly anticipated would be a problem for his transplanted *anciens*. In Paris, surrealism's wars had been fought and won not in the classroom or lecture hall but in the café: the Deux Magots, the Flore, Le Select, and a dozen other places colonized by tribes of often fiercely warring writers and artists. In Manhattan, this network of kerbside debating chambers simply did not exist.

As Anaïs Nin noted, Yves Tanguy was among the first to be struck down by *nostalgie du café*. 'We are all seeking to live in the present, to find our life in the present,' Nin wrote in 1940. 'We have forbidden [ourselves] to talk about the past or to live in the past. But Tanguy talks about Breton and the cafés in Paris, Gonzalo constantly recalls Montparnasse.... Tanguy complains, "I used to live in the streets. Here, I never want to go out."....The tragedy is that just as we were about to enjoy our maturity in Europe, which loves and appreciates maturity, we were all uprooted and placed in a country which loves only youth and immaturity.'[7]

As Breton would later be, Tanguy was also at a loss linguistically. Writing to his friend in Budapest, the surrealist textile designer Marcel Jean, he mourned, 'Naturally, I speak pretty well no English, which is beginning to make me feel like a joke.'[8] Gordon Onslow Ford remembered him as 'like a fish out of water...[with] only a small circle of friends, mostly French speaking'.[9] The effect of all this on Tanguy would be long-lasting. In 1947, Fred Becker recalled, '[The Scottish poet] Ruthven [Todd] and Tanguy would hit all those [Irish bars along Third Avenue] and when Tanguy got to Atelier 17 the next morning his hands would be trembling. We had coated a plate for him and he sat down and took an etching needle and made this perfect drawing, not a wiggle in it.'[10]

Eventually, a café-cum-bar called the Jumble Shop on West Eighth Street, known always to the French as '*le Jumble*', came to serve as a

62 CHAPTER 3

stand-in of sorts for St Germain. At seventy cents for dinner, it was at least affordable to the largely penurious exiles. But it could never take the place of Montparnasse, as Simone de Beauvoir noted on her only visit to *le Jumble* in 1947. 'Near Washington Square [my friends] show me a charming café, the Jumble Shop, which looks almost European with its red tiled floor and its quiet little tables arrayed along the walls,' De Beauvoir wrote. 'You can eat and drink there all night. During years of exile, French writers and painters tried to resuscitate Les Deux Magots and Le Café de Flore here, but they failed; their get-togethers were always too contrived. For one reason or another, New York doesn't have the right atmosphere for café life.'[11]

Into this breach stepped Atelier 17. As Hayter would recall, 'The great thing that was lacking in New York was somewhere to sit down and talk – cafés and so forth. And the Atelier was one of those places – a lot of chaps met there.'[12] As the boats began to arrive from France and Martinique, those chaps were, in 1941, increasingly French, or at least French-speaking. But they were also either working artists or on the New School faculty. André Breton was neither. A printmaking studio was not his natural milieu.

On 14 July, Peggy Guggenheim and her husband, Max Ernst, landed in New York – not, thanks to Guggenheim's money, by cargo boat but by Pan Am clipper from Lisbon.[13] Ernst found Breton already sidelined. 'André Breton does not speak English,' he noted drily. 'He persists in thinking that everything not French is *imbecile*.'[14] The following month, Kurt Seligmann wrote to the surgeon-surrealist Pierre Mabille that Breton's refusal to learn English had lost him a teaching job at the New School.[15] His intransigence was to cost him dear. Although Meyer Schapiro in particular was charmed by him, and vice versa – Schapiro's appeal lay in his fluent French – Breton was to have no official role at the New School. By contrast, Hayter, in return for space and time in which to run his new de facto French clubhouse, could offer the School both himself and his *anciens*. 'Of course,' he said pragmatically, 'I had a lot of people. Chagall, Miró...Masson. I mean, rather a distinguished clientele, that [the New School] probably wouldn't have managed to get on the faculty. Things were very tight in those days, very little money around.'[16]

TOP The café at the Brevoort Hotel photographed by Eisenman, 1937.

ABOVE Marcel Duchamp with group of friends. From left to right: André Breton, Esteban Francés, Suzanne Césaire, Jacqueline Matisse-Monnier, Denis de Rougemont, Elisa Breton, Sonia Sekula, Madame Nicolas Calas, Yves Tanguy, Nicolas Calas, Marcel Duchamp, Patricia Kane Matta, Matta, Alexina Duchamp and Aimé Césaire. New York, c. 1944–5.

64 CHAPTER 3

Breton was not the only one of Hayter's *anciens* to arrive in New York that May.[17] On the 29th, also by cargo boat from Martinique, had come André Masson, his wife, Rose, and their young sons, Diego and Luís.[18] As Hayter had discovered the previous October, the man in the American street was not necessarily prepared for the wilder shores of French surrealism. One of Masson's Parisian drawings, *Mythologie de la nature*, was of a landscape that could also be read as a tiny woman staring blankly into the vast vagina of another. When it was impounded as pornographic by a disapproving US customs officer, Masson was outraged. 'Vous n'avez aucune mythologie,' he spluttered: you have no mythology.[19]

The same could not have been said of Masson himself, who had come to America with a mythology ready-packed in his bags. Like Breton and the other exiled surrealists, he had devoured Chateaubriand's *Atala*, an early proto-Romantic novel based on its French author's travels in America.[20] Since these had taken place in 1791, a hundred and fifty years before Masson's arrival, and in Mississippi rather than New England, their relevance might have seemed tangential. Nonetheless, *Atala* shaped, and would continue to shape, the way in which Masson saw his place of exile. 'My idea of America, like that of so many French, was, and perhaps still is, rooted in Chateaubriand,' he would confess, shortly before leaving the United States in October 1945. 'Nature: the might of nature – the savagery of nature – the feeling that nature might one day recover its strength and turn all back to chaos.'[21]

It was a view that might have surprised his fellow townsfolk in placid exurban New England. After a short stay at the Hotel Van Rensselaer on East 11th Street, the Massons had set off for an extended visit to their old Paris friends Eugene and Maria Jolas, the Franco-American champions of Beckett and Joyce, at Lake Waramaug in Connecticut.[22] From Manhattan, André Masson had written to his collector and mentor Saidie Adler May in Baltimore: 'New York pleases me, but it is devouring me....I think I would be dead if I stayed there.'[23] Won over by the quiet of Connecticut, he and Rose took a house in New Preston, near Alexander and Louisa Calder's farm at Roxbury. 'Trepidating New York soon proved to be too disturbing...for Masson's highly sensitive nerves,' Eugene Jolas was to recall. 'I have always responded to the tormented quality of Masson's paintings of that period.'[24]

THE FRENCH ARRIVE
65

Even Manhattan above 59th Street might arouse this torment. 'The squirrels of Central Park are for me a symbol,' Masson shuddered. 'It always seems to me that one day they may overrun New York.'[25] He was not alone in this fear. In the month of the Massons' arrival, the exiled Swiss writer Denis de Rougemont had found himself caught in a thunderstorm near the Central Park Zoo. Throwing caution and geography to the winds, De Rougemont confided to his diary: 'To my left, the caymans made a noise which no word in any language could express. To my right, giraffes danced to this noise, a swaying, anguished ballet....Pure emotion, signifying nothing, relating to nothing, violent – American.'[26]

For all his trepidation, though, Masson was quick to recognize the electrifying effect that American 'savagery' was having on his art. The reasons for this were both theoretical and personal. If the starting point of French surrealism had been an accessing of the Freudian unconscious (whatever the means of that access, and uses to which it might be put), then Jungian America now conflated cause and effect. It was a place both of arrival and of departure, a means to an end and an end in itself. The collective unconscious of which Masson now found himself part was precisely shared by his exilic contemporary De Rougemont, as it had been by Chateaubriand and his itinerant hero, Chactas.

'Here I keep imagining a virgin forest about me,' Masson wrote. 'This has had its psychological influence on my painting....There has been no influence of the cities. What characterises my American work is rather its manner of expressing this feeling for nature.' Pictures such as *Printemps Indien*, *Paysage Iroquois*, and *Les Gens de Maïs* could never have been painted in Europe, Masson reflected. 'Perhaps,' he went on, 'I am temperamentally better fitted to understand the life of the pioneers, their struggle with the elements. In fact I think I understand the life of the past and the problems of the past....better than the city life of the present.'[27]

In 1941, though, the five works Masson was to list as ineluctably American had yet to be made. Although, a week after arriving, he had written to his friend and gallerist Curt Valentin that his painting and drawing were both going well, Masson had in fact neither studio to paint in nor materials to paint with.[28] His first American painting, *Chantier d'oiseaux*, done in his new studio in New Preston, would not be sent to

66 CHAPTER 3

Valentin until mid-September. Before that, though, he had made his first New World masterpiece: not a canvas, but a work on paper. 'I am glad that Hayter is helping you with the etching material,' his letter to Valentin had gone on to say.[29] The work he referred to would be hugely influential, both on the people who saw it and on Masson's own output in exile. It was made not in Connecticut but in New York, at Atelier 17, in the weeks after his arrival.[30]

Known as either *Rape* or *Rapt*, the work is notable for a number of reasons.[31] Apart from his piece for *Solidarité* (1937/8), it was Masson's first sally into intaglio printmaking since 1933/4. The prints he had made then, with names such as *Diomède* and *Sacrifices: Mithra*, were figurative, Picassovian in flavour and based on the classical myths. *Rape* is neither of the first two, and only covertly the last. If a pair of women's legs with attendant pubic hair can be read in the top right-hand corner of the composition and the eyed muzzle of a bull in the right-hand centre, then these are the only areas that are in any sense pictorial. Even those are easier to make out if you know that Masson had, since 1932, been at work on a series of images relating to the myth of Pasiphaë, whose intemperate fondness for the Bull of Minos had led to the birth of the Minotaur.

For all that, *Rape* is quite unlike any of the earlier Pasiphaë works. It is, though, strongly linked to the great painting *Pasiphaë*, which Masson would show in New York in May 1944 and would later, rightly, count as a defining moment in his own career. If Picasso is absent from *Rape*, then the influence on it of another artist is clear. In Paris, Masson had made only one print at Atelier 17, and that – the *Solidarité* piece – under the constraints of a shared and specific commission. Now, in New York, this new print, his first in four years, bears all the hallmarks of Hayter.

This is not to say that it looks like the kind of work Hayter himself was making in 1941, but that its methods are Hayterish. Even an artist as seasoned and self-assured as Masson seems to have been galvanized by the injunction at Atelier 17, reported by Jacob Kainen, to 'ruin the plate'; the creative destruction of Hayter's teaching. What Masson discovered on the seventh floor of the New School was a way of working that perfectly expressed the new-found savagery of America, yet one that was couched in a language he could follow. If he chose to make *Rape* in

THE FRENCH ARRIVE

67

drypoint rather than with Hayter's favoured burin, then rendering wildness with an etching needle rather than a gouge merely added to the challenge.

In Paris, in 1937–9, Masson had produced a series of paintings – *Dans la tour du sommeil* (1938) (FIG.16) is one – dubbed 'paroxyst' for their febrile subject matter and overwrought handling. These, though, had merely represented paroxysm: in *Rape*, Masson enacts it. Paroxysm becomes not a subject but a means of production, the webbed lines of his first New World print appearing as if traces of a convulsion. Or, rather, the making of the work, the visible history of how it was made, the paroxysmal sweep of the maker's hand, *is* its subject. *Rape* is, as it were, an action etching.

Figure and ground are conflated, Euclidean logic dispensed with. There is no top or bottom to *Rape*, no vertical or horizontal – the outcome, almost certainly, of Masson having followed Hayter's instruction to turn the plate as it was etched. Not since the automatic drawings of the 1920s had Masson worked with such ferocity, or, perhaps, such engagement. If one might think of this process as broadly automatist, then the intention behind the automatism seems different from that of the works of two decades before. Then, working automatically might produce results that needed *ex post facto* titivating. Now, rawness was all.

Or not quite all. As Hayter was later to note in the *catalogue raisonné* of Masson's graphic work, '[His] invention ha[d] always been completely adequate to his explicit or his unconscious purpose. Drypoint requiring no means but a point and plate, capable of rapid execution, was a method in keeping with his temperament, although later in New York the even more spontaneous line drawn directly through soft-ground was used.'[32] What Hayter had seen – what he had very likely helped to oversee – was that, for all its apparent spontaneity, *Rape* nonetheless observes the compositional proprieties. Few of the lines go over the margins of the print, and those that do neatly re-emerge to continue the arc they had been describing, as if the image had been cropped from a larger whole.[33] The density of these lines is also consistent across the print, so that the web they weave is never tangled or obscuring. *Rape*, in other words, conforms to Masson's earlier thinking in being automatic, but not quite.

68 CHAPTER 3

It was, for all that, only one of a number of different and often anti-thetical modes with which Masson was to experiment in the first six months of his American stay. Like his fellow refugee from Paris, Piet Mondrian, exile to the New World seemed to unleash a creative flood in him, although, typically of Masson, this meant re-examining the past rather than simply discarding it. 'It was in America that, for me, things were at their most concentrated,' he was to say. 'There, where I had travelled so far to get to, that I matured.'[34]

Rape would be not just the first but the only automatic drypoint Masson was ever to make, although that is by no means to play down its significance. If its convulsive aesthetic would reappear in his work only in 1944, and then in a painting rather than a print, that reappearance was to be hugely important both to Masson himself and to the history of art. Above all else, *Rape* is notable for its all-over composition. Hayter's emphasis on the fluency of the hand as a path to the subconscious is reflected in the print's swoops and whorls, its kinetic force. It is not so much a composition as an arena, a site of action.

As for many of its *anciens*, Atelier 17 in New York would be useful to Masson less as a place in which to make prints – he would produce only eighteen there in his four years in America – than as one in which to talk and experiment.[35] Hayter's belief that the process of printmak-ing was as much about metal as paper had ramifications for painters as well. In the atelier, Masson would finally see a great coming together of his skills as a painter and draughtsman; a synthesis preempted by *Rape*. Despite his lack of English, the fluency of his hand allowed his discoveries to be understood by habitués of the atelier who spoke no French.

In this regard, his exile differed from Breton's. As Kurt Seligmann was to note, the stubborn monoglottism of some émigrés rendered them mute to an American audience. 'But artists,' said Seligmann, 'speaking the lan-guage of forms, did not encounter this difficulty.'[36] Robert Motherwell also saw the importance of Atelier 17 as an arena for cultural exchange. 'One of the many difficulties for Europeans in exile, particularly the ones who didn't speak English very well, was the lack of public meeting places,' he said. 'Stanley William Hayter's Atelier 17 – Studio 17 – was one place where exiles worked rather than talked.'[37]

THE FRENCH ARRIVE

69

Masson's one and only automatic drypoint had been typical of Atelier 17 in another way as well. So insistent was Hayter on the primacy of plate over print that only one copy of *Rape* seems to have been pulled at the time of its making. Others – the one in MoMA's 1976 retrospective, for example – were made after Masson's return to France in October 1945 (FIG. 15). The original print, though, had stayed at Atelier 17, either kept in a portfolio or hung on a wall to be seen by visitors such as Pollock.[38]

———

Now, by boat from Fort-de-France via Puerto Rico, came Claude Lévi-Strauss. Although he had been safer in a French colony than in Pétain's pro-Nazi puppet state – Lévi-Strauss, like Rose Masson, was a Jew – Martinique in 1941 was rigidly pro-Vichy. After a harrowing crossing, these last escapees (the route would be closed in May) were left in no doubt as to their desirability. They were sent on arrival to the island's leper colony, repurposed for the occasion as an internment camp.[39] A horrified Breton recalled Lévi-Strauss' treatment by local officials: 'A very distinguished young scientist, invited to continue his research in New York, was told: No, you are not French, you're Jewish, and so-called French Jews are worse for us than foreign ones.'[40]

His reception in New York was to be warmer. Armed with an invitation from the Rockefeller Foundation to teach at the New School, Lévi-Strauss at first lodged around the corner from it with Yves Tanguy and Kay Sage in their flat at 30 West 11th Street. He quickly found himself a one-room apartment just down the block at number 51, in a room 'whose windows overlooked overgrown gardens'.[41] There was a bed, a table and two chairs. 'One accessed the studio by a long basement corridor leading to a private staircase at the back of the red brick house,' Lévi-Strauss recalled. 'The old Italian [owner] was called "doctor" and had a daughter, an anaemic creature of a certain age who remained unmarried.'[42]

On the wall of the studio, wrote his friend, the American art critic Patrick Waldberg, was a mural 'in sombre tones, absolutely surrealist in spirit, in which giant hands overlapped and faded into the other elements....It had something about it of certain works by Hans Bellmer,

70 CHAPTER 3

with less skill but...a certain romantic lyricism which lent it a particular seductiveness.'[43] The forest of hands was a familiar trope in surrealist imagery: it would appear in Masson's illustrations to *Martinique charmeuse de serpents*, his postwar book with Breton about their time in the Caribbean – a time that Lévi-Strauss had also shared. The hands in this mural, though, had been painted not by Masson but by Lévi-Strauss himself.[44]

<hr>

When he introduced himself on the gangplank of the SS *Capitaine-Paul-Lemerle*, Claude Lévi-Strauss had been an unknown young philosopher-turned-ethnographer and André Breton a middle-aged celebrity. Despite the differences in their age and fame, however, the two men were thrown together. If Lévi-Strauss was intrigued by the philosophy of surrealism, then it was in surrealist art that he was primarily interested. He recalled having been taken by his father, at the age of ten, to cubist exhibitions in Paris and being astonished to see that there was a kind of painting that was no longer merely representational. 'I also remember my own naive compositions,' he said ruefully. 'Everything was flat, two-dimensional, with no research into volume. But one thing was certain: they represented nothing.'[45]

Now, on the interminable voyage to Martinique, he and Breton began a debate about automatism and its centrality to the making of art – a discussion that Lévi-Strauss would note and present to the older man as an essay at the end of the trip, and which would in turn form the core of the last published work of his own lifetime.[46] This essay takes the form of a Socratic dialogue, although it is not always clear from the tone which of the two participants is Socrates and which Alcibiades.

Lévi-Strauss begins by recalling Breton's edict, promulgated in the *Manifesto of Surrealism*, that artistic creation consists solely in psychic spontaneity, or 'absolute liberty'. One might learn different methods of prompting this liberty, but the work of art was always, and only, to be judged by its presence. Given this, there were three possibilities. First, the best artwork would be the most spontaneous, or, to put it another way, the most automatic. Then the rhetorically trained Lévi-Strauss veers to the contrary position: that a work might necessarily require

THE FRENCH ARRIVE

71

what, echoing Freud, he calls *élaboration secondaire* – a conscious intervention – on its maker's part to qualify as art.[47]

Finally, he arrives at a compromise. In certain conditions (or among certain peoples), the line between the conscious and pre-conscious minds may be blurred. The very process of art-making might, of itself, constitute a kind of irrational rationality, in which the choice and manipulation of materials involved express what Lévi-Strauss calls 'mandatory structures', hotwired into the psyche. This was not a million miles from Jung's thinking on collective archetypes, or from Hayter and Wertheimer's on instinctual form. All these things would have been in the air at Atelier 17 by the summer of 1941, implicit in Hayter's teaching by day and explicit in discussions at night.

They also squared a circle in the thinking of André Masson. In Paris, he had argued that pre-conscious automatism and conscious reworking might happily coexist in the making of a work of art. Now, in New York, he saw that they didn't have to – that, *pace* Lévi-Strauss, they might be, and always had been, one and the same thing. At a stroke, an anxiety that had shadowed surrealism since the movement's beginning was removed. In the first *Manifesto*, Breton had written that surrealist activity had to be 'beyond any aesthetic preoccupation'. The critic Pierre Naville had taken this edict to its ineluctable end. In the first issue of the influential review *La Revolution surréaliste*, he pointed out that there could thus logically be 'no such thing as Surrealist painting: neither pencil lines made as a result of accidental gesturing, nor images tracing dream figures, nor imaginative fantasies can qualify as such'.[48] Breton's *Le surréalisme et la peinture* had attempted to defuse the so-called 'Naville crisis', seeing surrealist painting as a means of expression rather than as an aesthetic product. Now, in New York, the dichotomy had melted away. How far this new-found freedom is behind *Rape*'s explosion of energy is impossible to say.

There is, in the same way, no documentary evidence for Lévi-Strauss' participation in what was taught or talked about at the first American Atelier 17. Given the New School's encouragement of cross-disciplinary teaching, the young ethnologist's interest in visual – and specifically in surrealist – art, and his friendships with André Masson and Max Ernst, it seems impossible that he was not familiar with the studio.[49] Certainly,

he and Hayter were friends in New York, even if this friendship did not particularly continue in Paris after their return.[50] The presence of Lévi-Strauss, actual or intellectual, in that small room on the seventh floor in West 12th Street has to be deduced from the work that emerged from it in the years between 1941 and 1945.

———

Fred Becker, one of the earliest of Hayter's American *nouveaux*, echoed his mentor's belief in the primitive nature of printmaking. 'Engraving, the act of incising a groove into some resistant material, is found as early as the first traces of human activity,' Becker said, six decades after climbing the stairs to Atelier 17 in the autumn of 1940.[51] If Masson, via Jung, held that his psychic response to America had been identical to that of Chateaubriand a century before, then Hayter and Becker felt themselves tapping into something older still; as old as art itself.

Lévi-Strauss, meanwhile, had been struck by a 'primitive' America. Staying with the Massons in New Preston, he had come away with a sense of them living 'as the first colonists had'.[52] Denis de Rougemont noted that this ancient America was paid scant attention by Americans themselves. The country was, he said, 'the enemy of memory'.[53] When it wanted to do old – he cast an eye on the Gothic churches and Tuscan mansions of Fifth Avenue – it was to a European past that it turned. The *genius loci*, De Rougemont said, was 'the spirit of Mickey Mouse, grafted onto Superman'.[54]

Like him, Lévi-Strauss was most struck by this paradox in New York – 'decidedly not the ultra-modern metropolis I had expected', as he was to remember. 'Immense horizontal and vertical chaos attributable to some upheaval of the urban crust rather than urban planning.... Elsewhere emerged from the surrounding magma...the still visible remains of those upheavals: vacant lots, incongruous cottages, hovels, replacement buildings – the last already marked for demolition.'[55] Waxing Baudelairean, he said he found New York 'a magical place...where animals of more-than-human sweetness join their little paws together like hands, praying for the privilege of building the Chosen One a beaver's palace, or...teaching Him, with a mystical kiss, the language of the frog or the kingfisher'.[56]

THE FRENCH ARRIVE 73

His embrace of surrealism was more than just fanciful. What had dawned on Lévi-Strauss in his exchanges with Breton en route to Martinique was that surrealists and anthropologists were unexpectedly alike in their interests. Both were fascinated by otherness, both with the idea of a primitive – psychoanalytic in the case of surrealism, structural and societal in that of anthropology. By placing themselves outside the norms of morality and rationality, by shunning linguistic convention, surrealists put themselves in a place from which they could scrutinize societies and languages. Breton's *forces étranges* and Lévi-Strauss' *extrême pointe de la sauvagerie* were manifestations of the same urge.[57]

As he was only too happy to admit, surrealism's othering-of-the-self would have an enormous impact on Lévi-Strauss' thinking as an ethnographer. 'C'est des surréalistes que j'ai appris à ne pas craindre les rapprochements abrupts et imprévus,' he would say: It was from the surrealists that I learned not to fear sharp and jarring contrasts.[58] In his collection of essays, *Le Regard éloigné* (*The View from Afar*), Lévi-Strauss compares the structure of his own *Mythologiques* – the four-volume analysis of myth that, in the 1960s, would catapult him to international stardom – to the collages of Max Ernst.[59] One of the book's chapters, 'Une peinture méditative' ('A meditative painting'), is given over to Ernst's work. The friendship of the two men would survive their return to Paris after the war, lasting until Ernst's death in 1976.

The exchange between ethnography and surrealism was by no means all one way. If Lévi-Strauss' eyes as an anthropologist had been opened by his dealings with the likes of Breton and Ernst, then he in turn brought expertise and connoisseurship to their engagement with the tribal arts of the Americas. Breton may have found the contemporary United States barbarous and uncouth, but his animus did not extend to the arts of its First Peoples. His scholarly interest in these had begun at least two decades before – it was he who, in Paris in 1927, had arranged for Yves Tanguy's work to be shown alongside pre-Columbian artefacts from Mexico and contemporary tribal works from British Columbia.[60] In his catalogue to that show, Breton had written of America as a place of Tanguy's imagining, one that 'he had truly discovered'. Now, both he and Tanguy could build on their discoveries.

74 CHAPTER 3

One of the places where they did this was in the emporium run by Julius Carlebach, a German Jew who had fled the Nazis to New York in 1937. In Paris, Breton had scoured the flea market at St Ouen for additions to his ethnographic collection. Pickings had been costly and slim. By contrast, said Lévi-Strauss, Carlebach's Third Avenue shop was 'an Ali Baba's cave...[of] precious stone masks from Teotihuacan, admirable sculptures from the Pacific Northwest coast', most available for just a few dollars.[61] Max Ernst, who had found Carlebach's first, bought a Canadian Haida spoon, 'the four figures of its black bone totem staring, from iridescent abalone eyes, their superb refusal of the surrounding bric-a-brac', as Ernst's soon-to-be lover, Dorothea Tanning, was to recall.[62] When they discovered that Carlebach's own source was the Museum of the American Indian – its director had been selling off duplicates from the cash-strapped museum's Bronx storerooms – Ernst, Breton and Matta hired a taxi and went to parley with him face-to-face.

The role of African and Oceanic art in cubism is well catalogued, the influence of the native art of the Americas on the transplanted Parisian surrealists rather less so. A recent exhibition in New York paired Yup'ik masks with works directly inspired by them: these included pieces by Max Ernst and Kay Sage, both Yup'ik collectors.[63] Ernst and Tanguy amassed considerable collections of American ethnographic art – the MoMA trustee James Thrall Soby took a photograph called *Max among Some of His Favourite Dolls* of Ernst surrounded by his twenty-nine Kachina figures – and the work of both men post-1941 showed the impact of their collecting. In the early 1940s, Ernst, fascinated by Native American sand paintings he had seen in the catalogue to the MoMA show, began to make images of his own in sand, working flat on the ground in the Navajo manner. It was André Masson, though, whose work would be most shaped by American ethnographic art, paintings such as *La Graine et l'étoile* (*The Seed and the Star*, 1942) and *Le Cimitière de Sioux* (*Cemetery of the Sioux*, 1942) taking on a hallucinatory palette their maker intended as shamanistic.

While Masson's new fascination for American ethnographic art is at its most visible on canvas, it had first manifested itself on paper. Ernst's sand paintings showed a determination on the part of the French surrealists not merely to work in an ethnic American style, but

Yup'ik mask previously in the collection of André Breton, bought from Julius Carlebach in 1945.

in an ethnic American way. Fred Becker's remarks on the 'primitive' history of intaglio printing – a thesis often expounded by Hayter in the studio – suggested why etching and engraving might have taken on a new interest for Masson in the New World. The Navajo may not have pulled prints, but they and other First Peoples had certainly etched, immemorially, on wood and clay.

In late 1941, Masson set to work on a commission for an original print to be included in the deluxe edition of a book of poems and pen-and-ink drawings published by Wittenborn & Co. the following year as *Mythology of Being*.[64] The print, called *Emblème*, is variously extraordinary (FIG.17). The apparent simplicity of its composition belies its technical bravura. *Emblème* is a soft-ground drypoint etching with a grey-green wash in aquatint. The print's making will have involved several hard-to-juggle stages, its copper plate being by turns coated with an acid-proof ground, etched with a needle, soaked in an acid bath and inked up in black before

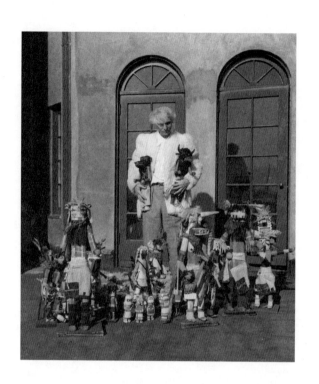

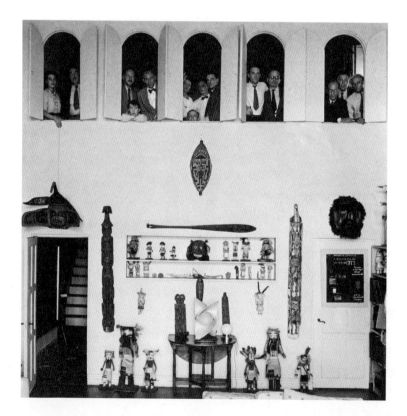

THE FRENCH ARRIVE 77

being baked with a granular coating, soaked in another bath and re-inked in colour. Nothing in Masson's past as a printmaker comes near it in technical complexity.

In compositional terms, too, *Emblème* is more complicated than it seems. At first glance, its skull-like central motif looks as though it might have been made as a Rorschach test, its two halves folded over and blotted along a vertical axis marked by a mouth, a single, Massonian eye-vagina and, above these, a star-shaped Ajna chakra. It calls to mind Gordon Onslow Ford's injunction to engage the cycloptic eye when looking at Hayter's work. Certainly, Hayter is behind the making of *Emblème*, the print's technical complexities impossible without his hand.

Where *Rape* had been Hayter-like in its abstract loops and whorls, though, *Emblème* is more straightforwardly illusional. Even more so is *La Génie de l'espèce* (1942), made a few months after the two prints above, although its Tanguy-esque *bizarrerie* of bamboo limbs and male/female pudenda seems surrealist in an oddly old-fashioned way (FIG.18).[65] The print's combination of burin and drypoint lines suggest Masson going over familiar territory as a template for trying out new ways of working. The date of their making apart, two things link these three very different prints. First, they show Masson in the grip of a creative frenzy, looking backward and forward technically, stylistically and icon-ographically. Second, *Rape*, *Emblème* and *La Génie de l'espèce* see him using the relatively unfamiliar tools of intaglio printing to ask questions whose answers would occupy him as a painter for the next five decades. Atelier 17 was not just a place to make prints for him, or even to learn the skills of printmaking. It was a laboratory of art.

Masson was not the only exiled Parisian painter to find himself now thinking in print, nor even the best known. In August 1941, Marc Chagall and his wife arrived in New York from their safe house in Provence. If they

OPPOSITE ABOVE Max Ernst surrounded by kachina dolls, photographed by James Thrall Soby, c. 1942.

OPPOSITE BELOW Peggy Guggenheim's apartment photographed by Hermann Landshoff, 1942. From left to right: Leonora Carrington, Fernand Léger, John Ferren, Berenice Abbott, Amédée Ozenfant, Peggy Guggenheim, Frederick Kiesler, Jimmy Ernst, Stanley William Hayter, Marcel Duchamp, Piet Mondrian, Kurt Seligmann, André Breton and Max Ernst.

chose Manhattan's sedate Upper East Side over Bohemian Greenwich Village as a place to settle, Chagall was soon on his way downtown to seek out Hayter and his atelier. In 1943, he would set to work there on a suite of etchings of scenes from the circus. Incorporating patterns made by pressing cloth and string onto the plate, these are as playful as their subject suggests, and as daring. The circus etchings would be shown as a group in Chagall's MoMA retrospective in 1946. '[Chagall's] work in Stanley William Hayter's *Studio 17* in New York has had a refreshing and vitalizing influence on his prints,' noted one critic.[66]

———

All the while this was going on, a change was taking place. Although Alfred Barr had been careful to divide his 1936 MoMA exhibition, 'Fantastic Art, Dada, Surrealism', into works that were oneiric and those that were automatic, the common perception remained that all surrealist art was dream-based. In earnest, Federal Arts Project America, this made it eccentric, which made it frivolous, which made it immoral. The high jinks of Salvador Dalí – in March 1939 he had infamously decorated one of the windows of the Bonwit Teller department store with a nude mannequin stepping into a fur-lined bath, only to smash the display in protest when staff tried to censor it – hardly helped. Never mind that, by 1941, Breton had expelled Dalí from surrealism, dubbing him, anagrammatically, 'Avida Dollars'. To the man in the American street, all surrealists were Dalí.

Thus the critic of *Time* magazine, writing up 'Fantastic Art, Dada, Surrealism', had described the deeply serious Breton, the 'founder' of surrealism, as someone 'who frequently dresses entirely in green, smokes a green pipe, drinks a green liqueur and has a sound of knowledge of Freudian psychology'.[67] All this was grist to the mill of critics such as Clement Greenberg, who, in his article 'Avant-Garde and Kitsch', attacked surrealism as both aesthetically lowbrow and lacking in moral seriousness.[68]

Thanks to Masson, though, this perception was changing. In October 1941, just five months after arriving in America, he was given a retrospective at the Baltimore Museum of Art. On the 31st, he accompanied this with a talk in the newly dedicated Members' Room, paid for by his

THE FRENCH ARRIVE

mentor, the collector Saidie May. Writing to her after the event – May had been unable to attend – he said, 'The exhibit was perfectly organised and is, I think, the most representative exhibit of my work ever held outside of France. My talk was well received.' Then he went on, 'It is true that I showed to advantage my own idea of Surrealism as opposed to the official view.'[69] A week later he wrote to his friend, the dealer Daniel-Henry Kahnweiler, to tell him that the great Baltimore collector Etta Cone had bought one of his new paintings. This was a coup, Cone's collection having previously stopped, chronologically, with early Picasso.[70] A month after, he wrote to Kahnweiler again: 'J'aime ce pays de plus en plus – j'aurais d'ailleurs mauvaise grâce à ne pas m'y plaire car nous y avons été reçus avec chaleur et compréhension' (I love this country more and more – I would be graceless not to like it, because we have been received there with such warmth and understanding).[71]

Even if the French did not particularly feel it themselves, the local perception of them was changing too. Slowly, they were becoming familiar, which is to say, accepted as American. Lévi-Strauss was now listed in the annual New School prospectus as Claude L. Strauss – in part to avoid his being confused with a well-known brand of denim workwear, but also to show his new status as a native.[72] In the words of Masson's friend Eugene Jolas, himself a Franco-American hybrid: 'A new language is in the process of developing in the United States. It doesn't yet have a name....It is a super-occidental form of expression. It has a polyglot dimension. – I call it atlantic, or the crucible language.' The book in which Jolas wrote this had a design by Yves Tanguy on its cover.[73] The name of Hayter's atelier, too, was undergoing a change. By the time the studio and its artists were given their own show at MoMA in August 1944, it would be known officially as Studio 17.

Towards A New Painting

CHAPTER 4

Such is the rigor of the New American Chauvinism that the Surrealist background of our postwar painting is often disavowed. But the parthenogenesis of the New York School is a dogma professed by the second generation of Tenth Street rather than the originators of the style, the men who were actually on the scene in the crucial early and middle forties when the exiled European artists were here.
William Rubin[1]

The influence of the European painters on American art at midcentury is a convenient myth. Most of the Europeans who came were Surrealists.
Clement Greenberg[2]

Max Ernst was not the only artist in New York in the early forties to have been beguiled by Navajo sand painting. Three months before Ernst's arrival, Jackson Pollock had been to a show at MoMA called 'Indian Art of the United States'.[3] The foreword to its catalogue was written by Eleanor Roosevelt. 'At this time, when America is reviewing its cultural resources,' Roosevelt said, 'this...exhibit...open[s] up to us age-old sources of ideas and forms that have never been fully appreciated.'[4] A section of the exhibition called 'Living Traditions' would showcase, in April, a live demonstration by two Navajo sand painters, Charlie Turquoise and Diney Chilli Bitsoey. Pollock went back again and again to watch them at work on the gallery floor.

If the First Lady wrote of Native American art as a neglected resource, then that view will have been put to her by the curator of MoMA's show, René d'Harnoncourt. An Austrian-born French aristocrat and future director of the museum, d'Harnoncourt had left Paris for Mexico in the late 1920s. It was he as much as anyone who had awakened contemporary Mexican artists – Diego Rivera and José Clemente Orozco among them – to the native arts of their own country. If, in May 1941, André Masson was to complain that Americans had no mythology, he and

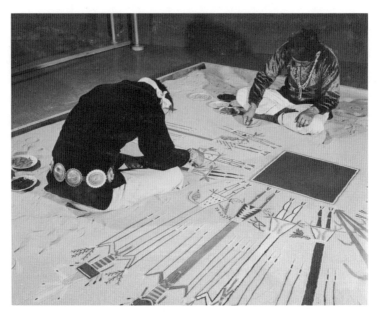

Navajo artists sand painting at the exhibition 'Indian Art of the United States', photographed by Eliot Elisofon. Museum of Modern Art, New York, 1941.

d'Harnoncourt would be among the *déracinée* Parisians who set out to unearth one.

Although the Federal Art Project had promoted an identifiably American style of painting, the iconography it had turned to was not that of America's First Peoples. Writing a few months after Pollock's visit to MoMA, the artist Barnett Newman mocked the kind of subjects FAP artists had gone for: 'the good old things we know and recognize...the beauty of our land, the traditions of our folklore, the cows coming home, the cotton-picker, the farmer struggling against the weather – the good old oaken bucket'.[5] The writer and budding gallerist Samuel Kootz agreed. Noting the 'curious fanaticism for native credentials' in American art of the 1930s, Kootz saw the Depression-hit 'middle class [as] reassured by the rich farmlands depicted, by the mines, water power,

TOWARDS A NEW PAINTING

83

the vast industries – the whole colossal evidence of self-sufficiency'. 'America's national school abandoned [Cézanne's] progressive trend,' he mourned. 'They adopted the gospel of the camera.'[6]

The problem, as Kootz saw it, was twofold: a taste for homespun subjects, tied to a homespun way of depicting them. Given this, the arrival in America of a new generation of French avant-gardists might have been expected to be greeted as a gift from the gods. Not so, however. Now, the problem was prurience. 'Just the right amount of peep-show pornography ha[s] crept into Ernst's canvases to provide final fashionable acceptance to an audience thrilled by its chi-chi eroticism,' Kootz harrumphed. 'When painters begin to smirk at sex, to tell squalid little jokes behind their fans, the spectator should begin to recognize the destiny of that form of painting.'[7]

Finally, he came to the point: the exiled artists, and their art, were foreign, and so by definition unmanly. 'Our flossier refugees (Ernst, Tanguy, Dalí, et al.) are, in most instances, concerned with Surrealism,' Kootz went on. 'So ardent has been their loud-speaker attack upon the American public, so well regarded are they in the high places of our museums and galleries, that our American spectators may very well make the mistake that this is an important development in contemporary painting....I believe Surrealism, which had its greatest appeal in the emptiness and decadence of France immediately before the present war, cannot survive in the sturdy soil of America.'[8] This identification of America's art with a national virility would, for good and ill, shape what came to be known as the New York School.

There were, though, dissenting voices. A year before Kootz, but with critics of his stripe presciently in mind, Newman had launched a broadside at American chauvinism. 'The art of the world, ranted [isolationists], as focused in the Ecole de Paris, is degenerate art, fine for Frenchmen, but not for us Americans,' Newman wrote, playing devil's advocate. 'The French art is like themselves, a foreign, degenerate, Ellis Island, international art appealing to international minded perverts....How could French art be any good anyway? The French people themselves are no good.'[9]

One of those no-good people was the surrealist poet Nicolas Calas. Rich, Greek and cosmopolitan – he had changed his name from

TOWARDS A NEW PAINTING

Kalamaris while living in Paris in the thirties – the ship-owner's son had arrived in New York in the summer of 1940. By September he was writing for the first issue of *View*, the avant-garde art magazine edited by his Paris friend, the American poet Charles Henri Ford.[10] Reviewing MoMA's exhibition 'Twenty Centuries of Mexican Art', Calas drew a parallel between surrealism's rejection of Western rationalism and 'the inner meanings of forms of culture that have developed in civilizations that were not humanistic and individualistic'.[11]

Seen like this, to be a surrealist was to be counted among the primitive: to have access to – perhaps to be part of – a native mythology. Unusually for a magazine of its kind, *View* was to be long-lasting, running to more than thirty issues before finally closing in 1947. It was also, from the beginning, unusually influential among New York's contemporary art world, which in large part subscribed to the magazine's slogan, 'You can't be modern and not read *View*.' When Jackson Pollock went to look at MoMA's Navajo sand painters, he had almost certainly already read Calas's Mexican review.

———

The consensus, then, was that Masson was right; that America lacked, and needed, a mythology. But which, and how and where to find it? For some young American artists, the search began at Atelier 17.

There were various reasons for this, the most immediate being Hayter's *anciens*. Ethel Baziotes recalled their presence in New York as 'overpowering....Its importance can't be overstated. These were fascinating men with highly perfected artistic ways. They had form, and the Americans were searching for form....It was like one flame meeting another and making a larger flame.'[12] For the sculptor Philip Pavia, the exiles were stars. 'Eighth Street and Sixth Avenue was about the centre of the art world at that time. Of course, Paris was quite closed down. And we would see Zadkine go to lunch and, of course, when he passed by we'd start this discussion about Zadkine and Cubism and Lipchitz.'[13]

OPPOSITE ABOVE Installation view of the exhibition 'Twenty Centuries of Mexican Art', Museum of Modern Art, New York, 1940.

OPPOSITE BELOW Yves Tanguy, cover of *View*, series 2, no. 2, May 1942.

86 CHAPTER 4

The only place where the likes of he and Baziotes could hope to meet these giants on anything like equal terms was Atelier 17.

Sue Fuller was one of the young Americans who signed up at Hayter's studio, in 1943. 'Who came?' Fuller asked. 'Abraham Rattner who was enjoying top billing at Knoedlers on 57th Street. Along with Rattner came Tanguy....All made plates and printed them. Rattner was hammering his plate with a nail and hammer *à la manière criblée*. Lipchitz was worrying along in an acid bath an image of a Minotaur....Alexander [Calder] made a zinc plate, *The Big I*....Who else came? André Masson, Max Ernst, Joan Miró, Marc Chagall and many more.'[14] One of these, in 1941, was Robert Motherwell.

The printmaker Enrique Zañartu recalled joining the studio the year after. 'It was,' he said, 'the only place [in New York] where you could make a print, or have it made for you. It was thus that I got to work with Tanguy, Masson, Chagall, Lipchitz, Dalí, Miró and others – or work for them.'[15] Fuller, too, had paid her way by acting as assistant to the *anciens*. Motherwell's *entrée*, though, was as an artist among artists, and it was not a happy experience. Then studying art history, he had been recommended to Kurt Seligmann by his teacher, Meyer Schapiro. After making one etching at Seligmann's studio in 1940, he had been passed on in turn to Atelier 17.

'Hayter repeatedly urged me to come down to his studio,' Motherwell recalled, 'which I did, reluctantly. As a neophyte, a self-taught artist, working publicly in a shop with André Masson, Max Ernst, and two dozen other well-known artists, with all their professional skill and some prestige, embarrassed me. Though Hayter did tell me several times I was a born printmaker, I, from my acute shyness made more so by working alongside professional artists, quit making prints there and only resumed years later.'[16] He never returned to the burin. 'There are lots of Moderns – Hayter himself – who have devoted much of their energy to intaglio,' Motherwell allowed. 'But I have never been drawn to it. I like prints with a relatively even surface, in the same way that I don't like heavy impasto painting in contemporary art.'[17]

For all his own misgivings, though, he saw the importance of the atelier's cooperative ethos to the forging of a new national art. 'Hayter's workshop', Motherwell said, 'was a beehive of professional activity, of

TOWARDS A NEW PAINTING

optimism, of accomplishment, of sheer human decency; of the will to continue. We had been surrounded, we Americans, by the dominance of "American" art of the '30s, of "social realism", "social protest", "regionalism" and so on, and Hayter's collaborative optimism felt – for those of us who were "modernists" – much more sympathetic.'[18] 'In that sense,' he observed, 'it was one of the outposts of modern civilization.'[19]

———

The fate of the work Motherwell made at Atelier 17 in the early forties says much about the studio's sidelining in art history. In 1981, nearly forty years after his time there, he wrote to Hayter in Paris.[20] Hayter was shortly to turn eighty; there was to be a celebratory exhibition of work made at Atelier 17 in what was by then the studio's half century of existence. Motherwell had been asked to submit one of his own prints.[21] His tone was warm:

Dear Bill,...I would love to honour your 80th birthday with a contribution of something done at Atelier 17. As I remember around 1942 or 1943, I made one soft-ground etching of a young woman in a chair called *The Jewish Bride* and at your insistence, two burin engravings in copper.[22] None of these were editioned – two or three proofs only – and I had no conception that much later on printing would become one of the prime passions of my life, though I remember you very supportively telling me at the time that I was a born engraver. I must have given my proofs away. Moreover you telephoned me several times to come and pick up my plates and I stupidly never bothered.

This seems a touch disingenuous. Motherwell certainly knew where at least one of the prints had gone, since he goes on to tell Hayter so: 'Fortunately at Christmas 1944, I did give one of the burin proofs to the Pierre Chareau(s), and it was photographed and appears in the standard catalogue raisonné of my prints as well as in the big Abrams volume on my work in general.' Five years before this letter, he had also passed Hayter's name and Paris address to an American curator, asking her to

88 CHAPTER 4

enquire after the whereabouts of his Atelier 17 prints.[23] For a man whose chief memory of his time at the studio was that it had put him off print-making for two decades, Motherwell seemed oddly interested in the work he had made there – and particularly in a print done with the hated burin.

Moreover, Pierre and Dollie Chareau were not the kind of people to give prints to unless the giver considered those prints important.[24] Motherwell had been introduced to the couple by Anaïs Nin, she having known them in Paris before their mutual American exile.[25] Pierre Chareau was a designer, responsible for one of the icons of French mod-ernist architecture, the Maison de Verre in St Germain; Dollie Chareau was an artist; the pair had been friends and collectors of, among others, Mondrian and Modigliani. In 1946, Motherwell would invite Pierre Chareau to be architecture editor of his new review, *Possibilities*; the following year, Chareau would design a Quonset hut house for the artist at East Hampton on Long Island. Motherwell ends his letter to Hayter on a note of something like despair: 'Dolly [*sic*] Chareau died ten or twelve years ago, and I have tried again and again through her friends to find out what happened to her collection in the hopes of recovering that unique proof, but no one knows.'[26]

What were these missing works like?[27] As might be imagined, very different from each other. *The Jewish Girl* – sometimes, and wrongly, known as *The Jewish Bride* – was the earliest, being signed and dated 'Motherwell 41' in the bottom right-hand corner (**FIG. 20**). The handling has the feel of a Matisse *odalisque*, although the subject's pose – skirt rucked up, feet in the fourth position, ungainly hand lying leaden in the lap – is hardly seductive. Neither is the girl's expression, which is blank and directed away from the viewer. Hanging on the wall to her left is what looks to be a far more obviously modern work, of two biomorphic shapes with a flavour of Tanguy, or an earlier gouache by Motherwell himself (**FIG. 19**). It seems to be there to point up the otherwise back-ward-looking feel of Motherwell's print: certainly, that is its effect. Since Motherwell would only begin to paint seriously when he returned from a six-month trip to Mexico at the very end of 1941, this print is likely to date from before his departure, ergo before he had committed himself to a life in art. The question, perhaps, that *The Jewish Girl* ponders is: what kind of artist am I to be?

TOWARDS A NEW PAINTING

The *Personage* prints are troubled by no such self-doubt. In making *The Jewish Girl*, Motherwell had taken, literally and figuratively, the line of least resistance. The print is a soft-ground etching, made by placing a sheet of paper over a metal plate covered in a wax coating and drawing on it with a pencil. It is the nearest thing to sketching that etching has to offer. As with its making, so with its manner: *The Jewish Girl* has a tentative feel, as though Motherwell was picking his way through a stylistic minefield. In the *Personage* prints, made with a burin, caution is thrown to the winds (**FIGS 21 & 22**).

The change must be put in context. Motherwell had spent the eighteen months between the two sets of prints at the cutting edge of exilic art and thought. He had gone to Mexico with the maverick young surrealist Roberto Matta, the two working alongside each other and experimenting with various forms of automatism. Motherwell and his new wife had also spent several weeks in Mexico City with the Austrian theorist and painter Wolfgang Paalen. Motherwell returned to New York with a new self-assurance.

'The fundamental principle that [Matta] and I continually discussed for his palace revolution, and for my search for an original creative principle (which seemed to me to be the thing lacking in American modernism) was what the surrealists called psychic automatism, what a Freudian would call free association, in the specific form of doodling,' Motherwell was to recall. 'Psychic automatism has potent characteristics, a kind of Occam's Razor. A: it cuts through any a priori influences – *it is not a style*; B: it is entirely *personal*; C: it is by definition *original*, that is to say, that which originates in one's own being; D: it can be modified stylistically and in subject matter *at any point during the painting process*: for example, *the same primitive doodle* in the hands of, say, Paul Klee, Tanguy, Miró, Baziotes, Masson, and Pollock, can end up as a Paul Klee, Tanguy, Miró, Baziotes, Masson, and Pollock, according to the aesthetic, ethic, and cultural values of each individual artist; E: in this sense I believe it is the most powerful creative principle – unless collage is – consciously developed within twentieth-century art.'[28]

This excursus is notable for a number of reasons. First, Motherwell's talk of a palace revolution is evidence of what was in effect a coup against

90 CHAPTER 4

André Breton. It also marked a shift in critical thinking from Freud to Jung that would typify surrealism in America. This conversion, made without his permission, was sufficiently clear to Breton to incur his wrath. Having co-opted Motherwell in December 1941 as co-editor of his new magazine, *VVV*, Breton sacked him before the first issue appeared in the spring of 1942.

This, then, was the changed Motherwell who came back to Atelier 17 in 1943. The *Personage* prints are remarkably different from *The Jewish Girl*. The large version of the newer works, the one Motherwell would give to the Chareaus that Christmas, clearly relates to a collaged piece, *Pancho Villa, Dead and Alive*, that he had made a few months before.[29] That image – a cartoonish Villa alive and priapic in the left-hand register, detumescent and fly-blown in the right – is oddly unevocative of the savagery of the Mexican revolutionary's actual murder. Much more so is an ink on paper drawing, *Three Figures Shot*, signed and dated '6 June 44' and dedicated to the writer Jane Bowles.[30] The large *Personage* is dated only as 1944. Whether it had come between *Pancho Villa* and *Three Figures Shot* is impossible to say.

The thought is worth entertaining nonetheless. Now known only from a photograph, the Chareaus' *Personage* is not the work of a skilled engraver. That is rather its point. If, as seems certain, Motherwell worked on the print with Hayter standing over him, then he would have been encouraged not to respect the plate but to destroy it. At this date, he was trying to integrate the spontaneity of automatism with the graphic structure of Mondrian. The sense here, though, is of gouging: the unevenness of the line running diagonally down the middle of the print, the varying thickness of the ovoid of the titular personage's head. The savagery that had been lacking in *Pancho Villa, Dead and Alive* (and spectacularly so in *The Jewish Girl*) is present in *Personage* in spades. And that brutality is down to the twist of the burin, and Motherwell's unfamiliarity with and lack of control of it.

The burin's inflected path has another quality as well. The thickness of a line in soft-ground etching will vary only by the degree of force with which a pencil can be pressed on paper before tearing it. It is essentially graphic. The line made by a burin, fluctuating and unevenly loaded with ink, is painterly. If many sculptors at Atelier 17 were to be inspired by

TOWARDS A NEW PAINTING

91

Hayter's favouring of the burin over the etching needle, of plate over print, then so, too, were painters.

That Motherwell's experience with the large *Personage* might lie behind the new-found freedoms of *Three Figures Shot* seems a notion at the very least worth entertaining. Certainly, the incised drawing of his paintings of the mid- to late 1940s – the Metropolitan Museum's *The Homely Protestant* (1948), say – derive directly from the engraved line; which is to say (they having been Motherwell's sole experience with the burin), from the suite of *Personage* prints he had made under Hayter's direction in 1943/4. Even then, after the French had gone home and Pollock made his first drip paintings, Motherwell was still following surrealist method. The title of *The Homely Protestant* had been chosen by the automatist expedient of its maker opening a copy of *Finnegans Wake* at random and jabbing a page with his finger. Reading the resultant text, the Episcopalian artist recalled, 'I thought, "Of course. It is a self-portrait".'[31]

———

One of the intriguing things about Motherwell's 1981 letter to Hayter is the picture it elliptically paints of life at Atelier 17. During the war, the studio was home to some of the great names in modern European art, as it would turn out to have been to many of the artists in the movement later known as the New York School. It was the arena where one of the most important cultural shifts of the 20th century took place. Yet the evidence of that shift – the work that was made at Atelier 17 by the coming generation of American painters and sculptors – is curiously sparse.

For that, Stanley William Hayter is to blame. Seven years after Motherwell's letter to him, at the memorial service for Hayter at the New School, Jacob Kainen had said: 'I remember an occasion in one of the Atelier shops in Paris when Bill was showing me some prints by the group then current. I asked if the Atelier had kept workshop proofs printed there because if it had, the archive would be a goldmine, literally and historically. I remember Bill saying, "I know it's done in America but I think the practice is rather disreputable. If I wanted to acquire a print from an artist, I'd buy it"....To him, money was the great corrupting

CHAPTER 4

influence....He once told us how amused he was by John Russell's reference to his "apostolic poverty".'[32]

This self-effacement has also had the unfortunate effect of effacing the studio from history. If its name is well known among printmakers, it is very much less so elsewhere. It would be pretty well impossible to tell the story of modern printing without tracing the extraordinary descent from Hayter via the people he taught and worked with at Atelier 17 – a bloodline that stretched to six continents, and continues. It has, unfortunately, proved all too possible to write a history of modern painting and sculpture without mentioning Hayter's name at all.

It was not only his poverty that was apostolic. Hayter's mission – not too strong a word – was to return intaglio printmaking to its historical place as a creative, rather than a reproductive, art. But that creativity had as much (or perhaps more) to do with a way of thinking as it had with the pulling of prints. It is worth noting Motherwell's throwaway reference to Hayter having repeatedly urged him to collect his plates from the studio, and his regret at having 'stupidly never bothered'. Money was always tight at Atelier 17, and copper plates expensive. If Hayter did not see the importance of building an archive for himself, he did recognize the importance of doing so for other people.

Thanks to his eminence as a printer, something else about Hayter that is often overlooked is the fact that he had first been a painter, and continued to see himself as such. His paintings were shown in New York throughout his ten years there, and were regarded as important. In 1948, the year of *The Homely Protestant*, the *New Yorker* reviewed one of his exhibitions: 'Stanley William Hayter, now showing at Durand-Ruel, is a member of a small but increasingly important group of contemporary American painters that includes such men as Robert Motherwell, Jackson Pollock, Hans Hofmann, William Baziotes and Arshile Gorky. The group is completely unorganized; there are wide stylistic differences between its members and since some of the men – notably Motherwell and Hayter – are extremely explicit and articulate about their own specific artistic theories, they may well resent being lumped together in this way....[S]ince Hayter was, in a sense, one of the founders of the movement, I think his work may fairly be considered typical.'[33]

TOWARDS A NEW PAINTING 93

Having nodded to its subject's place in the history of the art of New York, the review went on: 'What Hayter seems to be reaching for is a more fluent and more emotional abstraction, and if one accepts that this is his purpose, his work becomes far easier to understand.'[34] Then, setting a critical tone that was to haunt him as a painter for the rest of his life: 'Hayter, as you probably know, started out as an etcher, and though his early training undoubtedly contributed to his perfection of line (it would be hard to beat the sheer brilliance of draughtsmanship displayed in this collection), it also tend[s] to make his oils look rather dry and shallow.'[35] There was to be no violin allowed this particular Ingres.

———

In the first issue of *View*, in 1940, Nicolas Calas had found an equivalence between surrealism and civilizations, such as Mexico's, that 'were not humanistic and individualistic'.[36] This sense of virtue in group activity, in the erasure of the artist's hand, was widespread. The Bauhaus artists Anni and Josef Albers, also in exile in America, marvelled at the timeless forms of Mexican pottery and textiles, the lack of signatures or egos. Something of this spirit also informed Atelier 17. Collective practice and Jung's collective unconscious went hand in hand. It was not a place for egos or, despite its star-studded cast, for stars.

That the work of artists viewed now as canonical should simply have disappeared seems to tax credibility. And yet Robert Motherwell was by no means the only painter whose output at Atelier 17 has gone missing. Willem de Kooning is known to have made prints at the studio around 1943; none survive.[37] His earliest extant print, *Revenge*, was not made until 1957, more than a decade later.

Likewise, and despite his wife's recollection of Hayter's importance to him, the only print made by William Baziotes at Atelier 17 in the New School remains unpublished and barely catalogued. In 1984, Ethel Baziotes hazarded that 'two and possibly three etchings done by [William Baziotes] survive from his period at the Atelier'.[38] Working alongside Hayter would have been particularly valuable to her husband, Ethel suggested, because the two men shared a fascination with line. 'Linearity and calligraphy are an enormous element in Baziotes' work,' she said. 'He loved drawing obsessively, and saw line as the moment of

truth. I think he also saw line as a tightrope, and the artist as the tight-rope artist on that high-wire.'[39]

One of the works Ethel Baziotes recalled – not, in fact, two prints, but two versions of the same print – is now in the collection of the Reading Museum, in William Baziotes' home town of Reading, Pennsylvania.[40] On it, presumably after her husband's early death in 1963, Mrs Baziotes has written, 'The only etching William Baziotes ever made – 1948?', and her name. She was right about the uniqueness of the print, but not about its date.

The work clearly relates to a series of paintings, shown by Peggy Guggenheim at her Art of This Century Gallery in a one-man show of Baziotes' work in 1944.[41] One, *The Parachutists* (1944), is now in the Peggy Guggenheim Collection in Venice (FIG.23). Made in glowing Duco enamels, *The Parachutists* is a reminder that Baziotes had worked, as a young man, in a stained glass factory. The heavy black line of both the painting and the print have a feel of the lead cames between the pieces of glass in a church window. It marks a departure in Baziotes' style, a move away from the tentative cubism of works such as *The Prisoner* (c. 1942) towards the Mondrianish gridding of paintings such as *The Room* (1945). The new black line also feels sculptural. It calls to mind Ethel Baziotes' recollection of her husband seeing the line as a moment of truth.

———

Mark Rothko, too, worked at Atelier 17, as Hayter recalled in an inter-view with Jacob Kainen the year before his death.[42] 'I saw Rothko's work pass through what critics would call four different periods,' Hayter said blithely, prompting surprise from Kainen:

> JK You say Mark Rothko made prints?
> SWH Oh yes, he made several. I doubt he printed more than a single copy or a couple of copies. He was perfectly capable of executing any of the plates in the methods we were using and printing them.

These prints, too, have been assumed lost, although one of them has merely been misplaced.[43]

TOWARDS A NEW PAINTING

The Museum of Modern Art owns a single Rothko print, an untitled etching listed in the MoMA collections catalogue as dating from around 1951 (FIG.24). This is the only such work by the artist known to exist. If its attribution is beyond doubt, its dating is a surprise. By 1951, Rothko was already working in what is now seen as his classical style, making paintings such as the Tate's *Untitled* (c. 1950/52) – large-scale, portrait format canvases in which hazy rectangles of colour float one above the other. MoMA's print, of a pair of linear, biomorphic figures apparently by the sea's edge, could hardly be more different from these. But then the idea of Rothko making prints at all is surprising. As the artist's first biographer discreetly put it, Rothko's involvement in printmaking had been 'transient...graphic arts [being] hardly a strong point'.[44]

This lack became problematic only in February 1951, when the artist began teaching on a foundation course at Brooklyn College. One part of this was titled Graphic Workshop, and involved a study of the techniques of 'etching, engraving and block printing'.[45] Knowing little of any of these, Rothko took himself back to school. Hayter having left for Paris the year before, he signed up at the Art Students League for a week-long course in etching and lithography taught by the artist Will Barnet. On his own Graphic Workshop course at Brooklyn, recalled a student, Rothko began by admitting that 'he had no experience, or almost none', so that lessons with him would be 'purely exploratory'. 'He allowed you to do what you wanted, then he'd discuss what you did with you,' said the student. 'It was a very rich and generative experience.'[46]

This freewheeling approach would certainly not have come from the classically taught Barnet. Rothko's week as his student, though, remains the only documented evidence of his having had a training in printmaking, or of making prints at all. The assumption that any Rothko print must therefore have been made under Barnet's tutelage is understandable. A cursory examination of MoMA's etching suggests that, in this case, it is also mistaken. If the print in question bears no resemblance to Rothko's work of 1951 (or of any time after 1947, come to that), it bears a very strong resemblance to the kind of work he had been making around 1943.

Given that there is no obvious reason why Rothko, studying under Barnet in 1951, should have chosen to etch a new plate in a style he had

96 CHAPTER 4

discarded eight years before, the possibility exists that he pulled a print from a plate he had already made elsewhere. If this taught him nothing new about etching, it would at least have reminded him of the use of a press. This, though, still leaves the question of where and when that plate had been etched. Given Hayter's recollection of Rothko in the studio and his known insistence that artists there take their plates away with them, it seems clear that that place was Atelier 17. Apart from Rothko's week at the Art Students League, there is no other plausible answer.[47]

Seen alongside work made at Hayter's studio in 1943/4 by such seasoned surrealists as Yves Tanguy, MoMA's Rothko print is unexceptional. Its graphic recipe – humanoid biomorphs *au bord de la mer* – was a stock of surrealist (and cubist) iconography. It has the pastiched feel of the cod-modernist work hanging on the wall of Motherwell's *The Jewish Girl*. Seen in the context of Rothko's work of the time, though, the picture looks rather different.

The impact on him of the arrival of the exiles was possibly greater than on any other American artist. 'I remember some years ago talking to Rothko about automatism,' Motherwell would recall. 'He and I became friends in the mid-1940s. I told him a lot about Surrealism. He was one of the few American painters who really liked Surrealist painting, went to Surrealist shows and understood very well what I was talking about.'[48] If MoMA's nameless print does not feel revolutionary, it marked a loosening up in Rothko's style that would lead to the amorphous compositions of his late painting. His work of the years immediately before the exiles' arrival – the 1940 *Underground Fantasy*, for example – had been dominated by isolated figures divided from each other by vertical borders. Now, the figures in the etching, prosaic as they might seem, stand in undivided space. What started as a changed relationship of figure to figure would end in a new compact between figure and ground.

Rothko's solitary print belongs to a body of works thought to have been produced in 1943 and 1944. The best known of these is MoMA's painting *Slow Swirl at the Edge of the Sea* (FIG.25). As with the etching, this shows a pair of extra-terrestrial-ish creatures apparently dancing on a beach. An ink and pencil drawing shows the same subject, as does a more ambitious drawing in ink, pencil, watercolour and tempera.[49] Rothko said of his forms that they 'ha[d] no direct association with any

TOWARDS A NEW PAINTING

particular visible experience, but in them one recognizes the principle and passion of organisms'.[50] The *Slow Swirl* works, in their different mediums, bear a particularly strong resemblance to the pictures being made by André Masson in, or shortly before, 1943. In particular, they respond to the book of drawings, *Anatomy of My Universe*, that Masson published in New York in 1943; to the etiolated, vertical figures in images such as *Unity of the Cosmos*.[51]

It is tempting to link the new integration in space of Rothko's own figures with his contemporaneous rejection of isolationism in American art. In June 1943, the critic of the *New York Times*, Edward Alden Jewell, had confessed himself perplexed by Rothko's work and that of his friend Adolph Gottlieb, seen in a recent show.[52] The foreword to the catalogue to this had stated, 'We condemn artistic nationalism which negates the world tradition of art at the base of modern art movements....As a nation we are being forced to outgrow our narrow political isolationism. Now that America is recognized as the centre where art and artists of all the world must meet, it is time for us to accept cultural values on a truly global plane.'[53] Jewell, in facetious mood, had written, 'Maybe when you visit the exhibition...you will find all this graphically and plastically substantiated. For my part, I wasn't so sure, looking around Mr. Wildenstein's nice and graciously provided galleries, that anything globally halcyon had as yet materialized.'

Stung, Rothko and Gottlieb shot back with a five-point statement, gamely published in full in Jewell's column the week after. The fifth point was less barbed than abusive: '[O]ur work...must insult anyone who is spiritually attuned to interior decoration; pictures for the home; pictures for over the mantel; pictures of the American scene; social pictures; purity in art; prize-winning potboilers; the National Academy; the Whitney Academy, the Corn Belt Academy; buckeyes; trite tripe etc.'[54] Seeking to defuse the situation, the *Times* critic responded good-naturedly: 'I again agree that it is quite right that we should try to become global in our thinking. And if the art that has baffled me is to be accepted as in line with that effort, then I don't see why, taking Mr. Rothko's "Syrian Bull" by the horns, we shouldn't term the new movement that seems to be afoot "Globalism".[55] It may be esteemed at least as apt as such tags as "fauvism", "cubism" and "futurism".'[56]

98 CHAPTER 4

Jewell might have done better with 'Universalism', since at the heart of all this breaking-down – spatial, emotional, national – was the collective unconscious of Jung. Rothko was after an art that transcended not just political but psychic boundaries. Failing the discovery of some kind of studio record listing his works in date order, it is impossible to say whether the drawings of two figures on a beach mentioned here precede MoMA's mysterious print or follow it, or even whether they and the print pre- or postdate *Slow Swirl at the Edge of the Sea*. One thing that can be said with certainty, thanks to the etching, is that Rothko was at Atelier 17 in or around 1943, that he would have met and worked alongside European artists there, and that one of these was likely to have been André Masson. When Hayter told Jacob Kainen that he had seen Rothko's work pass through four distinct periods, he presumably meant over the course of his career rather than in his time at the studio. Still, Hayter's insistence that Rothko had made several prints at Atelier 17, and not just the one at MoMA, raises the vexing question of what the others might have looked like and where they might be.

———

Another question that arises is the extent to which these two sets of work, slight in themselves, can be read as runes of what was to come in American painting. One thing that is instantly obvious about Rothko's lone etching and Motherwell's *Personages* is how unlike each other they are. Another, linked to the first, is how little they resemble the work Hayter was making in 1943/4. Motherwell's prints are arguably more Hayterish in having been made with a burin, although there the resemblance ends. But then the unlikeness of all these prints is what makes them alike.

In the days before Hayter had arrived in New York, the artist Nathaniel Pousette-Dart, father of the future abstract expressionist Richard Pousette-Dart, had celebrated the state of painting in the United States. Positioning American individualism against the state-ordained monoliths of Soviet realism and Nazi *Blut und Boden*, Pousette-Dart had written, 'America is at the moment in a very healthy condition for the very reason that it has no one individual or group dominating it. In America, the artists still have freedom of expression and

TOWARDS A NEW PAINTING

it is the one thing we must fight to retain.'[57] If Hayter's firmly held view that Atelier 17 was a workshop, that projects made there were jobs of work, chimed well with artists who had been employed by the Federal Art Project as workers, then his insistence that art had a duty to be individualistic also struck a chord.

Onto this native individualism would be grafted another, French one. Looking back at the early forties from the proximity of the early fifties, Robert Motherwell would reason that abstract expressionism, by then in its heyday, had 'arose from a feeling of being ill at ease in the universe, so to speak – the collapse of religion, the old close-knit community and family'.[58] What Atelier 17 had demonstrated in the decade before was that individualism and collectivism were not mutually exclusive; that working together could be a path towards working alone.

Motherwell's casual use of the word 'abstract' in 1951 suggests another war fought and won. In October 1943, a few months after their row with Edward Alden Jewell, Rothko and Gottlieb had broadcast on the future direction of American art:

> **MR. ROTHKO** Neither Mr. Gottlieb's paintings nor mine should be considered abstract paintings. It is not their intentions either to create or to emphasize a formal colour-space arrangement. They depart from natural representation only to intensify the expression of the subject implied in the title – not to dilute or efface it.[59]

This was certainly true of Rothko's painting of the time – pictures such as *Iphigenia and the Sea*, say – although his work was clearly moving towards precisely the kind of formal colour-space arrangement he was then at such pains to deny. Clement Greenberg had warned against the tendency to decoration in abstraction, this being allied to craft and thus, inescapably, to womanliness.[60] Perhaps as importantly, André Masson disliked the genre. 'Personally,' he wrote to Saidie May's companion, Alfred Jensen, 'I cannot allow myself to be called "abstract"....The best abstract painting would be a geometry textbook.'[61]

Fourteen months later, though, Rothko's attitude to abstraction had softened to a grudging affection: 'I quarrel with surrealist and abstract

100 CHAPTER 4

art only as one quarrels with his father and mother; recognizing the inevitability and function of my roots, but insisting upon my dissension: I being both they, and an integral completely independent of them.'[62] The line between abstraction and surrealism was becoming blurred. In his attempt to take the pulse of American art in 1944, Sidney Janis had puzzled over whether to list Rothko as a surrealist or an abstractionist. In the end he hedged his bets and invented a 'middle ground' for him between the two.[63]

Motherwell, too, was shifting his position. If Janis had classed Rothko as a typological hybrid, Motherwell was simply an American abstract painter. The artist himself had taken issue with this. 'The schism between the factions', he wrote in an artist's statement, 'is not as insurmountable as their members believe.'[64] In an essay in *Partisan Review* – Clement Greenberg's normal soapbox – he paraphrased Samuel Kootz in suggesting that the 'hard and conventional English-speaking world' had proved too much for the 'various devices for finding pleasure' that the surrealists had invented in Paris before the war (this in spite of having experimented with these same devices in New York himself). Instead, Motherwell sees the émigrés as the ones who are changing, and not just the surrealists. In Mondrian's *Broadway Boogie Woogie*, he notes a 'marked shift...from an intent of simple purification to one of expressiveness'. Calder's mobiles, too, have animated neoplasticism.[65] It is Masson and his like, though, who have been most marked by their American experience. 'Here,' Motherwell wrote, in the past tense of a *fait accompli,* 'it was the Surrealists who were transformed.'[66]

As well as becoming more expressive, this new mid-Atlantic art was becoming more formalist and materials-based. Marking the change, Motherwell noted, 'Painting, like music, tends to become its own content.'[67] In 1943 Jackson Pollock had had his first solo show, at Peggy Guggenheim's gallery, Art of This Century. Analysing it in his *Partisan Review* essay, Motherwell identified Pollock's 'principal problem' as having yet to find his 'true *subject*'. This, he said, 'must grow out of the process of his painting itself'.[68] This was more than simple truth to materials. By 'process', Motherwell meant the actual making of a painting, the physicality of it. Sure enough, this idea of what one might call a muscular automatism – a channelling of the psychic through the physical – would

TOWARDS A NEW PAINTING

101

become central to Pollock's work. It had been at the heart of Hayter's own teaching and making at Atelier 17 for nearly two decades.

———

In June 1944, the atelier and its artists were the subject of a show at the Museum of Modern Art organized by MoMA's director of exhibitions, Monroe Wheeler.[69] A veteran of 1920s Paris, Wheeler, Hayter said, 'had suggested that we should make a show of things that didn't look like etchings, which sounded to me like a very good program because this of course was very much what we were about. At the time we started this thing here we were reacting very strongly against what was conventionally called an etching.'[70] The un-etching-like works in the MoMA show included Calder's *The Big I* (1944), Ian Hugo's *Night Gods* (1943), André Masson's *Petit génie du blé* and *Le Génie de l'espèce* (both 1942), and prints made at the Paris atelier by Miró, Chagall and Lipchitz.

The foreword to what was in effect the show's catalogue – an entire issue of the *Bulletin of the Museum of Modern Art* – had been written by the curator, collector and future Guggenheim director James Johnson Sweeney. It was remarkable for its prescience. Linking what was going on at Hayter's atelier to a new kind of American art, Sweeney wrote: 'One of the dominant interests...of recent painting has been the restoration of the unity of the painted surface. With Hayter and his associates burin engraving has recovered its dignity as a medium of original expression. For them the copper plate is not merely a surface on which to draw.'[71] What, four years later, Clement Greenberg would dub 'the all-over picture' was beginning to appear.[72] Its future chief advocate would shortly climb the stairs to the seventh floor of the New School.

Pollock Makes A Print CHAPTER 5

Barbara Rose .. Then you don't know what inspired the 'drip' technique?
Lee Krasner For me it is working in the air and knowing where it
will land.
'Jackson Pollock at Work: An Interview with Lee Krasner'[1]

In each instant of their lives men die to that instant....[W]hen afterwards
they look back...it is not themselves they see....but strange ghosts made
in their image.
Charles Morgan, *The Fountain*[2]

Lives are written backwards, Jackson Pollock's no less so than most.
From the wrecked car outside Springs, NY that August night in 1956,
the story runs in ineluctable reverse to the Pollock of Hans Namuth's
film *Jackson Pollock* – 'the jeans-clad, chain-smoking poster boy of
abstract expressionism' – on to the 'talented, cranky loner' of the early
forties, in a small walk-up flat on East Eighth Street; to the 15-cents-a-
beer Cedar Tavern around the corner; the drunken rages and vomit and
fistfights that, played forward again, have become Jackson Pollock, full
stop.[3] If European artists were aristocrats, this brawling Pollock was
their antithesis. Whether, in Cold War America, he was also a necessary
invention – brutish precisely so as to seem non-European – is a poss-
ibility at the very least worth considering.

Pollock the brawler was certainly only one of the Pollocks recalled
by those who had known him pre-Namuth. Preeminent among these, in
New York, had been Reuben Kadish. Kadish and Pollock had become
friends in 1929 when both were in their late teens and studying art in Los
Angeles. They had, Kadish said, 'liv[ed] in a European fantasy', poring
over the quarterly magazine *transition*, published in English in Paris by
Eugene and Maria Jolas from April 1927 until the spring of 1938.

It was in the pages of this that Pollock would have had his first
encounters with surrealism. *transition*'s inaugural issue had included
reproductions of paintings by Max Ernst; a later edition would show

Jackson Pollock photographed by Reuben Kadish
in his studio at 46 East Eighth Street, 1943.

André Masson's automatic *Battle of the Fishes*, painted in 1926 and bought by the Museum of Modern Art in 1937. In 1940, when Stanley William Hayter was on his way from London to New York, Kadish had studied with him at the California School of Fine Arts in San Francisco. By 1944, he had followed Hayter to the New School. It was here that he would introduce Pollock to him, and to Atelier 17.[4]

Hayter's Pollock was also more nuanced than the one of current myth. The younger man would come to the house at 247 Waverly Place that the Hayters had moved into in early 1944 – a grand, four-floor Romanesque revival structure, designed by the architect of Carnegie Hall – to drink beer and discuss art. These visits continued, off and on, until his hosts returned to Paris in 1950. 'When half drunk, Jack could talk intelligently about the source of inspiration and about the limits of working from the unconscious,' Stanley Hayter recalled forty years later. 'He pointed out that there is a problem when you have plumbed its depths in how to go beyond that level and produce further content....How do you develop something that is unconscious? People used to come from all corners of the United States to talk to me about automatic drawing.'[5]

POLLOCK MAKES A PRINT 105

This was the same problem André Masson had been wrestling with for a decade, the one that Claude Lévi-Strauss had debated with André Breton on the *Capitaine-Paul-Lemerle*: whether images produced entirely automatically could also be works of art. One pictures Pollock, young, avid, finally able to discuss the things he had read about in *transition* with an artist who had actually lived them. He was, Hayter said, sensitive, highly intelligent: the idea of Pollock as a High Plains bumpkin who had merely struck lucky with the *zeitgeist* bothered him. So, too, what came afterwards. 'Later, when we drank at the White Horse, what horrified me and left me feeling helpless was Jack's drinking not to feel good but to *hurt* himself,' Hayter recalled in an interview, twenty-five years after Pollock's death. On tape, you can hear him wince.[6]

If, as Hayter noted, Pollock acknowledged two masters – Thomas Hart Benton, with whom he had studied in the early thirties, and himself – he was careful to distinguish between the relationships.[7] 'Jack, who never mentioned his own father, had found a substitute one in Benton and in me a friend, but not, as has been said, another older brother,' Hayter insisted. 'He didn't treat me with any degree of veneration – we didn't play it that way – but he trusted me and I trusted him.'[8] For all that, it is hard not to see the dance of Namuth's film as having been choreographed, at least in part, at Waverly Place.

'I don't like "automatism",' Hayter said, recalling his discussions with Pollock there. 'I don't use it myself. It suggests it does itself. I prefer to think it's the back of the mind, we're as responsible for it as the rest of us....The more you do it, the clearer it becomes; the more access you get to the material.' Prefiguring Pollock's later practice, he moved on to describe his teaching at Atelier 17. 'I show them how to draw standing, that is, completely relaxed. You then take a pencil like this in your hand, and you draw by moving your whole body....It gives you a line of extraordinary clarity and precision.'[9]

At the beginning at least, Pollock was open about the effect of all this on his art, and on that of his fellow New York painters. In an interview with Howard Putzel published in the magazine *Arts and Architecture* in February 1944, he described the influx of European émigrés and the discovery of a local mythology as part of the same process. 'The fact that good European moderns are now here is very important for they

106 CHAPTER 5

bring with them an understanding of the problems of modern painting,'
Pollock said. American artists had 'generally missed the point of modern
painting from beginning to end...the concept of the source of art being
the unconscious'. In a burst of internationalist generosity unthinkable a
decade later, he went on: 'The idea of an isolated American painting, so
popular in this country during the 'Thirties, seems absurd to me, just as
the idea of creating a purely American mathematics or physics would
seem absurd....An American is an American and his paintings would
naturally be qualified by that fact, whether he wills it or not....The basic
problems of contemporary painting are independent of any one country.'[10]

————

If there is a defining moment for Pollock in Namuth's film, it is his mobile
application of paint to the canvas that would become *One: Number 31,
1950*. Thirty years after making the film, Namuth recalled the scene:

> A dripping wet canvas covered the entire floor. Blinding shafts
> of sunlight hit the wet canvas, making its surface hard to see.
> There was complete silence....Pollock looked at the painting.
> Then unexpectedly, he picked up can and paintbrush and
> started to move around the canvas. It was as if he suddenly
> realized the painting was not finished. His movements, slow
> at first, gradually became faster and more dancelike as he
> flung black, white and rust-coloured paint onto the canvas....
> My photography session lasted as long as he kept painting,
> perhaps half an hour. In all that time, Pollock did not stop.
> How could one keep up this level of activity? Finally, he said,
> 'This is it.'[11]

Documentary filmmaking is not, by and large, a spontaneous skill:
Namuth's interpretation of Pollock's work is that of a man whose own
craft called for the calculating of camera angles, measuring of expo-
sures; of take after take, until the correct image was arrived at. What
he saw, or thought he saw, was the very opposite of that, an art that
looked entirely spontaneous. (Pollock claimed to have finished the
canvas before Namuth's arrival, only deciding to work on it again for

the filming). The filmmaker's description is laced with words suggesting the body rather than the mind, the inference being that the action he had recorded had somehow been – a word that was to haunt writing on Pollock – 'primal'. The sole meaning of the canvas lay in its making, the action that had produced it.

How misleading this assumption was is suggested by Pollock's own reaction to it. In 1950, *Time* magazine ran a review of his work that described his painting as 'chaos'. 'It is easy to describe a [Pollock],' the reviewer went on. 'Think of a canvas surface on which the following have been poured: the contents of several tubes of paint of the best quality; sand, glass, various powders, pastels, gouache, charcoal....It is important to state immediately that these "colours" have not been distributed according to a logical plan (whether naturalistic, abstract or otherwise). This is essential. Jackson Pollock's paintings represent absolutely nothing: no facts, no ideas, no geometrical forms.'[12] Pollock's response to this diatribe was a telegram to the magazine including the three trenchant words: NO CHAOS DAMMIT.

This provided the title for a study of his paintings by the Museum of Modern Art. 'One of the things that's emerging with our study is that Pollock had a pretty clear notion of how his materials handled, how they worked, how they interacted with one another,' MoMA's chief conservator remarked. 'There's a level of consciousness, intention, about that that liberates him to paint as unconsciously as he does....He might be just grabbing materials that seem appropriate in the flush of the moment of creation, but he hasn't got a full universe of materials to grab. He's narrowed that universe because he knows that the materials are going to work and because he's come to know how they're going to work.'[13]

He went on: 'There is a great deal of consciousness, balance, use of materials, and craft [in Pollock's painting].' Asked if the study had yielded any surprises, he replied: 'Well, the level of intentionality is the biggest. It just flies in the face of everything people have generally thought. Pollock's painting is just so declarative of process. If nothing else is apprehensible in the picture, there is process though it's not that straightforward once you start to examine it.' There had been other surprises as well. 'When you look at the surface of a Pollock, it is very

abstracted...it takes a fair amount of dedicated looking to begin to see what his shorthand is for any sort of figuration that might be going on in these works. But when we can peer beneath the surface [with X-rays] to see the underlying construction of the work, there you begin to see that the final surface organization is actually pretty much laid down earlier on.'[14]

He and a colleague had tried to make a Pollock of their own. Studying Namuth's film, they pinned a sized canvas to the studio floor and poured paint onto it from a tin. 'What this allows you to do is make an infinite line,' a bemused conservator recalled. 'You can just go on and on and on. So these thin lines give one great control over the width because you can come down closer to the canvas and expand the width, slow down the pour so that you apply more paint and you get a slightly thicker line. Come back up and you make it thinner. I thought this was a brilliant insight. Then we went back and looked at the Namuth film again with him painting on the glass, and gee, there he is with a can with a hole punched in it.'[15]

———

In 1956, the year of his death, *Time* dubbed Pollock 'Jack the Dripper' – a nickname that stuck, and has helped to shape popular perception of him. It suggests that the dripping of paint onto a canvas was unique to Pollock, that it was the only way that he worked, and that it lay behind the febrile energy of his paintings. None of these things is entirely true. Nonetheless, in the jostling for ownership of Pollock's dripping, many names have been put forward.

The earliest is the Mexican muralist David Alfaro Siqueiros, whose experimental workshop at 5 West 14th Street Pollock had attended in 1936–7.[16] Siqueiros encouraged participants to drip, pour, splatter and throw liquid paint at canvases, to work on them with spray guns of automobile lacquer. Harold Lehman, a friend and fellow member of the workshop – known always to habitués as 'the shop' – was insistent that it was under Siqueiros that Pollock learned his later style. 'There's no question that that is where he got the whole idea of dripping paint,' Lehman said.[17]

There were other claimants to the crown. Peter Busa, known for his 'Indian space' paintings, maintained that 'Jack saw my drip works'

POLLOCK MAKES A PRINT 109

around 1940, adding 'and anyway Bill Baziotes had a drip period and so did others'.[18] Both Patrick Waldberg and Roberto Matta had Max Ernst as the source of Pollock's dripping, the former specifying two paintings – *La Planète affolée* (FIG.26) and *Tête d'homme intrigué par le vol d'une mouche non-euclidienne* – as having been particularly influential. If not entirely convincingly, he recalled that, 'When these were exhibited, at the end of 1942, the painters Motherwell and Jackson Pollock were astonished by the delicacy of the structures and begged Ernst to tell them his secret. This was simple enough: Jackson Pollock later used, more systematically, his "dripping" technique.'[19]

Matta, for his part, recalled that in 'the summer of 1942, in Cape Cod, at our house...Max [Ernst] started working with different cans, making holes in them. He put pictures on the floor and made the cans move above them as if they were mobile. They dripped paint on the canvas. These are the first drip paintings I was aware of.'[20] Pollock had been one of the party.[21]

The abstract imagist painter Buffie Johnson meanwhile insisted that Pollock had learned the drip technique from his wife-to-be, Lee Krasner, she having 'brought the idea home from [her teacher, the German artist, Hans] Hofmann, who used drips but never as an entire painting'.[22] Johnson's evidence for this claim is unclear. More authoritatively, Gerome Kamrowski recalled William Baziotes bringing Pollock to his Sullivan Street studio in the winter of 1940–1 and the three men producing the joint canvas known as *Collaborative Painting* there. 'Baziotes was enthusiastically talking about the new freedoms and techniques of painting and noticing the quart cans of lacquer asked if he could use some to show Pollock how the paint could be spun around,' said Kamrowski. 'He asked for something to work on and a canvas that I had been pouring paint on and was not going well was handy. Bill then began to throw and drip the wet paint on the canvas. He handed the palette knife to Jackson and Jackson with his intense concentration, was flipping the paint with abandon.'[23]

It was Hayter who tied Pollock directly to Namuth's can-with-the-hole-punched-in – the so-called compound pendulum, consisting of a tin filled with paint, hung by string from the ceiling of Atelier 17 and played with by various of the studio's visitors. 'The typical case of discontinuous

cyclic motion,' Hayter said of the pendulum. 'It makes very amusing patterns....If you interfere, you get some extraordinarily interesting and beautiful shapes.'[24] He went on, 'If you let it go, it will make either a doughnut or a disc, depending on whether you intervene. I have to tell you, there are paintings of Max Ernst that were made on that machine. And I discovered two of mine that were the other day....The reason that I know [Pollock] had already been working with this machine was that we teased him about it. We said, "We're going to sell these for two dollars apiece: every man his own Pollock." And he thought that was funnier than hell, too.'[25]

Where Hayter differed from the other claimants to Pollock's genius was in his recognition that the dripping of paint was, in the end, a red herring. This was not on the grounds of Pollock having been just one of its many practitioners – 'There must have been hundreds of drip works at Atelier 17,' Hayter noted – but that what mattered was not chaos but control.[26] The idea that anyone could make a Pollock by swinging a tin of paint from a string was ridiculous, which was why he had suggested it.

'A lot of our people, at this time, said. "This is nonsense. Anyone can do [what Pollock] is doing",' Hayter recalled. 'And this infuriated me. So I said, "All right. Go to it. And I bet you not one of you can make one square inch of anything that can be mistaken for what Pollock's done." And they tried it....You can't be fooled. It's more than handwriting.'[27] What dripping represented was less a way of painting than a philosophy, a means of freeing the mind through repeated, cyclic motion. The results of this freedom would still need the mediation of the conscious. As Pollock was to put it in 1950, 'Technique is just a means of arriving at a statement.'[28]

———

Ascribing influence in art is problematic, ascribing sole influence almost always misguided. The role of this book is not to suggest that Atelier 17 was the only place in New York in which the kind of freedoms championed by Hayter and his colleagues were put into practice, although it was certainly one of very few. It is the precise nature of those freedoms, and how they were taken up, that is its subject.

That Pollock had first encountered the systematic use of liquid paint as a medium at Siqueiros' Experimental Workshop in 1936/7, and that

POLLOCK MAKES A PRINT

that encounter shaped the body of work he made between 1947 and 1950, seems beyond doubt. There were limitations to the discovery, however.

The first, and most obvious, was that the aim of the workshop was to produce large-scale murals accessible to the proletarian viewer. Automatic methods might throw up useful shapes or effects, but these were to be pressed into the service of realism. There was no suggestion of abstract mark-making as an end in itself. Siqueiros, in 1936, counted himself a surrealist, and would be shown as one in MoMA's 'Fantastic Art, Dada, Surrealism' show of that year.[29] But this was first-generation, oneiric surrealism of the kind Hayter and others had already come to reject.

The other problem with Siqueiros' liquid paint was his insistence on a lack of control in its use. The workshop's term 'controlled accident' put the emphasis firmly on the second word. Paint was to be distributed randomly. One of Pollock's fellows at the workshop recalled a lazy Susan, pilfered from a local café, being pressed into service as a centrifuge, hurling arbitrary combinations of lacquer onto waiting canvases.[30] Artists were passive in this process. That would certainly not be true of Pollock's later drip paintings, as his angry telegram to *Time* magazine would suggest. What he was to learn at Atelier 17 was a way of working that looked accidental while being wholly controlled, an abstraction that was illustrative only of itself.

If Jackson Pollock acknowledged two masters, then it is easy enough to see the place of the older and first in his work. What Pollock had learned from Thomas Hart Benton was a feel for the link between scale and the sublime that was to become typical of American postwar avant-garde painting. Robert Motherwell recognized this. 'The large format, at one blow, destroyed the century-long tendency of the French to domesticize modern painting, to make it intimate,' he said. 'We replaced the nude girl and the French door with a modern Stonehenge, with a sense of the sublime and the tragic that had not existed since Goya and Turner.'[31]

It was Benton the muralist who was to have the greatest effect in this regard. In 1931, Pollock had helped him install his ten-panel, room-sized

panorama *America Today* on the third floor of the New School for Social Research, having modelled for several of its figures first.[32] *America Today* was remarkable in its sense of cinematic motion, its trains and airships and aeroplanes bent out of shape by their speed as they raced across the vastness of a continent and Benton's canvas. Motion and velocity would be key elements of Pollock's own later work, albeit in a different way.

But what of Hayter? Broadly, Pollock's second master helped him transform the things he had learned from his first into a style of painting that was new, non-figurative and Jungian. It was also, or was seen by Greenberg and others to be, a style that was uniquely American – a claim that the Pollock of 1944 would have dismissed as ridiculous, but was happy to let pass by 1954. How much of this transformation was due to Hayter's direct intervention in Pollock's art-making and how much to the atmosphere of experiment he had created at Atelier 17 is an intriguing but unanswerable question. As we have seen, the reason Atelier 17 proved such a magnet to young, non-French-speaking, ex-FAP Americans was its air of workaday egalitarianism, of learning-with rather than learning-from. 'It's not a question of language, what we're doing,' Hayter said. 'You can't do it with words.'[33]

———

Given that so many of his contemporaries had made their way up to the New School's top floor in the first two years of Atelier 17's existence there, it seems likely that Pollock did so, too. Certainly, he had attended Gordon Onslow Ford's surrealist lectures at the school in the opening months of 1941.[34] However, it seems to have been only with the return to New York of his friend Reuben Kadish from serving with the US Army Artists' Unit in Burma in the middle of 1944 that Pollock's attendance at the studio became anything like regular. If he had made other work there before Kadish's return, it is lost. What remains is a set of eleven plates, engraved by Pollock at Atelier 17 in the autumn of 1944 and spring of 1945. As is the way of work made there, these too were lost before being rediscovered a decade after their maker's death.

Hayter recalled Pollock's participation in the studio. 'Jack was doing things [such as experimenting with the compound pendulum]

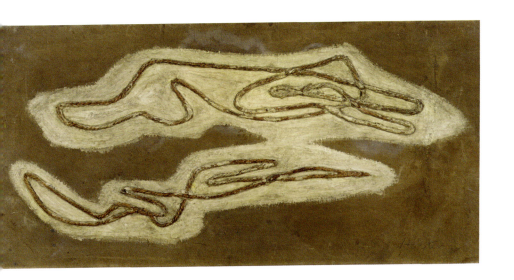

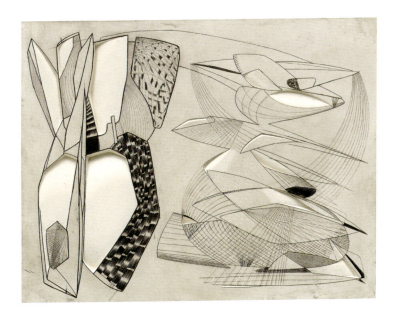

1 Stanley William Hayter, *Composition with String*, 1934. Oil pigments, zinc white on unprepared canvas, 36.5 × 73 cm (14⅜ × 28¾ in.).

2 John Ferren, *Untitled (No. 34)*, 1937. Carved plaster and ink in artist's frame, 48.3 × 58.4 cm (19⅛ × 23 in.).

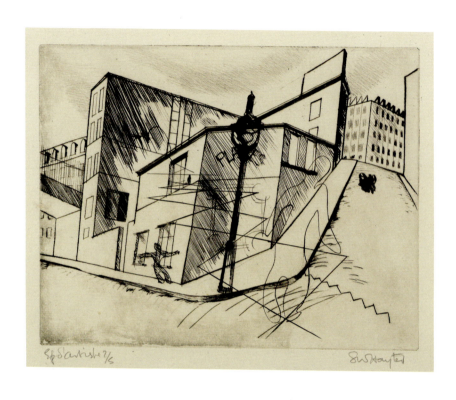

3 Stanley William Hayter, *Rue de la Villette*, 1930. Etching and drypoint, 28.5 × 39 cm (11¼ × 15⅜ in.).

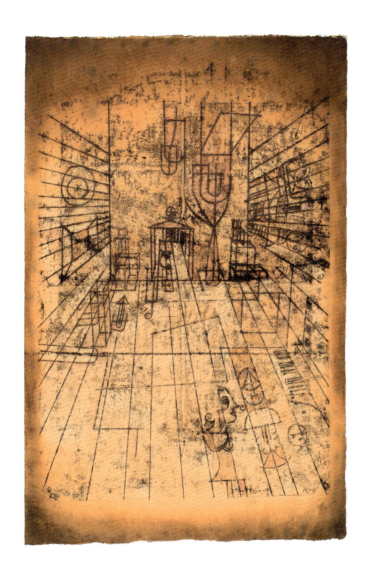

4 Paul Klee, *Zimmerperspective mit Einwohnern*, 1921.
Oil transfer drawing and watercolour on paper on cardboard,
48.5 × 31.7 cm (19⅛ × 12½ in.).

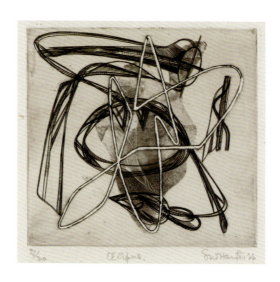

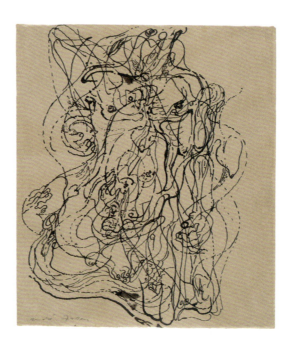

5 Stanley William Hayter, *Oedipus*, 1934. Engraving, scorper and soft-ground etching, 14.9 × 16.2 cm (5⅞ × 6⅜ in.).

6 André Masson, *Automatic Drawing*, 1924. Ink on paper, 23.5 × 20.6 cm (9¼ × 8⅛ in.).

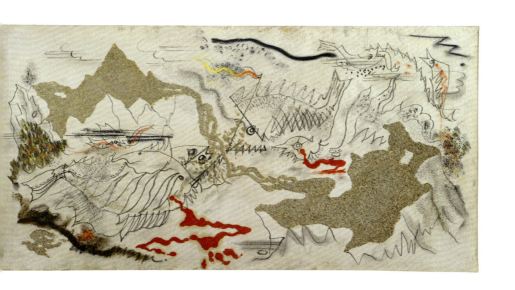

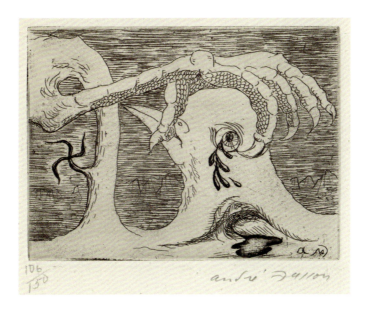

7 André Masson, *Battle of Fishes*, 1926. Sand, gesso, oil, pencil and charcoal on canvas, 36.2 × 73 cm (14⅜ × 28¾ in.).

8 André Masson, *Untitled*, from *Solidarité*, 1938. Engraving on laid paper, 16.5 × 22.7 cm (6½ × 9 in.).

9 Yves Tanguy, *Titre inconnu (noyer indifférent)*, 1929.
Oil on canvas, 91.1 × 73.2 cm (35⅞ × 28⅞ in.).

10 Yves Tanguy, frontispiece for Paul Éluard's *La Vie immédiate*, 1932.

11 Stanley William Hayter, *Paysage anthropophage*, 1937. Oil on board, 100 × 200 cm (39⅜ × 78¾ in.).

12 Stanley William Hayter, *Falling Figure*, 1947. Engraving and soft-ground etching in black with colour screenprint on wove paper, 45.1 × 37.8 cm (17¾ × 15 in.).

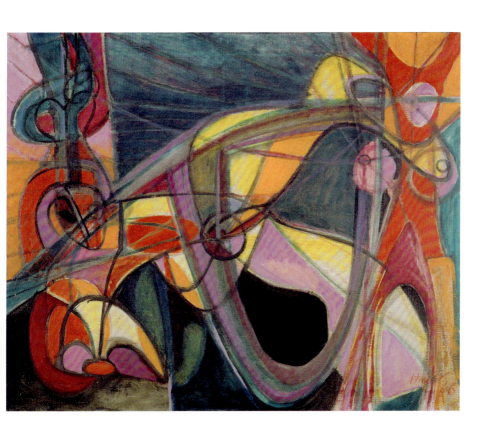

13 Stanley William Hayter, *Untitled*, 1946. Oil on canvas, 101.6 × 127 cm (40 × 50 in.).

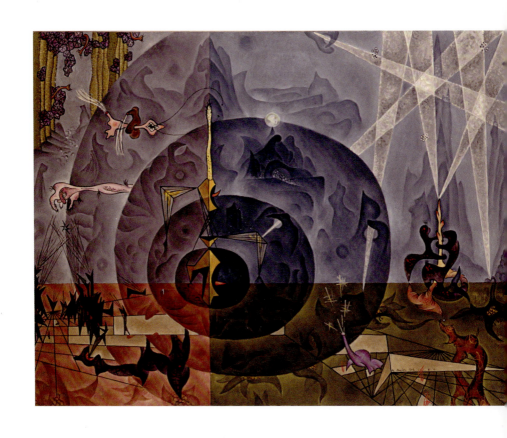

14 Gordon Onslow Ford, *Temptations of the Painter*, 1941.
Oil on canvas, 116.8 × 152.4 cm (46 × 60 in.).

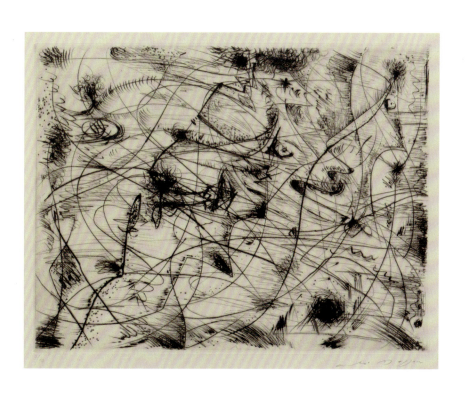

15 André Masson, *Rape (Rapt)*, c. 1946. Drypoint, 49.3 × 64.8 cm (19½ × 25½ in.).

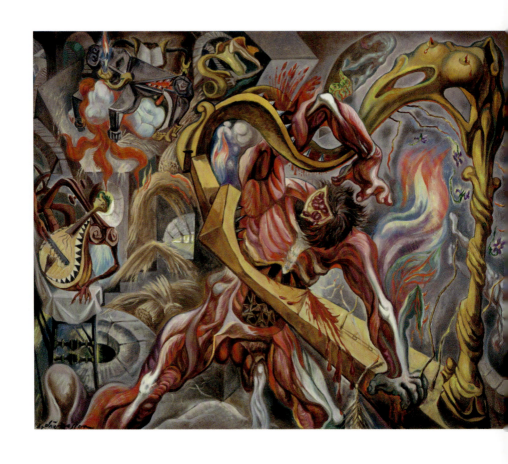

16 André Masson, *Dans la tour du sommeil (In the Tower of Sleep)*, 1938. Oil on canvas, 81.3 × 100.3 cm (32⅛ × 39½ in.).

17 André Masson, *Emblème (Emblem)*, 1942. Soft-ground colour etching and aquatint, 24 × 22.3 cm (9½ × 8⅞ in.).

18 André Masson, *Le Génie de l'espèce (The Genius of the Species)*, 1942.
Drypoint and engraving, 36.5 × 27.5 cm (14 3/8 × 10 7/8 in.).

19 Robert Motherwell, *Untitled*, 1940. Gouache, watercolour and graphite on Masonite, 25.4 × 20.3 cm (10 × 8 in.).

20 Robert Motherwell, *The Jewish Girl*, c. 1941. Soft-ground etching, 24.8 × 19.1 cm (9⁶/₈ × 7⁴/₈ in.).

21 Robert Motherwell, *Personage*, 1944.
Burin engraving, 33.3 × 25.1 cm (13 1/8 × 9 7/8 in.).

22 Robert Motherwell, *Personage*, 1944.
Burin engraving, 21.6 × 22.9 cm (8 4/8 × 9 in.).

23 William Baziotes, *The Parachutists*, 1944. Duco enamel on canvas, 76.2 × 101.6 cm (30 × 40 in.).

24 Mark Rothko, *Untitled*, c. 1951. Etching, 24.5 × 25.4 cm (9⅝ × 10 in.).

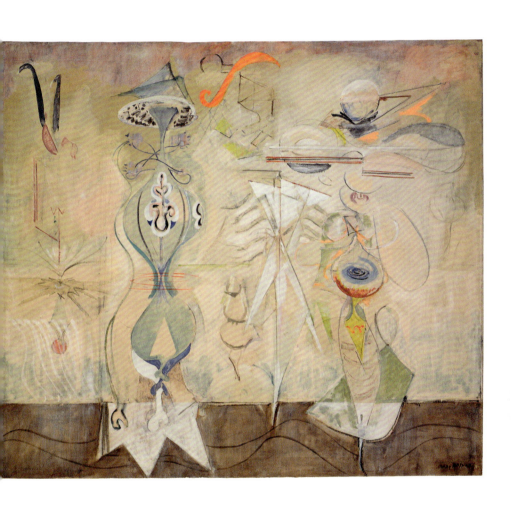

25 Mark Rothko, *Slow Swirl at the Edge of the Sea*, 1944. Oil on canvas, 191.4 × 215.2 cm (75⅜ × 84¾ in.).

26 Max Ernst, *La Planète affolée*, 1942. Oil on canvas, 110 × 140 cm (43⅜ × 55⅛ in.).

27 Alexander Calder, *Score for Ballet 0-100* from
VVV portfolio, 1942. Drypoint, 35.7 × 45.7 cm (14⅛ × 18 in.).

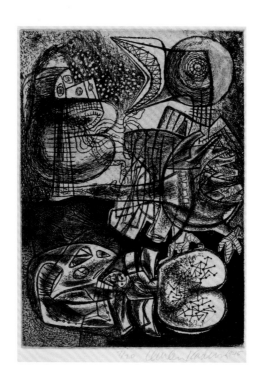

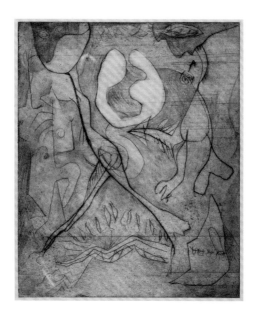

28 Reuben Kadish, *Lilith*, 1945. Etching and aquatint, 52.2 × 37 cm (20⅝ × 14⅝ in.).

29 Jackson Pollock, *Untitled (1)*, state I of III, 1944. Engraving, 48 × 31.1 cm (18⅞ × 12⅜ in.).

30 Jackson Pollock, *Birth*, c. 1941. Oil on canvas, 116.4 × 55.1 cm (45⅞ × 21⅝ in.).

31 Jackson Pollock, *Untitled (4)*, state I of III, 1944–5.
Engraving and drypoint, 50 × 66 cm (19⅝ × 26 in.).

32 Jackson Pollock, *Untitled (6)*, c. 1944–5, printed in 1967.
Engraving and drypoint in brown-black on white Italia wove paper,
51.2 × 34.6 cm (20⅛ × 13⅝ in.).

33 André Masson, *Pasiphaë*, 1945. Pastel on black paper, 69.8 × 96.8 cm (27½ × 38⅛ in.).

34 Stanley William Hayter, *Laocoön*, 1943. Soft-ground etching and engraving with scorper, 38.1 × 63.9 cm (15 × 25⅛ in.).

35 Stanley William Hayter, *Centauresse*, 1944. Colour engraving and soft-ground etching, 28.6 × 23.2 cm (11⅛ × 9⅛ in.).

36 Ian Hugo, *Under Sea Ballet*, 1944. Engraving and soft-ground etching, 27.1 × 40.5 cm (10⁶⁄₈ × 16 in.).

37 Ian Hugo, *Twilight Meeting*, 1945. Colour woodcut, 18.2 × 13.3 cm (7¼ × 5²⁄₈ in.).

38 Stanley William Hayter, *Cinq personnages*, 1946.
Colour engraving and soft-ground etching with embossing,
51 × 66.5 cm (20⅛ × 26⅖ in.).

39 Joan Miró, *Self-Portrait I*, 1938. Pencil, crayon and oil on canvas, 146.1 × 97.2 cm (57½ × 38¼ in.).

40 William Blake, restrike from fragment of cancelled plate for *America: A Prophecy*, 1793. Relief etching, pulled on coloured background, made by rolling up the other side of the plate with inks and running it through the press.

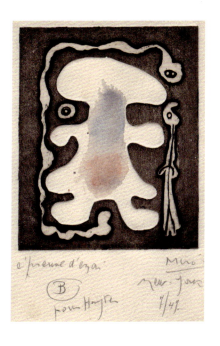

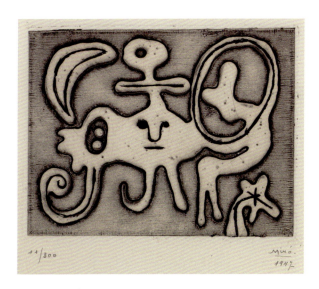

41 Joan Miró, *L'Antitête (diptych)*, 1947–8.
Open bite etching, each 25.4 × 16.2 cm (10 × 6⅜ in.).

42 Joan Miró, *Femme et oiseau devant la lune*, 1947.
Etching, 19.7 × 23.2 cm (7⅞ × 9¼ in.).

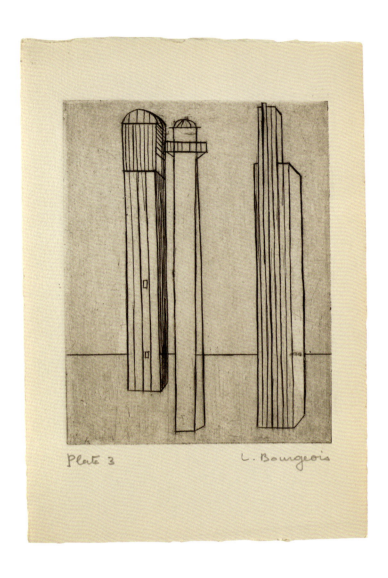

43 Louise Bourgeois, *He Disappeared into Complete Silence*, plate 3, 1947. Engraving in black on wove paper, 25.7 × 17.8 cm (10 × 7 in.).

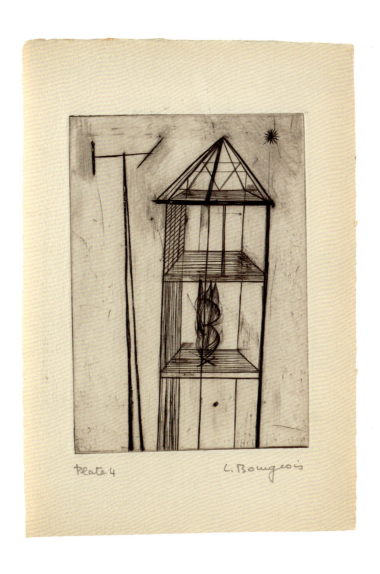

44 Louise Bourgeois, *He Disappeared into Complete Silence*, plate 4, 1947. Engraving in black on wove paper, 25.7 × 17.8 cm (10 × 7 in.).

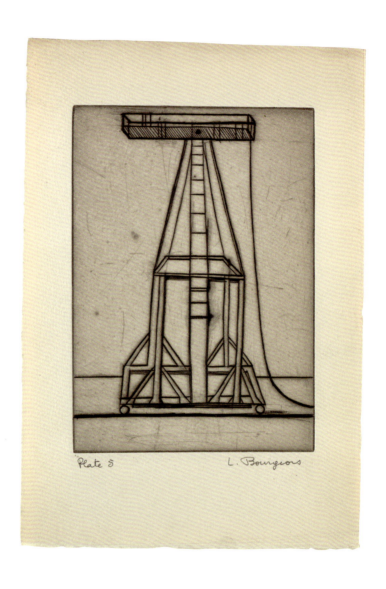

45 Louise Bourgeois, *He Disappeared into Complete Silence*, plate 5, 1947. Engraving in black on wove paper, 25.7 × 17.8 cm (10 × 7 in.).

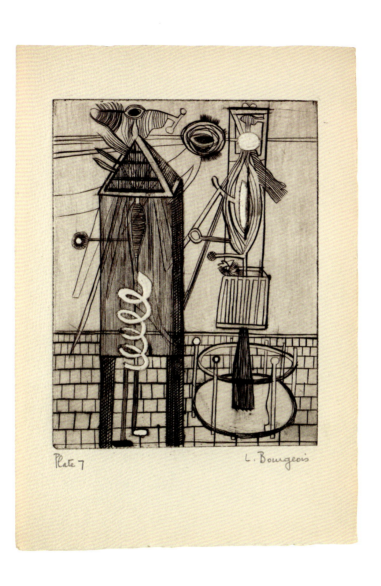

46 Louise Bourgeois, *He Disappeared into Complete Silence*, plate 7, 1947. Engraving in black on wove paper, 25.7 × 17.8 cm (10 × 7 in.).

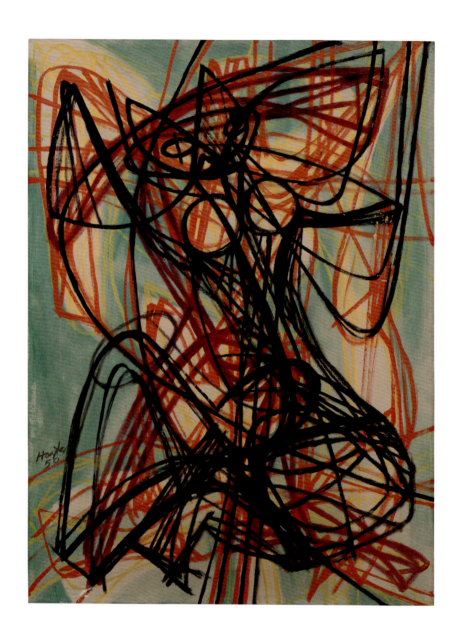

47 Stanley William Hayter, *Marionette*, 1950. Oil on canvas, 100 × 73.2 cm (39⅜ × 28⅞ in.).

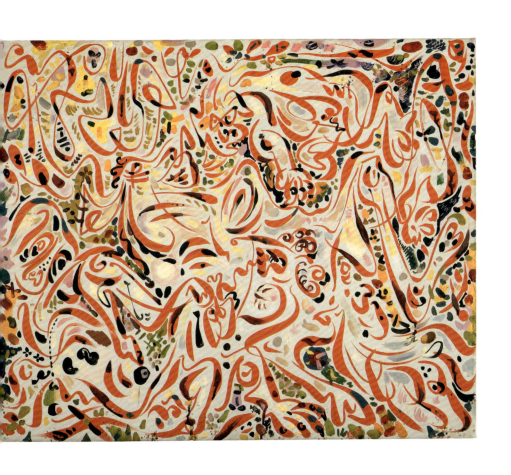

48 André Masson, *The Kill*, 1944. Oil on canvas, 55.2 × 67.9 cm (21⁶/₈ × 26⁶/₈ in.).

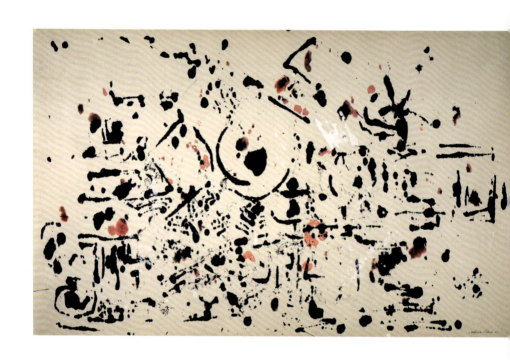

49 Jackson Pollock, *Untitled*, 1951. Ink and gouache on paper, 63.1 × 99.9 cm (24⅞ × 39⅜ in.).

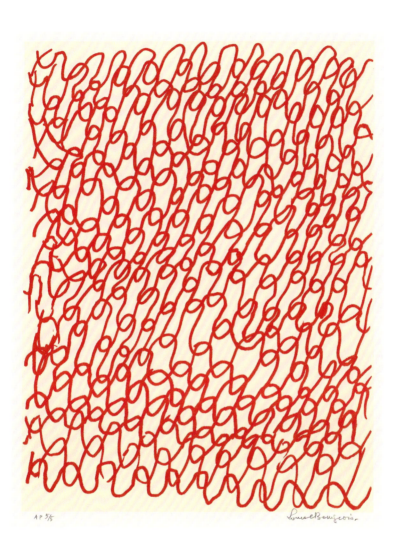

50 Louise Bourgeois, *Le Cauchemar de Hayter*, 1996.
Lithograph, 63.5 × 49.5 cm (25 × 19½ in.).

51 Louise Bourgeois, *Reply to Stanley Hayter*, 1996. Lithograph, 69 × 76.2 cm (27⅔ × 30 in.).

POLLOCK MAKES A PRINT

at Atelier 17, but he didn't work much with a lot of people in the print shop,' Hayter said. 'He'd come in at odd hours and at night with Reuben Kadish when nobody else was there.'[35] Whether this was due to secretiveness on the young American's part or to the diffidence at working alongside giants such as André Masson and Max Ernst that had afflicted Robert Motherwell can only be supposed. Certainly, not all artists found the proximity of the Europeans intimidating. 'Actually, some of the so-called celebrities among the artists there were extremely friendly with us who were nobodies yet,' Karl Schrag said. 'They were very helpful and even helped us with painting. They were very, very cooperative and everything.'[36]

As to Kadish, he had a particular reason for wanting Pollock to experiment with burin engraving: 'I inveigled Jackson into trying it because I thought his work had a kinship to Hayter's prints,' he said.[37] It was a similarity that had already been remarked on in the pages of *Art News*. In 1942, the critic James Lane had compared the 'general whirling figures' of the two men in a review of Pollock's work, the American then being so little known that Lane had misspelled his name 'Pollack'.[38]

If the comparison of Pollock with Hayter was intended to flatter the former, it was not a flattery Hayter himself would have recognized. In the studio as at Waverly Place, the relationship of the two men was one of co-discoverers rather than of pupil and master. In the four years since Atelier 17 had reopened in New York, Hayter's own work had been going through a process of change. As with Pollock's, this would have to do with an exploration of motion in space.

In Paris, Hayter's friendship with Alexander Calder had been influential on the art of both men. Now, in New York, this back-and-forth continued. In 1942, a portfolio of works in various media had been commissioned by the new and short-lived avant-garde magazine *VVV*. Planned by André Breton as a way of reasserting his rule over a surrealism mutating rapidly out of his control, the first issue had contained Breton's *Prolégomènes à un troisième manifeste du surréalisme ou non*: a broadside at Wolfgang Paalen's 'Farewell to Surrealism', published shortly before in *Dyn*.[39] Modelled on *Minotaure* and ranging across

114 CHAPTER 5

'poetry, plastic arts, anthropology, sociology, psychology', the three issues of *VVV* would carry, among much else, a piece by Claude Lévi-Strauss on face-painting by the indigenous Kadiweu people. But the magazine was always strapped for cash. Sales of the portfolio, of eleven works on paper, were meant to swell *VVV*'s coffers.[40] Among its contents was Calder's *Score for Ballet 0–100*, engraved and printed at Atelier 17 (FIG.27).

Calder's work had already seen an evolution from drawing in two dimensions to drawing in three, his mobiles adding motion through space as a medium a decade before. *Score for Ballet 0–100* reverses this process, describing, or purporting to describe, the three-dimensional path of a mobile in two dimensions. It is rather like a choreographer's chart.

If this is typical of Calder's playfulness, it is play with intent. The spatial back-and-forth of his *Ballet* is echoed, in a more sombre way, in a series of dance-based works that Hayter would make at Atelier 17 at much the same time. In Paris he had produced a few prints with names such as *Pavane* (1935). Now, in New York, came a series of engravings with titles such as *Tarantelle* (1943), as well as oil paintings in the same titular vein: *Untitled (The Dancers)* (1944) is one.

Where Calder's *Ballet* had mapped the movement of a hypothetical sculpture, Hayter's dance pieces log the movement of the artist himself as he turns the plate to attack it from all sides, 'walking into [his] drawing like a map'.[41] Here, too, his interests paralleled those of Jackson Pollock. On a 1943 drawing, Pollock had scrawled the cryptic words 'effort of the dance'.[42] In the voice-over to Namuth's film of him painting, the artist would echo Hayter almost verbatim. 'I enjoy working on a large canvas,' Pollock says, his delivery oddly stiff. 'This way I can walk around it, work from all four sides and be *in* the painting.' He goes on: 'There is no accident. I have no fear of destroying the image.'[43]

At least part of the reason for Hayter's working in this way in 1944–5 was the research he had undertaken with Wertheimer at the New School in 1940–1. This had found, among other things, that the eye tracks unvaryingly from left to right, and imposes an up-and-down orientation on every image it sees. Working from all sides at once thwarted these habitual ways of seeing, calling for a new (and unfamiliar) form of perception. At the same time, Hayter encouraged the transposing of figure and ground in his students' compositions, so that the old certainties of

POLLOCK MAKES A PRINT

front and back would be rendered useless. By removing these props, he turned the very act of making into a means of accessing the unconscious.

Attacking the work from all sides had two predictable outcomes. First, it tended to produce images that reflected the circular turning of the plate, which is to say the sweeps and whorls typical of Hayter's own burin prints of the 1940s. Second, it suggested a force that was centrifugal, which in turn drove the composition outwards to the edge of the plate. As with Masson's Hayterish *Rape* of 1941, the boundaries of an image now became something to be pushed against, a constraint to creative energy. This dynamic would lead, in America, to an art synonymous with all-over composition and, eventually, with size.

Hayter's experiments with Wertheimer had also shown that images produced by this new, all-round way of working could invoke in both maker and viewer an actual sense of flying or falling. The illusionistic falsehoods of perspective were now replaced by a genuine sense of depth, of a world not just perceived, but experienced, as being three-dimensional. In a film made at Atelier 17 in 1950 – the same year as Namuth's of Pollock – Hayter would comment on his turning of the plate as he worked on it: 'The plate turns under the tool, as the land appears to turn under a plane when it is banking.'[44] So, too, in his contemporaneous writing: 'In line engraving with the burin the engraver drives a sharp tool against the turning plate; he has the sensation of navigating inside the web of his design which turns as the landscape seems to turn beneath a banking plane. He moves in depth, and as the variation in depth in his groove is moulded on the print as relief, his experience remains visible. Thus the result has three concrete dimensions.'[45]

Warming to his theme, he exposed its Jungian underpinnings. Jung had written of 'the unsatisfied yearning of the artist reach[ing] back to the primordial image in the unconscious'.[46] Now, Hayter paraphrased him: 'The space of the imagination is not limited by the restricted experience of the individual in his own lifetime. In the unconscious mind one might expect to find traces of the experience of space derived from other species from which the human has evolved, the freedom of movement in three dimensions in water reconquered in some respect by the conquest of the air.' For Pollock, who had been in Jungian analysis from 1939 and, in 1944, possibly still was, these ideas must have come

116 CHAPTER 5

with the clarity of revealed truth.[47] The doyen of Atelier 17 was not his master but his co-explorer. Along with his dance-based works, Hayter now produced engravings with names such as *Flight* and *The Principle of Flight*. Both were made in 1944, the year Jackson Pollock began his Atelier 17 engravings.

———

In part because his paintings of 1944–6 were lost in a studio fire, in part because he later practised largely as a sculptor, Reuben Kadish and his part in the shaping of a new kind of New York painting are now largely forgotten. And yet, a decade before his return to Atelier 17 in 1944, David Alfaro Siqueiros had counted Kadish as one of the two shining lights in what then passed for an American avant-garde. Seeing the mural that he and a Californian friend, Phillip Goldstein, had made for the Mexican University of Michoacan in 1935, Siqueiros pronounced the pair 'the most promising young painters in either the US or Mexico'.[48] Goldstein, in his later incarnation as Philip Guston, lived up to this promise. Kadish, in terms at least of fame, did not.

The effect on his art of meeting Hayter had been startling. In 1939, Kadish had worked on a set of mural studies called *Duarte Scenes*, made in fresco and marrying a faintly ludicrous Michelangelesque classicism to Federal Art Project literalness. A short year later, he painted a small, nameless canvas in oil and sand that might easily have been made in a studio in Montparnasse the month before. In between had come *Untitled (Surreal Etching)*, a work whose endlessly looping line shows a conversion to Hayteresque method, a mind set free by the hand. The liberation that showed itself in oil paint had been fought for in printer's ink.

It was presumably his own experience that made Kadish recommend Atelier 17 to his friend Jackson Pollock. Etchings such as *Lilith* (FIG.28) and *Job*, both made in the time when Kadish and Pollock were working alongside each other at Hayter's studio, see the ex-army artist picking up the strands he had been forced to drop by war service in 1941. Despite the lapse of time, the prints are accomplished, made by a hand that knew what it was doing. Kadish was certainly qualified to pass on to Pollock the lessons he had learned from Hayter in 1940. 'The thing was

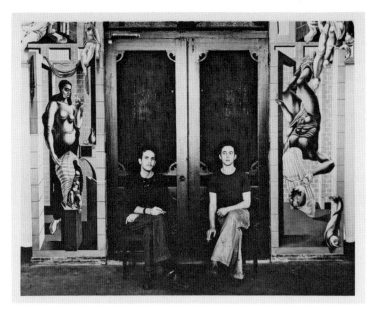

Reuben Kadish and Phillip Goldstein (Guston) posed in front of their WPA mural *Physical Growth of Man* at the City of Hope TB Sanitarium in Duarte, California, c. 1936.

that Jack didn't like working with other people around him,' he recalled. 'So he used to come in after ten o'clock, eleven o'clock, when everybody else had gone home. And [then] he would work on his plates.'[49]

If he had hoped to turn his friend into a printmaker, though, Kadish was to be disappointed. Like many Federal Art Project artists, Pollock had experimented with printmaking in the 1930s – in his case, in a series of a dozen or so lithographs with titles such as *Farm Workers*, made between 1934 and 1935. The experience had obviously not excited him. It was not until his late-night visits to the New School a decade later that he would return to printmaking, and then in a narrow and specific way.

When the plates Pollock had worked on during his six months at Atelier 17 in the mid-1940s were finally rediscovered in the mid-1960s, the artist's widow, Lee Krasner, decided to have them editioned. As was typical of Atelier 17, Pollock had never done so himself. Nor had he made the very few prints that had been taken from the plates at the time.[50]

118 CHAPTER 5

'[T]hose plates had been pulled before,' Kadish later recalled, '[but] I had done the original prints.'

Given his experience with Pollock's work on paper, he had offered to pull the ones for the new edition in 1967, but Krasner turned him down. 'Lee has a way of rejecting any kind of relationship that anyone ever had with Jack,' Kadish remarked bitterly. 'So that was it.' He went on: 'I thought [the new prints, made by Emiliano Sorini] were very poorly done. Very antiseptic. If you like a flush toilet...' He paused. 'They weren't like the original prints....Jack liked the idea of all his prints having a bit of character, instead of being antiseptically uniform. You can imagine, the kind of guy that he was – he would like to have seen as much of the accidents as he could. Those prints that Lee approved had been done methodically.'[51]

––––––

Whatever the things that Pollock had hoped to learn at Atelier 17, then, skill as a printmaker was clearly not one. So what had he been looking for?

Intaglio printmaking seems an unlikely place to have found liberation. Etching and engraving are heavily reliant on techniques learned through long practice. They are, as Reuben Kadish would have said, methodical. Quite apart from the necessary fluency of the hand with a needle or burin, pulling a complex print may require several separate inkings on one or more presses, as well as all the printer's paraphernalia of acid baths, resin powders, wax grounds, et cetera. Pollock's own experience of the medium had amply proven his unsuitability to it.

His FAP prints had been made in the New York workshop of the lithographer Theodore Wahl. 'He'd come up and say "I want to do a lithograph,"' Wahl recalled. 'I'd flip him a stone, and he'd make a lithograph. He'd come back six weeks later, and it was the same thing. The problem with Jackson and printmaking is that you have to stick to the medium – it's very technical – and Jackson couldn't stick to the medium.'[52] One day Wahl, having left Pollock alone in the studio, came back to find him painting a tabletop with oils he had found in a drawer. Wahl threw him out. His later comment – 'Jackson wasn't very serious about printmaking' – is a model of understatement.[53]

It might equally have applied to Pollock's time at Atelier 17. What he was experimenting with in those six months at the New School studio

POLLOCK MAKES A PRINT

119

was only incidentally to do with the making of prints. His real interests were in the integration of movement into art, finding a Massonian balance of abandon and control.

———

In 1967, a decade after the artist's death, the Museum of Modern Art held an encyclopaedic show of the work of Jackson Pollock.[54] The previous year, its curator, William Lieberman, had been out to what is now the Pollock-Krasner House on Long Island to look for potential exhibits. In the course of his research, he came across the plates Pollock had made at Atelier 17, some with trial proofs: the prints that Lee Krasner would at last have editioned.[55]

There had originally been eleven plates, but two, by 1966, had been lost. Of the nine that remained, another two had deteriorated beyond saving.[56] Or that, at least, was the conservatorial consensus. Hayter disagreed. 'When I was back in America, I saw them and they *were* rather badly corroded,' he said in 1982. 'I suggested...that there was a method of restoring those plates, but not many people know how to do it. It's done by a process of electrolysis that not many people would have the nerve to undertake for fear of destroying the plate....It might take fifty hours, or something like that.' He paused. 'Anyway, the plates were printed and kept, which was rather lucky. There's no doubt that during the time he was with us, Jack got into the method of working that turned out to be so valuable to him. Before that, he was doing much more formal things.'[57]

Where he was unwilling to assert his own role in Pollock's formation as an artist, Hayter was quite happy to acknowledge the place of Atelier 17. Asked in an interview in 1983, 'Why do not more people associate you with [Pollock], as an influence?', he had snapped, 'Why should I be? I don't see any sense in that.'[58] This distaste for blowing his own trumpet was not to stand his American posterity in good stead.

Whatever the vector for Pollock's discoveries at Atelier 17 – Kadish, Hayter, a general philosophy of working, or all three – the changes in his art there are evident from his prints. That his ideas had been running on parallel lines to Hayter's is clear from their contemporaneous paintings. As well as *Guardians of the Secret* Pollock had, also in 1943, painted a vast, 15-square-metre (49-square-feet) mural on canvas for the hall of

120 CHAPTER 5

Peggy Guggenheim's flat on East 61st Street: a composition of looped forms strongly reminiscent of Hayter's own.[59] This raises the intriguing, if unanswerable, question of whether the two men had known each other before Reuben Kadish's return to America in 1944, or whether Pollock was at least aware of Hayter's work and thinking. This would explain his odd readiness to return to a printmaking studio despite a less-than-happy experience of them.

That earlier experience, perversely, may have been the very thing that impelled Pollock to Atelier 17. A form of printmaking that was everything that printmaking was not meant to be – not methodical, not mechanistic, not skilled – had the appeal of unfamiliarity. Then, too, there was the perversity of Hayter's own work: the reliance on a line whose point was its evident fluency and ease, but whose making had been neither easy nor fluent. Later, looking through the catalogue to MoMA's 1967 Pollock show, Hayter had recognized this in comparing his friend's work to his own. Pointing to a Pollock painting, he said, 'This is the other side of the mirror! *This* was done with an open gesture like *that*, whereas mine was done by a movement against the resistance of metal; and when it appears to move at enormous speed, it is actually moving very, very slowly.'[60] Experimenting with metallic slowness may have struck Pollock as a promising test-ground for rapid painting. His Atelier 17 prints would all be made with a burin.

———

The original studio works break down into three rough-edged groups. Although the prints made by Sorini in 1967 are useful as indicators of Pollock's progress through the studio, they are also misleading. As Reuben Kadish complained, they are simply too printmakerly. Sorini, trained at the Accademia in Rome and in the Tamarind print workshops, could not unlearn his experience at will. The tone and shading of the 1967 prints are polished in a way that the originals could never have been. Although of different states of the work, MoMA's two versions of *Untitled (1)* – the first pulled at Atelier 17 in 1944/5, the second by Sorini twenty-odd years later – show the problem (FIG.29).[61]

Untitled (1) belongs to the least adventurous of the groups of prints, the ones in which Pollock is simply trying to replicate with burin on metal

POLLOCK MAKES A PRINT

the iconographic experiments he had been making in paint. The dance, here, is depicted rather than enacted: the print seems to show a group of four anthropoid figures leaping around, and perhaps over, a fire. In feel, *Untitled (1)* seems a step backwards to works such as the Tate's *Birth* of around 1941 (FIG.30). The air is of Pollock trying to conjure up a cod-shamanism in an attempt to come to grips with the Navajo sand painting he had seen at the Museum of Modern Art three years before.

A second group finds him looking sideways rather than backwards. In this series, Pollock is clearly responding to the work of Joan Miró, the subject of a large and much-publicized MoMA retrospective in 1941-2.[62] These prints include *Untitled (8)*, some elements of which – the cockscomb in the image's top right-hand corner, for example – are straight lifts from the work in Miró's show.[63]

It is the third group that shows the real importance to Pollock of his time at Atelier 17. *Untitled (4)* and *Untitled (6)* in particular see a climactic change in his understanding of line, from a tool that can be used to surround or delineate to an autonomous thing of its own (FIGS 31 & 32). In *Untitled (4)*, the most ambitious and finished of the works, a fine, net-like line pulls together the forms behind it as in a web.[64] Unlike oil paint, burin engraving does not allow for correction. A line can only be amended by the addition of another line. The feel in *Untitled (4)* is of Pollock at first attempting to deface an image he had found unsatisfyingly traditional and then realizing that his defacement had actually enhanced it: that the scrawled line was more powerful, more immediate, than the image behind it. Another line is added, then another. What had originally been the figure in his composition is now the ground, and vice versa.

It is in *Untitled (6)* that he takes this new realization to its obvious end. For the first time in the prints, figural representation is all but abandoned. There are no anthropoids or biomorphs in *Untitled (6)*, no borrowings from Miró. Now, the line is the subject and the subject the line; so, too, implicitly, the movement – the Hayteresque whirling and turning – that had generated both. Like Hayter's evocation of flight, Pollock's swoops and whorls trace the movement in space of the man who had made them. In his eliding of earth and sky, old certainties of figure and ground are lost. As Rothko's ground was to become his figure, so Pollock's figure now becomes his ground.

Five years after all this, Pollock was asked about his working method in a radio interview. Predictably, the interviewer's interest was in his subject's use of sticks rather than brushes to paint with, of liquid paint rather than paint from a tube.

> **WILLIAM WRIGHT** How do you go about getting the paint on the canvas? I understand you don't use brushes or anything of that sort, do you?
>
> **JACKSON POLLOCK** Most of the paint I use is a liquid, flowing kind of paint. The brushes I use are used more as sticks rather than brushes – the brush doesn't touch the surface of the canvas, it's just above.
>
> **WW** Would it be possible for you to explain the advantage of using a stick with paint – liquid paint rather than a brush on canvas?
>
> **JP** ...to have greater freedom and move about the canvas, with greater ease.
>
> **WW** Well, isn't it more difficult to control than a brush? I mean, isn't there more a possibility of getting too much paint or splattering or any number of things? Using a brush, you put the paint right where you want it and you know exactly what it's going to look like.
>
> **JP** No, I don't think so...with experience – it seems to be possible to control the flow of the paint, to a great extent, and I don't use the accident.[65]

A few months later, a rather less patient Pollock would send his fractious telegram to *Time*.

If critics did not understand what was going on in his work, then other artists certainly did. Prime among these was Stanley William Hayter. In old age, leafing through the 1967 Pollock catalogue, he seemed surprised at the incomprehension that surrounded his dead friend's art. 'The idea of this as being chaotic and meaning nothing to me is meaningless,' he said, puzzled.[66] What he saw was not the random splatters smirked at in

POLLOCK MAKES A PRINT

123

Time but the playing out of his own teachings on drawing with the whole body, Pollock's ability to 'hit a point, like *that*, with greater precision than with measurements or with compasses'.[67] Attempts to trace his so-called 'drip paintings' – an unhelpful term – back to swinging tins of paint or Onslow Ford's *coulage* had been misleading. In those, the artist had been passive: the most he could hope to do was work with what he was given. Pollock's painting was entirely active, and all about control.

Another artist who understood this was André Masson. In February 1943 Masson had shown his new canvas, *Pasiphaë*, at Buchholz in New York (**FIG. 33**).[68] As he recalled: 'Un jeune peintre de l'époque, Pollock, devenu célèbre depuis, est allé voir ce tableau sur les conseils d'un critique, Greenberg; il est sortie en disant: "Eh bien! moi aussi, je cherche Pasiphaë, je ferai une Pasiphaë"' ('A young painter of the time, Pollock, later to become famous, went to see this work on the advice of a critic, Greenberg; he left saying, "OK! Me too, I'm looking for Pasiphaë, I'm going to make a Pasiphaë"').[69]

The influence may have been more direct. 'Masson a while ago said he was getting critics all the time from America asking whether he actually met Pollock during the time he was in America and he couldn't quite remember,' Hayter was to say. 'I recalled to him an instance which he did remember when he did actually meet Pollock in my workshop on Eighth Street in the Village.'[70] As Atelier 17 only moved from the New School in the spring of 1945 and Pollock – who lived directly across Eighth Street from the new studio – left New York for Long Island that summer, the meeting must have taken place at the time that he was working on his prints.

For his part, Pollock was uncharacteristically open about the effect Masson's work had had on his own. As John Bernard Myers, editor of the influential magazine *View*, recalled, Pollock told him that 'the only person who really did get through to me was Masson'.[71] Masson was to reciprocate in kind. 'Pollock', he said, 'pushed [painting] to extremes that I myself couldn't have envisioned.'[72] In 1955, a few months before Pollock's death, Masson's son, Diego, was to retrieve a painting from a rubbish bin in his father's studio. Painted by André Masson, this was a gestural work, Pollock-like in flavour, a response to the new American painting. It is now known as *Dance*.[73]

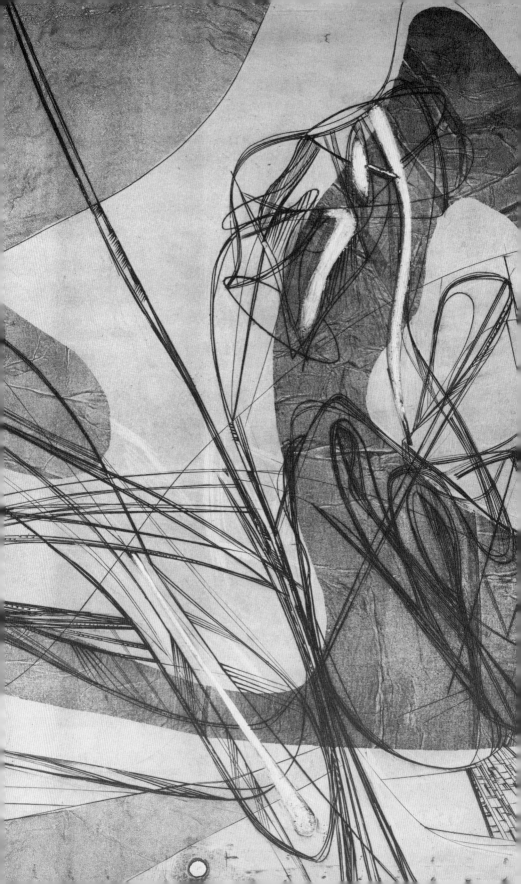

To Eighth Street

CHAPTER 6

[American artists] have clustered around [Hayter] like athletes who discover a natural leader for their games...like a magnetic field that knits haphazard particles into lines of force.
A. Hyatt Mayor[1]

You know, that place of Hayter's that...practically changed the course of the history of printmaking had one lousy little press.
Gabor Peterdi[2]

On 9 May 1945, Charles Henri Ford, editor of *View*, wrote to his mother in triumph. There had, he said, been 'a position won' for the magazine, wrested from a 'rival'. 'Paris from now on will always look toward New York,' a self-satisfied Ford went on. 'There is no Museum of Modern Art [there], for example.' That the day before had seen another victory – it was VE Day, the end of the war in Europe – was passed over without mention.[3]

Now, the tide of exile turned. In October 1945, the Massons sailed for France: *Elk Attacked by Dogs* was to be André Masson's last American painting. The homecoming was not all the family might have hoped for. In November, Masson wrote to Curt Valentin in New York – '*mon cher vieux Curt*' – from La Sablonnière, the house near Poitiers where they had settled. 'A sumptuously edited magazine that replaces *Minotaure* and is called *Vrille* is going to publish some of my American *tableaux* in colour,' he said.[4] The periodical, a postwar attempt to revive surrealism, folded after one issue.

It was a gloomier Masson who wrote again, three months later: 'America seems so happy and peaceful to me now, when I see the rubble of France'; then, 'But I don't for a second regret coming back. Even if art is coming to an end, this is *where* it will end.' Rose Masson adds a plea for American luxuries: toy soldiers to replace ones Diego had broken ('Il sanglote, et je lui ai promis que vous en enverrez d'autres immédiatement'); 'tea, Martinson coffee; a little chocolate, rice and sugar, with perhaps some jars of jam'; then, '*Life, Saturday Post* – les comics de Walt

126 CHAPTER 6

Disney (Donald Duck, Mickey Mouse, a.s.o.)'.[5] In May 1946, Masson wrote to Valentin again: 'Thank you *pour les excellents* chocolates'; a belated, if slight, sally into English.[6] In the same month, André Breton and his new wife, Elisa, sailed for France.

———

Masson's departure was not the only change at Atelier 17 that year. In the early summer of 1945, the studio had moved out of the New School.[7] There were various reasons for this. After five years, the room had simply become too small. 'I could only take, I think, twelve there because that was all the space there was,' Hayter said. 'So it was suggested I should do about six classes of twelve different people and I said no.'[8] Then again, the school authorities had finally balked at his practice of allowing the Paris *anciens* access to the seventh floor when the building was closed, and not charging them for the studio's use or for materials.[9] 'Unless I [could] have the equipment available to my people all the time they would not be able to pursue their work effectively,' Hayter had argued. To no avail: 'So in the end there was a difference of opinion.'[10] The new studio would be a quarter of an hour's walk from the old, at 41 East Eighth Street.

Eighth Street had long associations with modern art in New York. Before the Great War, Gertrude Vanderbilt Whitney had bought a mews house in MacDougal Alley, running south from West Eighth Street, and turned it into a sculpture studio. She soon added the house at 8 West Eighth Street, then the ones on either side of that. These, in November 1931, she would open as the Whitney Museum of American Art, the Metropolitan Museum having refused the gift of her collection.

The idea of a gallery devoted to a specifically American art had quickly been attacked, not least by the collector and aesthete Albert Gallatin.[11] It was an attitude that persisted. In 1944, even as Pollock was working on his prints at Atelier 17, the US Federation of Modern Painters and Sculptors had criticized the anti-American bias of the Museum of Modern Art's exhibitions policy. The patrician response of James Thrall Soby, MoMA's director of painting and sculpture – 'You cannot possibly present twentieth-century American painting as we have presented School of Paris painting' – spoke volumes.[12]

Number 41 East Eighth Street was a tired-looking brownstone recalled by Hayter's poet friend Ruthven Todd as 'rather tumbledown, but humane'.[13] The block in which it stood was owned by a charity called Sailors' Snug Harbor, dedicated to the care of retired seafarers. The block included number 46 across the road, where Jackson Pollock lived with his soon-to-be wife, Lee Krasner. It was there that Pollock had painted Peggy Guggenheim's *Mural*, illicitly pulling down a partition wall to do so.[14]

It thus may well have been Pollock who found the room on the first floor of 41 East Eighth Street that would house the new Atelier 17. Certainly he knew the occupant of the floor below, the owner of a shop

41 East Eighth Street, showing Rosenthal's Art Supply Shop, 1939–41.

128 CHAPTER 6

bearing the sign 'Robert Rosenthal, Inc., Artists' and Draftsmen's Materials'. Hard up as ever, in February 1943 Pollock had asked Lou Rosenthal if he would trade twenty-five dollars' worth of supplies for a painting. Rosenthal had refused.[15]

The move from the New School had been a typically vaudeville affair. The Japanese American sculptor Isamu Noguchi, a habitué of the old studio and neighbour in MacDougal Alley, had driven the atelier's sole printing press to Eighth Street in his estate car; a group of stalwarts had manhandled it up the stairs. A Californian friend of Hayter's wife Helen Phillips, the sculptor David Slivka, divided up the single room with wooden partitions.[16] 'There was no sign on the door,' a student recalled. 'One could follow the pungent aroma of Frankfurt black and plate oil up the wooden staircase and turn into the left-hand door on the first landing. The room was not large by workshop standards. The front windows were richly patinated with New York grime....The place was heated by evil-smelling gas radiators and the smell of heated dust and grime, scorched resin and melting grounds together with the acids was heady. Equipment was strictly do-it-yourself and the workshop had a held-together-by-sheer-love look.'[17]

———

The timing of the move was unfortunate. Hayter had made free access to the New School studio for his *anciens* a sticking point for his staying, just as many of those *anciens* were about to leave. Their place was now taken by younger Americans, provided, at first, by the New School.

Despite the atelier's departure, its teaching was still listed on the school's prospectus for 1945–6:

> Experimental courses in Modern Technique of Etching and Engraving. Facilities and equipment for original research by experienced artists. Group activities with present and past members. Workshop open for work without supervision. Introductory Course: Mondays 5pm – 10pm. Advanced course: Thursdays 5pm – 10pm. Fees $40 term. Material fee $5 payable in advance. Admission to course by consultation with Director. S.W. Hayter.[18]

Installation view of the exhibition 'Hayter and Studio 17: New Directions in Gravure', photographed by Soichi Sunami. Museum of Modern Art, New York, 1944.

'I moved my equipment over to [East Eighth Street],' Hayter recalled, 'worked with [the school] for a certain time, let's say they scheduled courses, handled papers and so forth for me and then we carried on together.'[19] But the balance had shifted. 'The émigrés had helped to keep the international character of the group,' he said ruefully.[20] With the exception of the artists discussed in Chapter 7, Atelier 17 in New York would now be an American project.

The departure of Masson and his fellow Europeans was not the only cause of this. On 18 June 1944, as Allied troops fought their way towards Paris, an exhibition of work made at Atelier 17 had opened at the Museum of Modern Art in New York. In anticipation of changes to come, the workshop's name had been anglicized for the occasion. The show was called 'Hayter and Studio 17: New Directions in Gravure'.[21]

The inference was clear. If Atelier 17 was a European workshop with an American following, Studio 17 was the other way about – this despite

130 CHAPTER 6

only a third of the works in the show having been made by American artists, and then only if the essentially Parisian Calder and Ian Hugo were counted among them. Included in the sixty works shown were Marc Chagall's *Chevalière* and *Femme violoncelle* (1944), four prints by Joan Miró made at Atelier 17 in Paris, and eleven by Hayter, among them *Laocoön, Centauresse, Flight* and *Tarantelle* (**FIGS 34 & 35**). Some of these had also come with him from Paris, as had prints by Árpád Szenes, Roger Vieillard and others.

The exhibition had been the brainchild of Monroe Wheeler, MoMA's director of exhibitions and publications, who had spent the 1920s and '30s in Paris. Correctly anticipating the interest the show would generate, he had arranged for the entire summer issue of the *Museum of Modern Art Bulletin* to be given over to 'Hayter and Studio 17', the magazine effectively doubling as the show's catalogue. Wheeler's secretary ordered 9,400 copies for the museum bookshop, alerting the Penthouse Restaurant to lay in stocks of 'beer and white wine cooled' for the opening.[22]

Hayter, typically, played down the exhibition's triumph. 'Well, we made that show at the Museum of Modern Art in '44, though under the downstairs in the auditorium,' he laughed in an interview in the 1970s. 'You know the place – down below, where you go through to get to the toilets. A lovely idea. Everybody would see it sooner or later.'[23] Even he had to allow, though, that 'the show...had enormous success and was circulated for two years all over America', before spending two more touring South America.[24]

Now, suddenly, Atelier 17 – or Studio 17, as it had newly become – was in the news. The exhibition acted as the graphics section for a raft of shows held to celebrate MoMA's fifteenth anniversary and collectively titled 'Art in Progress'. This received an unusually rapturous critical reception in the New York press: 'The most beautiful display in the museum's history,' enthused one paper; 'A genuine source of public enjoyment and profit,' another; 'I cannot imagine any living artist passing through this exhibition and remaining unaffected by it,' a third.[25] Predictably, applications to join Hayter's atelier now shot up. These came not from Parisian *anciens*, nor yet from professional American artists of the stripe of Pollock and Rothko. One woman student already at the atelier

TO EIGHTH STREET 131

summed up the new intake when she wrote crossly to her parents: 'Mr. Hayter [is being] besieged by new pupils...all twittering ladies.'[26]

If this was true in part, it was not quite the whole story. While Hayter's studio would lose the academic imprimatur of the New School in moving to East Eighth Street, this loss would be more than made up for by the enthusiastic support of the Museum of Modern Art. The understanding of curators such as Monroe Wheeler and James Johnson Sweeney was impressive, and occasionally hard bought. William Lieberman, appointed assistant to MoMA's director, Alfred Barr, on his return from Paris in 1945, had braved the twittering ladies to sign up as a student at Atelier 17. 'I actually studied with Hayter,' Lieberman recalled, 'because too many print curators, they may know all about how different impressions look and things like that, but they don't know actually how to make a print. What I did was terrible, but I did learn how to etch, how to handle a burin. I still advise people going into the field to do that. In fact, I think it's essential.'[27]

———

As Atelier 17's star rose, so too did Hayter's. The prints in 'New Directions in Gravure' were not his only works to be shown at MoMA in 1944. There was also a drawing in red ink on green paper, called *Fish and Figures* (1943), in the exhibition 'Modern Drawings', which, like the Studio 17 show, was part of 'Art in Progress'.[28] Three months after 'New Directions in Gravure' ended, a one-man exhibition of Hayter's paintings opened at the Mortimer Brandt Gallery on 57th Street.[29] A solo show at Brandt was a feather in the cap: the exhibition that followed Hayter's was of Matisse, Braque, Kandinsky and Picasso.[30] The following winter, Brandt would show Mark Rothko.[31]

For all that, headway as a painter remained slow. If Lieberman and his colleagues understood Hayter's work, a more general critical response was of incomprehension. A triple review called 'Miró, Hayter, Rothko' in the *New York Times* began promisingly enough: 'Modernism of the types we are currently at grips with is not to be brushed impatiently aside unless our minds are closed by dense prejudice and locked with a lazy key.'[32] It then brushed Rothko impatiently aside. 'Rothko is still beyond my grasp,' the review went on. 'The unsigned statement

132 CHAPTER 6

in the [exhibition] catalogue...may or may not help.'[33] Miró's paint-
ings, by contrast, showed 'a steady swing toward an all-over design',
a term newly in the critical air. *Art News*, too, praised Miró for his 'all-
over pattern...all woven together in taut relationship and tied by thin
electric lines'.[34]

It was with Hayter, though, that the *Times* reviewer had the great-
est problem. 'Hayter', he said, 'is "difficult". Beside him, Miró...appears
almost as simple as a patchwork quilt. Hayter baffles with what James
Johnson Sweeney calls his "imaginative ambiguity".' Sweeney had
written the foreword to the show's catalogue, the cover of which, unex-
pectedly, advertised its subject as 'William S. Hayter'. Since it is hard
to imagine this having been a mistake, Hayter's name had presumably
been purposely Americanized – forename, initial, surname – in the
same way as his atelier's had at MoMA. Perhaps 'William' was thought
of as having more gravitas than 'Stanley', with its distant echo of Laurel
and Hardy. 'Mr. Sweeney helps clarify the issue, too, when he asserts
that line is the "backbone" of Hayter's idiom,' the *Times* review ended.[35]

Difficulty of his work aside, the episode suggested two other prob-
lems facing Hayter's career in America. The first was his temper. If he
was infinitely patient with people in need of his help, he was very much
less so with those whose help he needed. Sweeney's essay to the Brandt
exhibition shows an unusually sensitive grasp of Hayter's work. So, too,
had his foreword to the catalogue to 'Hayter and Studio 17', which made
a prescient link between what was happening at the atelier and devel-
opments in the work of painters such as Jackson Pollock.

'One of the dominant interests...of recent painting has been the res-
toration of the unity of the painted surface,' Sweeney had written. 'With
Hayter and his associates burin engraving has recovered its dignity
as a medium of original expression. For them the copper plate is not
merely a surface on which to draw.'[36] He had also intuited why Hayter's
plate-centred practice would appeal to sculptors such as the American
surrealist David Hare and, later, Louise Bourgeois. 'Thanks to the dif-
ferent depths and types of stroke possible to the burin, line engraving
exists in a middle realm between relief sculpture and drawing,' Sweeney
said, adding that Hayter's experiments with printing on plaster bridged
a gap between engraving and sculpture.[37]

TO EIGHTH STREET

His Brandt essay was not just perceptive but generous. Sweeney was a senior curator at MoMA; to lend an artist at a private gallery his public endorsement was to lay his reputation on the line. Hayter's response to Sweeney's kindness was, at the very least, ungracious. On a copy of the Brandt catalogue, he has written, in the margins to the essay, 'This is of course utter nonsense and a complete absurdity. It is high time someone kicked the tongue out of these "artists" [*sic*] cheeks.' In a furious scrawl, twice underlined, he added, 'Do not mail any more of such rot to me.'[38]

He could also be deeply patronizing towards Americans. In an interview twenty years after leaving New York, he suggested that he had made himself unpopular with the abstract expressionists in holding that automatism 'was very arduous and difficult to do, painful, even'. 'I found that rather defeated the American dream,' a very English Hayter drawled. 'The short cut to fame and fortune with no pain.'[39] If his American posterity was not as great as it should have been, he had partly himself to blame.

———

The other American problem specifically affected Hayter's career as a painter. In the eyes of the public, including many critics, he was, and could only ever be, a printmaker. Typical of this assumption was the review of the Brandt show in the New York *World-Telegraph*. 'Hayter', this breezily said, 'is little known hereabouts, except, as I remember it, for his engravings.'[40] Gabor Peterdi, Hayter's chief collaborator at the American atelier, spelled it out: 'What happens is that unfortunately when you become too well known in a certain direction it sometimes acts practically as a prejudice against you. This is particularly true in America because here everything is specialized. They specialize you; you know, they put you in a box....This is the same curse that Hayter has. As a matter of fact, this is one of the bitternesses of his life. No matter what he does, he's just known as a printmaker.'[41]

This blinkeredness hampered sales of Hayter's paintings and drawings. A week before the Brandt exhibition closed, the gallery wrote to the director of programmes at the Cincinnati Modern Art Society, offering to send her the show '– some ten to twelve paintings, mostly painted in

1944, and ten to fifteen large drawings (about 55 × 25 in.)' – later in the year.[42] A week later, the director replied, regretting the impossibility of showing Hayter's paintings in either the current or the following year.[43] In March, Brandt sent Hayter a breakdown of sales from his exhibition. Four drawings had been sold for a total of $625, $400 being for a single work bought by *Fortune* magazine. The other three had sold for $75 apiece. The paintings had found no buyers at all. After the deduction of gallery expenses, Hayter would receive $237.08.[44]

Even the Museum of Modern Art could not always be relied on for support. Grumblings at the New School about the unfettered access of Hayter's *anciens* to the seventh floor had obviously begun to chafe some time before the move to Eighth Street. In late 1944, Hayter wrote to Monroe Wheeler, enclosing information about the history of Atelier 17 for a press release to the MoMA travelling show. 'If the Museum would care to sponsor the workshop, either as a pure research project, or together with elementary teaching – perhaps in the 5th Ave building – the cost of installation should be very slight,' Hayter had gone on, hopefully. 'The scheme would support itself completely as it has done at the New School. Space required would be one large room with adequate light, table space etc. or two small rooms – using one for printing. It is to be noted that such a scheme would not commit the museum to the sponsorship of an art school, a particular direction in art or other workshops as the work done is unlike that of any other workshop.'[45] As with Cincinnati, the offer was politely refused.

———

Hayter's influence was not confined to the room above Rosenthal's art shop. In the summer of 1945, he and Phillips rented a fishing shack on Louse Point at Gardiners Bay, Long Island. They had spent the previous summer at nearby Amagansett. Phillips recalled, 'There were so many [of us] there...that a pair of women all dressed up stopped me in Amagansett Main Street and said, "We're from Southampton. Can you tell us where we'll find the Surrealists?"'[46]

The new rental had a roof that leaked, water that had to be pumped by hand and no electricity; Hayter, who still had to go up to East Eighth Street, found it too far from the local train station. He and Phillips rented

TO EIGHTH STREET

another, more convenient house and handed on the first to Reuben and Barbara Kadish, who invited Pollock and Lee Krasner to stay with them. The Hayters came over for weekends of clamming and barbecues.

They were not alone. Jimmy Ernst, son of Max, described the general decampment of the New York avant-garde to East Hampton township that summer. 'Friends like Breton, Ernst, Duchamp, Léger, Matta, David Hare and Motherwell...played chess and engaged in severely regimented intellectual party games on the beach,' he recalled, 'much to the annoyance of local Bonackers.'[47] Peace was eventually restored between the Europeans and Long Islanders, with Hayter acting as a bilingual go-between. Young Americans such as Pollock and Krasner had a warmer reception from locals.[48] It was now that they decided to make the farm they found in nearby Springs their year-round home.[49]

It was in the blocks around East Eighth Street, though, that the osmotic influence of Atelier 17 was most strongly felt. 'We finally organized a sort of evening at a café called the Jumble Shop on West Eighth Street,' Hayter told his old friend Jacob Kainen. 'Every Friday evening from 6 p.m. onwards there'd be some chaps and we'd meet and talk and so forth. You see, it was a sort of imitation of the Café Place Blanche, near Pigalle in Montmartre, where the Surrealists used to meet in the '30s. Many of these people...like, say, Viera da Silva, Giacometti, Max Ernst, did not produce a great body of work in the atelier, but it seems to me that the work they did there had a definite effect on their total outlook. Their prints showed up in their sculpture, their painting, and all the things they were doing.'[50]

Talking was the point of Atelier 17; it did not have to be done in the studio. The Jumble Shop – *le Jumble* – was part café, part tap room, decorated by its lady owners with faux Tudor beams in the manner of an English pub. If Simone de Beauvoir would be unimpressed by it, artists found the Jumble's prices attractive; so, too, its habit of accepting artworks in lieu of payment.[51] The Cedar Tavern, around the corner and later notorious as the drinking hole of Jackson Pollock, was another favourite.[52] 'The reason – you know, why we used it – it had a round table,' Hayter said of the Cedar. 'We could get a lot of people round to talk and drink beer....We talked about everything in creation. We had our poets. Even an odd mathematician occasionally.'[53]

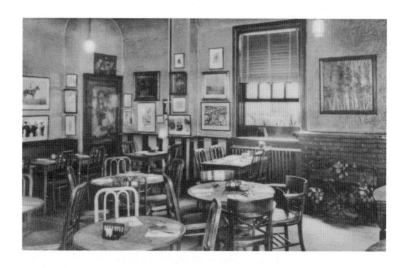

Postcards showing the Jumble Shop on West Eighth Street.

Karl Schrag, who had joined Atelier 17 as it moved from the New School, described it as 'a meeting place where problems far beyond printmaking were discussed. It was not at all like a crafts school or anything like that.' He recalled, 'What most of [the studio's artists] had on their mind was to use their gifts as painters or sculptors in another medium. Hayter usually came at five and left at ten. After the work was

done we all went out to the Cedar Tavern or some other place. There would be a lot of very interesting discussion mixed with jokes.'[54] After one semester, students would be given a key to the atelier to come and go as they pleased; more advanced artists were handed one on the first day.[55] 'You could work [in the atelier] all day and all night if you had a project going, but it wasn't that you would just sit there day after day and work,' Schrag explained. 'It was like your own studio.'[56]

One artist who used it in this way was Ian Hugo. The long-suffering husband of Anaïs Nin and the first of the Paris *anciens* to rejoin Atelier 17 in New York, Hugo was also to be the most fervent apostle of Hayter's ideas on the burin, set out in his own book, *New Eyes on the Art of Engraving*.[57] In January 1944, Nin not only self-published but self-printed *Under a Glass Bell*, the collection of short stories that would set her on the road to fame. The printing was done in a one-woman workshop, the Gemor Press, set up in nearby MacDougal Street with the assistance of Nin's Peruvian lover, Gonzalo More.

In 1942, printing her incestuous two-part novella *Winter of Artifice* on the Gemor's old-fashioned letterpress, Nin had confided to her diary, 'Gonzalo and I decided to use the William Blake method learned from William Hayter.'[58] Now, two years later, she warmed to the theme. 'The first copy of *Under a Glass Bell*. An exquisite piece of workmanship,'

Anaïs Nin at her printing press.

she mused. 'Gonzalo has a gift for book designing. He took a copy to Hayter's Atelier 17 and it was admired by Hayter, Lipchitz and other artists working there.'[59]

Her gratitude was, as often, partial: if her lover had helped print the book, its cover and nine illustrations had been engraved by her husband, Ian Hugo (FIGS 36 & 37). So, too, had those of *Winter of Artifice*. Hayter seems to have handled this predicament with what, for him, passed for tact. 'I meet Hayter on the street and he tells me how happy he is that Gonzalo has created something he could be proud of,' Nin wrote, blithely oblivious to the back-handedness of Hayter's praise. 'That he never thought Gonzalo could accomplish anything, and that it was a miracle.'[60]

Hugo's prints for his wife are unusual images, marrying a surrealist taste for the macabre to Hayter's for the unfettered line. As Nin had suggested, they have a strong flavour of William Blake; Hugo would be central to attempts at Atelier 17, described in the next chapter, to

Ian Hugo working on an engraved copper plate.
From *New Eyes on the Art of Engraving*, 1946.

TO EIGHTH STREET

139

resurrect Blake's so-called 'revealed' method of printing, claimed by the poet to have been imparted to him in a dream by his dead brother. The engravings for *Under a Glass Bell* in particular show what Leo Katz, in his foreword to *New Eyes on the Art of Engraving*, called Hugo's 'sensitive and lyric charm'.[61] For all that, Katz noted that 'one has to see [his copper] plates...rather than the prints to experience [that charm to the full].'[62] As ever at Atelier 17, the print was secondary to the thing that had made it, the thinking behind the making.

———

This is not to put the cart entirely before the horse. Atelier 17 was, of course, a print shop. If the drive to experiment there excited painters and sculptors, it inspired printmakers as well. In the case of Hayter himself, it allowed him to turn personal agony into his greatest intaglio work to that date.

In December 1945, Hayter's son David died of tuberculosis at the age of sixteen.[63] The boy had been ailing for some time. Edith Fletcher, his mother and Hayter's ex-wife, had brought him to New York for treatment; the pair moved into the Hayters' house on Waverly Place. Since divorcing Edith in 1929, Bill Hayter had seen little of David. Now he grieved for his past and present loss.

Throughout 1945, he had been experimenting with a revolutionary printing process at Atelier 17, one in which the engraved image and applied colours were run through the press in a single pass. Traditional intaglio colour printing had involved pulling the engraved design first, then adding colours – usually aquatint – from a number of different plates each inked in its own shade, one on top of the other, until the desired effect was reached. This process had always been problematic. The paper had to be dampened each time it was run through the press, making it prone to tearing and creasing. Registration of colours was uncertain. Now, with his son's death, Hayter at last managed the apparently impossible task of printing in black and colour simultaneously in a single impression. The resultant work was called *Cinq personnages* (FIG.38).

In an essay on Kandinsky published earlier in the year, Hayter had spoken of how the Russian's rendering of a continuous space freed from compositional gravity by the elimination of a base line had been influential

140 CHAPTER 6

on his own spatial constructions.[64] In *Cinq personnages*, what he had meant by this weightlessness becomes clear. The print is nothing less than a Deposition, but one in which the participants – David Hayter's body to the lower right, four grieving figures spread out across the plane – writhe in a torment of non-Newtonian agony. The viewer is thrown back on the not-quite-translatable French word *bouleversée*. There is no up or down to this scene of grief, no front or back; no order at all.

What makes *Cinq personnages* so hard to look at, though, is its colour. The print's studiedly strident palette – acid green, purple, the red of tubercular haemorrhage – is agonizing to the eye, a scream in chromatic form. The power of this palette lies in the harsh juxtaposition of its jarring components, which in turn relies on Hayter's having been able to see them all at the same time, together, and in conjunction with the engraved image.

It is hard to imagine *Cinq personnages* having been produced by traditional intaglio printing techniques, its colours layered one by one onto the black-inked engraving over a period of days and passes through the press. Its immediacy relies on it actually having been immediate – seen in a single moment, printed in a single pass. It is, to put it simply, painterly rather printerly, made by a man as at home with oil on canvas as ink on paper. If the printmaking done at Atelier 17 was to inspire painters and sculptors, then the inspiration also worked the other way.

Bought at whatever cost, *Cinq personnages* was to be Hayter's undoubted American masterpiece, and quickly recognized as such. Examples of it are now in the print collections of the Smithsonian and Metropolitan museums as well as other public galleries across America. In May 1946, Curt Valentin wrote to Hayter in unusually enthusiastic voice. 'For the amount of $1200, payable in $100 monthly installments, I receive the following prints of "Cinq Personnages": 1 copper plate, 1 plaster proof in colour, 1 1st state (black), 1 second " ", 1 third " "...5th " " 1 colour trial – colours without black, 1 " " – violet, 1 " " – orange/green/violet-green/orange-green/violet-orange/1 4th state – full colour/30 final state – full colour.'[65] The sum named by Valentin was five times that Hayter had made from his show at Mortimer Brandt. Whether this sweetened the pill of losing his eldest son can only be guessed at. So, too, the fact that while Valentin clamoured for this painterly print, he had still bought none of Hayter's paintings.

TO EIGHTH STREET 141

In that same year of change Hayter wrote to his friend, the critic René Renne, in Paris: 'Thus, like Masson, I am a dissident Surrealist. My work derives from a basis of automatism, from the subconscious, but I feel that no artist should be ignorant of the thinking of his time.' He went on: 'I never accepted the oneiric phase of Surrealism....I see no difference between the reality of my own images and the visual, transitory ones found in "Nature". Nature passes through my imagination without stopping at the surface of my retina. The phenomenal world contains my image like the reflection we receive in a spherical mirror.'[66]

Masson had left for France that month; David Hayter lay dying at the house on Waverly Place. His father's letter to Renne is unusually raw and revealing. Image-making is a two-way process: to see is to be seen. Perception is not a special or separate phenomenon, but part of humanity's being in the world. The question was how best to hone it, to sharpen the focus; by doing so, to fix his place in Nature.

As before, Hayter's answer was to work automatically. But what did that mean? In counting himself a dissident surrealist, he distanced himself from the old Bretonian idea of automatism as an end in itself, true simply because unmediated. Six months after his letter to Renne, Hayter published an essay on Paul Klee, by then a demigod of American abstractionists. What Hayter sees in Klee is his own reflection, caught in a spherical mirror.

'It appears to be a paradox', he writes, 'that the artist with whom automatism, the activity of the unconscious, is most generally associated, should have felt impelled to control the form and consequence of everything he made by [a] kind of strict and uncompromising morality.'[67] And yet the imposition of a morality – a notable choice of word – is precisely what Hayter's own automatism set out to achieve. For all his support of the Popular Front in the Spanish Civil War – hard up as he was in America, he still sent regular contributions to republican causes – it seems that Hayter saw himself as an anarchist.[68] Atelier 17, its communitarian spirit, its accessing of a Jungian unconscious, was at heart a politics, a Shelleyan world legislated by artists.

142 CHAPTER 6

That Hayter should see Jackson Pollock as shaped by Klee was no small praise. 'At one time...Paul Klee was a major influence [on Pollock], as he was both in the case of Motherwell and in the case of Mark Rothko, surely. And Bill Baziotes, who was with us quite a lot,' Hayter recalled not long before his death. 'There was a time when Pollock was quite obviously understanding some of the implications of Paul Klee. I think that is rather important because Klee was a man who covered an enormous amount of territory from point of idea.'[69] In 1946, Pollock would begin the first of his so-called 'drip' paintings.[70] In 1945, works such as *Moon Vessel* had still consisted of a skeined 'veil' superimposed on the totemic figures of his earlier style.[71] Now the looped line would serve as both figure and ground.

Karl Schrag recalled that line at Atelier 17. 'For a long time, really, there was a group of people sitting making these loops, which look a little like Hayter's,' Schrag mused. 'But I think a real Hayter was something far beyond that.'[72] He went on, 'The burin – I don't know whether you've ever used one; it makes these marvellous loops. It's almost sensuous pleasure to take that tool and to make these loops. And when they overlap, certain spaces are created and so on.'[73]

———

In 1946 as well, Hayter returned to Paris for the first time in seven years. His trip that June was variously disheartening. He found the atelier unusable, its press and plates confiscated by the Vichy government as payment for rent on a studio they held Hayter to have occupied during his five-year absence. Although he saw many old friends, what they had to say was hardly encouraging. After a few weeks he returned to New York, to what he clearly thought of as a second exile. He carried a selection of prints with him. In January 1947, Monroe Wheeler wrote to him – 'Dear Bill –' asking him to bring in 'some more of the most original and progressive work' from these so that he and James Thrall Soby could use it as the basis for a 'small print show' at MoMA.[74] In the event, this seems never to have happened.

A few months before Hayter's departure for Paris, one of the old friends he would see there had made the same trip going the other way. Jeanne Bucher, doyenne of the eponymous gallery, had published

Hayter's suite of six engravings, *L'Apocalypse*, in 1932. Now, meeting him in New York, she had offered to show his new work back in Paris. His trip in June would be made in part for this exhibition.[75]

It was not a success. At a speech Bucher had given at the Worcester Art Museum in Massachusetts during her trip to America – 'the first I have ever given in English!' – the veteran gallerist had eulogized her host country. 'Since the first few months I have been here I have been extremely impressed by the progress of the art in America,' Bucher said. 'When I was here ten years ago, I followed the art movement, and today I find not a difference of ten, but of fifty years in the strides made by the artists and public alike. I was totally unprepared for this. In France, things do not go so quickly.'[76]

Her measure of this change was calibrated by the artists whose work she knew best. 'How generously and warmly the exiled artists of Paris have been received here!' Bucher went on. 'Chagall, Lipchitz, Masson, Mondrian, Léger, Ozenfant, Max Ernst, Tanguy and Hayter have magnificently developed in the free climate of America.'[77] For all that, though, she ended by saying that her intention now was to represent not these old and transformed friends but new, American ones – specifically Robert Motherwell, 'recently shown at the Kootz Gallery', and the calligraphic painter Mark Tobey. 'This new school attracts me extremely,' Bucher concluded. 'It is not my gratitude alone which urges me to study them closely. In the same sense of the word, that has been proudly used of the artists of Paris, they are, for me "Seekers".' When she set off back across the Atlantic, she took the work of both men with her.

Thus it was that Hayter, back in Paris, was presented to the public not as an *ancien* returning home in triumph but as the representative of a new world order in art. His show at the Bucher gallery was advertised as part of the same *série d'Expositions Anglo-américaine* of which Motherwell et al. would also form part.[78] Hayter's response to being reintroduced to the French in this way is not known. Mentioned in passing in a couple of round-ups of current shows, his exhibition at Bucher received only a single dedicated review, and that brief and in a tone that hovered between incomprehension and antagonism.[79] As Breton would discover in the same year, the motives of those who had left for New York during

144 CHAPTER 6

the war were not always clearly understood back home, nor the new American Century necessarily welcomed.

———

It is tempting to think of Wheeler and Soby's failure to show the prints brought back by Hayter from Paris in the summer of 1946 as a sign of the sudden switch in polarity of Franco-American influence remarked on by Bucher and, often, taken as fact by art history. That is rather too neat a picture, however.

In January 1945, four months before the end of the war in Europe, France's greatest postbellum cultural export arrived in New York in the form of Jean-Paul Sartre. He had been preceded by his own calling card, an essay published in the *Atlantic Monthly* a few weeks before.[80] In this, Sartre introduced to his American audience all the themes that would soon become known to them by the catch-all name 'existentialism': loneliness, isolation, pessimism in the face of death, the absurdity of man's existence.

As a self-publicist, Sartre was without equal. Soon his writings were everywhere – not least in American *Vogue*, which published his 'The New Writing in France' that summer and a photo-portrait of the philosopher by Cecil Beaton the one after.[81] The latter showed Sartre standing in front of a modern painting and surrounded by folio-sized books on art left casually open. The year before her visit to *le Jumble*, Simone de Beauvoir now joined her lover in American print. In *Harper's Bazaar*, she introduced Sartre as 'a man who hates the country...[who] feels at home only in cities, in the heart of an artificial universe filled with man-made objects'.[82] If there was an opposite to Federal Art Project regionalism, then this was it.

This urbanism – and, perhaps, Beaton's art books – caught the eye of Clement Greenberg. In an essay on Jean Dubuffet published the month after *Vogue*'s portrait of Sartre, Greenberg pronounced existential pessimism and isolation 'an historical mood...aesthetically appropriate to our age'.[83] If admitting to the influence on American artists of French art was counted a crime, the influence on them of French philosophy was given the grudging Greenbergian nod. Almost at once, artists from Rothko to Motherwell announced that they were

TO EIGHTH STREET 145

existentialists. Abstract expressionism, said Motherwell, grew from 'this sense of being unwedded to the universe. Abstract art is a true mysticism...an effort to close the void.'[84] Even Greenberg's nemesis, Harold Rosenberg, agreed that the AbExers had been American existentialists *avant la lettre*, setting out as they had to be anti-group, to paint alone in 'an atmosphere of isolation, anguish and struggle'.[85]

If the Sartrean paradox of a collective isolation now unified the abstract expressionists in disunity, though, the battle was not yet won. In October 1946, an exhibition with the boosterish title of 'Advancing American Art' opened at the Metropolitan Museum in New York. Heavily funded by the Central Intelligence Agency, this was intended to travel the world, proclaiming the fact that America's military victory in the recent war was now to be matched by a cultural one. Once the show had left for Prague, however, it came under increasing attack in the US press and, eventually, in Congress. At least part of the reason for this was that many of the artists in the exhibition – Gottlieb and Baziotes among them – were held to have roots that were too European, or political beliefs too far to the left, or both. When President Truman, echoing Mayor La Guardia, offered his critical take on 'Advancing American Art' – 'If that's art, I'm a Hottentot' – the show was called back to America and disbanded.[86]

In the melee that surrounded all this, few things could be generally agreed on. One was Barnett Newman's pronouncement, also of 1946, that 'Surrealism [was] dead'.[87] As Masson and Breton were quickly discovering, this was as true in France as in America. Hayter's distinction between surrealism and dissident surrealism no longer mattered. In the eighteen months after the war, to be identified as either was to count as yesterday's man. So, too, as an artist working in New York, to be seen as European. The émigrés of Atelier 17 were now increasingly isolated. The following year, 1947, would be the studio's last great hurrah.

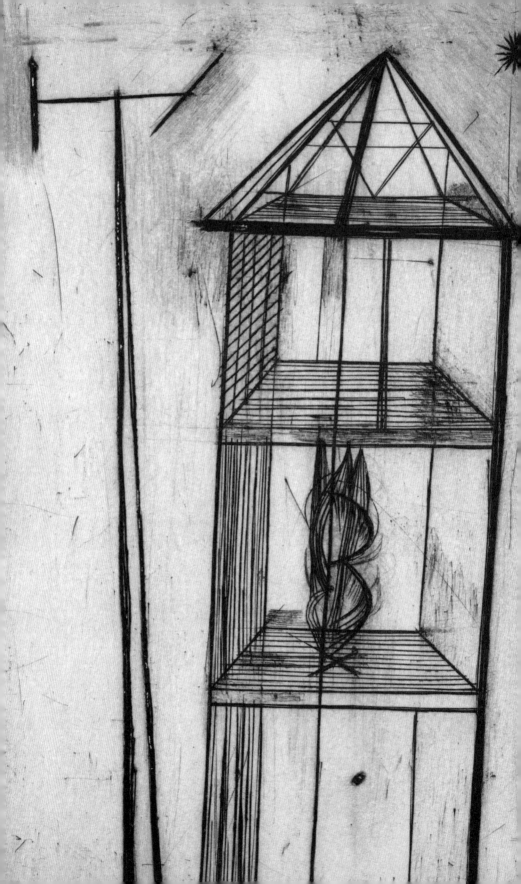

Blake, Bourgeois, Miró

CHAPTER 7

When Miró, Chagall, came to work [at Atelier 17], they already had a big body of work; and yet what they did there was entirely different.
S.W. Hayter [1]

Always there is tomorrow and the copper waiting,/Extending its invitation like a gilt-edged card.
Ruthven Todd [2]

On 12 February 1947, one of the first and certainly the most illustrious of Hayter's *anciens* landed at what was shortly to be renamed La Guardia Airport. Joan Miró and his wife were met there by Alexander Calder. 'The Mirós and their daughter, Dolores, arrived in the United States,' Calder wrote to a friend a few days later. 'So I drove the LaSalle (open, top down) straight to LaGuardia, and got there just in time. So we installed them in a little apt. on 1st Ave. (very nice), and then had a bite at Matisse's.' [3]

The Catalan had come to New York to work on the commission for a mural for the Gourmet Restaurant on the roof of the Terrace Plaza Hotel in Cincinnati, Ohio, then being built by the architectural firm of Skidmore, Owings & Merrill. [4] Calder had already made a mobile for the hotel's lobby; Miró's commission came via Pierre Matisse, who had dissuaded the clients from using Raoul Dufy in his favour. [5] Yves Tanguy found the visitor a large studio at 119th Street and Lexington Avenue belonging to the German painter Carl Holty. There Miró set to work on the vast Cincinnati canvas, nearly three by ten metres (ten by thirty-three feet).

Like the émigrés before him, he soon felt homesick for Europe; additionally, he was drowning in invitations from New Yorkers seduced by the cachet of his name. 'Here in New York I cannot lead the life I want to,' Miró complained to an interviewer in Robert Motherwell's new magazine, *Possibilities*. 'There are too many appointments, too many people to see, and with so much going on, I become too tired to paint.' [6]

Like the earlier *anciens*, too, he found his way to East Eighth Street, travelling the hundred-odd blocks downtown to Atelier 17 by elevated

148 CHAPTER 7

railway. 'Miró came every day at nine, worked until one, went to lunch for two hours and quit at five,' John Bernard Myers recalled. 'Then he would take the Third Avenue El uptown after buying a Spanish newspaper and smoking his little pipe while waiting for the train.'[7] Hayter had met Miró sharing a flat with André Masson in the rue Blomet in the late 1920s; all three men had shown in the London International Surrealist Exhibition in 1936. Miró arrived at a time when Hayter and his friend Ruthven Todd were absorbed in one of Atelier 17's most intense, eccentric periods of experiment.

———

Between October 1937 and March 1938, Miró had painted the three-times-life-sized *Self-Portrait I*, now in the collection of the Museum of Modern Art (FIG. 39).[8] Made in pencil, crayon and oil on canvas, it is a highly experimental work. In his studio notes to it, Miró wrote, 'Think of William Blake when doing the self-portrait.'[9] In 1947, in New York, he would speak of Blake as a source of inspiration, 'a pure poet...who wrote without premeditation'.[10] *Self-Portrait I* is suffused with something of the English master's febrile vision, as also his freedom of line.

Miró was by no means alone among Parisian artists in finding himself drawn to Blake. The surrealists viewed madness as a channel to the unconscious: Blake's fabled oddity put him in a league with Friedrich Hölderlin and Poor Tom in *King Lear* as objects of interest. Masson had been introduced to Blake's verse in the early 1920s by the poet Louis Aragon. In 1938, the year of Miró's Blakean self-portrait, he made a number of images of the English mystic, followed by a series of portraits apparently based on Blake's fabled *Visionary Heads* of about 1820.[11] The previous year, a joint show of Blake and Turner's works on paper at the Bibliothèque Nationale in Paris had had the surrealists agog.[12]

For printmakers, Blake held another fascination. The poet had printed his own verses, using a self-invented method of relief etching to combine word and image on a single plate. In normal etching, the image is eaten into the plate using acid; in relief etching, by contrast, it is the plate that is eaten away, leaving the image or text – or both at once, in the case of Blake – standing proud of the eroded surface. Discovering precisely how the poet-printer had managed this feat had long been an

BLAKE, BOURGEOIS, MIRÓ

obsession with printmakers, a Holy Grail of intaglio. Now, in the summer of 1947, Hayter and his colleagues set out to find the answer.

In this they were aided by Lessing Rosenwald, heir to the Sears, Roebuck department store fortune. Rosenwald, a noted aesthete, had made himself America's premier print collector, buying not just prodigiously but with taste. His collection included everything from old master engravings to experimental contemporary work: he had, Hayter wrote to Curt Valentin, 'bought a bunch of plasters, plates and prints' from the Studio 17 show at MoMA.[13] Now, in 1947, Hayter set off to see Rosenwald at his house, Alverthorpe Manor in Jenkintown, Pennsylvania, to beg a favour.

The collector owned a fragment of one of the copper plates to Blake's *America: A Prophecy*, an object whose diminutive size – 82 × 58 mm, the rough dimensions of a credit card – belied its importance (**FIG. 40**).[14] Although the plate from which the fragment comes was eventually rejected by Blake, and the whole broken up and recycled, it was, and remains, the only surviving example of a work relief-etched by the poet's own hand.[15] In a moment of extraordinary generosity, Rosenwald agreed to lend this to Hayter, to take back to Atelier 17 for research into Blake's lost printing method.

Whether, as Hayter and his colleagues at the studio maintained, they were successful in their attempts to recreate this technique is beyond the remit, or interest, of this book. Todd described the process: 'My words, however crudely, once safely upon the copper plate, Miró then made his designs around them with a brush, using [an] acid-resistant varnish. The plate was then given a backing of a different protective varnish and lowered into a bath of dilute nitric acid. There it was left until the unprotected parts were bitten away to a depth of about two millimetres.'[16] There is much more in this vein. How accurate a reconstruction of Blake's method all this was is still debated, with much feeling, in the pages of specialist journals.[17] What is beyond doubt is that the research into Blake's relief etching undertaken at Atelier 17 in the summer of 1947 sparked a wave of experiment in the artists who took part in it, among them Alexander Calder, Max Ernst, Yves Tanguy and Joan Miró.

Work on the Blake method plates at Atelier 17 photographed by Martin Harris, c. 1947. From left to right: Karl Schrag, Alfred Russell, Jacques Lipchitz, Stanley William Hayter, Ruthven Todd and Hope Manchester.

The most obvious evidence of their excitement is the work commonly known as the Ruthven Todd Portfolio and more properly as *Fifteen Poems, a Collaboration using the Printing Methods of William Blake*. The poems in question had been specially written for the project by Todd, for embellishment by the artists to whom they were addressed. The poet, newly arrived in New York, was a longtime surrealist fellow-traveller: it was he who had rescued a suffocating Salvador Dalí from his diving helmet at the 1936 London exhibition.[18] Todd's intention had been to publish the finished portfolio as an illustrated book, although this was never to happen.

The portfolio contains eighteen etchings from a planned thirty, seven of them surface (which is to say, Blakean relief) prints, including one each

BLAKE, BOURGEOIS, MIRÓ

by Calder, Hayter, Tanguy and Ernst and three – the largest number in the portfolio – by Miró, who additionally contributed two etchings made by more traditional means.[19] If 1947 marked a high point of interest in Blake at Atelier 17, Anaïs Nin's mention of the revealed method in the foreword to *Under a Glass Bell* shows that that interest was not new.[20] Hayter himself viewed the simultaneous colour process he had used in making *Cinq personnages* as a by-product of his earlier Blake researches.[21] All eighteen of the Todd portfolio plates were etched and printed at the New York atelier, in a run of no more than ten each.

It was the arrival of Rosenwald's Blake fragment that had lent new energy to the project. Far from treating the small piece of copper with awestruck reverence, the group subjected it to whatever rough indignity took their fancy. Fred Becker recalled them printing from it 'in the most lurid colours' they could find.[22] When he and the others had finished with the fragment, it was posted back to Rosenwald in the US Mail.[23]

Miró in particular seems to have enjoyed playing with the object, and to have found its seditious treatment liberating to his own work (FIG. 41). Like Blake's, his plates in turn became part of a communal game, in the manner of Exquisite Corpses. Becker recalled how he, Todd and Hayter had spent the summer 'playing with Miró's plates, printing them in every possible combination'.[24] Todd agreed. '[Miró] loved playing around,' he said, twenty years later. 'There are eight Miró plates which have no centre. The centre is an irregularly shaped separate plate....No two impressions are the same.'[25]

As with Ernst's orange fumes at the Parisian atelier, disaster could be turned to triumph. Old blankets were used at Eighth Street as beds for prints in the press. Becker remembered Miró accidentally printing directly onto one of these, then showing the result to Hayter. 'It's beautiful, isn't it?' sighed the Spaniard, gesturing at the printed blanket. Hayter's response – 'It will come out with some benzene' – was untypically cloth-eyed. 'Imagine destroying it!' Becker marvelled. 'It would be worth thousands today.'[26]

Something of the atmosphere of that summer was captured by the filmmaker Thomas Bouchard, who shot a short documentary at Atelier 17 called *Joan Miró Makes a Color Print*.[27] Its commentary was written by Todd and Hayter and voiced by both. '[Here is Miró] with a copper plate,'

A still from Thomas Bouchard's film *Joan Miró Makes a Color Print*, 1948.

the soundtrack says, in the hyaline tones of the then BBC. 'He takes up a jar of black pitch and pours it on the plate, forming archipelagos of shining islands. This pitch will withstand the strongest forces of the acids used in etching....Fingers make shapes. Miró is intent like a child playing with its first pot of finger paint. But the play with which he is occupied is controlled by the intense feeling of a lifetime's experience of the image. There is no preliminary drawing upon the plate, which has a surface like a richly glowing volcanic pool.'

On film, Hayter moves from press to ink vat to acid bath with the tautness and speed of a dancer; Miró, a middle-aged cherub, wears a striped tie under his printer's apron. The commentary goes on: 'The images that grow now upon the plate emerge like crystals thrown up by the sudden bubbling of a lake of lava. But these are not haphazard shapes....Miró traces with an expert brush the peninsulas, the promontories and the desert island lagoons with the black pitch which once formed only one long island with its reefs upon the inviting ocean of the

empty plate. This is the work of a new Mercator, planning the projection of a novel universe.'[28]

———

Ruthven Todd also joined in the printerly anarchy at Atelier 17 that summer, helping Miró with his etching *Fillette, sautant à la corde, femmes, oiseaux* by attacking it with a horseshoe nail and shooting cold water onto its hot plate from a tap.[29] As Pollock's were to be in the 1960s, the resultant print was spoiled by later improvement. Only the so-called *épreuves d'essai* (trial proofs) were pulled at Atelier 17. For its editioning, the plate to *Fillette, sautant à la corde* was re-faced with steel or chromium. In Todd's words, 'the inept technicians involved in performing this process somehow managed to coarsen all the delicacies of the plate'. All was not lost, however. 'Miró had insisted that, in view of my contributions, physical as in the horseshoe nail and speculative in the splashing of water, I should be given first choice [of the original proofs],' Todd went on. 'I congratulate myself that I have the pick of that half dozen.'[30]

Fillette, sautant à la corde had been made not for Todd's portfolio but another called the *Brunidor*.[31] Underwritten by Robert Altmann, a cultured Jewish banker and collector who had fled Paris for Havana in 1941, the first *Brunidor Portfolio* – there would be six more over the next twenty-five years – also appeared in the summer of 1947. This consisted of lithographs and etchings by seven artists of a surrealist bent including Hayter, Tanguy, Max Ernst and Miró, each chosen by the critic Nicolas Calas.

As so often at Atelier 17, the project flopped. 'I had difficulties selling the portfolios when they were ready,' a rueful John Bernard Myers would admit. 'Prints were not popular at the time in America, even though, like drawings, they were inexpensive. The bookseller Weyhe on Lexington Avenue was quite alone in carrying a regular stock of [them]....The curator of prints at the Museum of Modern Art, William Lieberman, was loyal – but it cannot be said that Brunidor portfolios [*sic*] was a success.'[32]

Nor was *Laurels*, the small, boxed portfolio of six prints, priced at a modest 25 cents, that appeared in May 1947 and of which two, Miró's *Femme et oiseau devant la lune* (FIG. 42) and Hayter's *Night Moth*, had

154 CHAPTER 7

been made at Atelier 17 that same summer. Published by the Laurel Gallery in East 57th Street in a run of 300, this had been meant as the first of a quarterly offering, bringing together 'the best graphic artists of America and Europe', the size of both portfolio and print run to increase in line with demand. In the end, just four *Laurels* were produced, the last in May 1948. The gallery that had published them closed not long after.

For all that, Miró's time at Atelier 17 was marked by an unusual fecundity. Yves Tanguy recalled bumping into his fellow Paris *ancien* at the studio that July, 'working on some thirty etchings at Hayter's place'.[33] Given that Miró was also trying to finish his Cincinnati mural commission at the time and that his stay in New York extended to just over six months, the figure Tanguy mentions seems extraordinary.

More, a new imagery appeared in Miró's work at Atelier 17, typified by the print called *Composition* now in the Tate collection.[34] If the etching's central moon-and-woman figure had been a familiar part of Miró's iconography for a decade, the amoebal shapes that now surround it are entirely new. One thinks of Hayter's description of the Spaniard in Bouchard's film, conjuring up a new Creation from a primordial Blakean slime. These Eighth Street biomorphs would remain part of the signature of Miró's later style. Asked, in an interview, whether he felt that his stay in America would have a lasting influence on his work, Miró had replied, 'Yes, very much so. Especially as force and vitality. To me the real skyscrapers express force as do the pyramids in Egypt.'[35] Of the dingy brownstone in Greenwich Village, there was no mention.

As for Todd's *Fifteen Poems*, they did at least catch the attention of a new and briefly influential avant-garde magazine. As well they might: called *Tiger's Eye*, this had been named for Blake's well-known poem 'The Tyger'. The magazine's founder, Ruth Stephan, set it the task of 'selecti[ng] material [that] will be based on these questions: Is it alive? Is it valid as art? How brave is its originality? How does it enter the imagination?' More prosaically, *Tiger's Eye* was to be 'the counterpart of the English pub without the ale, and of the Parisian café, without the chairs and coffee'.[36] It was the Jumble Shop in printed form.

The first issue of *Tiger's Eye* included a four-page spread of the prints from Todd's portfolio. It was to be their first and, for many years, their last public outing. The poem Todd had composed to accompany

Hayter's Blake etching, 'Personnage virtuelle', portrayed its maker as an alchemist:

> From dull matter suddenly to create/Something which had not been before; the skill/Of hand moves in expanses where mind/Eye, imagination – call it what you will –/Seek out the riches it will never find:/Always there is tomorrow and the copper waiting,/Extending its invitation like a gilt-edged card…

Among those impressed by Miró's Stakhanovite workload at Atelier 17 was another Parisian arrival called Louise Goldwater, now better known by her maiden surname of Bourgeois. Miró's production 'was enormous

Louise Bourgeois and Joan Miró parodying Jean-Auguste Ingres' *Jupiter and Thetis*, 1947.

compared to mine', Louise Bourgeois would admiringly recall. 'He had great powers of concentration – he was a hard worker, working long hours.'[37]

Occasionally, she would be allowed to help him. She confided these breathless moments to her daybook:

> Miró: technique completely free all the plates are done in a few minutes....some elements *are thrown on the surface, several* are enclosed in a shape such as this [sketch] the sight of an empty beautiful clean plate excites him – he throws something on it instinctively he gets 10 or 12 plates. he has a passion for <u>color</u> any thing is seen in terms of colors
>
> very bright ones
>
> he is daring
>
> 1. enormous $10 plate with *soft ground* he sticks his hand right on it. 3 fingers and a round rubbing...
>
> 3. the same plate is taken inked in black with fingers put bright colors on the plate, then printed monoprints –
>
> *the trial proof is printed by me myself.*[38]

The proof Bourgeois had so proudly pulled from its enormous plate was clearly not one of Miró's small Blake reliefs. Even so, she can hardly have been unaware of the Blake project, or – given her worship of the Spanish master – untouched by it.

She had come to the studio a few months before Miró, and was to work there intensively for a year. She would continue to visit Atelier 17 off and on until late 1949. In 1947, the time she had free to devote to her art was defined by the teaching hours of her husband, the art historian Robert Goldwater, and the school timetable of her three young sons. Like her Spanish hero, Bourgeois will have been a nine-to-five printmaker, walking cross-town to the studio from the flat she

and Goldwater lived in at 142 East 18th Street, in the once fashionable but now fading block known as Stuyvesant's Folly. It was in 1947, while Miró was at Atelier 17, that she would have her own transitional moment, in the form of the suite of nine parables with matched engravings to which she gave the title *He Disappeared into Complete Silence* (FIGS 43,44,45 & 46).

———

Bourgeois had arrived in New York from Paris with Goldwater in October 1938, when she was twenty-six. After taking a mathematics degree at the Sorbonne, she had studied at a number of Paris art schools and ateliers before opening a print shop next to her father's tapestry gallery. Despite dealing in prints, there is no evidence of her having worked at the Parisian Atelier 17, and, given her youth and inexperience, it is unlikely that she would have done. It was only in New York, studying at the Art Students League with Will Barnet, that she developed a serious interest in printmaking as a medium for her own work. One of her earliest prints, *Escalier de 63*, was made in 1939 under Barnet's tutelage.[39] Bourgeois' principal focus at the time, though, remained on the paintings she was making for a show at the new Norlyst Gallery.[40]

Her position as an émigré was different from that of the *anciens*. Masson and Breton had come to New York intending to return to Paris the moment they safely could, and did. Yves Tanguy, married, like Bourgeois, to an American, had stayed on, but in a France-away-from-France he had created for himself in rural Connecticut, a world whose exchanges were conducted largely in French. Miró was a visitor, a bird of passage. Bourgeois, with an American husband and three American sons, was there to stay. Hers was not the sharp loss of a Breton suddenly bereft of the Café de Flore, or of a newly arrived Tanguy pining for pastis. It was of a longer, duller kind that merged with an old sense of psychic pain which Bourgeois was even then beginning to weave into her own mythology.

If her attending the Paris atelier seems doubtful, and there is no mention of her at the New York one before 1946, Bourgeois had certainly met Hayter in 1944. That summer, both he and Robert Goldwater had taken part in the third Pontigny-en-Amérique conference at Mount

158 CHAPTER 7

Holyoke College in South Hadley, Massachusetts, the recreation of an
annual gathering of European intellectuals held, before the war, at the
French abbey of the same name.[41] The theme of the 1944 conference
was 'L'idée de crise et notre crise'. Its plastic arts section was headed
by André Masson, with discussions led by Hayter. Bourgeois is on the
guest list as accompanying her husband.

On 7 August, Goldwater gave a paper called 'Individualism and the
Present Crisis'. The title of Hayter's, given the next day, was 'Crise de
l'art et crise de confiance': its text, if ever transcribed, is lost. 'A new
and gratifying factor in this year's Pontigny', reported Mount Holyoke's
yearbook, 'was the great degree of American participation requested
by the émigrés and generously given by American scholars, many of
them from our own faculty.'[42] One of the non-faculty scholars had been
Robert Motherwell, whose paper was called 'The Place of the Spiritual
in a World of Property'.

Running through the lectures by these new American partici-
pants was the covert (and sometimes not so covert) denunciation of
an assumed European precedence. Motherwell's was no exception.
Described in a college press release as 'amount[ing] to a manifesto
of the younger group of American artists', 'The Place of the Spiritual'
called for an overthrow of Breton's growingly corporatist surrealism
in favour of a vaguely numinous individualism. The unconscious, now,
was to be accessed not through trances or party games but through
an artist's materials. Automatism qua automatism was dead. Turning
the transatlantic tables, Motherwell now claimed Masson and Miró
as plastic, rather than psychic, automatists *avant la lettre*, their work
having always been 'actually very little a question of the unconscious'.
The tenor of his speech was strongly Greenbergian.[43]

It was the most coherent sign yet of the beginnings of a shift in trans-
atlantic self-confidence. In 1960, Bourgeois' husband was to recall the
impact the French had had on the New York of 1940. 'The predominantly
Surrealist group that had arrived,' Goldwater wrote, 'international in
character, bohemian in a self-confident fashion possible (after so many
Depression years) to none of the New York artists...had this in common
with the artist who had experienced the WPA: they too existed on the
margins of society, though it was perhaps a brighter margin.'[44] He went

on: 'To see, occasionally to talk with, Mondrian, Masson, Ernst, Tanguy, Léger, Lipchitz, Duchamp, among others, was, so to speak, to join the School of Paris, to join that is, on to the central creative tradition of twentieth century art, and through it to become part of the series of artistic revolutions that went back to Cézanne and Monet.'[45] By the time his wife was working at Atelier 17 in 1947, Monet and Cézanne had been largely supplanted in the American pantheon by masters from nearer home.

———

For Louise Bourgeois, all this was complicated by her position as a newly minted Franco-American. Certainly, it is hard to imagine her extending the worship she lavished on Miró in 1947 to his local equivalent, had such a thing yet existed. A photograph of the time, presumably staged by Bourgeois, shows her kneeling at Miró's feet in mock obeisance, beaming broadly while the Spaniard looks at her with evident embarrassment.

'I first encountered Joan Miró in Paris in the early '30s,' Bourgeois said. 'He did not know me, as I was only a student at the Ecole des Beaux Arts and he was already famous.' Later, and typically, she rewrote this history, turning Miró into the supplicant and herself his superior. 'At the dinners of Pierre Matisse on East 96th Street, Miró would hardly say a word,' Bourgeois remembered, adding, with a sniff, 'He spoke broken French....Everyone was courting Miró, who looked a little mousey.' By way of *coup de grâce*, she ended, 'He was surrounded by people who praised him, and he liked that. When they told him what he was doing was marvellous, he went on doing it....Miró was too successful for his own good. In making sculpture he went out of his league.'[46]

This transition from two dimensions to three was one Bourgeois herself was making in 1947, and at Atelier 17. In October she would show her now celebrated suite of paintings, *Femme Maison*, at the Norlyst Gallery on West 56th Street.[47] As often in her work, the central conceit of these rested on the impossibility of rendering French into English: *femme-maison* – 'housewife' – translates literally as 'woman-house'. In the seventeen paintings in the show, Bourgeois' woman becomes a house and vice versa, an architecture of entrapment. As was her way, she would revisit this idea a dozen times before 2001, latterly as sculpture in fabric, steel or marble. The process, though, had begun in copper.

160 CHAPTER 7

It seems unlikely that she had come to Atelier 17 with this translation in mind. Nor – Masson and Breton having left for France, and Matta and others variously moved on – can she have been hoping to recapture the familiarity of a Paris studio. Miró's descent on East Eighth Street was yet to be announced. In the autumn of 1946, Atelier 17 was going through the same process of de-Europeanization as was American art, and Bourgeois herself. Bound up with all this was the death of surrealism first announced by Wolfgang Paalen in 1942 and lately confirmed by Barnett Newman.[48] This had made the *anciens* seem suddenly like yesterday's men. Probably, like Motherwell and the rest, Bourgeois was simply intrigued by reports of experiment at the atelier, perhaps passed on to her directly by Hayter at Mount Holyoke.

The prints she made in her early months at Atelier 17 relate to her paintings of the time. Like these, the first intaglio works look for a way forward. Spurred by the sudden animus against surrealism, they try to take its one-time stylistic certainties in a new direction. These split along typical lines: *Sacs ouvert* (1946) veers towards a sexually suggestive abstraction, *Vase of Tears* (c. 1946) a simplified figuration.[49] Like the untranslatable *femme-maison*, Bourgeois' future work was to be an elision of both of these things. *He Disappeared into Complete Silence* was a first step towards this new idiom.

———

The nine texts in Bourgeois' book are moral fables of a peculiarly French kind. In one, number five, a man leans out of an ascending lift to wave at a friend and has his head cut off by the approaching floor. The accompanying illustration looks like the gantry of a guillotine, complete with trailing rope. Number eight sees a man deafened by surgery, number three, another whose excellent stories are rendered unintelligible by the speed of his speech. Several involve food. Number seven tells of a husband who kills his wife and serves her up to friends as stew, number four of a greedy French girl – apparently Bourgeois' mother – who buries sugar in the ground without stopping to think that it will dissolve. They are stories not so much of crime and punishment as of loneliness; of a world rendered cruel by misapprehension.

BLAKE, BOURGEOIS, MIRÓ

The nine accompanying engravings are not illustrative of the fables, other than being studies in a comparable isolation. If the figures in the *Femme Maison* paintings conjured up the stultifying life of a woman trapped in domestic routine, the prints of *He Disappeared into Complete Silence* take loneliness to a new architectural level. The decapitated man of story five is killed by height; the need for his building to have a lift. He dies of living in Manhattan. Bourgeois was quite open that the book was autobiographical. Of the plate called *Famille*, she said that it showed her crossing Eighth Avenue, an odyssey for which she 'always asked someone for help'.[50] All of the figures in the *Complete Silence* engravings – the guillotine, the oven in which the murderous husband stews his wife – are vertical, tall and free-standing. Collectively, they form a cityscape of New York as seen by a woman raised in Paris.

They are also sculptural. The figures in the *Femme Maison* paintings were integrated into their surroundings. The ones in the new prints are solids defined by voids. Like good modernist sculptures they are plinthless, sitting on an implied floor. In their solidity, the figures in the *Complete Silence* series might be maquettes for actual sculptures. In broad terms, they were.

———

In the following year, in *Tiger's Eye*, Alexander Calder, one of fourteen American sculptors asked to discuss their work, wrote not about mobiles or stabiles but about printmaking.[51] This was not as perverse as it might have seemed: the process he described was sculptural. Calder's description was of etching with acid. Bourgeois had made the *Complete Silence* images using a burin, a glyptic process of creation by subtraction not a million miles removed from the marble carving of Michelangelo, or of Barbara Hepworth.

Why Bourgeois had chosen to work in this way is a mystery. Her memories of the burin were, possibly genuinely, tinged with horror. Among the milder of them was of the physical hardships involved. 'If you use a burin...you need a lot of strength,' she was to say. 'It's very difficult – not woman's work. You have to be really strong.'[52] Possibly, she chose the instrument to flatter Hayter; as with Miró, Bourgeois was prone to please

162 CHAPTER 7

her male teachers, only later to dismiss them. Certainly, her memories of Hayter were not happy ones.

When lifting a curl of metal from a plate with a burin, a burr, or raised edge, is left where the curl breaks. These are generally held as undesirable: unbroken curls are thus a measure of proficiency among burin users. Hayter, in Bourgeois' memory, fetishized this. 'You were worth the length of that copper hair,' she recalled, 'and Hayter could get an enormously long strip.' She went on, 'I exasperated Hayter. He was a printer-perfectionist. His impatience came because very few people had control of the hand. He wasn't interested in beginners. He would shout. He would throw things.'[53] The only reason he tolerated her, she said, was for the usefulness of her speaking French.

Extrapolating from the personal to the general, Bourgeois went further. Hayter, she said, not only disliked her, but 'hated women'.[54] This is a surprising assertion, given the gender balance at Atelier 17 during the immediate postwar years – a time, in America as in Britain, when women were pressured to give up their jobs and return to a prewar model of keeping house and raising children. It would take a full twenty years for this attitude to change comprehensively; Yale College, its art school included, only went coeducational in 1969. Yet half the students at the New York Atelier 17 during the decade that Hayter ran it were women – an extraordinary figure.

Despite her fear of him, Bourgeois was furious at not being included in Hayter's 1949 book *New Ways of Gravure*.[55] In her diary, she wrote: 'fulmination + *angoisse* over Hayter's book how should I object – scene scandal (picketing) argument?? sly remarks.'[56] She was likewise enraged, in the same year, to find that her work had not been hung in a group show of recent prints from Atelier 17. Visiting it before the opening, Bourgeois had remedied this by hanging two of her works herself; when Hayter arrived later the same day, he took them down again and hid them.[57] In spite of these battles of will, Bourgeois' diaries show that she remained a regular visitor to Atelier 17 until 1950, the year that Hayter returned, finally, to Paris. After that, she said, she no longer took the workshop seriously.[58] She would make no more prints until the mid-1970s.

Another oddity in Bourgeois' memory of the studio is the premium she claimed to have been placed there on the making with a burin of

BLAKE, BOURGEOIS, MIRÓ

163

parallel lines – 'a test of greatness!' as she put it, her voice laced with sarcasm.[59] It is possible that some instructors stressed the importance of this, but it seems unlikely that Hayter – a man whose name was synonymous with loops and whorls – should have been one. On the rare occasions where parallel lines do occur in his work of the time – in *Death by Water* (1948), say – their role is as a counterpoint to his more typically freewheeling style, like the strung wires in a Gabo sculpture. This is true of most prints made at East Eighth Street from 1945 to 1949. One searches in vain for parallel lines in the work of Abraham Rattner, Louise Nevelson, Helen Phillips et al. (never mind Joan Miró). The one place where they do regularly occur is in the engravings of Louise Bourgeois and, more particularly, in the nine plates she made for *He Disappeared into Complete Silence*.

———

Like so many Atelier 17 projects, the book was a failure. Bourgeois had aimed for a modest enough run of forty-four copies, to be sold at $20 apiece. In the event, around half that number were made and only a handful sold. This was not for want of trying. An able self-publicist, Bourgeois sent review copies to, among others, Clement Greenberg, and to Alfred Barr at the Museum of Modern Art. She also took out advertisements in *Partisan Review*, pointing out that the book was available for purchase from the Betty Parsons Gallery, 15 East 57th St, NYC.[60]

Copies were printed, apparently at Hayter's suggestion, by Anaïs Nin at the Gemor Press – an intervention that Bourgeois fails to mention in her recollections of him.[61] (Presumably he had refused to turn Atelier 17's solitary press over to the project. 'Hayter was such a sadist by frustrating people with his "We will do it tomorrow,"' was Bourgeois' only comment).[62] In 1946, Nin, who had finally persuaded a mainstream publisher, E.P. Dutton, to take on her novel *Ladders to Fire*, was preparing to shut the Gemor. Hayter persuaded her to print Bourgeois' book by way of a swan song. Disappointingly, neither woman appears in the other's diaries; they may never have met. Also typically of Atelier 17, the original plates for *He Disappeared into Complete Silence* were later lost.

164 CHAPTER 7

In his introduction to *He Disappeared into Complete Silence*, Peggy Guggenheim's assistant and future Rutgers professor Marius Bewley wrote of the prints and accompanying parables as 'tiny tragedies of human frustration'. Doubtless with their author in mind, he went on, 'The protagonists are miserable because they can neither escape the isolation which has become a condition of their own identities, nor yet accept it as wholly natural.'[63] Bourgeois, for her part, saw the book as 'a drama of the self'. In a moment of frank self-appraisal, she explained, 'It is about the fear of going overboard and hurting others. Controlling oneself is always the goal...so one will not project one's own violence on others.'[64]

———

Is *He Disappeared into Complete Silence* Blakean? In any concrete sense, of course not. The images are traditional intaglio, not relief prints; the texts were printed separately from them, on a letterpress. In discussing the relationship between parables and plates, Bourgeois had, she said, had no real interest in matching images and texts. In her anxious rearrangings of the book in 1947, she may have paired them differently at different times.[65] If the work is in any sense prophetic, it is a less hopeful anticipation of America than Blake's of a century and a half earlier.

And yet, for all that, it is a vision of America, a place of which Bourgeois was, willy-nilly, becoming part, and where she would spend the last seven decades of her long life. Like Rosenwald's fragmentary plate to *America: A Prophecy*, *He Disappeared into Complete Silence* is almost perversely sculptural. The considerable effort of making relief plates must have been all about Bourgeois at Atelier 17, as she herself was trying to master the burin; a tool she found difficult, beyond her strength.

It was also a tool whose use and line hovered between the graphic and the sculptural, two dimensions and three. One notable feature of the flat images in Bourgeois' book is their preoccupation with the way they occupy space, as though the glyptic force called for by a burin has forced their maker to think sculpturally. Soon, those images would rise like Lazarus from the plate and come to plastic life. In October 1949, a show called 'Louise Bourgeois, Recent Work 1947–1949: Seventeen Standing Figures in Wood' opened at the Peridot Gallery on Madison

BLAKE, BOURGEOIS, MIRÓ

Avenue.[66] To the plinthless sculptures of the show's title, Bourgeois gave the collective (and Hayterish) name *Personages*. They included *Portrait of C.Y.*, *Woman in the Shape of a Shuttle*, *Dagger Child* and the Tate's *Knife Couple*. All bore a strong resemblance to the plates from *He Disappeared into Complete Silence*. They announced Bourgeois' debut as a sculptor, and the end of her life as a painter. They also marked their maker's transition from France to America, and from second-generation surrealism to whatever lay beyond it.

During this time, Jackson Pollock was making the first of those canvases – *Eyes in the Heat* (late 1946), *Full Fathom Five* (1947) – that would come to be known, for good or ill, as drip paintings. Like Bourgeois' sculptures, these would be marked by the time their maker had spent at Atelier 17, and by the demands and freedoms of the burin. Pollock had left for Long Island the year before Bourgeois arrived at the studio, moving from his flat across the street to the farm in Springs, New York. There, in the barn, he set to working in the way that Hans Namuth would immortalize on film in 1950.

He had not entirely abandoned Hayter's studio, even so. According to Joan Miró, Pollock and he had met there in the first half of 1947, while Bourgeois was also working at 41 East Eighth Street. 'Pollock and I would greet each other, but we could not have a conversation because he only spoke English and my English is very poor,' Miró recalled. 'I did not really know his work until I saw the black and white show at Facchetti in Paris in 1951. It was stunning – really bold and impressive.'[67]

It was not quite four years since Clement Greenberg, reviewing Pollock's first one-man show at Peggy Guggenheim's gallery, had anointed the painter the crown prince of a new New York art. 'The strongest abstract paintings I have yet seen by an American,' the critic had enthused. 'Pollock has gone through the influences of Miró, Picasso...and what not, and has come out on the other side...[H]e is liable to relapse into influence, but if the times are propitious, it won't be for long.'[68]

The influence of Europe wasn't the only danger to this protean young American. There was also the problem of decoration, an ever-present

166 CHAPTER 7

threat in abstract painting. The two, in Greenberg's view, often went together. He allowed that Matisse and Klee, albeit European, had sidestepped the perils of decoration by 'consciously and deliberately [courting its] dangers'; but this was an aberration, a one-off. Much more typical was Georgia O'Keeffe, whose work, despite being American, Greenberg dismissed as 'precise', 'neat' and 'lapidarian', which is to say, feminine.

On the Greenbergian scale, femininity trumped even Europeanness as an undesirable. It was certainly not part of his imagining of Jackson Pollock. Decoration was allied to craft, which was allied to femininity. His Pollock would be masculine, undecorative and thus, of necessity, unskilled. Pollock's paintings, Greenberg said, 'eliminated the factor of manual skill and seemed to eliminate the factor of control along with it... excluding anything that resembles control and order, not to mention skill'.[69] If this misreading was that of what Greenberg called 'the uninitiated eye', it would nonetheless become the standard line on Pollock. In defending his hero's rejection of skill, Greenberg turned him into raw instinct. He also erased the man who had taught Pollock how to order that instinct. As so often, Hayter was wiped from the history of American painting.

For him, as for Bourgeois, there was a further problem. Along with decoration, Greenberg raged against art that he saw as commercial. Printmaking, which could take in anything from Dürer to flyers for a baseball game, was inherently suspect. So, too, any whiff of surrealism.

Just as Pollock was starting at Atelier 17, Greenberg had published an attack on the movement as a 'vulgarization of modern art'. 'The Surrealist image provides painting with new anecdotes to illustrate, just as current events supply new topics to the political cartoonist,' he sniffed. 'But of itself [it] does not charge painting with a new subject matter. On the contrary, it has promoted the rehabilitation of academic art under a new literary disguise.'[70] Surrealism, Greenberg added, had 'proved a blessing to the restless rich, the expatriates, the aesthete-flaneurs in general who were repelled by the asceticisms of modern life'.[71] Hayter at least had gender on his side. Bourgeois, as an expatriate woman making sort-of-surrealist prints, was never going to enter the Greenbergian pantheon. She had sent the critic a copy of

He Disappeared into Complete Silence. She might have saved herself the stamp.

And yet, despite Greenberg's polarizing of the kinds of art made by Pollock and Bourgeois as irredeemably unalike, they share a genetic likeness. Pollock, too, will have seen the copper hair curl from the plate, a solid born of a void. His paintings reverse this process. If they elide figure and ground, they also create a depth of their own, a web of palimpsest. In their layering of paint, they seem to exist in relief, the opposite of a plate gouged with a burin. It is easy enough to imagine *Full Fathom Five*'s inverse, a surface from which lines have been excised rather than one onto which they have been poured. Bourgeois' lines imagine depth in a very different way, and yet they, too, see themselves as plastic, a form of sculpture.

After

CHAPTER 8

Many of us – though all of us are abstract artists – were in contact with the Parisian surrealists, many of whom were in New York during the late World War. I mean only to remind you that modern art (of which the School of New York is possibly a part) has a history.
Robert Motherwell[1]

Actually some of those who should be very grateful to him are not grateful to him. Like it often is also how you feel toward your father or something like that. But frankly the truth really is that I do believe that Hayter really esteemed an artist for being himself.
Karl Schrag[2]

Venice, early summer 1948. For the first time in a decade, the gravel paths of the city's Giardini ring with French and English voices, the accents of Paris and New York. It is the 24th Venice Biennale. The 22nd had been held in 1940, just after the fall of France; the 23rd in 1942. The works in both were from Axis-aligned or neutral countries; the exhibitions of 1944 and 1946 were cancelled. This, the first postwar Biennale, is a chance for participating nations to set out their cultural stalls; to announce their hopes for the sunlit uplands of peace.

It is, by and large, an unimpressive display. The British show Henry Moore, the French, Chagall and Braque. Moore, by some way the youngest of the trio, has just turned fifty. All three men have had established careers since before the war. After six years of chaos, the message seems to be 'business as usual'.

The American Pavilion goes for gigantism. It shows seventy-nine artists – George Bellows, Edward Hopper, Grant Wood, Thomas Hart Benton – united only in being American and having worked at some date in the 20th century. At the chronological tail end of these are new names and young men: William Baziotes, Mark Rothko, Arshile Gorky. In 1946, the foreign antecedents of these militated against their being chosen for inclusion in 'Advancing American Art'. The passing of the

170 CHAPTER 8

Truman Doctrine in 1947 has changed this: now, justification is by pass-port alone.[3]

If Italian critics notice these young artists – or, indeed, the American Pavilion at all – they keep it to themselves. Neither *Ulisse* nor *Rinascita*, both powerful voices, so much as mentions them.[4] Their reviews focus, as they had before the war, on the art of Paris. Only one major periodi-cal remarks on the young Americans, and then as lacking metaphysical depth, in being a trifle Technicolor.[5]

Among the longest queues, surprisingly, are those outside the Greek Pavilion, tucked away at the back of the Giardini. The explanation for this is that Greece, in the grip of civil war, has pulled out of the Biennale. Instead, it has turned over its space to Peggy Guggenheim, who has used it to display her collection. She, too, has gone for size, exhibiting 136 works by 73 artists in a show curated by the Italian art historian Giulio Carlo Argan. 'What I enjoyed most was seeing the name of Guggenheim appearing on the maps in the public gardens next to the names of Great Britain, France, Holland,' a cheery Guggenheim would recall. 'I felt as though I were a new European country.'[6]

While the hang in the US pavilion seeks to suggest an art history that is hermetically American, Guggenheim's appends American mod-ernism to its European parent. Rothko and Gorky are also in her show, as are Pollock, Baziotes, Motherwell and Stanley William Hayter, who shows three engravings, only one of them made in New York.[7] If the intention is to present these artists as the natural heirs to a French tradition, though, then it backfires. Hung chronologically at the end of a show that opens with the likes of Kandinsky and Picasso, Rothko and the rest seem less like the latest thing and more like an afterthought; a cadet branch. Neither Guggenheim nor Argan mentions the newcom-ers in their essays in the Biennale catalogue.[8]

They are widely ignored by critics, too, although not by the vener-able art historian Bernard Berenson. Guggenheim, with sweet candour, was to recall her excitement at the visit to her pavilion of the man whose writings on the Renaissance had been her first guide to the art of Europe as a girl. 'I greeted him as he came up my steps and told him how much I had studied his books and how much they had meant to me,' she would say in her memoir. Berenson, in front of the Rothkos and Hayters, had

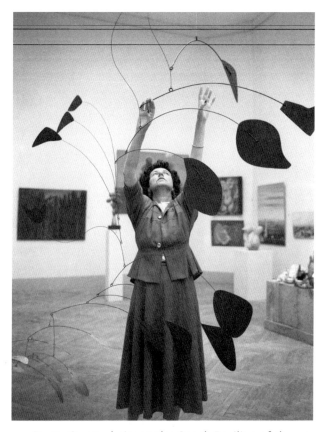

Peggy Guggenheim at the Greek Pavilion of the 24th Venice Biennale with Alexander Calder's *Arc of Petals* (1941), 1948.

turned to her puce-faced and snapped, 'Then why do you go in for *this*?'[9] It would be the 25th Biennale, in 1950, that finally propelled the abstract expressionists to the European centre stage, with Jackson Pollock, Willem de Kooning and Arshile Gorky taking over the American Pavilion.

Guggenheim's Biennale exhibition is now increasingly described as the first exposure in Europe of the abstract expressionists. This was not entirely true. Not only were several of her artists also on show at the American Pavilion, both exhibitions had been trumped by another in Paris the year before. In April 1947, 'Introduction à la peinture moderne

CHAPTER 8

américaine' had opened at the Galerie Maeght, organized by the New York dealer Samuel Kootz.[10] For all his fulminating against surrealism, Kootz was a businessman. He knew that, in 1947, Paris still had a market cachet that New York, as yet, did not. His aim, at least in part, was for the six young Americans in his show – Baziotes and Robert Motherwell among them – to return from Europe sprinkled with profitable French fairy dust.

To this end, he had co-opted Harold Rosenberg to write the introduction to the show's catalogue. Rosenberg had read his Sartre and thought he knew his French audience. 'Art for [the young Americans] is...the standpoint for a private revolt against the materialist tradition that does surround them,' he wrote. 'They are not a school, they have no common aim, not even the common tension that comes from rejecting the validity of the same art history. They have appropriated modern painting...to what is basically an individual sensual, psychic and intellectual effort to live actively in the present.'[11] While carefully avoiding the word – its coinage was, after all, French – Rosenberg recruited Baziotes, Motherwell and the rest under the lonesome flag of existentialism.[12] In this he seems to have succeeded rather too well. Local critics had wanted to see something new in Kootz's show, something *American*. What they got, in Rosenberg's telling, was recycled French. 'Those Americans...are from the School of Paris,' protested one critic. Another, puzzled, asked why 'no autonomous school [wa]s taking off in the United States?'[13]

Rosenberg was not alone in his appropriating of existentialism for America. A few months after 'Introduction à la peinture moderne américaine', his nemesis, Clement Greenberg, upped the ante. 'There is no use in deceiving ourselves with hope,' a saturnine Greenberg wrote, out-glooming Sartre. 'The American artist has to embrace and content himself, almost, with isolation, if he is to give the most of honesty, seriousness, and ambition to his work. Isolation is, so to speak, the natural condition of high art in America. Yet it is precisely our more intimate and habitual acquaintance with isolation that gives us our advantage at this moment...[when] the true reality of our age is experienced.'[14]

Just as Robert Motherwell's Pontigny-en-Amérique paper had, in 1944, retroactively enlisted Miró and Masson as Americans in being

AFTER

173

plastic rather than psychic automatists, so Greenberg saw existentialism as a naturally American rather than a French state of mind. American artists having had a head start in isolation, it was in America (rather than France) that an answer to it would be found. 'As dark as the situation still is for us,' Greenberg went on, 'American painting in its most advanced aspects – that is, American abstract painting – has in the last several years shown here and there a capacity for fresh content that does not seem to be matched either in France or Great Britain.'[15] Hope lay in a new, American sublime, the accessing of which, as often in Greenbergian aesthetics, would have to do with size. 'Abstract painting, being flat, needs a greater extension of surface,' Greenberg concluded. 'When confined within anything measuring less than two feet by two... [the work becomes] trivial.'[16]

———

While all of this was going on, a less subtle form of nationalism was abroad in New York. Where once Philip Pavia had loitered on the corner of Eighth Street and Sixth Avenue in the hope of seeing Zadkine or Lipchitz pass by, he now shunned Europeans in the self-same place. In 1950, an informal talking-shop for artists called The Club opened at 39 East Eighth Street, right next door to Atelier 17. The mood of the two spaces could scarcely have been more different. In an interview in 1965, Pavia said, 'I just want to give a brief sketch of some of the things that went on in The Club, to show how we combatted Surrealism....It was like everybody knew that the Surrealists were all-powerful and we just avoided it. It was taken for granted to avoid the Surrealists.'[17] He went on, '[Kurt] Seligmann used to come to The Club once in a great while. But I think he knew the odds were against him. Surrealists couldn't open their mouths at The Club. We wanted something contemporary. In Paris they couldn't do that, but we did it in America.'[18]

Peggy Guggenheim had been quick to note this change, and to read its runes. In May 1947, with sales dropping, she had shut Art of This Century. 'Well, they [Guggenheim and her gallery] were Surrealistic,' Pavia reasoned. 'But she closed shop in 1946 [*sic*]. See, 1946 was the big cross, the big hiatus in the whole thing. The soldiers came back in – the artists – and all this Surrealist chi-chi class went back.'[19] Now, American

artists would themselves be enlisted as soldiers in the cultural battles of the Cold War. They would be, or would be seen to be, rugged, masculine, quick with their fists. 'I wanted to be on the side of the Americans naturally,' Pavia ended. 'I do think Paris had the talent and the brains, but they didn't know how to fight the Surrealists like we did. We fought the Surrealists, got rid of them, we exiled them and we were able to clear the air for it.'[20]

It was, variously, not a good time to be Stanley William Hayter. Helen Phillips recalled the change that took place in Eighth Street after the momentous year of 1947. 'Bill associated with the Europeans,' she said. 'He would have nothing to do with [The Club]. The Club was anti, you see? It was pro-American. It was on Eighth Street. There was Atelier Dix-Sept, and there was The Club.'[21] Philip Pavia said the same.

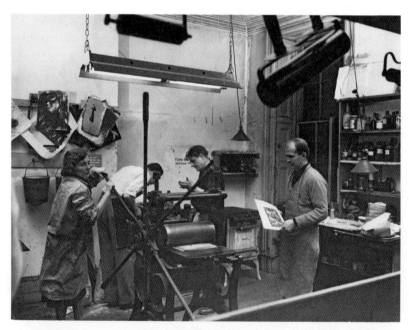

Jean Morrison (left) and Stanley William Hayter (middle) with members of Atelier 17, photographed by Martin Harris, c. 1947.

AFTER 175

'We asked Hayter to be a member of The Club after it started,' he added. 'He wrote us a letter which somebody in The Club has. He called us a bunch of homosexuals, that we wanted a social life, and that he didn't want anything to do with us....That's not true,' Pavia ended, sadly. 'We were just artists looking for company.'[22]

Given the number of Hayter's acquaintances who actually were gay – among them Isamu Noguchi, Charles Henri Ford and Robert De Niro, Sr – it seems likely that this attack was primarily an attempt to provoke. Hayter was aware of the new trend towards a 'masculinizing' of New York art, and he disapproved of it. 'Paris was feminine and seductive,' Gordon Onslow Ford had said – condemning the French, in postwar America, to a life of being not just foreign but unmanly. New York, by contrast, was supposedly 'masculine, individualistic and pragmatic'.[23] Even Atelier 17 was not immune from this kind of thinking: in the wake of Greenberg's Bauhausian dismissal of craft as feminine, men at the studio began to masculinize their work, and this shift was noted approvingly in the press. The (female) critic of *Art News* eulogized the 'masculine signature in the clean tension of [the burin's] line', praising Atelier 17 as having forged 'one of the most virile and productive directions in contemporary art'.[24] Hayter, however, was having none of it. 'The idea of being hairy-chested men and superior to women – bugger!' he would say in his eighties.[25] Cheap shot or no, calling the sexuality of his hirsute tormentors into question must have been peculiarly satisfying to him.

He had another reason for disliking the new, male dispensation. The bigging-up of work called for by Greenberg was part of the same mood, both linked to the expansionism of postwar American foreign policy. Hayter's centrifugal forms, like Masson's automatic ones, had tended to push outwards; but their power had lain in containment, in a tension between whorl and edge. Even the largest and wildest of Hayter's images had observed this; they worked in increments of control. That paradox had also informed Jackson Pollock's printmaking at Atelier 17. His engravings were less than half the size of two-feet-by-two now demanded by Greenberg; they were, by definition, trivial. So were the vast majority of etchings and engravings made at the studio, or anywhere else, come to that. Whether or not this was his intention,

176 CHAPTER 8

Greenberg's interdict placed on small work was a blow to printmaking. Hayter's ambition to make the burin a tool of modernist choice seemed suddenly dead in the water.

It may have been this that prompted a change in his painting. Helen Phillips was to recall the effect of Pollock's new poured paint works on the prints made at Atelier 17 after 1947, the sudden popularity there of deep bite engraving.[26] But an article by Ruthven Todd, written in 1950 – the year of Hans Namuth's Pollock film – suggests that Pollock's influence on Hayter may not have been confined to printmaking.

In the first of a series of articles in *Art News* following the genesis of single works by various artists, Todd described Hayter at work in his studio on the top floor of 737 Washington Street. The picture, *Marionette* (FIG. 47), begins as a pair of random drawings in felt-tip pen on paper, these being superimposed on each other and then transferred to a canvas on the floor.[27] To this, over a course of days, are added thin washes of paint, followed by an arabesque of brush marks in black Duco enamel making up a mesh or web. Among its other oddities, *Marionette*, at 100 × 73.2 cm (39⅜ × 28¹³⁄₁₆ in.), is, for the time, unusually large in Hayter's oeuvre.

———

But problems remained. When Hayter had taught at the California School of Fine Arts in the summer of 1940, the ideas he brought with him from Paris had been new and revolutionary. Now, returning to San Francisco to teach a summer school in 1948, he found himself viewed with suspicion. Students had shifted their allegiance: eight years on, they were fervent abstract expressionists.

Their thoughts on automatism were no longer shaped by Hayter or Breton or Masson, but by Rothko and Clyfford Still. As one of those students, Richard Diebenkorn, was to recall, surrealism had been 'wiped out' at the CSFA by 1948.[28] Elsewhere, it might be made the butt of jokes. Worden Day, one of Hayter's ex-students at the New York atelier, had got a job teaching at a college in Missouri. 'I had [them] invite [him] as visiting artist,' Day recalled. 'Hayter was disturbed when I and two other department members met him at the airport in a grey hearse replete with a working cocktail bar. After a couple of martinis, he

AFTER 177

seemed more at ease.' Day paused. 'I had always thought Surrealists loved death ideas.'[29]

As ever, there were also money troubles. Interviewed in the 1970s, Hayter would attack the by-then fabled Tamarind Lithography Workshop for teaching what he called 'artisanship'. 'Our view on the matter is exactly the reverse,' Hayter sniffed. 'Anything can be done and is probably worth trying. That it should be profitable, that it should pay anybody for anything is the last thing that we worry about. The workshop itself is not going to make money. [Nor is] the production of prints out of it.'[30] It was a noble sentiment, but a self-defeating one.

So, too, Hayter's refusal to grow the studio. 'I suddenly realized this was not something that could increase in scale,' he said. 'That a group over [sic] or about forty people altogether is all the people you can remain in close intimate personal contact with and that ten more and you will no longer have it.'[31] When it became clear that the only alternative to growth was closing down altogether, it was the latter choice he took. The end of the New York studio was as knockabout as the beginning had been. 'At Bill's request...we had to dismantle the presses, to pack and move day and night in the record-breaking heatwave, and to send out a press statement on 7 September 1955 that the Atelier 17 in New York was closed,' recalled Leo Katz, who had been running it. 'All in all, many people believe that having had the Atelier 17 in New York has certainly been a strong factor in making this city the centre of the art world. To me it was a tragic day.'[32]

———

By then, Hayter had been back in Paris for five years. In 1950, life in New York had finally become unbearable to him. On top of everything else, the one wise financial decision he had made – the purchase of the house on Washington Street – seemed suddenly to have gone wrong. Louise Bourgeois, herself pondering buying a house, had characteristically weighed up the risks:

the very small houses that are still available [in the] Greenwich Street neighborhood are tenements with stores downstairs; a fish place or funeral parlor may come next to you once the

178 CHAPTER 8

place is bought....look at what happened to Hayter he paid
$6,500 for his house (wonderful) then he spends his time
and thoughts on it. then the threat of expropriation comes

he clings onto his belongings fighting the coming housing
project and this attitude is disastrous for an artist.[33]

One way or another, the return to a potentially unwelcoming Paris
seemed preferable to life in an undeniably hostile New York.

These last years would leave Hayter with a deep animus against
America and Americans, a dislike that was not to help his transat-
lantic posterity. He universalized his own experience of the country.
'I can't think of a single one of the American artists of the Abstract
Expressionist time who wouldn't rather have worked in France than in
America,' he claimed, aloof and implausible.[34] Then: 'New York is not
a satisfactory way of living. It's never interested me. There's too much
pressure, I think....The whole thing is based on the peculiar myth of
success....The idea that America is an ideal place to follow the arts – it
may be getting a little better now, but if you were to ask the first hundred
people who passed you on the corner of Union Square what they think
of modern art, apart from the fact that the third or fourth would prob-
ably hit you – you wouldn't find a great deal of sympathy.'[35]

Paris, by contrast, 'is a place where they leave you alone. It is a place
where an ordinary workman in the street, if he is informed that you are
an artist, will say it is a good trade. It has about the dignity of a foreman
in some semi-skilled trade.'[36] There is something oddly childlike about
this imagining of the French as a race of ploughman poets, as handy
with the brush as the wrench. 'In America, as you know, an artist is a
sort of freak,' Hayter went on. 'I never liked living in New York. In fact
I don't like living in America at all. I was there for ten years on and off,
although I did return here in '46, but I couldn't get back at that time.
But I was really on an extended visit and I never considered it to be
anything else.'[37]

Whether Hayter's rejection of America preceded America's of Hayter
or vice versa, the results were the same. The man and his studio were
quietly written out of US art history. Apart from historians with an

AFTER

179

informed interest in the period, the names of Hayter and Atelier 17 are now familiar mostly to US printmakers who view both with a kind of awe: ironically, given that Hayter's views on techniques other than burin engraving – woodblock, lithography, drypoint etching – tended to the contemptuous, and that Atelier 17 in New York was only ever coincidentally a print workshop. In an interview in his eighties, Hayter affected to brush off this more general forgetting. 'Somebody wrote a piece in which they said, Maybe this fella had something to do with [Abstract] Expressionism and so forth, but you won't hear much about that because there was a certain local chauvinism,' Hayter said. 'He wasn't an American and he rather turned his nose up at America and Americans. They've never forgiven me for going back to France.' After a pause, he laughed: 'Americans want to be loved.'[38]

————

This forgetting was ably assisted by Clement Greenberg. In 1965, twenty years after the event, the critic insisted to an American doctoral student that Jackson Pollock had 'learnt nothing from Hayter or any of the other Europeans in person or by physical proximity'. 'Automatism was something we all knew by 1940 at the latest,' a tetchy Greenberg went on. 'All this I know at first hand.'[39] It was, in its way, as ridiculous a claim as Hayter's of an art-minded French proletariat. Greenberg had, after all, not spent nights with Pollock in Atelier 17, and had presumably never seen the as-yet-unrediscovered plates or prints he had made there, then still stacked up in the barn at Springs. That he should have singled Hayter out as the most dangerous pretender to Pollock's automatism is curious, and oddly flattering. Compared with, say, Masson, Hayter was small fry, and certainly made no such claims himself. Who breaks a butterfly upon a wheel?

All this was part of a more general Americanizing of modern art history. In 1948, Greenberg had written, 'As more and more of the recent work of the masters of the School of Paris reaches this country after the six years' interruption between 1939 and 1945, any remaining doubt vanishes as to the continuing fact of the decline of art that set in in Paris in the early thirties.' This was linked to a moral decay. 'If artists as great as Picasso, Braque, and Léger have declined so grievously, it can only

180 CHAPTER 8

be because the general social premises that used to guarantee their functioning have disappeared in Europe,' Greenberg went on.

Scarcely troubling to hide his sense of triumph, he ended: '[W]hen one sees, on the other hand, how much the level of American Art has risen in the last five years, with the emergence of new talents so full of energy and content as Arshile Gorky, Jackson Pollock, David Smith... then the conclusion forces itself, much to our own surprise, that the main premises of Western art have at last migrated to the United States, along with the centre of gravity of industrial production and political power.'[40]

He was not alone in this view. In 1940, Harold Rosenberg, a less tendentious critic, had mourned the Nazi invasion of Paris as a loss to art everywhere. The point of the city had been that it was supranational, a world capital of art rather than merely a French one. 'Because Paris was the opposite of the national in art, the art of every nation increased through Paris,' Rosenberg had written.[41] Now, in the late 1950s, his tone changed. It was, Rosenberg said, 'pretty much settled... that the new Abstract Expressionism or Action Painting was not just a cork that popped out of an old bottle of French wine'.[42] It was, that is to say, innately American.

This is not to question the power or newness of New York School painting, nor the excitement it generated among artists in Europe as in America. To Masson, and maybe to Hayter, the post-1947 work of men such as Jackson Pollock would come as a revelation – perhaps also as a liberation. In 1970, Joan Miró was interviewed in Paris by Margit Rowell, a young American curator at the Guggenheim in New York. 'Could it have influenced your work – the freedom, the boldness of [American] painting?' Rowell asked him. 'Yes, definitely,' Miró replied. 'It showed me the direction I wanted to take but which up to then had remained at the stage of an unfulfilled desire. When I saw those paintings, I said to myself, "You can do it, too; go to it, you see, it is OK!" You must remember that I grew up in the School of Paris. That was hard to break away from.'[43]

Yet the break was not entirely a clean one. In 1949, Miró wrote from Barcelona to Hayter in New York: 'Could you tell me whether you have any plans to go to Paris, and if so when? I would like to rework some of the copper plates that I began in your workshop [in New York], and to continue with the one we had been working on together. Also, I would

AFTER

181

like you to take care of the printing, especially the prints in colour. And for the book with the poems of Toddy that we illustrated – where are we with that?'[44] Miró's engagement with Atelier 17 was not over.

This was, as we have seen, not typical. Of Willem de Kooning's time at the studio, there is no trace at all. Robert Motherwell and Louise Bourgeois would lose the plates they had made there; Pollock's Atelier 17 plates and prints would lie hidden and forgotten until the 1960s. In their whole careers, Mark Rothko and William Baziotes would make just a single engraving apiece, both of them at Hayter's studio. The plates for these are long lost. Rothko's solitary work is miscatalogued in the prints and drawings collection of the Museum of Modern Art; Baziotes' is misdated in its catalogue, with no mention of its provenance or uniqueness.

It was not just Americans who were careless with Hayter's history. In 1962, he received a letter from Marc Chagall in reply to one of his own. 'I have had your letter of 10 May in which you ask me to share with you old bits and pieces from the time when we worked together in that faraway land,' Chagall writes. 'I would so much like to, but…it's terrible. I don't know where to find *anything* from that time. I hope you will understand me and forgive me.'[45]

As to Hayter's own work, it, too, suffered a postwar American forgetting. In November 1955, he had a letter from the Curt Valentin Gallery in New York. Valentin had died suddenly the year before, on holiday in Italy: his gallery was to be closed. Hayter had not replied to this first letter. Now, three weeks later, Valentin's assistant wrote with new urgency: 'We have to move out of the gallery in two weeks; therefore we are most eager to know as soon as possible what we should do with the works here by you.' She lists the unsold artworks that had been lying in the gallery's storeroom for a decade: '4 plasters, 1 copper plate, 1 1944 drawing, 9 × *Centauresse* (1944, colour), 16 × *Amazon* (1945, b+w), 13 × *Five Personages* (1946, colour) and 13 × b/w; 15 *Tarantelle* (1943, b+w), etc etc etc.'[46]

———

The Paris Hayter found in 1950 was very different from the one he had left in 1939. Then, surrealism had been in the ascendant; now, it had become a dirty word. An international surrealist exhibition had been held three years before his return.[47] Organized by Breton and Duchamp,

182 CHAPTER 8

the staging of this had fallen back on an antebellum formula of sensationalism and visual puns: access to the upper floor was via a red staircase whose steps were the spines of books, suggesting an upward progress towards Knowledge. The show's mix of occultism and myth went down badly with postwar critics, who had come to associate such things, not unreasonably, with fascism. That the show's two organizers had seen out the war in American exile also did it no favours. It was to be the last such surrealist exhibition. There would be one more international surrealist exhibition in Paris, in 1959, but by then it was clear that the city was no longer the movement's world capital, and nor was surrealism predominantly French or Bretonian.[48]

That Hayter had quit the surrealists long before made scant difference: the returning exiles all bore the double mark of Cain. The new Paris atelier, often on the move, was to be very different from the old. Although it would last until its founder's death nearly forty years later, and hundreds – possibly thousands – of artists would pass through its various doors, these were not of the order of the *anciens*. Generally younger than before, the newcomers came to learn avant-garde printmaking rather than avant-garde thought. Pierre Alechinsky apart, one searches the list of alumni from 1950 to 1988 in vain for familiar names. These students and their descendants remain a formidable presence in printmaking all over the world. Few are well known as artists in other mediums; none is of the stature of a Pollock or Motherwell or Bourgeois.

———

In April 1950, a three-day colloquium of artists is held at Studio 35, successor to the short-lived Subjects of the Artist School opened by Baziotes, Motherwell and Rothko in 1948.[49] The school's new name is taken from its address, 35 East Eighth Street. It is difficult not to hear an echo of Atelier 17 in this. Louise Bourgeois attends the meetings; Hayter does not. Motherwell is in the chair.

There is a general inveighing against skill in art, even more so against 'finish' and 'beauty', 'the beautifully made object'. These things, curiously, are now deemed to be French, the Ecole de Paris toiling as it does under the heavy and unshakeable yoke of 'cultural heritage'. Speaking for America, Motherwell says, 'We are involved in "process" and what

AFTER 183

is a "finished" object is not so certain.' That process and a lack of finish
are precisely the things Hayter has spent the last decade teaching three
doors away seems to pass him by.

There are two submissions from the floor. Adolph Gottlieb remarks
'that in the last fifty years the whole meaning of painting has been
made international. I think the Americans share that heritage just as
much, and that if they deviate from tradition it is just as difficult for an
American as for a Frenchman.' This is met with silence. So, too, Jimmy
Ernst's question, 'To what extent are the artists in this group making
use of the methods and theories that were developed by the various
earlier movements and groups of modern art?' Discussion turns to the
finding of a name for what Motherwell, six months later, will immortally
dub 'the New York School'. Alfred Barr, who is also present, suggests
'abstract expressionist', 'abstract-symbolist' or 'intra-subjectionist'.
Others hazard 'direct', 'concrete' or 'self-evident'. It is De Kooning who
brings the discussion to a close. 'It is disastrous to name ourselves,'
he says.[50]

Pollock, too, was not quite free of the Europeans he had met at Atelier 17.
Reuben Kadish recalled the off-handedness his friend now affected
towards the once-fearsome *anciens*. 'He was always flattered, very flat-
tered, if European painters expressed enthusiasm [for his work],' Kadish
said, 'and there were a number who did. But he had a funny kind of thing
about Europe. He'd get a little drunk and say, "Well, Europe can come
and see me; I don't have to go to Europe."'[51]

This is a lightly edited version of the truth. In fact, signs of the influ-
ence of André Masson would recur in Pollock's work until his death
– particularly so in such late canvases as the Guggenheim's *Ocean
Greyness* (1953) and *Sleeping Effort* (Kemper Art Museum, 1953). In these,
Pollock, tormented by the ever-present fear of being taken for a deco-
rative painter, returned to a form of figuration. The elision of the nude
and landscape painting in the latter work is classically Massonian.

Nor would it only be Masson's pre-1945 work that Pollock kept
in mind. Following his return from America, the Frenchman's long-
standing fascination with Zen Buddhism had begun to appear in his art,

184 CHAPTER 8

leading to a series of strongly graphic artworks in a variety of mediums whose style critics would dub 'calligraphic *informel*'.[52] That these would appeal to Pollock comes as little surprise. As the gallerist Betty Parsons noted, 'He was exceptionally occupied with the internal world....He had a sense for mysteries. His religiousness was in these concepts...the big order – like those of oriental philosophy.'[53] The idea of a mark that was both free and somehow legible – which is to say, not simply decorative – was bound to pique Pollock's interest.

Between 1951 and 1953, he was to produce a series of around fifty canvases known collectively as the Black Paintings, twenty-eight of these in the four months between May and September 1951 alone.[54] Painted on rice or mulberry paper or on raw canvas, works such as the Tate's *Number 14* (1951) are, as Pollock predicted they would be, very much less well known than his pictures of the years immediately before. 'Some of my early images [are] coming through,' he wrote to a friend. 'Think the non-objectivists will find them disturbing – and the kids who think it's simple to splash a Pollock out.'[55]

Masson's influence on the Black Paintings, and on the other calligraphic works Pollock made in the same period, has gone largely unremarked (**FIG. 48**).[56] This is par for the course. As one historian has put it, 'What is most striking about the enormous body of scholarship that we have about Pollock, and about Abstract Expressionism more generally, is its focus on him, and on it, as American phenomena.'[57] Of the smaller graphic works on paper, one – an untitled drawing now in the collection of the National Galleries of Scotland – is particularly lovely (**FIG. 49**).[58] Created by bleeding black ink and red gouache through two sheets of rice paper, it was probably made spontaneously at a birthday party in New York in January 1951 and given to the celebrant as a present. The birthday was Clement Greenberg's.

———

Hayter and his atelier were not quite forgotten in New York. Louise Bourgeois had never recovered from the 1947 failure of *He Disappeared into Complete Silence*. Her inability to forget was matched only by a refusal to forgive. In some unspecified way, the book's lack of success had come to be Hayter's fault. It is scarcely overstating the case to say

AFTER

185

that Bourgeois turned the bearing of a grudge into an art form. Slights, betrayals, perceived abuse would reappear again and again in her oeuvre, with new twists and in new materials, over the course of decades. Now it was Hayter's turn.

The plates to *He Disappeared into Complete Silence* having themselves disappeared, Bourgeois, in the 1980s, set about buying up such copies of the original prints as she could find in the hope of reissuing them. When it became clear that this would not be possible, she had new plates photogravured from the prints, and new prints made from these. *He Disappeared into Complete Silence* was finally reissued by the Museum of Modern Art in 2005 in an edition of just forty-seven copies, with the addition of touches of watercolour by Bourgeois herself and a new print from her *Spider* series.[59]

A decade before this, in 1998, she had made a set of five prints called the *Crochet* series. Hayter had died ten years earlier, in 1988. On the verso of the source drawing to the first version of the print, (**FIG.50**), Bourgeois has written, in red ink, the words *Le cauchemar de Hayter/fil conducteur/ ligne tirée/ligne poussée* (The nightmare of Hayter/conducting wire/pulled line/pushed line).[60] From the French, it is unclear whether the nightmare of the inscription is meant as Hayter's own or whether the dead man continued to haunt Bourgeois' dreams. Given her sly way with double meanings, the confusion was very possibly intentional.

What might Hayter have found nightmarish in Bourgeois' new image? *Crochet I* was to be made in a workshop that had pioneered a form of reverse relief printing in which the artist fixes objects to a plate, a cast being made of the result and a copy plate moulded from the cast. For the maquette to *Crochet I*, Bourgeois had drawn in red string. The image that resulted would be pulled from a copper plate engraved without any physical effort on her part, certainly without the need for masculine strength called for by a burin. Yarn and cloth had long featured in Bourgeois' work as symbols of feminine power. Now, *Crochet I* would demasculinize the whole act of intaglio printing, making a strength of weakness. It neatly castrated Hayter.

There had been another print in the same vein, made a couple of years before. This, *Reply to Stanley Hayter* (1996), also turned the skills of engraving against its decade-dead master (**FIG.51**). After half a century,

186 CHAPTER 8

Bourgeois said, she had suddenly remembered her difficulties with the burin at Atelier 17, in particular with the cutting of the kind of long, curved lines that make up *Reply to Stanley Hayter*. Here, these difficulties are avoided by the simple expedient of the image being made as a lithograph; a method of printing that calls for no great strength and for which, as Bourgeois would have known, Hayter had frequently voiced contempt. The central figure is of a watchful eye, or a vagina, or perhaps both.

————

And yet, if served cold, Bourgeois' revenge on Hayter ironically preserved him. In 2022, an exhibition of her late, cloth-based work opened in London.[61] This included some ninety pieces, ranging in date from around the time of the *Crochet* series to the artist's death in 2010 at the age of ninety-eight.

The show took its name, 'The Woven Child', from the title of a portfolio of six weavings bound in a lithographed cloth cover which Bourgeois had made in 2003. As she had instructed, these were shown not in their binding but hung in page sequence on the gallery wall. The same was true of another fabric book, *Ode à la Bièvre*, made the year before.

Both these were, in various senses, autobiographical. Bourgeois had been an indefatigable hoarder – of memories (her family had stayed on the Bièvre river when she was a child), of slights, of traumas; of fabric. Many of the works in the show were made from the cloth of garments she had worn and then squirrelled away for decades. But the show was also a reprise of the artist's life in another way. The constant switching of dimensions from three to two and back again suggested both the variety of Bourgeois' seventy-year practice and a key feature of it.

Cloth might be embroidered, but that embroidery then became the skin of a sculpted head or of a trio of legs hung from the gallery ceiling. A fabric book was transformed into a suite of what looked like abstract paintings or prints. In a sculpture such as *Untitled* (1996), Bourgeois' life was written as a history of dresses – from gauzy pink baby clothes via lace camisoles to slinky black cocktail frocks, suspended from beef bones hanging on a metal stand. What gave the show its coherence was a sense that, for all their disparities of genre and dimension, the works

AFTER 187

in it were underwritten by their maker's own damaged history. They were the opposite of abreactive. Through their many iterations, their unvarying message was that time does not heal all wounds. Or, to put it in French, *plus ça change, plus c'est la même chose.*

Metamorphosis does not equal change; that idea remained a constant in Louise Bourgeois' work. And yet making this point called for ceaseless transformation. Central to that, as we have seen, was the shift from one dimension to another, three-dimensional fabric book to two-dimensional picture on a wall. This shift in turn called for a defiance of gravity, a sense that things not made to fly or hang or hover suddenly might rise, wraithlike, from table to wall, from drawer to meat hook. There remained, in Bourgeois' late art, a fascination with weight and with weightlessness. Looking at the work in 'The Woven Child', one was led back to another perceived trauma in the artist's life: the moment when, bullied by Stanley William Hayter, her art had risen from the plate to the plinth, from low-relief metal sculpture to sculpture in the round.

By the time these late works were made, they were the last that could trace their pedigree directly to the grubby room above Rosenthal's supply shop, or to the cramped New School studio that had preceded it. Those places had seen one of the great cultural shifts of the 20th century, of the epicentre of modern art from Europe to America. The late work of Louise Bourgeois, a French artist become American, typified it. Bourgeois had outlived Pollock, Rothko, Baziotes, De Kooning and Motherwell. With her refusal to move on, her drive constantly to evolve but never to change, she had preserved a moment in the history of Franco-American art as though in amber.

Acknowledgments

I should like, first, to thank the wives and children of various of the protagonists of this book, who were unfailingly generous with their knowledge and time: Mme. Désirée Levy-Hayter, widow of Stanley William Hayter, who additionally read the complete manuscript in its first draft; Mme. Carla Esposito Hayter; Mme. Monique Lévi-Strauss; Diego Masson; Christopher Rothko.

My thanks, also, to those who provided expert advice, sometimes with a well-earned cuff around the ear: to Professor Dawn Adès, who peer read the finished book; to Helen Harrison at the Pollock–Krasner House and Study Center; Katy Rogers at the Dedalus Foundation (Robert Motherwell); Maggie Wright at the Easton Foundation (Louise Bourgeois); Michael Preble and Scott Schweigert at the William Baziotes Catalogue Raisonné project; the Calder Foundation; Farida Bogzaran at the Lucid Art Foundation, Inverness, CA (Gordon Onslow Ford); Pilar Ortega at the Successió Miró in Palma de Mallorca. Some of these also waived copyright for images and citations, for which my gratitude.

My thanks as well to the many librarians, archivists and historians who made this book possible – as ever, to the Archives of American Art at the Smithsonian Institution in Washington, DC; the archives of the Museum of Modern Art in New York; the New School Archives and Special Collections; the Harvard Film Archive; to Christopher Benfey at Mount Holyoke College; Piri Halasz; Christina Weyl; Margit Rowell; Frances Morris; the Tate Library and Archive in London; the archives of the Centre Pompidou and Kandinsky Library in Paris, and the Bibliothèque nationale de France; the Peggy Guggenheim Collection in Venice.

The staff at Thames & Hudson have been customarily wonderful. I would like in particular to thank the book's designer, Aman Phull; picture researcher, Nikos Kotsopoulos; production controller Ginny Liggitt; and editor, Camilla Rockwood. And, of course and as ever, my gratitude to Sophy Thompson, Mohara Gill and Roger Thorp, for their unending support.

Last, I would like to thank Achim Borchardt-Hume. Achim was endlessly kind about this book, offering me advice and encouragement and contacts as only he could. His death hangs like a cloud. I wish he could have lived to see it.

Notes

189

Introduction

1 Robert Motherwell in John H. Baur (ed.), *Bradley Walker Tomlin*, exh. cat., New York: Macmillan for the Whitney Museum of American Art, 1957, pp. 11–12.

2 It was by no means the last time he was to make such a claim. See, for example, Stephanie Terenzio (ed.), *The Collected Writings of Robert Motherwell*, Oxford and New York: Oxford University Press, 1992, p. 119: 'I believe...that the fact of the Parisian surrealists being here in New York in the early forties had a deep effect on the rise of what is now called abstract expressionism.'

3 Martica Sawin, *Surrealism in Exile and the Beginning of the New York School*, Boston: MIT Press, 1995.

4 Christina Weyl, *The Women of Atelier 17: Modernist Printmaking in Midcentury New York*, New Haven: Yale University Press, 2019.

Before

CHAPTER 1

1 In Ian Chilvers (ed.), *The Oxford Dictionary of Art*, Oxford: Oxford University Press, 3rd ed., 2004.

2 See Hayter Papers, Tate Archive, TGA 200510/2/51: letter from Mrs Edith Fletcher Hayter (21 March 1967, Saratoga Springs, NY) to *Who's Who*, pointing out the omission of her marriage to Hayter in his entry. 'December 18, 1926, at the British Consul General, Paris, France, to Edith Fletcher of New York, and the subsequent divorce in Reno, Nevada on September 23, 1929.'

3 From Stanley William Hayter, 'Alexander Calder at Paris', in 'Homage to Alexander Calder', special issue of the *XXe siècle Review* (1972), pp. 6–11.

4 Alexander Calder, 'The Ides of Art: 14 Sculptors Write', *Tiger's Eye* 1, no. 4 (15 June 1948).

5 Hayter, 'Alexander Calder at Paris', p. 7.

6 Today Villa Santos-Dumont.

7 For more on Hayter's early years in Paris, see Carla Esposito (ed.), *Hayter e l'Atelier 17*, Milan: Electa, 1990.

8 *Ibid.*, p. 13.

9 In an interview by Judith Goldman, *Print Review* 15 (1982). Wills was an eight-time Wimbledon tennis champion, having won her first singles title in 1927.

10 *Ibid.*

11 Etching involves drawing with a needle onto a waxy ground laid on a metal plate. The exposed pattern is then burned onto the surface of the plate using acid. On the exclusion of engraving from Hecht's syllabus, I am indebted to Mrs Désirée Levy-Hayter.

12 Esposito, *Hayter e l'Atelier 17*.

13 Hayter, 1960, quoted in Esposito, *Hayter e l'Atelier 17*, p. 12.

14 For more on Ferren's work at Atelier 17, see Una E. Johnson, *Ten Years of American Prints, 1947–1956*, New York: Brooklyn Museum, 1956; and John Ferren, 'Epitaph for an Avant-Garde', *Arts* xxxii (November 1958).

15 Roger Fry, 'Line as a Means of Expression in Modern Art', *The Burlington Magazine for Connoisseurs* 33, no. 189 (December 1918), pp. 201–3, 205–8.

16 Published as the *Pädagogisches Skizzenbuch*, the second of the fourteen Bauhaus Books edited by Gropius and László Moholy-Nagy.

17 *Ibid.*, p. 1.

NOTES

18 This appeared beneath work No. 365, a 1938 drawing called *Süchtig* (*Addicted*).

19 'Trente-neuf aquarelles de Paul Klee illustrant le mot du peintre', 21 October–14 November 1925.

20 13–26 November 1925.

21 René Crevel, *Paul Klee, Les Peintres Nouveaux*, Paris: Gallimard, 1930, p. 10.

22 For more on Klee's German reception as a surrealist, see Makoto Miyashita, 'Die Kritik als Strategie? Die Ausstellung "Paul Klee" in der Galerie Vavin-Raspail, Paris 1925, und danach', *Aesthetics* 44, no. 3 (1993), pp. 12–22.

23 Quoted in Catrin Lorch, 'Klees feine kleine Klumpgeister', *Frankfurter Allgemeine Zeitung*, 4 January 2007.

24 Esposito, *Hayter e l'Atelier 17*.

25 Anthony Gross in *For Stanley William Hayter on his 80th birthday*, Oxford: Oxford Gallery, 1981.

26 The earliest of these, *Study for 'Birds and Architecture'*, may date from late 1923. Masson would make thirty-six known automatic drawings between 1924 and 1927.

27 Breton claimed this as the first work of surrealism.

28 André Breton, 'Entrée des médiums' (1922), in *Œuvres complètes* vol. 1, Paris: Bibliothèque de la Pléiade, 1988, pp. 273–9.

29 That said, the American playwright and critic Lionel Abel noted that the handwritten manuscript of Breton's supposedly 'automatic' 'Ode to Charles Fourier' was heavily corrected. See Lionel Abel, *The Intellectual Follies: A Memoir of the Literary Venture in New York and Paris*, New York: W. W. Norton & Co., 1984, p. 96. As the 'Ode' was written in 1947, perhaps Breton's own views had changed.

30 André Masson, 'Propos sur le Surréalisme' (1961), in Françoise Will-Levaillant (ed.), André Masson, *André Masson, Le rebelle du surréalisme:*

Ecrits et propos sur l'art, Paris: Editions Hermann, 1976, p. 37. For the link between Masson's method and French dynamic psychiatry, see Jennifer Gibson, 'Surrealism before Freud: Dynamic Psychiatry's "Simple Recording Instrument"', *Art Journal* 46, no. 1, 'Mysticism and Occultism in Modern Art' (Spring 1987), pp. 55–60.

31 André Masson, 'Je Dessine', from J-P. Clébert, *Mythologie d'André Masson*, Geneva: Pierre Cailler, 1971.

32 *Second manifeste du surréalisme* (Paris: Kra, 1930, p.184), an expanded version of the original, published in *La Révolution surréaliste* 12 (15 Dec 1929).

33 In the pamphlet *Le cadavre*, Paris, 15 January 1930, np.

34 *Acéphale*, no. 1, 24 June 1936.

35 Quoted in Joseph Goddu and Debra Wieder, '*Eccentric Orbits: Stanley William Hayter, Charles Howard, Knud Merrild, Kay Sage*', exh. cat., New York: Hirschl & Adler Galleries, 1998.

36 André Breton, *The Second Manifesto of Surrealism*, 1929.

37 Tieu van den Berk, *Jung on Art: The Autonomy of the Creative Drive*, London: Routledge, 2012, p.124.

38 'Tanguy and Objects from America', 27 May–15 June 1927. The gallery, at 16 rue Jacques Callot, closed the following year.

39 Paul Éluard, *La Vie immédiate*, Paris: Editions des cahiers libres, 1932. For more on the print, see Wolfgang Wittrock, *Yves Tanguy: Das Druckgraphische Werk*, Düsseldorf: Kunsthandel, 1976.

40 Gilbert Kaplan (ed.), *Surrealist Prints*, with Timothy Baum; Riva Castleman; Robert Rainwater, New York: Harry N. Abrams, Inc., 1997.

41 See Wittrock, *Yves Tanguy*.

42 At Galerie Pierre, name and dates unknown. Picasso also signed up for burin lessons at Atelier 17 in 1934. As Hayter recalled, 'We did

CHAPTER 1 191

some burin plates together. He came to my place, I made some tools for him, and then I worked at his place, and so on.' See Goldman, *Print Review*.

43 The Paris shows were at Galerie aux Quatre Chemins (1936, 1937) and Galerie de Beaune (1939). The London show, called 'Eighth Exhibition, Studio 17: Engravings, Etchings, Plaster Prints', was at Guggenheim Jeune, 8–23 June 1939. For a full chronology of Atelier 17's exhibitions, see Christina Weyl, *The Women of Atelier 17: Modernist Printmaking in Midcentury New York*, New Haven: Yale University Press, 2019.

44 Gabor Peterdi, oral history interview by Paul Cummings, 29 April 1971, Archives of American Art, Smithsonian Institution, Washington, DC.

45 *Ibid.*

46 Julian Trevelyan, *Indigo Days*, London: MacGibbon & Kee, 1957.

47 'Portrait de Roger Vieillard, ou une trajéctoire pure', interview with Vieillard by L.-R. Berge, *Arts et Metiers du Livre* cxlix (March–April 1988), p. 110.

48 Michel Leiris in *André Masson, Line Unleashed: A Retrospective Exhibition of Drawings*, exh. cat., London: Hayward Gallery, 1987, p. 56.

49 London: Cobden-Sanderson, 1935.

50 David Gascoyne, *Stanley William Hayter and the Surrealists*, 1992, http://www.stanleywilliamhayter.com/anglais/surrealist.htm.

51 *Ibid.*

52 *Ibid.*

53 Michel Rémy, *Peinture Surréaliste en Angleterre 1930–1960*, exh. cat., Paris: Galerie 1900/2000, 1984.

54 Quoted in Emmanuelle Loyer, *Paris à New York: intellectuels et artistes français en exil (1940–1947)*, Paris: Bernard Grasset, 2005, p. 125.

55 Exposition Internationale du Surréalisme, Galérie Beaux-Arts, 140, rue du Faubourg Saint-Honoré, Paris, 17 January–24 February 1938. Among the sixty artists to have work in the show were Miró, Masson, Tanguy, Max Ernst and Hayter.

56 For more on this work, see Johnson, *Ten Years of American Prints*, p. 37.

57 *Ibid.*, p. 37.

58 *Une Semaine de Bonté, ou Les Sept Elements Capitaux (A Week of Kindness, or the Seven Capital Elements)*, Paris: Editions Jeanne Bucher, 1934. The *édition de luxe* on which Ernst was working in 1937 was never completed.

59 Michel Conil Lacoste, 'L'atelier 17', *L'Œil* no. 53 (15 May 1959), pp. 56–65.

60 Anaïs Nin, *The Journals of Anaïs Nin, 1934–1939*, London: Peter Owen, 1967.

61 See Susan M. Anderson, *Pursuit of the Marvelous: Stanley William Hayter, Charles Howard, Gordon Onslow Ford*, Laguna Beach, CA: Laguna Art Museum, 1990.

62 Quoted in Michael McNay, 'Gordon Onslow Ford: Surrealist Painter on a Quest for the Inner Worlds of Life and Art' (obituary), *Guardian*, 24 November 2003.

63 Gordon Onslow Ford, oral history interview with Michael Oren, 23 December 1991, from *Interviews with Artists: Transcripts, 1979–1991*, Archives of American Art, Smithsonian Institution, Washington, DC.

The New School

CHAPTER 2

1 Il...décrivait avec son autre main des mouvements circulaires de plus en plus rapides.... Ses gestes fébriles et répétitifs, pareils à ceux d'un derviche

en état de transe...entièrement concentré sur son activité, comme s'il retournait aux origines du monde. Il semblait accomplir...le rituel immémorial d'une tribu disaprue. Christophe Boltanski recalling his uncle, Christian; *La Cache*, Paris: Éditions Stock, 2015, p. 301.

2 In Press Clippings 20: 1940–1942 June, New School for Social Research Archives and Special Collections.

3 All information from the New School Scrapbooks (NS.08.01), Box 8 SB 18, New School for Social Research Archives.

4 This was due to a back problem. See www.stanley-william-hayter.com.

5 Hayter, letter to Roger Vieillard, 20 April 1945; Stanley William Hayter Papers, Tate Archive, London.

6 Phillips had moved to Paris in 1936, joining Atelier 17 soon afterwards. She and Hayter married in Reno, Nevada, in 1940 and divorced in 1972.

7 Stanley William Hayter, oral history interview by Paul Cummings, 11 March 1971, Archives of American Art, Smithsonian Institution, Washington, DC. In fact, he and Phillips came in September.

8 Carla Esposito (ed.), *Hayter e l'Atelier 17*, Milan: Electa, 1990, p. 34.

9 The New School Scrapbooks.

10 Meyer Schapiro, 'The Nature of Abstract Art', *Marxist Quarterly*, 1 (January–March 1937), p. 80.

11 Schapiro had given two seminars on surrealism in January 1938, effectively introducing the movement to the New School.

12 Stanley William Hayter, *About Prints*, Oxford: Oxford University Press, 1962, p. 44.

13 Ozenfant, delighted (and evidently not a little surprised) by his new academic status, took proudly to signing letters 'Professor Ozenfant'. See Archives, Sari Dienes Foundation.

14 Martica Sawin, *Surrealism in Exile and the Beginning of the New York School*, Boston: MIT Press, 1995, p. 152.

15 André Fermigier, 'Paris–New York, 40–45', *Art de France* no. 3 (1964), pp. 218–38.

16 Audrey McMahon, 'A General View of the WPA Federal Art Project in New York City and State', in Francis V. O'Connor (ed.), *The New Deal Art Projects: An Anthology of Memoirs*, Washington, DC: Smithsonian Institution, 1972.

17 Nouritza Matossian, *Black Angel: The Life of Arshile Gorky*, New York: Overlook Press, 2000.

18 In 'Populist Realism', review of exhibition 'An Artist in America', Thomas Hart Benton, *Partisan Review* 4, no. 2 (January 1938), p. 56.

19 Donna Marxer, 'Interviews of Artists, 1977–1992: Stanley William Hayter in Paris, May 1977, in the presence of Minna Citron', Archives of American Art, Smithsonian Institution, Washington, DC.

20 Hayter and Cummings interview, 11 March 1971.

21 See Julian Trevelyan, *Indigo Days*, London: MacGibbon & Kee, 1957, ch. 1.

22 Milton Gendel, foreword to *Da margine a centro*, Bari: 2RC, 1993, p. 4.

23 'An exhibition of paintings and engravings by Stanley William Hayter was opened yesterday afternoon with a reception in the artist's honor at the New School for Social Research.' *New York Times*, 18 October 1940.

24 Stanley William Hayter, interview by Jeffrey Potter, 18 June 1983: Jeffrey Potter Collection, Pollock-Krasner House and Study Center, Stony Brook University, Stony Brook, NY.

25 Hayter died on 4 May 1988.

26 Hayter Memorial, New School, 17 November 1988; New School Archives.

CHAPTER 2

27 Anaïs Nin, *The Journals of Anaïs Nin, 1934–1939*, New York: Harcourt Brace Jovanovich, 1969, p. 125.

28 *Ibid.*

29 Becker showed two wood-engravings, *Monster* and *John Henry's Hand* (1936).

30 Notes from an interview between Fred Becker and Laurie Delphin, *c.* 2003.

31 Becker had studied at the Otis Art Institute in Los Angeles (1931–33), then at New York University.

32 Quoted in Martica Sawin, 'Recollections of Atelier 17: Fred Becker in conversation with Martica Sawin, 26 May 1999', in *Les Surréalistes en exil et les débuts de l'école de New York*, exh. cat., Strasbourg: Musées de Strasbourg, 2000.

33 Leo Katz, 'Atelier 17', *Print: America's Graphic Design Magazine* 14, no. 1 (January–February 1960), https://leokatz.com/Atelier-17.

34 Jacob Kainen, interview by Avis Berman for the Archives of American Art's *Mark Rothko and His Times* oral history project, 10 August–22 September 1982.

35 Robert Motherwell in John H. Baur (ed.), *Bradley Walker Tomlin*, exh. cat., New York: Macmillan for the Whitney Museum of American Art, 1957, pp. 11–12.

36 Motherwell first used the term at the Mid-Western Conference of the College Art Association on 27 October 1950, at the University of Louisville, Kentucky.

37 From the transcript to the symposium *American Prints, 1913–1963*, held at the Museum of Modern Art, 3 December 1974.

38 Hayter and Cummings interview, 11 March 1971.

39 Ian Hugo in Adelphi College Symposium of the Creative Arts, Garden City, Long Island, NY, July 1946. Quoted in Hugo, *New Eyes on the Art of Engraving*, Yonkers: Alicat Book Shop Press, 1946, np.

40 *Ibid.*

41 Piri Halasz papers: Writings and related materials, Box 1/2: 'Some Documentation for Ambiguity: Interview with Stanley William Hayter', 20 May 1983, Archives of American Art, Smithsonian Institution, Washington, DC.

42 For more on this see Joann Moser, 'The Impact of Stanley William Hayter on Post-War American Art', *Archives of American Art Journal* 18, no. 1 (1978), pp. 2–11.

43 See Stanley William Hayter, 'Orientation, Direction, Cheirality, Velocity, and Rhythm', in György Kepes (ed.), *The Nature and Art of Motion*, New York: George Braziller, 1965, p. 7.

44 Rudolf Arnheim, *Art and Visual Perception: A Psychology of the Creative Eye*, Berkeley: University of California Press, 1954, p. 219.

45 Rudolf Arnheim, essay in *S.W. Hayter Acquaforti e Bulini dal '68 al '78*, exh. cat., Rome: Istituto Nazionale per la Grafica, Calcografia, 1978.

46 Stanley William Hayter, *New Ways of Gravure*, New York: Pantheon, 1949.

47 Ernst Kris, 'On Preconscious Mental Processes', *Psychoanalytic Quarterly*, 19 (1950), pp. 540–60.

48 *Le surréalisme et la peinture*, Paris: Gallimard, 1928, p. 61.

49 *The Collected Works of C.G. Jung, vol. 15: Spirit in Man, Art and Literature*, London: Routledge & Kegan Paul, 1966, p. 115. For more on this, see Tieu van den Berk, *Jung on Art: The Autonomy of the Creative Drive*, London: Routledge, 2012.

50 Seligmann had arrived in New York in late 1939, but was occupied in setting up his own private printing press at his studio in Bryant Park. He was also, of course, not a native English speaker.

51 In the short film *A New Way of Gravure*, made by Jess Paley in 1950.

52 See Moser, 'The Impact of Stanley William Hayter on Post-War American Art'.

53 Stanley William Hayter, 'Interdependence of Idea and Technique in Gravure', *Tiger's Eye* 1, no. 8 (June 1949), pp. 41–63.

54 Motherwell's first exhibition was held in Paris in 1939 at the Akademia gallery of Isadora Duncan's brother, Raymond. Akademia also published a monthly journal, *Exangelos et New-Paris-York*, the latter being the name he gave to a city he proposed building in the mid-Atlantic in 1948.

55 For more on Putzel's possible involvement with the shows, see Melvin P. Lader, 'Howard Putzel, Proponent of Surrealism and Early Abstract Expressionism in America', *Arts Magazine* 56, no. 7 (March 1982), pp. 86–7.

56 Tanguy had arrived in America in November 1939. After a Reno divorce, he had married Kay Sage and moved with her to 30 West 11th Street, a block from the New School.

57 Kainen and Berman interview, 1982.

58 Hayter and Potter interview, 18 June 1983.

59 Gordon Onslow Ford, New School lecture notes (1941), Lucid Art Foundation Archives, Inverness, CA.

60 *The Collected Works of C.G. Jung, vol. 10: Civilisation in Transition*, London: Routledge & Kegan Paul, 1964, pp. 317–18.

61 *The Collected Works of C.G. Jung, vol. 8: Structure and Dynamics of the Psyche*, London: Routledge & Kegan Paul, 1969, p. 745. The quotation is from Aquinas's *De veritate*.

62 Onslow Ford, in his fourth and final lecture. Quoted by Martica Sawin in *Jimmy Ernst* (Weinstein Gallery, San Francisco, 2010, p. 10), from a handwritten draft in the Lucid Art Foundation archives.

63 Rosamund Frost, 'The Chemically Pure in Art: W. Hayter, B.Sc., Surrealist', *Art News* xl, no. 7 (1941), pp. 13ff.

64 For more on the 5 March exhibition, see Caterina Caputo, 'Towards a New "Human Consciousness": The Exhibition "Adventures in Surrealist Painting during the Last Four Years" at the New School for Social Research of New York, March 1941', University of Florence, paper at *Surrealism in the United States International Conference*, 27–29 November 2017, German Centre for Art History, Paris.

65 Letter, Gordon Onslow Ford to Charles Stuckey, May 1994, Gordon Onslow Ford Archive, Lucid Art Foundation, Inverness, CA. For more on Onslow Ford in America, see Sepp Heikisch-Picard, 'Gordon Onslow Ford in New York, 1940–1941', in Dawn Adès et al., *Gordon Onslow Ford: A Man on a Green Island*, Inverness, CA: Lucid Art Foundation, 2019.

66 Letter, Robert Motherwell to Gordon Onslow Ford, 2 October 1984: correspondence, Dedalus Foundation archives.

67 Quoted in Stephanie Terenzio (ed.), *The Collected Writings of Robert Motherwell*, Oxford and New York: Oxford University Press, 1992, p. 290.

68 In his lecture 'The Place of the Spiritual in a World of Property', Pontigny-en-Amérique Conference, Mount Holyoke College, 10 August 1944. Published in *Dyn* (November 1944) as 'The Modern Painter's World'.

69 In 'What Abstract Art Means to Me: Statements by Six American Artists', *The Museum of Modern Art Bulletin* 18, no. 3 (Spring 1951), pp. 12–13.

70 Cf. Caputo, 'Towards a New "Human Consciousness"'. Onslow Ford

CHAPTER 2 195

also confirmed that Pollock had attended his lectures although he 'didn't remember talking to him'. See Gordon Onslow Ford interview by Ted Lindberg, 26 March 1984, p. 32, Archives of American

Art, Smithsonian Institution, Washington, DC.

71 It would run from 23 May to 2 September.

72 Rosamund Frost, exhibition review in *Art News*, April 1941, p. 12.

The French Arrive

CHAPTER 3

1 Stanley William Hayter, transcript of interview by Pat Gilmour, spring 1982, Hayter Papers, Tate Archive.

2 Martica Sawin, *Surrealism in Exile and the Beginning of the New York School*, Boston: MIT Press, 1995, p. 139.

3 Varian Fry, *Surrender on Demand*, Boulder, CO: Boulder Books and the United States Holocaust Memorial Museum, 1997, pp. 115–17.

4 Vichy censors had described Breton as 'the very antithesis of [Pétain's policy of] National Revolution'. André Parinaud (ed.), *André Breton, entretiens*, Paris, 1952, p. 196.

5 The Bretons would soon move to a fifth-floor walk-up at 265 West 11th Street. 'Breton's wife, Jacqueline, filled their Greenwich Village apartment with a little jungle of house plants framing a somnolent bush baby and a trapeze for the gymnastics of the lady of the house.' Milton Gendel, 'Kiesler Helped Me Go to War', in Eva Kraus et al., *Friedrich Kiesler: Art of This Century*, Berlin: Hatje Cantz, 2003.

6 In 'Joe Gould's Secret' (1964), *Up in the Old Hotel and Other Stories*, New York: Vintage Books, 1993, p. 651.

7 *The Diary of Anaïs Nin, Volume 3, 1939–1944*, New York: Harcourt Trade Publishers, 1971, p. 121.

8 Addressed/dated 20 October 1940, 30 West 11th Street, NYC, *Yves Tanguy: Lettres de loin, addressées à Marcel Jean*, Paris: Le Dilettante, 1992, p. 23.

9 'Yves Tanguy and the New Subject in Painting', in Karin von Maur et al.

(eds), *Yves Tanguy and Surrealism*, Ostfildern-Ruit: Hatje Cantz, 2001.

10 In interview with Laurie Delphin, c. 2003/4, p. 27.

11 In *L'Amérique au jour le jour*, Paris: Gallimard, 1948.

12 Stanley William Hayter, interview by Jeffrey Potter, 18 June 1983: Jeffrey Potter Collection, Pollock-Krasner House and Study Center, Stony Brook University, Stony Brook, NY.

13 News of their arrival was eclipsed by that of another passenger on the flight, a scientist carrying a box of lab rats. '8 Rodents Here By Clipper Travel', reported the *New York Times*.

14 Quoted in André Fermigier, 'Paris–New York, 40–45', *Art de France* no. 3 (1964), pp. 218–38.

15 Mark Polizzotti, *Revolution of the Mind: The Life of André Breton*, London: Bloomsbury, 1995.

16 Hayter and Potter interview, 18 June 1983. Hayter is talking about his entire time at the New York atelier, 1940–50; Miró did not arrive in New York until 1947.

17 Much of the information in the section that follows comes from conversations and/or correspondence between the author and Diego Masson, Mme Monique Lévi-Strauss, Désirée Levy-Hayter and Carla Esposito Hayter, 2019–20.

18 The Massons had had an even worse crossing than the Bretons, the 3,700-ton steamer, the *Carimare*, on which they sailed having 304 passengers

crammed onto its small decks. Also on board were 17 paintings sent to Wildenstein & Co. in New York, including works by Greuze, Watteau, Corot and Hubert Robert. (See file T 209/7/1/ Ministry of Economic Warfare: Identification of looted works of art, National Archives, Kew.)

19 It was a complaint voiced by other Parisian exiles in New York. Thus, for example, Anaïs Nin: 'I ask myself where I am now? In a place which denies myth, and sees the world in flat, ordinary colours.' (*The Journals of Anaïs Nin, 1934–1939*, New York: Harcourt Brace Jovanovich, 1969, p. 121.)

20 François-René de Chateaubriand, *Atala, ou Les Amours de deux sauvages dans le désert* (1801). As his friend, the dealer Daniel-Henry Kahnweiler, recalled, Masson was also a fan of the novels of J. Fenimore Cooper, author of, *inter alia*, *The Last of the Mohicans*. 'It was a shame I did not see a rodeo,' he mourned in 'Eleven Europeans in America', *Museum of Modern Art Bulletin*, XIII, nos 4–5 (1946). 'But I became cloistered as it were in New Preston.'

21 Masson, 'Eleven Europeans'.

22 'We stayed there for maybe two months before moving to New Preston, another village in Connecticut – we lived outside the village.' Diego Masson, oral history interview by Peggy Frankston, 12 March 2014. Archives of United States Holocaust Memorial Museum.

23 Undated letter, Masson to May, Saidie A. May Papers, Correspondence, Folder 6, Archives and Manuscripts Collections, The Baltimore Museum of Art.

24 Eugene Jolas, *Man from Babel*, New Haven: Yale University Press, 1998, p. 187. Masson had suffered from shell shock during the First

World War, having been seriously wounded at the Battle of the Somme.

25 Masson, 'Eleven Europeans'.

26 Denis de Rougemont, *Journal des deux mondes*, Paris: Editions Gallimard, 1948 (my translation).

27 Masson, 'Eleven Europeans'.

28 'La peinture et le dessin marchent bien.' Masson to Valentin, June 1941. In André Masson, *Les Années surréalistes. Correspondance 1916–1942*, ed. Françoise Levaillant, Paris: La Manufacture, 1990, p. 272.

29 'Je suis content que Hayter t'aide pour le matériel d'eau-forte.' *Ibid*.

30 For this dating, see Lawrence Saphire and Stanley William Hayter, *André Masson: The Complete Graphic Work. Volume 1: Surrealism, 1924–49*, New York: Blue Moon Press, 1990.

31 How this double-naming came about, I have been unable to find. Given the print's subtitle of *Violated*, *Rape* seems the more likely name, and was the one used by William Rubin and Carolyn Lanchner in their authoritative catalogue to the 1976 exhibition 'André Masson' at the Museum of Modern Art. It is thus the one I have also used. The confusion may have been linguistic. Although Masson was to be influential through both his American exhibitions and his presence at Atelier 17, he was never to learn English – 'Pas un mot,' according to his son, Diego.

32 Saphire and Hayter, *André Masson: The Complete Graphic Work*; quoted in Martica Sawin, 'André Masson, The American Years 1941–1945', *André Masson in America*, New York: Zabriskie Gallery, 1999.

33 Indeed, the dead straight, unindented margins of the print suggest that this may have been the case – that Masson had made a larger plate, the edges of which were masked before printing. I am

CHAPTER 3

indebted to the artist Mandy Bonnell for this analysis.

34 Quoted in C. Miglietti and S. Guégan, *André Masson: de Marseille à l'exil americain*, Marseilles: Musée Cantini/Lienart, 2016.

35 By contrast, he made twenty-three lithographs in under a year at the studio of George Miller. Saphire and Hayter, *André Masson: The Complete Graphic Work*, p. 17.

36 Seligmann, 'Eleven Europeans'.

37 Motherwell in panel discussion 'A Special Genius', 1976. Dedalus Foundation Archives, container IX.B.14.

38 This was first suggested by Bernice Rose in her catalogue to the Museum of Modern Art/Drawing Society exhibition 'Jackson Pollock: Works on Paper', New York: Museum of Modern Art, 1969.

39 'Out of the 222 passengers on board the *Paul Lemerle*, which arrived here on 20 April 1941, only three will be settling in Martinique.... All the other passengers have...been interned at the Lazaret camp.' In Eric Jennings, 'Last Exit from Vichy France: The Martinique Escape Route and the Ambiguities of Emigration', *The Journal of Modern History* 74, no. 2 (June 2002), pp. 289–324.

40 In André Breton, *Martinique, charmeuse de serpents*, Paris: Editions du Sagittaire, 1948, p. 57.

41 Claude Lévi-Strauss, 'New York post- et préfiguratif', in *Paris–New York 1908–1968*, exh. cat., Paris: Centre Pompidou, pp. 123–9.

42 *Ibid.*

43 Patrick Waldberg, 'Au fil de souvenir', in Jean Pouillon and Pierre Maranda (eds), *Echanges et communications. Mélanges offerts a Claude Lévi-Strauss a l'occasion de son 60e anniversaire*, Paris and The Hague: Mouton, 1970.

44 In his influential *Foundations of Modern Art* (1928), Amédée Ozenfant had written of the wall paintings in the caves at Les Eyzies: 'Ah, those hands! Those silhouettes of hands, spread out and stencilled on an ochre ground! Go and see them. I promise you the most intense emotion you have ever experienced. Eternal Man awaits you.' He also described the frescoes as 'pretty Surrealist'. Perhaps Lévi-Strauss had them in mind.

45 Claude Lévi-Strauss and Didier Eribon, *De près et de loin*, Paris: Editions Poches Odile Jacob, 2001, p. 273.

46 Claude Lévi-Strauss, *Regarder, écouter, lire*, Paris: Librairie Plon, 1993, pp. 144–51.

47 For more on the Freudian basis of Lévi-Strauss' theories of artistic production, see Boris Wiseman, 'Lévi-Strauss, l'inconscient et les sciences humaines', in Antoine Compagnon and Céline Suprenant (eds), *Freud au Collège de France*, Paris: PSL Research University, 2018. Michel Foucault's *Les Mots et les choses. Une archéologie des sciences humaines*, Paris: Gallimard, 1966, also draws a parallel between Lévi-Strauss' ethnology and Freudian theory.

48 Paris, December 1924.

49 Claude Lévi-Strauss: 'For a while, Masson and I were great friends' [*très amis*]. *De près et de loin*, p. 40.

50 Again, I am indebted to Mmes Lévi-Strauss and Levy-Hayter for this information.

51 Martica Sawin, 'Recollections of Atelier 17: Fred Becker in conversation with Martica Sawin, 26 May 1999', in *Les Surréalistes en exil et les débuts de l'école de New York*, exh. cat., Strasbourg: Musées de Strasbourg, 2000, pp. 403–6.

52 Quoted in Denis Bertholet, *Claude Lévi-Strauss*, Paris: Plon, 2003, p. 142.

NOTES

53 De Rougemont, *Journal des deux mondes*, p. 167.
54 *Ibid.*, p. 170.
55 Claude Lévi-Strauss, 'New York en 1941'; in *De près et de loin*, p. 47.
56 Claude Lévi-Strauss, in *Gazette des Beaux-Arts* no. 24 (1943), pp. 175–82.
57 For more on this, see Lieve Spaas, 'Surrealism and anthropology: in search of the primitive', in *Paragraph* 18, no. 2, 'Mapping the Other: Anthropology and Literature's Limit' (July 1995), pp. 163–73.
58 *De près et de loin*, p. 54.
59 Claude Lévi-Strauss, *Le Regard éloigné*, Paris: Plon, 1983.
60 In the exhibition 'Tanguy et objets d'Amérique' at the Galerie Surréaliste, 7 May–15 June 1927. See p. 29.
61 Quoted in Alain Paire, 'André Breton et Claude Lévi-Strauss', http://www.galerie-alain-paire.com/index.php?option=com_content&view=articl e&id=120:andre-breton-et-claude-levi-strauss-marseille-new-york&catid=.
62 Quoted in Paul McRandle, *Surrealist NYC*, 31 January 2013, https://surrealistnyc.tumblr.com/post/44368544263/artists-in-exile.
63 'Moon Dancers: Yup'ik Masks and the Surrealists': Di Donna Galleries, New York, May–June 2018.
64 New York, February 1942.
65 Along with other American prints of Masson's, this was published by Curt Valentin at the Buchholz Gallery. For more on these prints, see Gilbert Kaplan et al. (eds), *Surrealist Prints*, New York: Harry N. Abrams, Inc., 1997.
66 Carl O. Schniewind, 'The Prints of Marc Chagall', in James Johnson Sweeney, *Marc Chagall*, New York: Museum of Modern Art, 1946, pp. 72–87.
67 Quoted in Gary Comenas, 'Andre Breton: Surrealism, Dada and the Abstract Expressionists', https://www.academia.edu/3719929/Andre_Breton_Surrealism_Dada_and_the_Abstract_Expressionists.
68 Clement Greenberg, 'Avant-Garde and Kitsch', *Partisan Review* 6, no. 3 (Fall 1939), pp. 34–9.
69 Letter, André Masson to Saidie May, November 1941. Saidie A. May Papers, Correspondence, Folder 6, Archives and Manuscripts Collections, The Baltimore Museum of Art.
70 Masson, *Les Années surréalistes*.
71 Masson to Kahnweiler, 2 December 1941. In André Masson, *Les Années surréalistes. Correspondance 1916– 1942*, ed. Françoise Levaillant, Paris: La Manufacture, 1990, p. 279.
72 To the end of his life, Lévi-Strauss would receive letters and bankers' drafts, often from Africa, placing orders for blue jeans.
73 Eugene Jolas, preface to *Words from the Deluge*, New York: Gotham Book Mart, 1941, np.

Towards a New Painting

CHAPTER 4

1 William Rubin, 'Notes on Masson and Pollock', *Arts* 34, no. 2 (November 1959), pp. 36–43.
2 In John O'Brian (ed.), *Clement Greenberg: The Collected Essays and Criticism*, Chicago: University of Chicago Press, 1986, vol. 1; quoted in Steven Naifeh and Gregory White Smith, *Jackson Pollock: An American Saga*, London: Barrie & Jenkins, 1990, p. 418.
3 This ran from 27 January–22 April 1941. Ernst owned the catalogue to the exhibition.
4 *Indian Art of the United States*, exh. cat., New York: Museum of Modern Art, 1941, p. 8.

5 Barnett Newman, 'What About Isolationist Art' (1942), in John P. O'Neill et al. (eds), *Barnett Newman: Selected Writings and Interviews*, Berkeley: University of California Press, 1992, pp. 20–8.

6 Samuel Kootz, *New Frontiers in American Painting*, New York: Architectural Book Publishing Co., Inc., 1943, p. 16.

7 *Ibid.*, pp. 18–19.

8 *Ibid.*, pp. 18–19.

9 Newman, 'What About Isolationist Art'.

10 Kootz was surpassed as a homophobe by André Breton, who described Ford and his co-editor, Parker Tyler, as 'belonging to the detested race of homosexuals' and dubbed *View* 'pederasty international'. See Mark Polizzotti, *Revolution of the Mind: The Life of André Breton*, London: Bloomsbury, 1995.

11 Museum of Modern Art, 15 May–30 September 1940; Nicolas Calas, 'Mexico Brings Us Art', *View* 1, no. 1 (September 1940), np.

12 Quoted in Steven Naifeh and Gregory White Smith, *Jackson Pollock: An American Saga*, London: Barrie and Jenkins, 1990, p. 418.

13 Philip Pavia Papers, transcript of taped interview of Philip Pavia by Bruce Hooton, 19 January 1965, Archives of American Art, Smithsonian Institution, Washington, DC.

14 Archives of American Art/Smithsonian Institution: Priscilla Cunningham Papers regarding Sue Fuller, 'Atelier 17 and the New York Avant-Garde, 1940–55'. Panel presentation by Sue Fuller, Pollock-Krasner House and Study Center, 1 May–31 July 1993.

15 Enrique Zañartu in Eugene Berman et al., *Artistes en exil*, exh. cat., Paris: American Centre for Students and Artists, 1968, p. 50.

16 Robert Motherwell in Riva Castleman et al., *American Prints 1913–63*, exh. cat., New York: Museum of Modern Art, 1972, p. 111.

17 Quoted in Heidi Colsman-Freyberger, 'Robert Motherwell: Words & Images', *The Print Collector's Newsletter* iv, no. 6 (January–February 1974), p. 24.

18 In Riva Castleman et al., *American Prints 1913–63*, exh. cat., New York: Museum of Modern Art, 1972.

19 Quoted in Piri Halasz, 'Stanley William Hayter: Pollock's Other Master', *Arts Magazine* 59, no. 3. (November 1984).

20 Letter from Robert Motherwell to Stanley William Hayter, 909 North Street, Greenwich, CT 06830, 14 April 1981. Hayter Papers, Tate Archive, TGA 200510/2/65.

21 'Atelier 17: 1927 Paris–New York 1950', Galerie de Seine, Paris, 22 October–28 November 1981.

22 The print has customarily been known – see, for example, Siri Engberg et al., *Robert Motherwell: Prints 1940–1991, Catalogue Raisonné* – as *The Jewish Girl* rather than *The Jewish Bride*, the latter being the name of one of Rembrandt's most famous etchings, an early state of which is in the Metropolitan Museum of Art. Motherwell's misnaming of his own work is intriguing.

23 Letter to Stanley William Hayter from Heidi Colsman-Freyberger, sent from Motherwell's Greenwich, CT studio, 11 April 1976. Hayter Papers, Tate Archive, TGA 200510/2/29.

24 He also gave the Chareaus another 1944 work, an ink on paper drawing called 'Constructed Figures.'

25 The Chareaus were Jewish.

26 Letter, Motherwell to Hayter, 14 April 1981. Hayter Papers, Tate Archive, TGA 200510/2/65.

27 Two impressions of *The Jewish Girl/Bride* have been found since Motherwell's letter, one having been

given to a relation of his and the other to a classmate at Columbia.

28 Stephanie Terenzio (ed.), *The Collected Writings of Robert Motherwell*, Oxford and New York: Oxford University Press, 1992, p. 203.

29 Drawings and Prints Department, Museum of Modern Art, New York, object no. 77.1944.

30 This is listed in the Dedalus Foundation's *catalogue raisonné* as *Three Personages Shot*.

31 See *An Exhibition of the Work of Robert Motherwell*, exh. cat., Northampton, MA: Smith College Museum of Art, 1963, np; no. 3, ill., describes the origins of this work's title.

32 Hayter Memorial, New School, 17 November 1988; New School Archives.

33 Robert M. Coates, 'The Art Galleries: New Ideas', *New Yorker*, 3 January 1948, pp. 44–5.

34 *Ibid.*, pp. 44–5.

35 *Ibid.*, pp. 44–5.

36 See footnote 11, above.

37 See British Museum artists' notes: 'De Kooning was first introduced to printmaking at Hayter's Atelier 17 in New York, where he worked briefly in about 1943, although no prints have survived.'

38 Halasz, 'Pollock's Other Master'.

39 *Ibid.*

40 The whereabouts of the other, smaller version is unknown.

41 I am indebted to Michael Preble, head of the Baziotes catalogue raisonné project, for linking the Atelier 17 print to another painting in the 1944 series, *The Boudoir*.

42 Jacob Kainen, 'An Interview with Stanley William Hayter', *Arts Magazine* 60, no. 5 (January 1986).

43 On the supposed loss of Rothko's Atelier 17 prints, see Martica Sawin, 'Stanley William Hayter at 84', *Arts*

Magazine 60, no. 5 (January 1986), p. 61.

44 James Breslin, *Mark Rothko: A Biography*, Chicago: University of Chicago Press, 1993, p. 289.

45 *Ibid.*, p. 289.

46 *Ibid.*, p. 289.

47 I assume the misdating to have come about thanks to the confusion surrounding Rothko's estate following his death.

48 Terenzio, *Collected Writings*, p. 166.

49 Both untitled; Museum of Modern Art object numbers 462.1986 and 459.1986 respectively.

50 In 'The Romantics Were Prompted', *Possibilities*, I (Winter 1947/8), p. 53.

51 André Masson, *Anatomy of My Universe*, New York: Curt Valentin, 1943.

52 Jewell, 'Modern Painters Show Opens Today'; review of the Third Annual Exhibition of the Federation of Modern Painters and Sculptors, Wildenstein Gallery, New York, 3–26 June 1943. *New York Times*, 2 June 1943, p. 28; and 'End-of-the-Season Melange', *New York Times*, 6 June 1943.

53 3rd Annual Exhibition of the Federation of Modern Painters and Sculptors, exh. cat., New York: Wildenstein Gallery, 3–26 June 1943, np.

54 'A Letter from Mark Rothko and Adolph Gottlieb to the Art Editor of the New York Times', *New York Times*, 13 June 1943.

55 *Syrian Bull* was the title of one of the offending works.

56 '"Globalism" Pops Into View/Puzzling Pictures in the Show by the Federation of Modern Painters and Sculptors Exemplify the Artists' Approach', *New York Times*, 13 June 1943.

57 Nathaniel Pousette-Dart, 'Freedom of Expression', *Art & Artists of Today*, June–July 1940, p. 49.

CHAPTER 4

58 George L.K. Morris et al., 'What Abstract Art Means to Me: Statements by Six American Artists', *The Museum of Modern Art Bulletin* 18, no. 3 (Spring 1951), pp. 12–13.

59 In 'The Portrait and the Modern Artist', WNYC's *Art in New York* radio show, 13 October 1943; see https://www.wnyc.org/story/rothko-and-gottlieb-discuss-portrait-and-modern-artist-wnycs-art-new-york/.

60 Clement Greenberg, 'Avant-Garde and Kitsch', *Partisan Review* 6, no. 3 (Fall 1939), pp. 34–9.

61 André Masson to Alfred Jensen, 12 August 1941, in Masson, *Les Années surréalistes. Correspondance 1916–1942*, ed. Françoise Levaillant, Paris: La Manufacture, 1990, p. 275.

62 Statement in *A Painting Prophecy – 1950*, exh. cat., Washington, DC: David Porter Gallery, 1945.

63 Sidney Janis, *Abstract and Surrealist Art in America*, New York: Reynal & Hitchcock, 1944, p. 89.

64 *Ibid.*, p. 51.

65 Robert Motherwell, 'Painters' Objects', *Partisan Review* 11, no. 1 (Winter 1944), pp. 93–7.

66 *Ibid.*

67 Robert Motherwell, 'The Modern Painter's World', in Terenzio, *Collected Writings*, p. 31.

68 Motherwell, 'Painters' Objects'.

69 'Hayter and Studio 17: New Directions in Gravure', Museum of Modern Art, New York, Exh. #259, 18 June–8 October 1944, then travelling around the USA and South America until February 1948.

70 Stanley William Hayter, oral history interview by Paul Cummings, 11 March 1971, Archives of American Art, Smithsonian Institution, Washington, DC.

71 *Museum of Modern Art Bulletin* (Summer 1944), pp. 4, 5.

72 Clement Greenberg, 'The Crisis of the Easel Picture' (1948), in O'Brian, *Clement Greenberg*, vol. 2, pp. 221ff.

Pollock Makes a Print

CHAPTER 5

1 From Barbara Rose, 'Jackson Pollock at Work: An Interview with Lee Krasner', *Partisan Review* 47, no. 1 (1980), pp. 82–92.

2 Charles Morgan, *The Fountain*, London: Macmillan, 1932, p. 49.

3 Quotes from Ferdin and Protzman, 'The Photographer's Snap Judgment', *Washington Post*, 23 May 1999.

4 For more on Kadish's early friendship with Pollock, see B.H. Frieman, *Jackson Pollock: Energy Made Visible*, Boston: Da Capo Press, 1995.

5 Stanley William Hayter, interview by Jeffrey Potter, 11 June 1983: Jeffrey Potter Collection, Pollock-Krasner House and Study Center, Stony Brook University, Stony Brook, NY.

6 *Ibid.*

7 Hayter: 'Jackson Pollock always claimed that he had two masters, Benton and me'; see Piri Halasz, 'Stanley William Hayter: Pollock's Other Master', *Arts Magazine* 59, no. 3 (November 1984).

8 Stanley William Hayter, interview by Jeffrey Potter, 18 June 1983: Jeffrey Potter Collection, Pollock-Krasner House and Study Center, Stony Brook University, Stony Brook, NY.

9 *Ibid.*

10 In an interview in November 1985, Robert Motherwell claimed that he had written Pollock's responses to Putzel for him. See Martica Sawin, *Surrealism in Exile and the Beginning of the New York School*, Boston: MIT Press, 1995, p. 347.

NOTES

11 Namuth in *Pollock Painting*, New York: Dodd, Mead & Co., 1980, np, cited in Kirk Varnedoe, *Jackson Pollock*, New York: Museum of Modern Art, 1998, p. 89. Namuth actually made two films of Pollock a few weeks apart, the first in black and white.

12 In 'Art: Chaos, Damn It', 20 November 1950. The *Time* review is an excerpt from one in *L'Arte Moderna* by the Italian critic Bruno Alfieri. Reproduced in translation as 'A Short Statement on the Painting of Jackson Pollock' in Pepe Karmel, *Jackson Pollock: Interviews, Articles, and Reviews*, New York: Museum of Modern Art, 1999, p. 68.

13 Anna Hammond, '"No Chaos, Dammit": An Interview with James Coddington, Chief Conservator': *MoMA* 1, no. 7 (November–December 1998), pp. 6–11.

14 *Ibid.*

15 *Ibid.*

16 Siqueiros opened the workshop in March 1936; it closed when he left to fight in the Spanish Civil War a year later.

17 Harold Lehman, oral history interview by Stephen Polcari, 28 March 1997, Archives of American Art, Smithsonian Institution, Washington, DC.

18 Jeffrey Potter, *To a Violent Grave: An Oral Biography of Jackson Pollock*, New York: Putnam, 1985, p. 101.

19 Patrick Waldberg, *Max Ernst*, Paris: Société des Editions Jean-Jacques Pauvert, 1980, p. 388. Motherwell disputed Waldberg's claim, both for himself and for Pollock: see William Rubin, 'Jackson Pollock and the Modern Tradition VI: An Aspect of Automatism', *Artforum* 5, no. 9 (May 1967), pp. 36–46.

20 Sidney Simon, 'Concerning the Beginnings of the New York School, 1939–1943: Interviews with Peter Busa, Roberto Matta and Robert Motherwell', *Art International* xi, no. 6 (Summer 1967).

21 Hayter insisted that Ernst's first drip paintings had been made at Atelier 17 in New York: 'Those things of his were done at my place.' See Piri Halasz papers: Writings and related materials, Box 1/2: 'Some Documentation for Ambiguity: Interview with Stanley William Hayter', 20 May 1983, p. 22, Archives of American Art, Smithsonian Institution, Washington, DC.

22 Potter, *To a Violent Grave*, p. 100.

23 Letter, Kamrowski to William Rubin, 10 April 1975; quoted in Jeffrey Wechsler, *Surrealism and American Art 1931–1947*, New Brunswick, NJ: Rutgers University Art Gallery, 1976, p. 55.

24 Hayter and Potter interview, 18 June 1983.

25 Hayter and Potter interview, 11 June 1983.

26 *Ibid.*

27 *Ibid.*

28 Jackson Pollock, 'Interview with William Wright' (1950), reprinted in Karmel, *Jackson Pollock*, p. 23. The interview was recorded in the summer of 1950 for a Rhode Island radio station, but was never used.

29 For more on this, see Irene Herner, 'Siqueiros and Surrealism?', *Journal of Surrealism and America* 3, nos 1–2 (2009), p. 124.

30 Axel Horn, 'Jackson Pollock: The Hollow and the Bump', *The Carleton Miscellany* 7, no. 3 (Summer 1966), pp. 85–6.

31 Motherwell in Max Kozloff, 'An Interview with Robert Motherwell', *Artforum* 4, no. 1 (September 1965), p. 37.

32 The New School sold Benton's mural in 1984 to the insurance company AXA, which in turn gifted it to the Metropolitan Museum of Art in 2012.

CHAPTER 5

203

33 Hayter and Potter interview, 18 June 1983.

34 See Chapter 2, pp. 53–7.

35 Potter, *To a Violent Grave*, p. 81.

36 Karl Schrag, oral history interview by Paul Cummings, 14–20 October 1970; Karl Schrag Papers, Archives of American Art, Smithsonian Institution, Washington, DC.

37 Quoted in Deborah Solomon, *Jackson Pollock: A Biography*, New York: Simon & Schuster, 1987, p. 149.

38 James Lane, 'Melange', *Art News* xl (15–31 January 1942), p. 29.

39 *VVV* 1, no. 1 (June 1942).

40 It failed to do so. Due to lack of demand, only twenty of the intended fifty examples were ever produced.

41 Quoted in Hayter's obituary by Michael Brenson, *New York Times*, 6 May 1988, p. 28.

42 Numbered 697 in Francis V. O'Connor and Eugene V. Thaw, *Jackson Pollock: A Catalogue Raisonné of Paintings, Drawings and Other Works*, New Haven and London: Yale University Press, 1978.

43 Namuth, *Pollock Painting*, cited in Varnedoe, *Jackson Pollock*, p. 89.

44 *A New Way of Gravure*, dir. Jess Paley (1950).

45 Hayter, 'Atelier 17', *Graphis* x, no. 55 (1954), intro. Max Clarac-Sérou.

46 *The Collected Works of C.G. Jung, vol. 15: Spirit in Man, Art and Literature*, London: Routledge & Kegan Paul, 1966, p. 130.

47 For more on Pollock's Jungianism, see Judith Wolfe, 'Jungian Aspects of Jackson Pollock's Imagery', *Artforum* 11, no. 3 (November 1972), pp. 65–73.

48 In 'Art: On a Mexican Wall', *Time* xxv, no. 13 (1 April 1935).

49 Reuben Kadish and Barbara Kadish, interview by Herman Cherry, Kadish Studio, 221 East Ninth Street, NY, 28 October 1981; Pollock-Krasner House and Study Center archives,

Stony Brook University, Stony Brook, NY.

50 *Ibid*. Hayter had encouraged him to edition the prints and sell them for $10–15 each. With the WPA programme over, Pollock had run out of money. He refused.

51 *Ibid*.

52 Quoted in Gary Comenas, 'Abstract Expressionism 1944', 2009 (updated 2016), at *Warholstars. org*, https://warholstars.org/ abstract-expressionism/timeline/ abstractexpressionism44.html.

53 *Ibid*.

54 'Jackson Pollock', MoMA exhibition #824, 5 April–4 June 1967.

55 William S. Lieberman, oral history interview by Sharon Zane, 6 April 1993, New York, Museum of Modern Art Oral History Program. Recalling his find, Lieberman had gone on to say, 'If you have time, go to Hirschl & Adler uptown. There are two interesting, small retrospectives there: upstairs, one of Stanley William Hayter – remember, several of the Abstract Expressionists studied printmaking with him.' It was a late, if fleeting, moment of recognition of Hayter's role. The exhibition Lieberman mentioned was 'Stanley William Hayter: The Prints to 1960', Hirschl & Adler, New York, 1 May–18 June 1993.

56 For a full description of the prints see O'Connor and Thaw, *Jackson Pollock: A Catalogue Raisonné*.

57 Stanley William Hayter, transcript of interview by Pat Gilmour, spring 1982, Hayter Papers, Tate Archive.

58 Hayter and Potter interview, 18 June 1983.

59 *Mural* is now in the Stanley Museum of Art, Iowa City. Typical of the myth of Pollock as a driven genius, the work was long held to have been painted in a single day (New Year's Day 1943).

NOTES

It is now known to have been made over a course of days or weeks: see O'Connor and Thaw, *Jackson Pollock: A Catalogue Raisonné*.

60 Hayter and Potter interview, 11 June 1983.

61 For comparison, these are, respectively, object numbers 1171.1969 and 440.1969 in MoMA's online catalogue.

62 'Joan Miró', Museum of Modern Art, 19 November 1941–11 January 1942.

63 Museum of Modern Art object number 1182.1969.

64 Museum of Modern Art object number 1180.1969.

65 Pollock, 'Interview with William Wright'.

66 Hayter and Potter interview, 11 June 1983.

67 *Ibid.*

68 In 'Paul Klee, André Masson and Some Aspects of Ancient and Primitive Sculpture', 23 February–20 March 1943.

69 Quoted in Jean-Paul Clébert (ed.), *Mythologie d'André Masson*, Geneva: Pierre Cailler, 1971. This would seem

to have been wishful thinking on Masson's part, perhaps the result of misreporting. Pollock's *Pasiphae* was originally called *Moby-Dick*: it was James Johnson Sweeney who suggested the change of name.

70 Jacob Kainen, 'An Interview with Stanley William Hayter', *Arts Magazine* 60, no. 5 (January 1986). In the interview, Hayter is quoted as saying 'State Street'; presumably a mistranscription of Eighth Street. Masson was certainly working at Atelier 17 in the winter of 1944–5; see letter from Masson dated 11 March 1971 in B.H. Friedman, *Jackson Pollock: Energy Made Visible*, London: Weidenfeld & Nicolson, 1973, pp. 72–3.

71 John Bernard Myers, 'Surrealism and New York Painting 1940–1948: A Reminiscence', *Artforum* 15, no. 8 (April 1977).

72 Interview, Guy Habasque, 1959; q. Jean-Paul Clébert, *Mythologie d'André Masson*, Geneva: Pierre Cailler, 1971, p. 75.

73 Sawin, *Surrealism in Exile*, p. 422.

To Eighth Street

CHAPTER 6

1 In *Atelier 17*, New York: Wittenborn & Schultz, 1949, pp. 4–6. Mayor was keeper of prints at the Metropolitan Museum of Art.

2 Gabor Peterdi, oral history interview by Paul Cummings, 29 April 1971, Archives of American Art, Smithsonian Institution, Washington, DC.

3 Charles Henri Ford to Gertrude Cato, Ford Papers, Harry Ransom Center, The University of Texas, Austin.

4 Museum of Modern Art Archives, Curt Valentin Papers, III.19.[1], 1/3.

5 Museum of Modern Art Archives, Curt Valentin Papers, III,

19 February 1946. '[Diego] is sobbing, and I have promised him that you will send replacements at once.'

6 *Ibid.*, 1 May 1946.

7 The precise date of the move is unknown although it must have been after 20 April, when Hayter wrote to Roger Vieillard in Paris: 'I teach at the New School here and also at the Print Club in Philadelphia. I have 50 students and could have a hundred if I would take them.' Hayter papers, Tate Archive.

8 Stanley William Hayter, oral history interview by Paul Cummings, 11 March 1971, Archives of American

CHAPTER 6 205

Art, Smithsonian Institution, Washington, DC.

9 See Joann Moser, *Atelier 17: A 50th Anniversary Retrospective Exhibition*, exh. cat., Madison: Elvehjem Art Centre, University of Wisconsin, 1977.

10 Hayter and Cummings interview, 11 March 1971.

11 In *Formes; revue internationale des arts plastiques*, vi (June 1930).

12 Museum of Modern Art Archives, James Thrall Soby Papers, 1944.

13 Ruthven Todd, 'Miró in New York: A Reminiscence', *Malahat Review: An International Quarterly of Life and Letters*, 1 (January 1967).

14 Pollock had not yet begun his practice of painting on the floor. See Barbara Rose, 'Jackson Pollock at Work: An Interview with Lee Krasner', *Partisan Review* 47, no. 1 (1980), pp. 82–92 (p. 87).

15 Deborah Solomon, *Jackson Pollock: A Biography*, New York: Simon & Schuster, 1987.

16 Hayter, interview with Peter Grippe, 9 February 1953, p. 2; Grippe Collection, Allentown Art Museum, Allentown, PA. In 1953, Slivka would gain momentary fame by breaking into the undertaker's where Dylan Thomas's body was lying and taking a death mask from the poet.

17 Doris Seidler *née* Falkoff was an Englishwoman who, like Hayter, had come to New York in 1940. Seidler and her husband were Jewish. She studied at Atelier 17 before going back to London in 1945. She returned to New York in 1948 and spent the rest of her life as a professional printmaker. Quoted in Christina Weyl, *The Women of Atelier 17: Modernist Printmaking in Midcentury New York*, New Haven: Yale University Press, 2019, p. 57.

18 Advertising flyer, Tate Archive, Hayter Papers TGA 200510/3/201/1.

19 Hayter and Cummings interview, 11 March 1971.

20 Hayter, letter to Roger Vieillard, 20 April 1945; Stanley William Hayter Papers, Tate Archive, London.

21 18 June–8 October 1944.

22 Memo from Miss Hawkins to Mr Antrobus, MoMA Exhibition Papers EXH #259, Museum of Modern Art Archives, New York.

23 Hayter and Cummings interview, 11 March 1971.

24 *Ibid.*

25 Emily Genauer, *New York World Telegram*; editorial, *New York Times*; Henry McBride, *The Sun, New York*. All quoted in an annexe to MoMA Exh. #0259 master checklist.

26 Letter dated 4 October 1944, Cynthia Brants Papers, Robert E. Nail Jr Archive, Old Jail Arts Center, Albany, TX. Quoted in Weyl, *The Women of Atelier 17*, p. 11.

27 William S. Lieberman, oral history interview by Sharon Zane, 6 April 1993, New York, Museum of Modern Art Oral History Program.

28 MoMA Exh. #0252, 16 February–10 May 1944.

29 'Hayter: Recent Paintings and Drawings', 6–31 January 1945.

30 'Colour and Space in Modern Art Since 1900', 19 February–18 March 1945.

31 'Mark Rothko: Exhibition of Watercolours', 22 April–4 May 1946.

32 *New York Times*, 14 January 1945. Rothko had been given his first solo show by Peggy Guggenheim at Art of This Century; Miró was showing at Pierre Matisse.

33 *Ibid.*

34 *Art News* no. 43 (15 January 1945).

35 *New York Times*, 14 January 1945.

36 *Hayter and Studio 17: New Directions in Gravure*, exh. cat., New York: Museum of Modern Art, Exh. #259, 18 June–8 October 1944, p. 4.

206 NOTES

37 *Ibid.*, p. 5.
38 Archives of American Art, Betty Parsons Papers, correspondence with S.W. Hayter. Parsons, later a noted gallerist herself, was working for Brandt at the time.
39 Hayter and Cummings interview, 11 March 1971.
40 *World-Telegraph*, 13 January 1945.
41 Peterdi and Cummings interview, 29 April 1971.
42 Betty Parsons to Mrs John F. Becker, Cincinnati Modern Art Society, 22 January 1945.
43 Mrs John F. Becker to Betty Parsons, 29 January 1945.
44 Betty Parsons to S.W. Hayter, 22 March 1945.
45 Letter from S.W. Hayter to Monroe Wheeler, undated; Museum of Modern Art Archives, New York. Exhibition Papers for Exh #259.
46 Helen Phillips Hayter, interview by Jeffrey Potter, 5 November 1982; Pollock-Krasner House and Study Center archives, Stony Brook University, Stony Brook, NY.
47 Jimmy Ernst, *A Not-So-Still Life*, Wainscott, NY: Pushcart Press, 1992, pp. 250–1.
48 Helen Harrison, *From Barbizon to Bonac: East Hampton As an Art Colony*, transcript of lecture given on 24 April 1998.
49 At 830 Fireplace Road, now the Pollock-Krasner House and Study Center.
50 In Jacob Kainen, 'An Interview with Stanley William Hayter', *Arts Magazine* 60, no. 5 (January 1986).
51 See Chapter 3, pp. 61–2.
52 It was then on Eighth Street, moving to University Place in 1953.
53 Piri Halasz papers: Writings and related materials, Box 1/2: 'Some Documentation for Ambiguity: Interview with Stanley William Hayter', 20 May 1983, Archives of American

Art, Smithsonian Institution, Washington, DC.
54 Karl Schrag, oral history interview by Paul Cummings, 14–20 October 1970; Karl Schrag Papers, Archives of American Art, Smithsonian Institution, Washington, DC.
55 See Robert Broner, oral history interview by Dennis Barrie, 3–8 May 1974, Archives of American Art, Smithsonian Institution, Washington, DC.
56 Karl Schrag, oral history interview by Paul Cummings.
57 Ian Hugo, *New Eyes on the Art of Engraving*, Yonkers: Alicat Book Shop, 1947. Alicat also published, among other chapbooks, Henry Miller's *Obscenity and the Law of Reflection* and Shelley's *The Necessity of Atheism*.
58 Anaïs Nin, *The Journals of Anaïs Nin, 1934–1939*, London: Peter Owen, 1967, p. 182.
59 *Ibid.*, p. 307.
60 *Ibid.*
61 Leo Katz, foreword to Hugo, *New Eyes on the Art of Engraving*, n. 57.
62 *Ibid.*
63 Hayter explains the diagnosis in a letter to Roger Vieillard, 23 October 1945, Tate Archive, Hayter Papers.
64 Stanley William Hayter, 'The Language of Kandinsky', *The Magazine of Art* 38, no. 5 (May 1945). Hayter singled out Kandinsky's *Point and Line to Plane* as particularly significant to him.
65 Letter, Valentin to Stanley William Hayter, 41 East Eighth Street, 21 May 1946, Curt Valentin Papers, Museum of Modern Art Archives.
66 Quoted in Pierre-François and François Albert, *Hayter le Peintre*, Montreuil: Gourcuff Gradenigo, 2011.
67 Stanley William Hayter, 'Paul Klee, Apostle of Empathy', *Magazine of Art* 39, no. 4 (April 1946), p. 127.

CHAPTER 6 · 207

68 I am indebted to Mrs Désirée Levy-Hayter for this. 'Bill never voted in his life,' she says.

69 Kainen, 'Interview with Stanley William Hayter'.

70 For more on this, see William Rubin, 'Jackson Pollock and the Modern Tradition VI: An Aspect of Automatism', *Artforum* 5, no. 9 (May 1967), pp. 36–46.

71 Now in the collection of the Museum of Fine Arts, Houston, object no. 96.1756. See Francis V. O'Connor and Eugene V. Thaw, *Jackson Pollock: A Catalogue Raisonné of Paintings, Drawings and Other Works*, New Haven and London: Yale University Press, 1978, 1, no. 130, p. 129.

72 Schrag and Cummings interview, 1970.

73 *Ibid.*

74 Letters to Stanley William Hayter and James Thrall Soby, both 30 January 1947, Monroe Wheeler Papers, I.175, Museum of Modern Art Archives, New York.

75 'Stanley William Hayter: Dessins, gouaches et gravures', Galerie Jeanne Bucher, Paris, 14–29 June 1946.

76 Speech given at the Worcester Art Museum, Sunday 24 February 1946; copy in the Dedalus Foundation Archive.

77 *Ibid.*

78 From a full-page advertisement in *Cahiers d'Art*, June 1946. Hayter's exhibition was to be the last dedicated by Bucher to a single artist. In November 1946, she died suddenly at the age of seventy-four. Motherwell's show never took place.

79 'Toutes les Expositions: Stanley William Hayter', *Arts*, 21 June 1946, p. 4.

80 Jean-Paul Sartre, 'Paris Alive: The Republic of Silence', *Atlantic Monthly*, December 1944, pp. 39–40.

81 Jean-Paul Sartre, 'The New Writing in France: The Resistance "taught that literature is no fancy activity independent of politics"', *Vogue*, July 1945, p. 84; 'Portraits of Paris', *Vogue*, June 1946, p. 162.

82 Simone de Beauvoir, 'Strictly Personal', *Harper's Bazaar*, January 1946, pp. 113, 160.

83 Clement Greenberg, 'Jean Dubuffet and French Existentialism', *Nation*, July 1946. Reprinted in J. O'Brian (ed.), *The Collected Essays and Criticism of Clement Greenberg: Arrogant Purpose, 1945–49*, Chicago: University of Chicago Press, 1986, pp. 91–2.

84 Motherwell, in George L.K. Morris et al., 'What Abstract Art Means to Me: Statements by Six American Artists', *The Museum of Modern Art Bulletin* 18, no. 3 (Spring 1951), pp. 12–13.

85 Harold Rosenberg, 'The American Action Painters', *Art News*, December 1952, pp. 22–3, 48–50.

86 For more on this, see P. Manoguerra et al., *Art Interrupted: Advancing American Art and the Politics of Cultural Diplomacy*, exh. cat., Athens, GA: Georgia Museum of Art, 2012.

87 In John P. O'Neill, *Barnett Newman: Selected Writings and Interviews*, Berkeley: University of California Press, 1992, pp. 94–5.

Blake, Bourgeois, Miró

CHAPTER 7

1 Stanley William Hayter, interviewed in his Paris studio for Colette Roberts' 'Meet the Artist' programme at New York University. Colette Roberts papers, Archives of American Art, Smithsonian Institution, Washington, DC.

NOTES

2 Poem written for Stanley William Hayter in *Fifteen Poems, a Collaboration using the Printing Methods of William Blake* (1947).

3 Letter, Calder to? Warner, 15 February 1947, Calder Archive. The apartment belonged to Yves Tanguy, who had lent it. The LaSalle was a less expensive version of the luxury Cadillac. Matisse was Pierre Matisse, whose gallery had shown Miró's work in New York since the early 1930s.

4 *Mural for the Terrace Plaza Hotel* (1947), now in the Cincinnati Art Museum.

5 Calder's mobile was *Twenty Leaves and an Apple* (1946), now in the Cincinnati Art Museum.

6 With Francis Lee; published in English as 'Interview with Miró', *Possibilities* no. 1 (Winter 1947–8), pp. 66–7.

7 In John Bernard Myers, *Tracking the Marvellous: A Life in the New York Art World*, London: Thames & Hudson, 1984, p. 87.

8 MoMA object number #1238.1979.

9 In Margit Rowell, *Joan Miró: Selected Writings and Interviews*, London: Thames & Hudson, 1986, p. 190.

10 Lee, 'Interview with Miró'.

11 For more on these, see Michel Leiris, 'Eléments pour un biographie' [1940], in Jean-Louis Barrault et al., *André Masson*, Marseilles: André Dimanche, 1993, pp. 7–17.

12 'Aquarelles de Turner, oeuvres de Blake', 15 January–15 February 1937.

13 Letter, Hayter to Valentin, Amagansett, Long Island, 26 August [undated, but presumably 1944]; Museum of Modern Art Archives, Curt Valentin Papers, III.A.13.[4].

14 This is now in the Library of Congress in Washington, DC, Lessing J. Rosenwald Collection (PR4144.A51794).

15 The fragment was given as practice material to a pupil of Blake's, Thomas Butts, Jr, who was training as an engraver. It bears marks made by Butts' hand.

16 Ruthven Todd, 'Miró in New York: A Reminiscence', *Malahat Review: An International Quarterly of Life and Letters* 1 (January 1967), pp. 77–92.

17 See, for example, the long-running feud in *Blake: An Illustrated Quarterly* provoked by the appearance of Martin Butlin's article, 'William Blake, S.W. Hayter and Colour Printing' in vol. 36, issue 2 (2002), et much seq.

18 For more on Todd, see Peter Main, *A Fervent Mind: The Life of Ruthven Todd*, Stirling: Lomax Press, 2018.

19 For more on this, see S. Clark et al. (eds), *Blake 2.0: William Blake in Twentieth-Century Art, Music and Culture*, London: Palgrave Macmillan, 2012.

20 The Fred Becker Papers at the Archives of American Art contain an intriguing object, a bound book bearing the title *Revealed* and containing glued pages from both *Winter of Artifice* and *Under a Glass Bell* together with a selection of prints by Ian Hugo, different from the ones in either book. It was presumably made as a dummy to the later work and given to Becker by Hugo as a gift, the two men having helped each other with its production.

21 Carla Esposito Hayter, 'Miró and Hayter: New York, 1947', unpublished essay, 2021.

22 *Ibid*. Esposito Hayter's information in turn came from a letter from Becker to David Acton at the Worcester Art Museum, Worcester, MA.

23 *Ibid*.

24 *Ibid*.

25 Todd, 'Miró in New York'.

26 Martica Sawin, 'Recollections of Atelier 17: Fred Becker in conversation with Martica Sawin, 26 May 1999', in *Les Surréalistes en exil et les débuts*

CHAPTER 7 209

de l'école de New York, exh. cat., Strasbourg: Musées de Strasbourg, 2000.

27 This is often, and erroneously, dated as 1951, the date of its release.

28 *Joan Miró makes a color print*, 1947, Thomas Bouchard Collection, Harvard Film Archive (HFA item no. 39011).

29 In the MoMA collection as *Young Girl Skipping Rope, Women, Birds*, object number #342.1947.7.

30 Todd, 'Miró in New York'.

31 A *bruñidor* is a kind of etching tool.

32 Myers, *Tracking the Marvellous*, p. 88.

33 Letter dated 9 July 1947, Town Farm, Woodbury, CT; in *Yves Tanguy: Lettres de loin, addressées à Marcel Jean*, Paris: Le Dilettante, 1992, p. 44.

34 This print was included in a volume published in New York in 1947 at the behest of Curt Valentin, reproducing a set of lithographs Miró had made in Paris in 1939.

35 Lee, 'Interview with Miró'.

36 Foreword, *Tiger's Eye* 1, no. 1 (1947). Ruth Stephan *née* Walgreen was heiress to the fortune amassed by her father's eponymous chain of drug stores.

37 In Deborah Wye and Carol Smith, *The Prints of Louise Bourgeois*, New York: Museum of Modern Art, 1994.

38 Louise Bourgeois, diary entry, 22–24 April 1947, © The Easton Foundation/Licensed by VAGA at ARS, New York and DACS, London.

39 The 63 of the title was the number on Park Avenue of Bourgeois and Goldwater's first flat in New York. See Wye and Smith, *The Prints of Louise Bourgeois*, cat. 1100.

40 This had been opened in 1943 by Jimmy Ernst, in part to act as a showcase for his own work.

41 For more on these, see Christopher Benfey, *Artists, Intellectuals and World War II: The Pontigny Encounters at*

Mount Holyoke College, 1942–1944, Amherst: University of Massachusetts Press, 2006.

42 Helen E. Patch, *Mount Holyoke Alumnae Quarterly* 28, no. 3 (November 1944), p. 109.

43 The talk was published in Mexico City in the November issue of *Dyn* as 'The Modern Painter's World'; see also Stephanie Terenzio (ed.), *The Collected Writings of Robert Motherwell*, Oxford and New York: Oxford University Press, 1992.

44 Robert Goldwater, 'Reflections on the New York School', *Quadrum* no. 8 (1960), p. 24.

45 *Ibid.*

46 Louise Bourgeois with Rosalind E. Krauss, Robert Rosenblum et al., 'Young at Art: Miró at 100', *Artforum* 32, no. 5 (January 1994), pp. 72–81.

47 'Louise Bourgeois', 28 October–8 November 1947.

48 See p. 35.

49 Respectively object numbers #131.1990.2 and #133.1990.1 in the Museum of Modern Art Prints and Drawings collection.

50 In *Louise Bourgeois, estampes, dessins*, exh. cat., Paris: Bibliothèque nationale de France and Centre Pompidou, 1 February–10 April 1995.

51 Alexander Calder, 'The Ides of Art: 14 Sculptors Write', *Tiger's Eye* 1, no. 4 (15 June 1948), ch. 1, n. 3.

52 Louise Bourgeois, *Destruction of the Father/Reconstruction of the Father: Writings and Interviews, 1923–1997*, Marie-Laure Bernadac and Hans-Ulrich Obrist (eds), Cambridge, MA: MIT Press, 1998, p. 302. Quoted in Christina Weyl, *The Women of Atelier 17: Modernist Printmaking in Midcentury New York*, New Haven: Yale University Press, 2019, p. 83.

53 Quoted in Wye and Smith, *The Prints of Louise Bourgeois*, p. 27.

54 *Ibid.*

210 NOTES

55 In Deborah Wye, *Louise Bourgeois: An Unfolding Portrait*, exh. cat., New York: Museum of Modern Art, 2017.

56 Louise Bourgeois, diary entry, 23–24 January 1949, © The Easton Foundation/Licensed by VAGA at ARS, New York and DACS, London.

57 Carla Esposito Hayter to the author, Paris, 12 November 2019. Esposito Hayter was retelling a story told to her by Gabor Peterdi, who had witnessed the episode. One of the works may have been *Ascension Lente* (1948, MoMA object number #144.1990.8), mentioned on a typewritten list headed 'Hayter 17 Group, Exhibition October 1–24' (1949), held at an unknown venue. Hayter Papers, Tate Archive, TGA 200510/3/205/1.

58 Wye, *Louise Bourgeois*. By contrast, Nevelson would return to Atelier 17 only after Hayter was safely back in France. See Moser, 'The Impact of Stanley William Hayter'.

59 Wye and Smith, *The Prints of Louise Bourgeois*, p. 27.

60 See *Partisan Review* 16, no. 3 (March 1949), no. 8 (August 1949) and no. 9 (September 1949).

61 See notes to the Graphic Arts Collection, 'Anaïs Nin and Louise Bourgeois', Firestone Library, Princeton University, https://graphicarts.princeton.edu.

62 Wye and Smith, *The Prints of Louise Bourgeois*, p. 27.

63 Introduction to Louise Bourgeois, *He Disappeared into Complete Silence*, New York, 1947, np.

64 Wye and Smith, *The Prints of Louise Bourgeois*, p. 72.

65 *Ibid.*, p. 72.

66 The brainchild of the gallerist Louis Pollack, the Peridot would also show the work of, among many others, Philip Guston and Esteban Vicente.

67 Barbara Rose et al., 'Interview with Miró', in *Miró in America*, Houston: Museum of Fine Arts, 1982, p. 120. The exhibition Miró saw was 'Jackson Pollock', Galerie Paul Faccheti, March 1952.

68 *The Nation*, 27 November 1943.

69 All quoted in Elissa Auther, 'The Decorative, Abstraction, and the Hierarchy of Art and Craft in the Art Criticism of Clement Greenberg', *Oxford Art Journal* 27, no. 3 (2004), pp. 341–64.

70 'Surrealist Painting', *The Nation*, 12 and 19 August 1944; republished in John O'Brian (ed.), *Clement Greenberg: The Collected Essays and Criticism*, Chicago: University of Chicago Press, 1986, vol. 1, p. 225.

71 *Ibid.*

After

1 Robert Motherwell, address to the Mid-Western Conference of the College Art Association (CAA), University of Louisville, Kentucky, 27 October 1950. In Stephanie Terenzio (ed.), *The Collected Writings of Robert Motherwell*, Oxford and New York: Oxford University Press, 1992, pp. 76–81.

CHAPTER 8

2 Karl Schrag, oral history interview by Paul Cummings, 14–20 October 1970; Karl Schrag Papers, Archives of American Art, Smithsonian Institution, Washington, DC.

3 The Truman Doctrine allowed the United States to interfere in the domestic affairs of third countries such as Greece in order to prevent them falling under the sway of the

CHAPTER 8

Soviet Union. State funding of the arts became a tool of cultural diplomacy.

4 For more on American participation at the 1948 Biennale, see Joan Marter (ed.), *Abstract Expressionism: The International Context*, New Brunswick, NJ: Rutgers University Press, 2007, p. 141ff.

5 Giorgio Castelfranco, *Bolletino d'arte*, October–December 1948.

6 In Peggy Guggenheim, *Out of This Century: The Autobiography of Peggy Guggenheim*, London: Andre Deutsch, 2005, p. 329.

7 As at the Mortimer Brandt Gallery in 1944 (see p. 132), Hayter is listed as 'William Hayter' in the Guggenheim catalogue. His place of birth is given as South Africa and date, 1915. He was born in London in 1901.

8 *XXIV Biennale di Venezia*, exh. cat., Venice: Edizioni Serenissima, 1948, pp. 330–2.

9 Guggenheim, *Out of This Century*, p. 329.

10 28 March–? April 1947.

11 Rosenberg, 'Introduction to Six American Artists', in *Introduction à la peinture moderne américaine*, exh. cat., Paris: Galerie Maeght, 1947.

12 He would expand on this in his article 'The American Action Painters', writing of the abstract expressionists as working in 'an atmosphere of isolation, anguish and struggle'; *Art News*, December 1952, pp. 22ff.

13 For more on this, see Catherine Dossin, '*Introduction à la Peinture Moderne Américaine* (Galerie Maeght, 1947): An Example of Franco-American Misunderstanding'; in Antje Kramer (ed.), *La circulation des stratégies discursives entre la critique d'art américaine et européenne après 1945: une autre guerre froide?*, Rennes: Archives de la critique d'art et Université de Rennes 2, 2016.

14 In 'The Situation at the Moment', *Partisan Review* 15, no. 1 (January 1948), pp. 80–4; reproduced in John O'Brian (ed.), *Clement Greenberg: The Collected Essays and Criticism*, Chicago: University of Chicago Press, 1986, vol. 2, p. 193.

15 *Ibid.*

16 *Ibid.*

17 Philip Pavia, transcript of taped interview by Bruce Hooton, 19 January 1965, p. 17. Philip Pavia Papers, Archives of American Art, Smithsonian Institution, Washington, DC.

18 *Ibid.*, p. 21.

19 *Ibid.*, pp. 21–2.

20 *Ibid.*, pp. 21–2.

21 Helen Phillips Hayter, interview by Jeffrey Potter, 5 November 1982; Pollock-Krasner House and Study Center archives, Stony Brook University, Stony Brook, NY.

22 Pavia and Hooton interview, 19 January 1965, p. 10.

23 'Yves Tanguy and the New Subject in Painting', in Karin von Maur et al. (eds), *Yves Tanguy and Surrealism*, Ostfildern-Ruit: Hatje Cantz, 2001, p. 203.

24 Rosamund Frost, 'Graphic Revolution: Studio 17' and 'Atelier 17 Group': respectively, *Art News* nos 43 (August 1944) and 44 (June 1945). Quoted in Christina Weyl, *The Women of Atelier 17: Modernist Printmaking in Midcentury New York*, New Haven: Yale University Press, 2019, p. 148.

25 Jeffrey Potter, *To a Violent Grave: An Oral Biography of Jackson Pollock*, New York: Putnam, 1985, p. 81.

26 Phillips and Potter interview, 5 November 1982.

27 *Marionette* (1950) is now in the collection of the San Francisco Museum of Modern Art, https://www.sfmoma.org/artwork/64.68.

28 In Susan M. Anderson, *Pursuit of the Marvelous: Stanley William Hayter, Charles Howard, Gordon Onslow Ford*, Laguna Beach, CA: Laguna Art Museum, 1990.

29 Worden Day, 'Autobiographical Journey as an Artist', Worden Day papers, 1935–1986: Writings, p. 6, Archives of American Art, Rutgers University, 1974.

30 Stanley William Hayter, oral history interview by Paul Cummings, 11 March 1971, Archives of American Art, Smithsonian Institution, Washington, DC. The Tamarind Lithography Workshop is now the Tamarind Institute in Albuquerque, New Mexico.

31 *Ibid.*

32 *Print* 14, no. 1 (January–February 1960).

33 Louise Bourgeois, diary entry, 18 November 1949, © The Easton Foundation/Licensed by VAGA at ARS, New York and DACS, London.

34 Donna Marxer, 'Interviews of Artists, 1977–1992: Stanley William Hayter in Paris, May 1977, in the presence of Minna Citron', Archives of American Art, Smithsonian Institution, Washington, DC.

35 Stanley William Hayter, transcript of interview by Pat Gilmour, spring 1982, Hayter Papers, Tate Archive.

36 *Ibid.*

37 Hayter and Cummings interview, 11 March 1971.

38 Stanley William Hayter, interview by Jeffrey Potter, 18 June 1983: Jeffrey Potter Collection, Pollock-Krasner House and Study Center, Stony Brook University, Stony Brook, NY.

39 Greenberg, quoted in Francis O'Connor, 'The Genesis of Jackson Pollock, 1912–1943', PhD thesis, Johns Hopkins University, 1965.

40 Greenberg, 'The Decline of Cubism', *Partisan Review* 15, no. 3 (March 1948), pp. 366–9.

41 In 'On the Fall of Paris', *Partisan Review* 7, no. 6 (December 1940), pp. 440–8; reproduced in Harold Rosenberg, *The Tradition of the New*, New York: McGraw-Hill, 1959, p. 209.

42 'Revolution and the Concept of Beauty' in Rosenberg, *Ibid.*, p. 80.

43 Miró interviewed by Margit Rowell, Paris, 20 April 1970; in Rowell (ed.), *Joan Miró: Selected Writings and Interviews*, New York: Da Capo Press, 1992, pp. 278ff.

44 Letter to Hayter from Miró, Pasage Crécito 4, Barcelona, dated 26 January 1949. 'Pourrais-tu me dire si tu comptes aller à Paris et quand? Je voudrais retravailler certains cuivres que j'ai commencé à ton atelier et continuer celui que nous avons commencé en collaboration, aussi je voudrais que tu t'occupes du tirage, surtout de ceux en couleur. Et pour le livre avec les poèmes de Toddy que nous avons illustré, ou en sommes nous?' Hayter Papers, Tate Archive, TGA 200510/2/91.

45 Unaddressed letter to Hayter from Chagall, 3 June 1962, Hayter Papers, Tate Archive, TGA 200510/2/88. 'J'ai bien reçu votre lettre du 10 mai par laquelle vous me demandez d'exposer avec vous les vieilles petites choses de quand nous avons travaillé ensemble, dans ce pays lointain. Oui, j'aimerais bien, mais...c'est terrible. Je ne sais pas ou trouver quoi que ce soit de cette epoque. J'espere que vous me comprenez et que vous me pardonnerez.'

46 Letters to Hayter, 287 rue de Vaugirard, Paris from Jane Wade, 10 and 29 November 1955; Museum of Modern Art Archives, Curt Valentin Papers; Valentin II.A.13. [4] – Hayter Correspondence.

CHAPTER 8

47 'Exposition Internationale de Surréalisme', Galerie Maeght, Paris, July–August 1947.

48 'Exposition inteRnatiOnale du Surréalisme' (EROS), Galerie Cordier, Paris, December 1959–January 1960. An exhibition called 'Surrealism Beyond Borders' at the Metropolitan Museum of Art in New York (11 October 2021–30 January 2022) and Tate Modern in London (24 February–29 August 2022) showed how the movement became largely a non-First-World tendency after 1960.

49 For more on this, see Robert Goodnough, *Artists' Sessions at Studio 35*, New York: Soberscove Press/Wittenborn Art Books, 1950.

50 *Ibid*. Quoted in 'A constant searching of oneself' in Barbara Hess, *Abstract Expressionism*, Cologne: Taschen GmbH, 2005, p. 6.

51 Reuben Kadish, interview by Jeffrey Potter, New York, 12 April 1983; Pollock-Krasner House and Study Center archives, Stony Brook University, Stony Brook, NY.

52 The mixed-media *Orage/Storm* (1951) is one.

53 Quoted in Gail Levin, 'Miro, Kandinsky, and the Genesis of Abstract Expressionism', in Robert Carleton Hobbs and Gail Levin, *Abstract Expressionism: The Formative Years*, Ithaca, NY: Cornell University Press, 1978, p. 32.

54 For more on these, see Nanako Kakei, 'Oriental Calligraphy in Jackson Pollock: A Study of the Formation of the Black Paintings', *Aesthetics (The Japanese Society for Aesthetics)* no. 21 (2018), pp. 45–54.

55 Letter from Pollock to Alfonso Ossorio,? May 1951, Archives of American Art, Smithsonian Institution, Washington, DC: Alfonso Ossorio Papers, microfilm reel #2000.

Ossorio would write the essay to the catalogue for Pollock's eponymous show at the Betty Parsons Gallery, 26 November–15 December 1951.

56 A laudable exception is William Rubin's 'Notes on Masson and Pollock', *Arts*, xxxiv (November 1959), p. 42.

57 Nancy Jachec, *Jackson Pollock: Works, Writings and Interviews*, Barcelona: Ediciones Polígrafa, 2011, p. 42.

58 *Untitled* (1951), National Galleries of Scotland, accession number GMA 849.

59 Museum of Modern Art object number #1277.2008.1–11.

60 This had been made three years earlier, in 1995.

61 'Louise Bourgeois: The Woven Child', Hayward Gallery, London, 9 February–15 May 2022.

Further Reading

This is not intended as an exhaustive bibliography, but as suggested reading around the subject. Articles and periodicals are cited in endnotes.

Hayter and his role at Atelier 17

Susan M. Anderson, *Pursuit of the Marvelous: Stanley William Hayter, Charles Howard, Gordon Onslow Ford*, Laguna Beach, CA: Laguna Art Museum, 1990

Carla Esposito, *Hayter e l'Atelier 17*, Milan: Electa, 1990

Stanley William Hayter, *New Ways of Gravure*, New York: Pantheon, 1949

Stanley William Hayter, *About Prints*, Oxford: Oxford University Press, 1962

Désirée Moorhead and Peter Black, *The Prints of Stanley William Hayter*, London: Phaidon, 1992

Joann Moser, *Atelier 17: A 50th Anniversary Retrospective Exhibition*, Madison, WI: Elvehjem Art Centre, 1977

Julian Trevelyan, *Indigo Days*, London: MacGibbon & Kee, 1957

The surrealists and the Parisians in New York

Denis Bertholet, *Claude Lévi-Strauss*, Paris: Plon, 2003

André Breton, *Manifestoes of Surrealism*, trans. Richard Seaver and Helen R. Lane, Ann Arbor, MI: University of Michigan Press, 1969

Jean-Paul Clébert, *Mythologie d'André Masson*, Geneva: Pierre Cailler, 1971

Gilbert Kaplan, Timothy Baum, Riva Castleman, Robert Rainwater (eds), *Surrealist Prints*, New York: Harry N. Abrams, Inc., 1997

André Masson, *Line Unleashed: A Retrospective Exhibition of Drawings*, exh. cat., London: Hayward Gallery, 1987

Karin von Maur, *Yves Tanguy and Surrealism*, Ostfildern-Ruit: Hatje Cantz, 2001

Jeffrey Mehlman, *Émigré New York: French Intellectuals in Wartime Manhattan, 1940–1944*, Baltimore and London: Johns Hopkins University Press, 2000

C. Miglietti and S. Guégan, *André Masson: de Marseille à l'exil americain*, Marseilles: Musée Cantini/Lienart, 2016

Mark Polizzotti, *Revolution of the Mind: The Life of André Breton*, London: Bloomsbury, 1995

Lawrence Saphire and Stanley William Hayter, *André Masson: The Complete Graphic Work. Volume 1: Surrealism, 1924–49*, New York: Blue Moon Press, 1990

The AbExers

James Breslin, *Mark Rothko: A Biography*, Chicago: University of Chicago Press, 1993

Robert Carleton Hobbs and Gail Levin, *Abstract Expressionism: The Formative Years*, Ithaca, NY: Cornell University Press, 1978

Nancy Jachec, *Jackson Pollock: Works, Writings and Interviews*, Barcelona: Ediciones Polígrafa, 2011

Sidney Janis, *Abstract and Surrealist Art in America*, New York: Reynal & Hitchcock, 1944

Joan Marter, *Abstract Expressionism: The International Context*, New Brunswick, NJ: Rutgers University Press, 2007

Steven Naifeh and Gregory White Smith, *Jackson Pollock: An American Saga*, London: Barrie and Jenkins, 1990

Jeffrey Potter, *To a Violent Grave: An Oral Biography of Jackson Pollock*, New York: Putnam, 1985

Bernice Rose, *Jackson Pollock: Works on Paper*, New York: Museum of Modern Art, 1969

Stephanie Terenzio (ed.), *The Collected Writings of Robert Motherwell*, Oxford and New York: Oxford University Press, 1992

The final phase

Louise Bourgeois, *Destruction of the Father/Reconstruction of the Father: Writings and Interviews, 1923–1997*, Marie-Laure Bernadac and Hans-Ulrich Obrist (eds), Cambridge, MA: MIT Press, 1998

Margit Rowell, *Joan Miró: Selected Writings and Interviews*, London: Thames & Hudson, 1986

Deborah Wye and Carol Smith, *The Prints of Louise Bourgeois*, New York: Museum of Modern Art, 1994

Miscellaneous

Rudolf Arnheim, *Art and Visual Perception: A Psychology of the Creative Eye*, Berkeley: University of California Press, 1954

Jimmy Ernst, *A Not-So-Still Life*, Wainscott, NY: Pushcart Press, 1992

Peggy Guggenheim, *Out of This Century: The Autobiography of Peggy Guggenheim*, London: Andre Deutsch, 2005

Anaïs Nin, *The Diary of Anaïs Nin, Volume 3, 1939–1944*, New York: Harcourt Trade Publishers, 1971

John O'Brian (ed.), *Clement Greenberg: The Collected Essays and Criticism*, Chicago: University of Chicago Press, 1986

Christina Weyl, *The Women of Atelier 17: Modernist Printmaking in Midcentury New York*, New Haven: Yale University Press, 2019

Picture Credits

Colour plates

1 Private Collection, Paris. Photo Suzanne Nagy. Hayter © ADAGP, Paris and DACS, London 2023; **2** Solomon R. Guggenheim Museum, Solomon R. Guggenheim Founding Collection, New York. Photo The Solomon R. Guggenheim Foundation/ Art Resource, NY/Scala, Florence. © John Ferren; **3** Private Collection. Photo courtesy Koller Auctions, Zurich. Hayter © ADAGP, Paris and DACS, London 2023; **4** Zentrum Paul Klee, Bern. Photo Bildarchiv, Zentrum Paul Klee, Bern; **5** The Museum of Modern Art, New York. Given anonymously. Photo The Museum of Modern Art, New York/Scala, Florence. Hayter © ADAGP, Paris and DACS, London 2023; **6** The Museum of Modern Art, New York. Given anonymously. Photo The Museum of Modern Art, New York/ Scala, Florence. Masson © ADAGP, Paris and DACS, London 2023; **7** The Museum of Modern Art, New York. Photo The Museum of Modern Art, New York/Scala, Florence. Masson © ADAGP, Paris and DACS, London 2023; **8** National Gallery of Art, Washington, DC. Reba and Dave Williams Collection, Gift of Reba and Dave Williams. Masson © ADAGP, Paris and DACS, London 2023; **9** Private Collection. Tanguy © ARS, NY and DACS, London 2023; **10** Private Collection. Photo Christie's Images/Bridgeman Images. Tanguy © ARS, NY and DACS, London 2023; **11** Private Collection. Photo courtesy Redfern Gallery, London. Hayter © ADAGP, Paris and DACS, London 2023;

PICTURE CREDITS

12 National Gallery of Art, Washington, DC. Reba and Dave Williams Collection, Gift of Reba and Dave Williams. Hayter © ADAGP, Paris and DACS, London 2023; **13** Tate. Presented by Robert Jay Wolff 1973. Photo Tate. Hayter © ADAGP, Paris and DACS, London 2023; **14** Collection and courtesy of the Lucid Art Foundation; **15** The Museum of Modern Art, New York. Gift of Craig and Mary Barnes. Photo The Museum of Modern Art, New York/ Scala, Florence. Masson © ADAGP, Paris and DACS, London 2023; **16** Baltimore Museum of Art. Bequest of Saidie A. May. Masson © ADAGP, Paris and DACS, London 2023; **17** Syracuse University Art Museum, New York. Photo Syracuse University Art Museum/Bridgeman Images. Masson © ADAGP, Paris and DACS, London 2023; **18** The Museum of Modern Art, New York. Gift of Curt Valentin. Photo The Museum of Modern Art, New York/Scala, Florence. Masson © ADAGP, Paris and DACS, London 2023; **19** Private collection. Motherwell © Dedalus Foundation, Inc./VAGA at ARS, NY and DACS, London 2023; **20** Private Collection. Motherwell © Dedalus Foundation, Inc./ VAGA at ARS, NY and DACS, London 2023; **21** The Metropolitan Museum of Art, New York. Stewart S. MacDermott Fund, 1974. Motherwell © Dedalus Foundation, Inc./VAGA at ARS, NY and DACS, London 2023; **22** Collection unknown. Dedalus Foundation. Motherwell © Dedalus Foundation, Inc./VAGA at ARS, NY and DACS, London 2023; **23** Solomon R. Guggenheim Museum, New York. Foundation Gift, Ethel Baziotes, 2004. Photo The Solomon R. Guggenheim Foundation/Art Resource, NY Scala, Florence. © Estate of William Baziotes; **24** The Museum of Modern Art, New York. Gift of The Mark Rothko Foundation. Photo The Museum of Modern Art, New York/Scala, Florence. © 2023 Kate Rothko Prizel & Christopher Rothko ARS, NY and DACS, London; **25** The Museum of Modern Art, New York. Bequest of Mrs Mark Rothko through The Mark Rothko Foundation, Inc. Photo The Museum of Modern Art, New York/Scala, Florence. © 1998 Kate Rothko Prizel & Christopher Rothko ARS, NY and DACS, London; **26** Tel Aviv Museum of Art. Gift of the artist. Photo akg-images. Ernst © ADAGP, Paris and DACS, London 2023; **27** Philadelphia Museum of Art. The Louise and Walter Arensberg Collection, 1950. © 2023 Calder Foundation, New York/DACS, London; **28** National Gallery of Art, Washington, DC. Reba and Dave Williams Collection, Gift of Reba and Dave Williams. Courtesy the Reuben Kadish Art Foundation; **29** The Museum of Modern Art, New York. Gift of Lee Krasner Pollock. Photo The Museum of Modern Art, New York/ Scala, Florence. © The Pollock-Krasner Foundation ARS, NY and DACS, London 2023; **30** Tate Modern, London. Photo Tate. © The Pollock-Krasner Foundation ARS, NY and DACS, London 2023; **31** The Museum of Modern Art, New York. Gift of Lee Krasner Pollock. Photo The Museum of Modern Art, New York/Scala, Florence. © The Pollock-Krasner Foundation ARS, NY and DACS, London 2023; **32** National Gallery of Art, Washington, DC. The William Stamps Farish Fund. © The Pollock-Krasner Foundation ARS, NY and DACS, London 2023; **33** The Museum of Modern Art, New York. Gift of André Masson. Photo The Museum of Modern Art, New York/Scala, Florence. Masson © ADAGP, Paris and DACS, London 2023; **34** Philadelphia Museum of Art. Gift of the Print Club of Philadelphia, 1944. Hayter © ADAGP, Paris and DACS, London 2023; **35** National Gallery of Art, Washington, DC. Ailsa Mellon Bruce Fund. Hayter © ADAGP, Paris and DACS, London 2023; **36** Philadelphia Museum of Art. Purchased with the Leo Model Foundation Curatorial Discretionary Fund, 2015. Courtesy The Anaïs Nin Trust; **37** Private collection. Courtesy The Anaïs

PICTURE CREDITS

Nin Trust. Photo Annex Galleries, Santa Rosa; **38** Smithsonian American Art Museum, Washington, DC. Gift of Jacob and Ruth Kainen. Photo Smithsonian American Art Museum/Art Resource/Scala, Florence. Hayter © ADAGP, Paris and DACS, London 2023; **39** The Museum of Modern Art, New York. James Thrall Soby Bequest. Photo The Museum of Modern Art, New York/Art Resource. © Successió Miró/ADAGP, Paris and DACS London 2023; **40** National Gallery of Art, Washington, DC. Rosenwald Collection; **41** Courtesy Dolan/Maxwell, Philadelphia. © Successió Miró/ADAGP, Paris and DACS London 2023; **42** Private Collection. Photo Heritage Auctions. © Successió Miró/ADAGP, Paris and DACS London 2023; **43, 44, 45, 46** National Gallery of Art, Washington, DC. Purchased as the Gift of Dian Woodner. Bourgeois © The Easton Foundation/VAGA at ARS, NY and DACS, London 2023; **47** San Francisco Museum of Modern Art. Gift of Mr and Mrs Archibald Taylor. Photo San Francisco Museum of Modern Art. Hayter © ADAGP, Paris and DACS, London 2023; **48** The Museum of Modern Art, New York. Gift of the artist. Photo The Museum of Modern Art, New York/Scala, Florence. Masson © ADAGP, Paris and DACS, London 2023; **49** National Galleries of Scotland, Edinburgh. Photo National Galleries of Scotland/Bridgeman Images. © The Pollock-Krasner Foundation ARS, NY and DACS, London 2023; **50, 51** The Museum of Modern Art, New York. Gift of the artist. Photos The Museum of Modern Art, New York/Scala, Florence. Bourgeois © The Easton Foundation/VAGA at ARS, NY and DACS, London 2023

Black and white illustrations

2, 76 (BELOW) Münchner Stadtmuseum. Sammlung Fotografie/Archiv Landshoff. © Münchner Stadtmuseum 2022. Photo Scala, Florence/bpk, Bildagentur für Kunst, Kultur und Geschichte, Berlin; **6** Private collection. Photo Breisbach; **14** The Museum of Modern Art, New York. Given anonymously. Photo The Museum of Modern Art, New York/Scala, Florence. Hayter © ADAGP, Paris and DACS, London 2023; **18** Médiathèque de l'Architecture et du Patrimoine, Charenton-le-Pont. Photo © Ministère de la Culture – Médiathèque de l'architecture et du patrimoine, Dist. RMN-Grand Palais/André Kertés. Calder © 2023 Calder Foundation, New York/DACS, London; **27** Getty Research Institute, Los Angeles. Masson © ADAGP, Paris and DACS, London 2023; **28** Private Collection. Tanguy © ARS, NY and DACS, London 2023; **36** Collection and courtesy of the Lucid Art Foundation; **38** Courtesy of Désirée Levy Hayter; **40** New School Course Catalogue Collection, The New School Archives and Special Collection, The New School, New York. Hayter © ADAGP, Paris and DACS, London 2023; **49** Photo akg-images/TT News Agency/SVT; **53** New School Publicity Office Records, The New School Archives and Special Collection, The New School, New York; **58** The Museum of Modern Art, New York. Gift of Curt Valentin. Photo The Museum of Modern Art, New York/Scala, Florence. Masson © ADAGP, Paris and DACS, London 2023; **60 (TOP)** Photo Ylla. © Pryor Dodge; **60 (ABOVE)** United States National Holocaust Museum, Washington, DC; **63 (TOP)** WPA Federal Writers' Project Photograph Collection, Municipal Archives, City of New York. 3377-15. Courtesy Municipal Archives, City of New York; **63 (ABOVE)** Philadelphia Museum of Art, Library & Archives. Gift of Jacqueline, Paul and Peter Matisse in memory of their mother Alexina Duchamp; **75** Musée du quai Branly – Jacques Chirac, Paris. Photo © musée du quai Branly – Jacques Chirac, Dist. RMN-Grand Palais/Jean-Yves et Nicolas Dubois; **76 (ABOVE)** The Museum

of Modern Art Archives, New York. James Thrall Soby Papers. Photo The Museum of Modern Art, New York/Scala, Florence; **80** Solomon R. Guggenheim Museum, New York. Foundation Gift, Ethel Baziotes, 2004. Photo The Solomon R. Guggenheim Foundation/Art Resource, NY Scala, Florence. © Estate of William Baziotes; **82, 84 (ABOVE)** The Museum of Modern Art Archives, New York. Photographic Archive. Photos The Museum of Modern Art, New York/Scala, Florence; **84 (BELOW)** Private Collection. Courtesy Swann Auction Galleries. Tanguy © ARS, NY and DACS, London 2023; **102** National Gallery of Art, Washington, DC. The William Stamps Farish Fund. © The Pollock-Krasner Foundation ARS, NY and DACS, London 2023; **104** Archives of American Art, Smithsonian Institution, Washington, DC. Courtesy the Reuben Kadish Art Foundation. Pollock © The Pollock-Krasner Foundation ARS, NY and DACS, London 2023; **117** Archives of American Art, Smithsonian Institution, Washington, DC; **124** Philadelphia Museum of Art. Gift of the Print Club of Philadelphia, 1944. Hayter © ADAGP, Paris and DACS, London 2023; **127** 1940s Tax Photograph Collection, Municipal Archives, City of New York. Courtesy Municipal Archives; **129** The Museum of Modern Art Archives, New York. Photographic Archive. Photos The Museum of Modern Art, New York/Scala, Florence; **136** Collection Charles Darwent; **137** Courtesy The Anaïs Nin Trust; **138** Collection Charles Darwent. Courtesy The Anaïs Nin Trust; **146** National Gallery of Art, Washington, DC. Purchased as the Gift of Dian Woodner. Bourgeois © The Easton Foundation/VAGA at ARS, NY and DACS, London 2023; **150** Fine Arts Museums of San Francisco. Gift of Robert Flynn Johnson, 2004.140.7.2. Courtesy estate of Martin Harris; **152** Thomas Bouchard Collection, Harvard Film Archive, Harvard College Library. Courtesy Harvard Film Archive; **155** The Easton Foundation. © The Easton Foundation/VAGA at ARS, NY and DACS, London 2023; **168** The Museum of Modern Art, New York. Gift of the artist. Photo The Museum of Modern Art, New York/Scala, Florence. Masson © ADAGP, Paris and DACS, London 2023; **171** Solomon R. Guggenheim Foundation, Venice. Photo Archivio Cameraphoto Epoche. Gift, Cassa di Risparmio di Venezia, 2005. Calder © 2023 Calder Foundation, New York/DACS, London; **174** Martin Harris Collection, Special and Area Studies Collections, George A. Smathers Libraries, University of Florida, Gainesville, Florida. Courtesy estate of Martin Harris

Index

Page numbers in *italics* refer to illustrations, **bold** to figure numbers.

A

Abbott, Berenice *2, 76*
abstract expressionism 7, 9, 12, 46, 99, 133, 145, 171, 176
abstraction 23–4, 28–9, 43, 50, 99, 166
Acéphale 26, 27, 55

Albers, Anni 93
Albers, Josef 54, 93
Altmann, Robert 153
anthropology 8, 57, 73
Aragon, Louis 29
Arnheim, Rudolf 48–50
Art News 113, 132, 175, 176
Art of This Century Gallery, New York 94, 100, 173

INDEX

Arts and Architecture 105
Atelier 17 10–13
 ~ American artists at 85–97, 101, 112, 129–30
 ~ Bourgeois at 159–63, 184–7
 ~ and The Club 174–5
 ~ collectivist ethos 48, 87, 93, 99, 141
 ~ decline 145, 174–5, 177, 179
 ~ at East Eighth Street 13, 125–45, *127*, 173–5, *174*
 ~ French exiles at 61, 62, 66, 68–9, 71, 77–8, 85–6, 113, 128–9
 ~ lectures 53–7, *53*, 112
 ~ Miró at 147–8, 151–7, *152*, 180–1
 ~ MoMA exhibition (1944) 101, 129–31, *129*, 149
 ~ at the New School (West 12th Street) 13, 37–57, *38*, *40*, *53*, 126
 ~ in Paris 12, 16–20, 23–4, 27, 29–35, 130, 182
 ~ Pollock at 104, 109–10, 112–20, 165, 179, 183
 ~ research into Blake's relief technique 149–51, *150*
 ~ during Second World War 34–5
 ~ as Studio 17 79, 129
 ~ teaching at 29–31, 37–9, 41, 45, 48–50, 54, 71–2, 95, 105, 128
 ~ women at 12–13, 24, 162, 166
Atlantic Monthly 144
Auden, W.H. 39
automatism 8, 11, 24–6, 32–5, 48, 50–2, 56, 67–8, 70–1, 89–91, 96, 104–5, 141, 158, 176
avant-garde 9, 17, 19, 22, 43, 46, 59, 83, 111, 116

B
Baltimore Museum of Art 78–9
Barnet, Will 95–6, 157
Barr, Alfred 44, 78, 131, 163, 183
Bataille, Georges 26, 55
Bauhaus 21, 23, 175
Baziotes, Ethel 85–6, 93–4
Baziotes, William 42, 56, 93–4, 109, 170, 171, 181
 ~ *The Parachutists* 94, **23**
Beauvoir, Simone de 62, 144
Becker, Fred 44–5, 61, 72, 75, 151

Benton, Thomas Hart 105, 111–12
Berenson, Bernard 170–1
Bewley, Marius 164
Bitsoey, Diney Chilli 81
Blake, William 148
 ~ relief technique 11, 137–8, 148–51, *150*, 164
 ~ *America: A Prophecy* 149, **40**
Bouchard, Thomas, *Joan Miró Makes a Color Print* (film) 151–3, *152*
Bourgeois, Louise 8, 13, 24, 31, 132, 155–67, *155*, 177–8, 181, 182, 184–7
 ~ and Hayter 157–8, 162–3, 184–6
 ~ *Le Cauchemar de Hayter* 185, **50**
 ~ *Crochet I* 185
 ~ *Escalier de 63* 157
 ~ *Femme Maison* 159, 160, 161
 ~ *He Disappeared into Complete Silence* 157, 160–4, 184–5, **43–6**
 ~ *Ode à la Bièvre* 186
 ~ *Personages* 165
 ~ *Reply to Stanley Hayter* 185–6, **51**
 ~ *Untitled* (1996) 186
 ~ *The Woven Child* (and exhibition) 186, 187
Braque, Georges 17, 169
Breton, André 2, 7, 8, 10, 22–3, 25–8, 29, 32, 33–4, 35, 52, 54, 57, 59–64, *60*, *63*, 68, 70, 73–4, *76*, 78, 90, 105, 113, 126, 143–4, 145
 ~ *Le surréalisme et la peinture* 51, 71
 ~ *Manifeste du surréalisme* 22, 24, 25, 27–8, 51, 70, 71
 ~ *Second Manifesto of Surrealism* 26, 27–8
 ~ and Soupault, *Les Champs magnétiques* 24–5
 ~ Yup'ik mask owned by *75*
Breton, Aube 52, 59
Breton, Elisa *63*
Brevoort Hotel, New York 61, *63*
Brunidor Portfolio 163
Bucher, Jeanne 142–4
Buddhism 183–4
burin tool 11, 18, 24, 30, 31, 50, 90–1, 101, 113, 137, 142, 176
 ~ Bourgeois on 161–2, 163, 164, 186
Busa, Peter 108–9

INDEX

220

C

Cahiers d'art 23
Calas, Madame Nicolas *63*
Calas, Nicolas *63*, 83–5, 93, 153
Calder, Alexander 15–18, *18*, 19, 20, 30, 31, 39, 44, 64, 100, 113, 130, 147, 151, 161
~ *Arc of Petals 171*
~ *Cirque Calder* 17–18, *18*
~ *Helen Wills* 17
~ *Score for Ballet 0–100* 114, **27**
Calder, Louise 64
California School of Fine Arts 176
Carlebach, Julius 74, *75*
Carrington, Leonora *2, 76*
Cedar Tavern, New York 135, 137
Césaire, Aimé 63
Césaire, Suzanne *63*
Chagall, Marc 77–8, 130, 169, 181
Chareau, Pierre and Dollie 87–8, 90
Chateaubriand, François-René, *Atala* 64, 65
Chirico, Giorgio de 22, 53
Club, The, East Eighth Street 173–5
Cone, Etta 79
Cornell, Joseph 44
Crevel, René 22, 23
cultural exchange 10, 32–3, 39, 42, 68
Cunard, Nancy 29

D

Dalí, Salvador 7, 25, 33, 53, 150
Davis, Stuart 43
Day, Worden 176–7
De Kooning, Willem 7, 9, 42, 93, 171, 181, 183
Diebenkorn, Richard 176
dreams 25, 27, 55, 78
drip technique 35, 103, 108–11, 123, 142, 165, 176
Duchamp, Alexina *63*
Duchamp, Marcel *2*, 33, *63, 76*
Dyn 35, 113

E

École Libre des Hautes Études, New York 39–41
Eisenman *63*
Elisofon, Eliot *82*
Éluard, Paul 23, 27, 29, 32, 33, 34

~ *La Vie immédiate* 29, **10**
Ernst, Jimmy *2, 76*, 135, 183
Ernst, Max *2*, 7, 12, 22, 29, 31, 34, 53, *60*, 62, 73–5, *76*, 81, 103, 109, 110, 151
~ *La Planète affolée* 109, **26**
~ *Une Semaine de Bonté* 34
ethnography 29, 73–4
existentialism 144–5, 172–3
Exquisite Corpses 53, 59

F

Federal Arts Project *see* Works Progress Administration
Ferren, John *2*, 19–20, *76*
~ *Untitled (No. 34)* 20, **2**
Fletcher, Edith (Hayter's first wife) 15, 23, 139
Ford, Charles Henri 85, 125, 175
Fortune 134
Francés, Esteban *63*
Fraternity 35
Freud, Sigmund 50
Freudianism 8, 11, 24, 26, 54–5, 65, 89–90
Fry, Roger 21, 22
Fry, Varian 59, *60*
Fuller, Sue 86

G

Galerie Maeght, Paris 172
Galerie Pierre, Paris 22
Galerie Surréaliste, Paris 29
Galerie Vavin-Raspail, Paris 22
Gallatin, Albert 126
Gascoyne, David 32, 33
Gendel, Milton 43
Giacometti, Alberto 29
Goldstein, Phillip (Guston) 116, *117*
~ *Physical Growth of Man 117*
Goldwater, Robert 156, *157*–9
Gorky, Arshile 42, 56, 170, *171*
Gottlieb, Adolph 97, 99, 183
Greenberg, Clement 78, 81, 99, 100, 101, 112, 144–5, 163, 165–7, 172–3, 175–6, 179–80, 184
Grohmann, Will 23
Gropius, Walter 21
Gross, Anthony 23

INDEX
221

Guggenheim, Peggy *2*, 53, 62, *76*, 94, 100, 120, 127, 170–1, *171*, 173
Guggenheim, Solomon R. 20
Guggenheim Jeune, London 29

H

Harnoncourt, René d' 81–2
Harper's Bazaar 144
Harris, Martin *150*, *174*
Hartley, Marsden 43
Hayter, David (son) 139–41
Hayter, Stanley William *2*, *6*, 8, 10–12, 44, 45, 59, *76*, *150*, *174*, 181
 ~ dance-based works 114, 130
 ~ essays 67, 139–42
 ~ exhibitions 43, 44, 53, 57, 87, 92–3, 101, *129*, 129–34, 143, 170
 ~ family 139–41; *see also* Fletcher, Edith; Phillips, Helen
 ~ finances 23, 30, 91–2, 177
 ~ flight-based works 116, 121, 130
 ~ homes 30, 104, 105, 134–5, 139
 ~ in Paris pre-war 15–20, 23–4, 26–35, 54
 ~ in Spain 34
 ~ move to New York 37–41
 ~ pedagogy 29–30, 41, 45, 48–50, 54, 66, 105, 110, 128, 176–7
 ~ return to Paris 45, 113, 142–4, 148, 177–9, 181–2
 ~ work during the Second World War 37, 57
 ~ and the WPA 42–3
 ~ *Centauresse* 130, **35**
 ~ *Chiromancy* 44
 ~ *Cinq personnages* 139–40, 151, **38**
 ~ *Combat* 34, 45
 ~ *Composition with String* 17, **1**
 ~ *Falling Figure* 50, **12**
 ~ *Fish and Figures* 131
 ~ *Laocoön* 130, **34**
 ~ *Marionette* 176, **47**
 ~ *New Ways of Gravure* 162
 ~ *Night Moth* 153–4
 ~ *Oedipus* 23–4, 31, **5**
 ~ *Paysage anthropophage* 35, 41, **11**
 ~ *Rue de la Villette* 20–1, 23, 31, **3**
 ~ *Tarantelle* 130
 ~ *Three Dancing Women* 55

 ~ *Untitled* 51, **13**
 ~ *see also* Atelier 17
Hecht, Józef 16, 18, 31
Hofmann, Hans 109
Holty, Carl 147
Hugo, Ian (Hugh Parker Guiler) 47, 130, 137–8, *138*
 ~ *New Eyes on the Art of Engraving* 137, *138*
 ~ *Twilight Meeting* 138, **37**
 ~ *Under Sea Ballet* 138, **36**

I

Imago 50
intaglio printmaking 11, 18, 66, 75, 77, 92, 118, 139, 185
International Surrealist Exhibitions 32, 33, 181–2

J

Janis, Sidney 100
Jean, Marcel 61
Jensen, Alfred 99
Jewell, Edward Alden 97–8, 99
Johnson, Alvin 39
Johnson, Buffie 109
Johnson, Jacqueline 56
Jolas, Eugene 64, 79, 103
Jolas, Maria 64, 103
Jumble Shop, New York 61–2, 135, *136*
Jung, Carl Gustaf, and Jungian analysis 28–9, 51, 54–5, 65, 72, 90, 93, 98, 115, 141

K

Kadish, Barbara 135
Kadish, Reuben 103, *104*, 112–13, 116–18, *117*, 120, 135, 183
 ~ *Lilith* 116, **28**
 ~ *Physical Growth of Man* 117
Kahnweiler, Daniel-Henry 79
Kainen, Jacob 44, 46, 47, 54, 66, 91, 94, 98, 135
Kamrowski, Gerome 109
Kandinsky, Wassily 35, 39, 139
Katz, Leo 45, 139, 177
Kertész, André, *Portrait of Alexander Calder 18*
Kiesler, Frederick *2*, *76*

222 INDEX

Klee, Paul 21–3, 141–2, 166
~ *Zimmerperspektive mit Einwohnern*
22–3, 25, **4**
Klemperer, Otto 39
Kootz, Samuel 82–3, 100, 172
Krasner, Lee 12, 103, 109, 117–18, 127, 135
Kris, Ernst 50–1

L

La Guardia, Fiorello 42, 145
Lam, Wifredo *60*
Lamba, Jacqueline 52, 59, *60*
Landshoff, Hermann *2, 76*
Lane, James 113
language 10, 32, 33, 51, 55–6, 61, 62, 68
Laurel Gallery, *Laurels* (portfolio) 153–4
Léger, Fernand *2,* 16, 35, *76*
Lehman, Harold 108
Leiris, Michel 26, 31
Lévi-Strauss, Claude 8, 12, 57, 59, 69–74, 79, 105, 107, 114
Lieberman, William 119, 131, 153
line 20–3, 25, 31, 32, 33, 45, 48–9, 90, 93–4, 108, 132
Lipchitz, Jacques *150*

M

Mabille, Pierre 62
Magritte, René 53
Manchester, Hope *150*
Marion Willard Gallery, New York 44–5
Marxism 28, 54
masculinity 12, 16, 83, 166, 175, 185
Masson, André 7, 8, 9, 10, 12, 22, 23, 24, 25–7, 31, 32, 35, 51, 56, 57, *60,* 64–9, 71, 72, 74, 78–9, 81–2, 85, 98, 99–100, 105, 123, 125–6, 141, 145, 148, 180, 183–4
~ *Anatomy of My Universe* 97
~ *Automatic Drawing* 25, **6**
~ *Battle of Fishes* 26, 104, **7**
~ *Chantier d'oiseaux* 65–6
~ cover of *Acéphale,* no. 1 26, *27,* 55
~ *Dance* 123
~ *Dans la tour du sommeil* 67, **16**
~ *Elk Attacked by Dogs* 125
~ *Emblème* 75–7, **17**
~ *Le Génie de l'espèce* 77, **18**
~ *The Kill* 184, **48**

~ *Martinique charmeuse de serpents*
70
~ *Mythologie de la nature* 64
~ *Pasiphaë* 123, **33**
~ prints for publications 26–7, *27,* 75, **8**
~ *Rape* or *Rapt* 66–9, 71, 77, 115, **15**
~ *Untitled,* from *Solidarité* 27, **8**
Masson, Rose 26–7, 64, 69, 125
Matisse, Pierre 10, 20, 147, 166
Matisse-Monnier, Jacqueline *63*
Matta, Patricia Kane *63*
Matta, Roberto 52, 53, 55, *63,* 74, 89, 109
May, Saidie Adler 64, 79, 100
Mayor, A. Hyatt 125
Mexican art and artefacts 8, 29, 73–4, 81–2, 93
migration to New York 7–8, 15, 47, 48, *49,* 53, 55, 59, 69
Miró, Joan 22, 23, 27, 29, 31, 35, 53, 56, 121, 130, 131–2, 159, *155,* 165
~ at Atelier 17 147–8, 151–7, *152,* 180–1
~ Bouchard's film, *Joan Miró Makes a Color Print* 151–3, *152*
~ *L'Antitête (diptych)* 151, **41**
~ *Composition* 154
~ *Femme et oiseau devant la lune*
153–4, **42**
~ *Fillette, sautant à la corde* 153
~ *Self-Portrait I* 148, **39**
Mitchell, Joseph 61
Mondrian, Piet *2,* 68, *76,* 100
Moore, Henry 169
More, Gonzalo 34, 137–8
Morgan, Charles 103
Morrison, Jean *174*
Mortimer Brandt Gallery, New York
131–4, 140
Motherwell, Robert 7, 9, 10, 46–7, 52, 56, 68, 86–91, 96, 99–101, 109, 111, 143, 144–5, 158, 169, 170, 171, 181, 182–3
~ *The Homely Protestant* 91
~ *The Jewish Girl* 87–9, 90, **20**
~ *Pancho Villa, Dead and Alive* 90
~ *Personage* (two prints) 89–91, 98,
20, 21
~ *Three Figures Shot* 90, 91
~ *Untitled* 88, **19**

INDEX

Museum of Modern Art, New York (MoMA) 10, 20–1, 69, 78, 107–8, 121, 126, 131, 134, 142, 153, 181, 185
- ~ 'Advancing American Art' (1946) 145
- ~ 'Art in Progress' (1944) 130, 131
- ~ 'Britain at War' (1941) 57
- ~ 'Fantastic Art, Dada, Surrealism' (1936) 44, 78, 111
- ~ 'Hayter and Studio 17: New Directions in Gravure' (1944) 101, 129–31, *129*, 149
- ~ 'Indian art of the United States' (1941) 12, 81, *82*
- ~ 'Jackson Pollock' (1967) 119, 120
- ~ 'Twenty Centuries of Mexican Art' (1940) *84*, 85
Myers, John Bernard 123, 148, 153
mythology 26, 54–5, 64, 66, 73, 81–2, 85, 105, 182

N

Namuth, Hans, *Jackson Pollock* (film) 103, 105, 106–8, 114
Native American art 12, 73–5, *75*, 81–3
- ~ Kachina dolls 74, *76*
Navajo sand painting 8, 12, 74–5, 81, *82*, 85, 121
Naville, Pierre 71
Nevelson, Louise 12, 13
New Burlington Galleries, London 32, 33
New School for Social Research, New York 112
- ~ Atelier 17 at 37–57, *38*, *40*, *53*, 126
New York Post 37
New York School 46, 83, 91, 180, 183
New York Times 37, 43, 97, 131–2
New Yorker 92
Newman, Barnett 82, 83, 145
Nin, Anaïs 34, 44, 45, 47, 61, 88, 137, *137*, 163
- ~ *Ladders to Fire* 163
- ~ *Under a Glass Bell* 137–8, 139, 151
- ~ *Winter of Artifice* 137, 138
Noguchi, Isamu 128, 175
Norlyst Gallery, New York 159

O

O'Keeffe, Georgia 44, 166
Onslow Ford, Gordon 35, 52–6, 61, 175
- ~ *coulage* 35, 123

- ~ lectures 52–7, *53*, 112
- ~ *Temptations of the Painter* 52, **14**
Orozco, José Clemente 81
Ozenfant, Amédée *2*, 39, 41, *76*

P

Paalen, Wolfgang 35, 53, 89, 113
Parsons, Betty 184
Partisan Review 100–1, 163
Pavia, Philip 85, 173–5
perception 48–50, 114, 141
Péret, Benjamin 25
Peridot Gallery, New York 164–5
Peterdi, Gabor 29–31, 125, 133
Phillips, Helen (Hayter's second wife) 37, 38, 128, 134–5, 174, 176
Picasso, Pablo 17, 22, 27, 56
Pollock, Jackson 7, 9, 10, 12, 19, 42, 46, 50, 55, 56, 81, 85, 100–1, 103–23, *104*, 127–8, 135, 142, 165–7, 170, 171, 175, 176, 179, 180
- ~ and Hayter 104–5, 110, 112–16, 119–20, 122–3, 166
- ~ *Birth* 121, **30**
- ~ Black Paintings 184
- ~ MoMA exhibition (1967) 119, 120
- ~ *Moon Vessel* 142
- ~ Namuth's film *Jackson Pollock* 103, 105, 106–8, 114
- ~ *Number 14* 184
- ~ *Ocean Greyness* 183
- ~ *One: Number. 31, 1950* 106–7
- ~ *Sleeping Effort* 183
- ~ *Untitled (1, 4, 6, 8)* 120–1, **29**, **31**, **32**
- ~ *Untitled* (1951) 184, **49**
Possibilities 147
Pousette-Dart, Nathaniel 98–9
Prévert, Jacques 28
'primitive, the' 8, 72–3, 75, 85
Putzel, Howard 53, 105

R

Ray, Man 22, 34, 44
Rémy, Michel 33
Renaissance 21
Renne, René 141
Revolution surréaliste, La 71
Rewald, John 59
Rivera, Diego 81

INDEX

Roosevelt, Eleanor 81
Roosevelt, Franklin D. 9, 42
Rosenberg, Harold 145, 172, 180
Rosenthal, Lou, art supply store *127*, 128
Rosenwald, Lessing 149, 151
Rothko, Mark 7, 9, 42, 56, 94–100, 131–2, 170, 181
 ~ *Slow Swirl at the Edge of the Sea* 96–8, **25**
 ~ *Untitled* 95–6, 98, **24**
Rougemont, Denis de *63*, 65, 72
Rowell, Margit 180
Rubin, William 81
Russell, Alfred *150*

S

Sage, Kay 52, 69, 74
Sartre, Jean-Paul 144–5, 172
Sawin, Martica 9–10
Schapiro, Meyer 39, 41, 42, 62, 86
Schrag, Karl 113, 136–7, 142, *150*, 169
Second World War 7, 16, 29, 33–4, 37, 39, 42, 59, 125
Sekula, Sonia *63*
Seligmann, Kurt *2*, 7, 53, 55, 62, 68, *76*, 86, 173
Siqueiros, David Alfaro 108, 110–11, 116
Slivka, David 128
Soby, James Thrall 74, *76*, 126, 142, 144
Solidarité 27, 34–5, **8**
Sorini, Emiliano 118, 120
Soupault, Philippe, and Breton, *Les Champs magnétiques* 24–5
Spanish Civil War 27, 34, 35, 141
Spender, Stephen 35
Stephan, Ruth 154
Studio 17 *see* Atelier 17
Studio 35, East 8th Street 182–3
Sunami, Soichi *129*
Sweeney, James Johnson 101, 131–3

T

Tanguy, Yves 27–9, *28*, 52, 53, 56, 61, *63*, 69, 73–4, 79, 147, 151, 154, 157
 ~ cover of *View* 84
 ~ frontispiece for Éluard's *La Vie immédiate* 29, **10**
 ~ *Self-Portrait* 28

~ *Titre inconnu (Noyer indifférent)* 28–9, **9**
Tanning, Dorothea 74
Tiger's Eye 16, 154–5, 161
Time 78, 107, 108
Todd, Ruthven 127, 148–53, *150*, 176
 ~ *Fifteen Poems* (portfolio) 150–5
Transition 103–4, 105
Trevelyan, Julian 17, 30–1
Truman, Harry S. 145
Turquoise, Charlie 81

U

unconscious, the 8, 11, 24–5, 51, 104–5, 141
 ~ collective 29, 65, 93, 98

V

Valentin, Curt 10, 65–6, 125–6, 140, 149, 181
Venice Biennale
 ~ 24th 169–71, *171*
 ~ 25th 171
Vieillard, Roger 31
View 84, 85, 93, 123, 125
Vogue 144
VVV 90, 113–14, **27**

W

Wahl, Theodore 118
Waldberg, Patrick 69, 109
Wertheimer, Max 48, *49*, 50, 52, 114–15
Weyl, Christina 13
Wheeler, Monroe 101, 130, 131, 134, 142, 144
Whitney, Gertrude Vanderbilt 126
Whitney Museum of American Art, New York 7, 46, 126
Willard, Marion 44–5
Wills, Helen 17
Works Progress Administration (WPA) 9, 12, 42–4, 78, 82, 99, 117, 118, 144
World-Telegraph 133

Y

Ylla (Camilla Koffler) *60*
Yup'ik masks 74, *75*

Z

Zadkine, Ossip 16, 85
Zañartu, Enrique 86